Scottish Watercolours
1740-1940

Scottish Watercolours
1740 - 1940

JULIAN HALSBY

B.T. Batsford Ltd · London

ISBN 0 7134 1868 0
ISBN 0 7134 1869 9 Pbk

Printed and bound in Great Britain by
Butler & Tanner Ltd,
Frome and London

for the publishers
B. T. Batsford Ltd
4 Fitzhardinge Street, London W1H 0AH

Contents

Preface and acknowledgements		7
List of illustrations		11
Abbreviations used in the text		14
1	Early Scottish watercolours	15
2	Towards a Scottish School 1790–1830	33
3	Sir David Wilkie and his influence	52
4	The mid-century 1830–1880	72
5	The influence of Pre-Raphaelitism	93
6	Towards a freer style	110
7	The Glasgow School and its influence	130
8	Art Nouveau and Symbolist watercolours	172
9	The twentieth century	202
	Postscript	241
	Biographical dictionary of Scottish watercolour painters	245
	Appendices	
	Presidents of the Royal Scottish Society of Painters in Water-Colours	290
	Original list of the Scottish Society of Water-Colour Painters	290
	Scottish members of the Royal Scottish Society of Painters in Water-Colours	291
	Notes	294
	Select bibliography	
	General	298
	Individual artists	299
	Index	307

Preface and acknowledgements

It is only within the last 20 years that Scottish painting has aroused interest among English collectors, art historians and dealers. Individual Scottish artists who moved south, such as Wilkie, Roberts and MacWhirter, have always been admired, but their contemporaries in Scotland, such as David Allan, Giles or McTaggart, were hardly known outside a small circle of enthusiasts. English ignorance has been replaced in recent years by an appreciation of many aspects of Scottish art, and this has been due not only to the publication of a number of detailed books, but also to the activities of the Fine Art Society, who started mounting exhibitions of Scottish art at the Edinburgh Festivals in the 1960s. Since then the Fine Art Society has opened branches in Edinburgh and Glasgow, and major exhibitions of Scottish art are brought south to their Bond Street galleries. These exhibitions, sometimes organized in conjunction with the Scottish Arts Council, are usually accompanied by scholarly catalogues, and, as a result, the volume of literature on Scottish art has grown apace. In addition, the National Gallery of Scotland has organized several major exhibitions of Scottish art in recent years, including *The Discovery of Scotland* (1978) and *Master Class: Robert Scott Lauder and his Pupils* (1983), both accompanied by catalogues which are in themselves invaluable reference sources. Similarly, many Scottish public galleries have published illustrated catalogues of their collections, adding to the literature on Scottish artists, both major and minor.

Few serious students of late-nineteenth-century British painting would now dispute the importance of the Glasgow School; similarly the significance of C. R. Mackintosh, George Walton and the Glasgow designers is now fully appreciated, not only in Britain but also elsewhere. Other aspects of Scottish art, however, have achieved less recognition. This applies to much Scottish watercolour painting, and this book hopes to redress the situation by showing the wealth and variety of Scottish watercolours over a period of 200 years. The 1740s mark the tentative beginning of Scottish watercolours with the work of the young Robert Adam, while 1940 – a somewhat arbitrary date – is intended to signify that this book does not cover post-war developments, except

as regards artists already working before 1939. The book is roughly chronological, although the longevity of many Scottish artists makes this difficult; E. A. Walton, James Paterson and Robert Weir Allan all lived well beyond the period that marks the height of the Glasgow School, and Allan actually outlived Cadell, Peploe and Hunter. Likewise Waller Hugh Paton lived to see the flourishing of the Glasgow School, dying only five years before Arthur Melville. Other artists' work spans different styles; thus MacWhirter appears both in the chapter devoted to the influence of Pre-Raphaelitism on Scottish watercolours and as a pioneer of the freer – seemingly incompatible – style of the 1870s C. R. Mackintosh also spans two chapters. The chronogical approach is therefore treated in a flexible manner, while the chapter devoted to genre painting covers a period of 150 years.

One major problem has been the definition of 'Scottish'. Broadly speaking the book covers artists living and working in Scotland. Some, like McTaggart, pose no problem – they were born, trained, lived, worked and died in Scotland. Others, like Bough or Crawhall, were born in England, but worked and exhibited in Scotland and not only became associated with the Scottish School, but actually exerted an influence upon its development: others, like Robert Walker Macbeth or James Orrock, moved south at an early age, making their reputations in London and being influenced by the English School. These artists are noted in the Dictionary section, but do not feature in the main text. Some artists, like Wilkie, Roberts and MacWhirter, moved to London to live and work, but returned regularly to Scotland and their style was not greatly influenced by the English School. This implies the existence of a Scottish style of watercolour painting, or at least Scottish characteristics – a subject which is tentatively discussed in the Postscript.

A further problem is the definition of a watercolour artist as opposed to an oil painter. Certain painters like Tom Scott or David Allan worked almost exclusively in watercolour; others, like McTaggart and Gillies, worked extensively in both oil and watercolour, their watercolours forming an important part of their *oeuvre*. Others still were primarily oil painters, but their watercolours are both interesting and significant. This applies to some of the academic painters like Sir George Harvey, Sir George Reid and Sir William Fettes Douglas, and to certain genre painters like Thomas Faed and John Burr. In some cases their watercolours are quite unlike their oils in content and style, and I make no apology for concentrating solely upon their watercolours. In some artists' work watercolour played no significant part, and despite the possible importance of their oils these artists are not mentioned in the main text. Thus the reader will find few references to Sir James Guthrie, a major figure in the Glasgow School, but an oil painter and pastellist – very rarely, if at all, a watercolourist. Likewise Sir John Lavery is mentioned in the Dictionary section only, having produced a small number of watercolours in the mid-1880s, which, while successful in themselves, are incidental to the main body of his work. The selection will be open to criticism, and may in certain cases prove

wrong, as new work comes to light, either in the salerooms or from artists' families.

This book intends to be informative and direct. There are many fascinating questions about influences, patronage and training which need to be investigated further, but my intention has been to provide as much information as possible about as many artists as possible, rather than to speculate upon broader questions of art-history. I have assumed some prior knowledge. It would, for example, be impossible in the space available to outline the history of the Glasgow School or the development of Pre-Raphaelitism, and I have assumed that the reader can find good general accounts elsewhere. The standard works on Scottish painting mentioned in the Bibliography should be used to 'fill in' the background to such chapters – I have avoided the simple repetition of such information.

The purpose of the Dictionary section is to provide further infor- mation on artists discussed in the main text – mostly dates of election to societies – and to mention watercolourists who do not appear in the text. Lists of names and dates would have overburdened the main text, and the Dictionary section is intended to prevent this. Where an artist appears in the main text, and no further information is required, his names does not re-appear in the Dictionary. Artists referred to in the main text are indicated with an asterisk in the Dictionary. The Dic- tionary is not compiled from exhibition catalogues: good lists thus compiled already exist. I have seen examples of almost every artist mentioned, or have read contemporary criticism of their work, and thus the Dictionary is intended to be both critical and subjective. Once again discoveries in the salerooms and from family collections will add names to this list.

I have received help and advice from many people and I am very grateful for this. Andrew McIntosh Patrick of the Fine Art Society originally suggested that I should write this book and he has taken a great interest in its development over six years, making recommenda- tions about the work of certain artists and locating photographs of suitable watercolours. Una Rota kindly read the Dictionary section, making many corrections and allowing me to use information which she has painstakingly collated about Scottish lady artists. Patrick Bourne of Bourne Fine Art has helped me over many years, pointing me towards artists whose work I had overlooked, and has made cor- rections to the text and the Dictionary. I am also grateful to James Holloway of the Scottish National Portrait Gallery for giving much needed help on the early Scottish watercolourists and to Peter Rose who read and commented upon the text. William Jackson of the Scot- tish Gallery, Elizabeth Cumming of the Edinburgh City Art Gallery, Francina Irwin of Aberdeen Art Gallery, Anne Donald of Glasgow Art Gallery, Lindsay Errington of the National Gallery of Scotland, Joseph McIntyre of the Orchar Art Gallery and the staff of Dundee Art Gal- lery, Perth Art Gallery, Kirkcaldy Art Gallery, the Smith Institute, Stirling, the Burrell Collection, the Hunterian Collection at Glasgow

University, the People's Palace, Glasgow, the Victoria and Albert Museum, the British Museum, the Ashmolean and the Fitzwilliam have all helped me locate watercolours in their collections, often at considerable inconvenience to themselves. William Baillie, President of the RSW, kindly enabled me to see those records of the RSW still in existence. Both Malcolm Innes and Daniel Shackleton have given me invaluable advice as dealers in Scottish art. Simon Edsor of the Fine Art Society provided photographs of Scottish watercolours, many of which are reproduced: and Tim Auger of Batsford ironed out inconsistencies in the text.

Many people have spared me the time to discuss the watercolours of particular artists or groups of artists and I must thank the following for sharing their specialized knowledge with me: Roger Billcliffe of the Fine Art Society, Mary Newbery Sturrock, John Kemplay, Mary Herdman, Ruth D'Arcy Thompson, Sally Dott, Gordon House, Ailsa Tanner and Brian and Rachael Moss. The late Jack Naimaster stimulated my interest in watercolours and gave insights into Scottish artists he had known in London between the wars. Finally I must thank my family, in particular June and Stig Suomimen of the Malcolm Hotel who provided a marvellous base in Edinburgh from which much of the book was written; my wife, Miranda, and my children, Alastair and Catriona, who had to put up with my absences both in Scotland and in my study; and Jerry Duggan who so often held the fort at Highgate Gallery.

All measurements of paintings are given in inches, height before width.

List of illustrations

BLACK AND WHITE
1 Robert Adam
Landscape with Castle and Lake NGS
2 John Clerk of Eldin
Lasswade NGS
3 Jacob More
View of Vicorano NGS
4 Alexander Runciman
Ruins of the Baths of Severus NGS
5 John Brown
Full Length Standing Female Figure NGS
6 David Allan
A Neapolitan Dance BM
7 David Allan
A Beggar with a Donkey and Children NGS
8 Alexander Nasmyth
Edinburgh from Dean Village Fitzwilliam
9 Patrick Nasmyth
Between Bridgenorth and Much Wenlock BM
10 Andrew Wilson
Lasswade, near Edinburgh BM
11 Patrick Gibson
The Priest's House, Quivig BM
12 Andrew Donaldson
Landscape with House and River People's Palace Museum, Glasgow
13 Sir David Wilkie
Two Women NGS
14 Sir David Wilkie
The Letter Writer, Constantinople Ashmolean
15 Alexander Carse
Oldhamstock's Fair NGS
16 Walter Geikie
Rival Artists BM
17 William Simson
Interior of a Cottage, Killin NGS

18 John Phillip
A Street Scene, Segovia Private collection
19 Thomas Faed
The Story BM
20 Robert Herdman
The Fern Gatherer Private collection
21 John Burr
By the Sea BM
22 Tom McEwan
The Sewing Lesson Perth Museum and Art Gallery
23 James Giles
Sorracte from Civita Castellana Aberdeen AG
24 William Leighton Leitch
Travellers in an Italian Landscape Moss Galleries
25 William Leighton Leitch
Mr Muir's House on the Gareloch Fine Art Society
26 David Roberts
Tsur, Ancient Tyre, from the Isthmus Fine Art Society
27 William 'Crimean' Simpson
Parnassus and Helicon from Corinth Fine Art Society
28 Charles Heath Wilson
The Church of the Ognissanti, Florence Spinks
29 D. O. Hill
The Tomb of Burns, Dumfries NGS
30 Sir George Harvey
Glenfalloch NGS
31 James Cassie
On the East Coast NGS
32 E. T. Crawford
Marine View with Dutch Fishing Vessels NGS
33 Thomas Fairbairn
Stockwell Bridge People's Palace, Glasgow

34 Kenneth Macleay
William Ord Mackenzie IV of Culbo NGS

35 William Dyce
Ben Nevis from Glen Rosa Ashmolean

36 William Bell Scott
Grace Darling Victoria and Albert Museum

37 Waller Hugh Paton
Sundown, Brodrick Bay, Isle of Arran Private collection

38 Waller Hugh Paton
Near Glen Cloy, Arran Private collection

39 John Adam Houston
Ben Blaven from Ord Private collection

40 John Adam Houston
Loch Long Private collection

41 James Ferrier
The Kyles of Bute Private collection

42 George Wilson
Fallen Trees NGS

43 Horatio McCulloch
Near Glencoe NGS

44 Sam Bough
Moonlight, St Monance Moss Galleries

45 Alexander Fraser
November's Workmanship – Fine as May NGS

46 John MacWhirter
On the Coast near Dunoon Private collection

47 John MacWhirter
The Watermill by the Sea Private collection

48 George Manson
Smailholm Tower and Sandy-Knowe Farmhouse NGS

49 Sir William Fettes Douglas
Lundin Tower NGS

50 Sir George Reid
Traquair House NGS

51 Robert Thorburn Ross
Study of Ferns, Grass and Stones NGS

52 Robert Weir Allan
Oudepore Private collection

53 James Paterson
Santa Cruz Glasgow AG

54 James Paterson
Springtime, Moniaive Private collection

55 E. A. Walton
Winchelsea Private Collection

56 George Henry
The Girl in White Glasgow AG

57 George Henry
The Koto Player Glasgow AG

58 Edwin Alexander
The Dead Peacock Fine Art Society

59 Robert Alexander
Donkeys in front of an Arab Tent, Tangiers NGS

60 D. Y. Cameron
Traquair House, Peeblesshire Fine Art Society

61 R. M. G. Coventry
Kirkcaldy Private collection

62 Garden Grant Smith
The Market, San Sebastian Private collection

63 William Fulton Brown
Woodland Scene Glasgow AG

64 James Watterston Herald
Old Shore Head, Arbroath Dundee AG

65 Patrick Downie
Running Ashore Private collection

66 William Wells
Peggy Bowker Edinburgh City Art collection

67 Tom Scott
The Border Hunt Fine Art Society

68 Robert Gemmell Hutchison
Sunlight and Shadow – The artist's daughter Mrs Bourne

69 Emily Murray Paterson
Venice Private collection

70 James Cadenhead
Moorland Edinburgh City Art Collection

71 C. R. Mackintosh
Harvest Moon Glasgow School of Art

72 Frances Macdonald
The Sleeping Princess Private collection

73 Margaret Macdonald
The Mysterious Garden Private collection

74 Jessie Marion King
Good Fortune Spin her Shining Wheel Right Merrily for Thee Fine Art Society

75 Annie French
Gather Ye Rosebuds While Ye May Fine Art Society

76 Norah Nielson Gray
The Missing Trawler Glasgow AG

77 Katharine Cameron
There were Two Sisters Sotheby's
78 Katharine Cameron
Butterflies Perth Museum and Art Gallery
79 John Keppie
Interior of St Marks Glasgow AG
80 John Duncan
The Coming of Bride Dundee AG
81 Robert Burns
Whe doun before Erle Douglas Speir, She saw proud Persie fa' Fine Art Society
82 Charles Mackie
St Marks, Venice Dundee AG
83 Eric Robertson
The Two Companions Mr and Mrs Kemplay
84 Cecile Walton
The Truant Wife is Captured Mr and Mrs Kemplay
85 Robert Traill Rose
The White Peace Edinburgh City Art Collection
86 George Dutch Davidson
The Hills of Dream Dundee AG
87 George Dutch Davidson
Ullalume Dundee AG
88 Frank Laing
The Yellow Girl Dundee AG
89 David Foggie
Getting Up Dundee AG
90 J. C. B. Cadell
View of Iona Scottish Gallery
91 George Leslie Hunter
Road in Provence Sir Norman Macfarlane
92 J. D. Fergusson
After the Concert Hunterian
93 John Maxwell
Harbour with Warning Light Scottish Gallery
94 Anne Redpath
The Grand Hotel, Concarneau Bourne Fine Art
95 William Wilson
A Village in the South of France Scottish Gallery
96 William Crozier
Berwick-on-Tweed Scottish Gallery
97 Penelope Beaton
Leith Harbour Scottish Gallery

98 Adam Bruce Thomson
The Sound of Iona Scottish Gallery
99 Warwick Reynolds
Jaguar and Black Panther Aberdeen AG
100 A. E. Haswell Miller
Rocher St Michel, Le Puy Glasgow AG
101 George Houston
The Erratic Boulder, Iona Glasgow AG
102 William Hanna Clarke
The Tolbooth, Kirkcudbright Glasgow AG
103 Robert Eadie
By the Sea Glasgow AG
104 James Cowie
The Striped Background Aberdeen AG
105 James McBey
The Long Patrol – Nightfall BM
106 David West
Lossiemouth Private collection
107 William Grant Murray
Marble Rock and Harbour, Portsoy Aberdeen AG
108 James McIntosh Patrick
Burnmouth, Newtyle Sir Norman Macfarlane
109 Sir William Russell Flint
The Pine Tree by Etna Glasgow AG
110 Sir David Muirhead Bone
The Court of the Lions, Alhambra Glasgow AG

COLOUR (Between pp. 192 and 193)

1 'Grecian' Williams
Boats on the Isthmus of Corinth NGS
2 W. McTaggart
Girl Bathers Orchar Gallery
3 Arthur Melville
Awaiting an Audience with the Pasha Mr and Mrs Tim Rice
4 E. A. Walton
The Briony Wreath Bourne Fine Art
5 Sam Bough
West Wemyss Orchar Gallery
6 Joseph Crawhall
The White Drake Private Collection
7 C. R. Mackintosh
Village of La Lagonne Glasgow AG
8 Sir William Gillies
St Monance from the Harbour SNGMA

Abbreviations used in the text

MUSEUMS

NGS	National Gallery of Scotland, Edinburgh
SNGMA	Scottish National Gallery of Modern Art, Edinburgh
SNPG	Scottish National Portrait Gallery, Edinburgh
Aberdeen	Aberdeen Art Gallery
Burrell	Burrell Collection, Glasgow
Glasgow	Glasgow Art Gallery and Museum
Hunterian	Hunterian Art Gallery, Glasgow University
Dundee	Dundee Museum and Art Gallery
Perth	Perth Museum and Art Gallery
Kirkcaldy	Kirkcaldy Museum and Art Gallery
Stirling	Stirling Smith Art Gallery and Museum
BM	British Museum
VAM	Victoria and Albert Museum

EXHIBITING SOCIETIES

ARA	Associate of the Royal Academy, London
RA	Member of the Royal Academy
PRA	President of the Royal Academy
HRA	Honorary Member of the Royal Academy
RSA	Royal Scottish Academy, Edinburgh
RSW	Royal Scottish Society of Painters in Water Colours
RWS	Royal Society of Painters in Water Colours
ROI	Royal Institute of Oil Painters
RI	Royal Institute of Painters in Water Colours
NEAC	New English Art Club
RBA	Royal Society of British Artists
RE	Royal Society of Painter-Etchers and Engravers
SSA	Society of Scottish Artists
SWA	Society of Women Artists
GAC	Glasgow Art Club
GI	Glasgow Institute
RCA	Royal Cambrian Academy

ART SCHOOLS

GSA	Glasgow School of Art
ECA	Edinburgh College of Art

1 Early Scottish watercolours

After the political turmoil of the early eighteenth century, Edinburgh developed rapidly both economically and culturally, and by the 1760s there was a nucleus of artists, including Robert Adam, Jacob More, Alexander Runciman and John Clerk of Eldin, interested in sketching the local countryside as well as following artistic developments abroad. This early period of Scottish watercolour painting does not bear comparison with its English counterpart, nor indeed can it be described as a 'school'. The Scottish artists mostly worked by themselves, isolated to a large extent from the development of their contemporaries both in England and in Scotland, and they aimed their work at different publics. By comparison early English watercolours were often closely related in style, type and purpose. Thus the study of early Scottish watercolours revolves around the work of individual artists, rather than schools or styles.

One of the leading artistic figures in Edinburgh society was **Robert Adam** (1728–1792), architect, interior designer, property developer and businessman, whose pen-and-wash drawings represented far more than a hobby, and played an important role in the development of his architectural and aesthetic ideas. Adam's father, William, worked for a period with the Board of Ordnance, advising on the design of forts in Scotland to prevent further uprisings, and the young Robert Adam, who accompanied his father on visits to the Highlands, kept sketchbooks of the landscape. The official draughtsman to the Survey of Scotland was Paul Sandby, whom Adam probably first met in 1747. Sandby's talent was already well developed and the clarity of his line combined with the accuracy of his eye greatly influenced Adam's development between 1747 and 1752 when Sandby left Scotland. We also know from his later career at Woolwich that Sandby was a good teacher. Through Adam and Adam's brother-in-law, John Clerk of Eldin, both well connected in Scottish society, Sandby met potential clients and found a market for his dramatic views set with castles such as Dunstaffnage, Rothsay and Bothwell. The importance of Sandby in both Scottish painting and in the English appreciation of Scotland has been described by James Holloway in the excellent catalogue *The*

Discovery of Scotland.[1] Sandby's views of Scotland were published many years later in 1778 as *A Collection of 150 Select Views in England, Wales, Scotland and Ireland*, the Scottish views being made more Scottish by the introduction of kilted figures and the heightening of mountains. Sandby's etchings and drawings were of great significance to Adam and John Clerk, especially in the handling of landscape and foliage. Sandby's street scenes, however, executed in pen and coloured washes, and full of life and observation, had less effect on Adam, who never became an accomplished figure draughtsman. Their influence on David Allan was far more important.

In 1754 Adam departed for an extended visit to Italy, a trip which introduced him not only to classical architecture but also to the current Continental ideas on painting and drawing. Rome was already established as one of the main goals on the Grand Tour and, as Basil Skinner has shown, it became a Mecca for many Scottish collectors, artistocrats and artists.[2] Allan Ramsay, Scotland's leading artist in the 1750s, made several trips to Italy, the first being in 1738–9 when he studied under Solimena and Imperiali. He was again in Italy from 1754 to 1757 when he acted as friend and adviser to Robert Adam, whom he had met in Edinburgh. Ramsay had plans to publish a book on the history of architecture and, for this purpose, he produced detailed watercolours of Roman ruins. A sketchbook (NGS) dating from 1755–7 shows Ramsay's interest in classical sculpture and architecture. John Fleming has documented the relationship between Robert Adam and Allan Ramsay in Rome, and has shown that Adam, lodged in style in the house of Madam Guernieri by the fashionable Spanish Steps, attempted, with some success, to take Roman society by storm.[3] Adam was impressed and influenced by Ramsay's knowledge of classical archaeology and came to admire Robert Wood, the author of *Ruins of Palmyra*, who was also in Ramsay's circle.

A further influence on Adam's style was the French artist Jacques-Louis Clérisseau (1722–1820), whose drawings were freer than anything Adam had seen before; he was particularly successful in his use of wash drawings with little preliminary use of pen-and-ink, creating a powerful sense of light and shade and employing contrasts of masses rather than individual details. Clérisseau's elegance of style contrasted with Adam's earlier topographical attempts, and he encouraged both Adam and Ramsay to sketch in the countryside around Rome. Other influences on Adam included Antonio Zucchi (1726–1795), who introduced him to a nostalgic taste for the classical past, Jean-Baptiste Lallemand (1716–1803) whose drawings depicted crumbling gardens and terraces rendered with Rococo charm, and J. L. L. C. Zentner who showed Adam the possibilities of pure landscape in which architecture played no part.

In 1758 Adam returned to London and was soon caught up in a busy life as an architect, with little time to draw. Nevertheless he produced a series of fantasies in which castles or ruins dominate a rocky landscape. The style of these drawings varies greatly. In some, pen is used

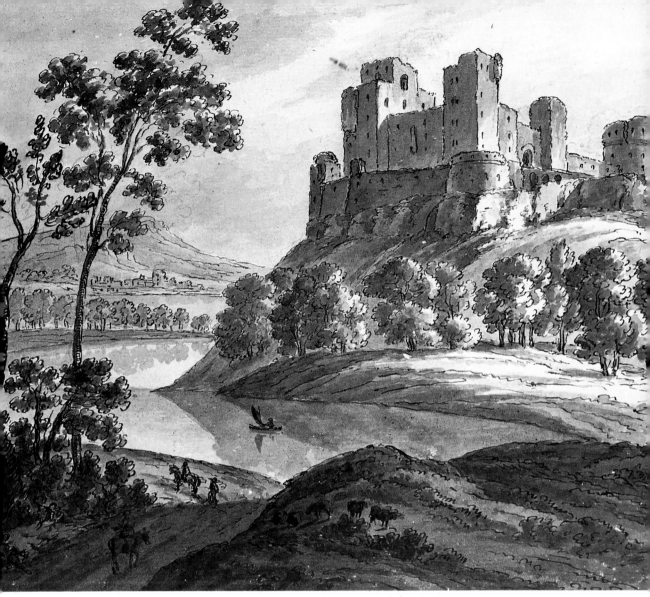

extensively for the outlines; in others only wash is used. Some are almost monochromes, while in others there is a use of full colour which, as Paul Oppé has written, 'would be quite bright were it not for the heavy under painting and a very free use of black to strengthen the foreground and the trees.'[4]

Adam often used a coarse, coloured paper which emphasized the restrained quality of the colours, resulting in an almost melancholic tonality of browns, with relieving touches of greens and blues. He used dramatically contrasting areas of sunlight and shadow, creating variety and movement. This concept of movement is described by Adam in the Introduction to his book *Works in Architecture of Robert and James Adam*:

> Rising and falling, advancing and receding, with the convexity and concav-
> ity, and other forms of the great parts, have the same effect in architecture
> that hill and dale, foreground and distance, swelling and sinking, have in

1 Robert Adam, *Landscape with Castle and Lake* $9\frac{1}{2} \times 12$ National Gallery of Scotland

landscape. That is, they serve to produce an agreeable and diversified contour that groups and contrasts like a picture, and creates a variety of light and shade which gives great spirit, beauty and effect to the composition.

Contemporary theories of landscape influenced Adam both towards the Picturesque and towards greater naturalism. The construction of Adam's *Landscape with Castle and Lake* (fig. 1) is clearly influenced by William Gilpin's *Essays on Picturesque Beauty*:

> A dark foreground makes, I think, a kind of pleasing graduation of tint from eye to the removed parts of landscape. It carries off the distance better than any other contrivance ... The middle and remote distances (which include the compass of the landscape) make the scene and therefore require most distinction.

Many of Adam's drawings show to what extent he saw landscape as an essential complement to architecture, in the true Picturesque spirit, and in a letter to Mrs Montague, he reveals his visual awareness of the Highlands seen through Picturesque eyes:

> I am not at all surprised that you found the castle of Inverary so defective. The surrounding mountains would humble a nobler piece of Human Art. The Pyramids of Egypt if situated near a Ben Lomond, or Skiddo, would look mean and despicable. Even the most admired efforts of the Greeks and Romans would appear altogether insignificant if placed near these unparalleled works of Nature.[5]

On the other hand Alexander Cozens's *Principles in Landscip*, which studied the changing effects of light and the different times of day, appears to have encouraged Adam to experiment with a more naturalistic approach to landscape drawing. This can be seen in two nocturnal scenes in the Blair Adam Collection, which represent the closest Adam was to move towards naturalism and the depiction of a precise moment in time.

Adam was never a professional artist and did not attempt to sell his drawings. They are personal records and suffer, to some extent, from repetition and varying quality. Adam was a prolific artist and on his death some 200 drawings were left in his London house, the bulk of which are today in four main collections; Blair Adam (Kinross), Sir John Soane's Museum, The National Gallery of Scotland and the Royal Museum of the Fine Arts, Copenhagen.

Until a recent exhibition the work of **John Clerk of Eldin** (1728–1812) had been overlooked.[6] The son of Sir John Clerk of Penicuik, he married Susannah, Robert Adam's younger sister, and remained a lifelong friend of the architect. His clothier business prospered and he was able to buy the Penicuik Coal Fields and estate near Lasswade, where he built his own house; here he retired from the clothing trade to run the estate and to sell its coal. This venture was not financially successful, and Clerk had to apply for an administrative post in Edinburgh, becoming Secretary to the Commission of the Annexed Estates for Scotland in 1783, and later adviser to the Port Authorities and the Admiralty, becoming recognized as an expert on naval tactics. Although Clerk had drawn as a child, it was the sketching expeditions

with Paul Sandby and Robert Adam between 1747 and 1754 that sti-
mulated his interest in art. In the 1760s Clerk was joined by Alexander
Runciman and Jacob More in sketching the countryside around Edin-
burgh, reflecting a growing interest in nature, which was a step away
from Sandby's strictly topographical style of the 1750s. Some years
earlier John Clerk's father had made a trip to the North of Scotland
and, like many of his contemporaries, he had not enjoyed the scenery:

> I could see nothing but a barbarous tract of mountains on both hands and
> scarce a stalk of grass to be seen. Neither were there fowls or birds of any
> kind to entertain our views.[7]

John Clerk did not share his father's views and produced both water-
colours and etchings which show a passionate interest in the Scottish
landscape and its changing light effects.

As a founder member of the Society of Antiquarians of Scotland,
Clerk took a great interest in Scottish architecture and worked on a
manuscript, *A Short Retrospective View of the State of Architecture in
Great Britain previous to Adam's time*, together with an account of the
style introduced by him. He did not reject the Gothic and was sym-
pathetic to the medieval Scottish Castle style. He travelled extensively
in Scotland in order to draw castles and abbeys. In most cases the
architecture is well drawn and is usually placed in the middle distance,
depth being created by shading in the foreground, while trees are used
to frame the main subject. Thus in compositional terms, Clerk's draw-
ings were conventional, relying upon the traditional device of *repous-
soirs*. Sometimes he captured the romantic feeling of a ruined abbey,
its walls overgrown and crumbling, while in other drawings he stressed
the rugged power of a massive castle. The weakest element in Clerk's
drawings are the figures which often appear clumsy.

In *Lasswade* (fig. 2) Clerk is painting an area he knew well; his own
house can be seen behind the trees on the top of the hill to the right;
thus topographical accuracy is combined with atmospheric feeling.
Clerk uses more colour than Adam. Sometimes red and brown pre-
dominate in the foreground, slowly progressing to blue and grey in
the distance; in other drawings a Claudian golden light is combined
with green or blue hues, while in others Clerk restricts his palette to
shades of grey. Similarly there are considerable variations in Clerk's
penwork; at times it is obscured by broad washes, while in other
drawings there is a fine use of pen influenced by his experiences with
etching.

Recently a series of drawings made for Dr James Hutton's *Theory of
the Earth* have come to light. They show that Clerk was also a careful
geological draughtsman. He accompanied Hutton to Glen Tilt in 1785
and to Galloway in 1786 and continued working on the project into the
1790s. William Playfair remarked that: 'Mr Clerk's pencil was ever at
the command of his friend, and has certainly rendered him most essen-
tial services.'[8] During his lifetime John Clerk rarely sold his etchings
and drawings and was an amateur. He must have been a stimulating

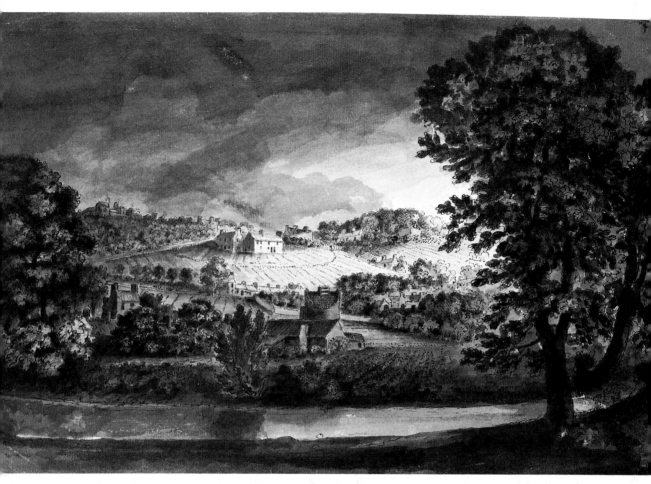

2 John Clerk of Eldin,
Lasswade
$9\frac{1}{2} \times 15\frac{1}{4}$ Sir John Clerk of
Penicuik

friend to Robert Adam for in later years he was described by Lord Cockburn as

> an interesting and delightful old man, full of the peculiarities that distinguish that whole family – talent, caprice, obstinacy, worth, kindness and oddity: a striking looking old gentleman, with grizzly hair, vigorous features and Scottish speech.

Amongst the younger generation of artists working in Edinburgh in the 1760s, **Jacob More** (1740–1793) earned the greatest reputation. Trained under the Nories and at the newly formed Trustees' Academy, he sketched in the open around Edinburgh, producing drawings which are not concerned with the minutiae of topographical details, but with a general feeling for light and shade. Unlike Adam and Clerk, More does not appear to have been influenced by the precision of Paul Sandby, and during this period More often used brown paper with sepia or green washes, heightened with white. The penwork is energetic and rhythmical, and many of these drawings are pure landscape with no buildings or figures. More could also turn to a more precise style as can be seen in a more detailed drawing of Dumbarton Castle (NGS).

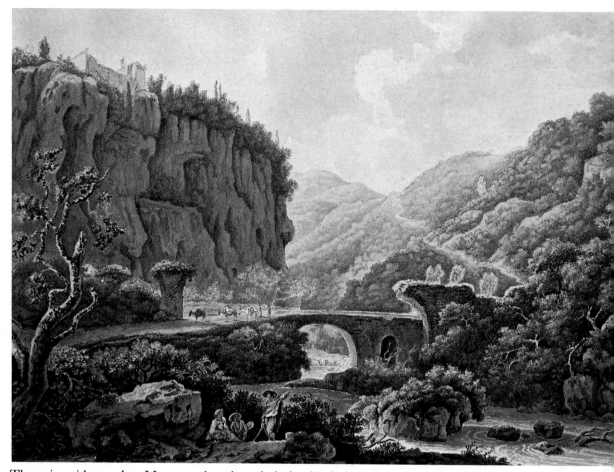

There is evidence that More produced a whole book of views in and around Edinburgh. It is referred to in a letter and was certainly taken to Rome by More, but has since disappeared.[9] During the 1760s More's reputation in Scotland grew steadily, and by the time he left for Rome in 1773, aged 33, he was considered one of the leading Scottish landscape painters. It is possible that he turned to landscape as a full-time profession as a result of his successful stage scenery for *The Royal Shepherd* of 1769. In designing scenery, More was following in the footsteps of his teacher, Robert Norie, and two of More's drawings for the theatre exist (NGS). The following years saw a series of oil paintings, *The Falls of the Clyde*, in which pen and wash drawings were used as preliminary studies. Already the influence of Italian artists can be felt.[10]

In Italy More continued to sketch in the countryside. In a letter of 1785 he wrote: 'Having finished my large picture for Prince Borghese, I propose going to the country for a month to make studies from nature.'[11] He painted both oils and watercolours, ranging over a wide area from Rome and its surroundings to Naples and Sicily, although Tivoli was one of his favourite sketching grounds, possibly reminding

3 Jacob More, *View of Vicorano*
$13\frac{1}{2} \times 19$ National Gallery of Scotland

him of the Clyde Falls. David Irwin has pointed out that More's compositions tend to be based on current eighteenth-century formulae – a prominent foreground motif of a tall tree or a rocky outcrop with one or two figures to give scale; a middle distance with a waterfall or river, taking the eye to the background of distant buildings and mountains.[12] Less conventional is his handling of colour in his drawings. Unlike his Scottish watercolours which tend to be restrained in colour, the Italian drawings have light and often sparkling greens and blues, and, at the same time, the whiteness of the paper is exploited to create an impression of Italian sunlight. Even the monochrome pen and wash drawings have a strong sense of sunlight, shade and depth (fig. 3).

While in Italy Jacob More became friendly with Alan Ramsay who was working on a treatise *An Enquiry into the Situation and Circumstances of Horace's Sabine Villa*. The villa had been situated near Licenza not far from Tivoli, and Ramsay visited the area to do some sketching in a relaxed, holiday mood. He actually began to write the treatise in 1777 and accompanied by More, he rented rooms in the Palace of Count Orsini at Licenza. James Holloway has shown how the two artists sketched together, and how More produced at least seven drawings which were intended for publication with the treatise.[13] These drawings, all dating from the 1777 visit, are done in the same style – typically light green and brown washes over rapidly drawn outlines in black chalk. Ramsay visited Licenza again in 1783 but More was too busy painting in Rome to accompany him. Nevertheless he agreed to work up Ramsay's drawings, and the *Rocca Giovina* (NGS) is an example of a drawing by Ramsay with colour added by More, who also added the figures and clouds.

Sir James Caw was critical of More's work:

> Owing to want of richness in the handling, and impasto and too little concentration in design (the lighting is too equally diffused for his pleasant but limited range of colours) most of his pictures are rather thin and flat in effect, but he painted with a fluent touch and distinct feeling ... and designed in the manner of Claude – best seen, perhaps, in his drawings in pen and wash – with a taste for line which, had it been supported by fuller tone and judiciously placed accents, would have been far more effective than it is.[14]

There is some justification for this criticism, as some of More's watercolours do lack contrast and 'bite'; however his freshness of colour and sense of light more than compensate for other weaknesses. More never returned to Scotland, dying in Rome in 1793.

The son of a builder and architect, **Alexander Runciman** (1736–1785) was born in Edinburgh and, after several years with Robert Norie, he attempted to make his living from decorative painting. While at work on decorations for Penicuik House, he was introduced to Sir John Clerk and his circle of friends, whom he joined in sketching trips around Edinburgh. Although Runciman's ambition was to be a history painter, his drawings from nature played an important part in his work. Several drawings from the first Edinburgh period (1760–67) survive

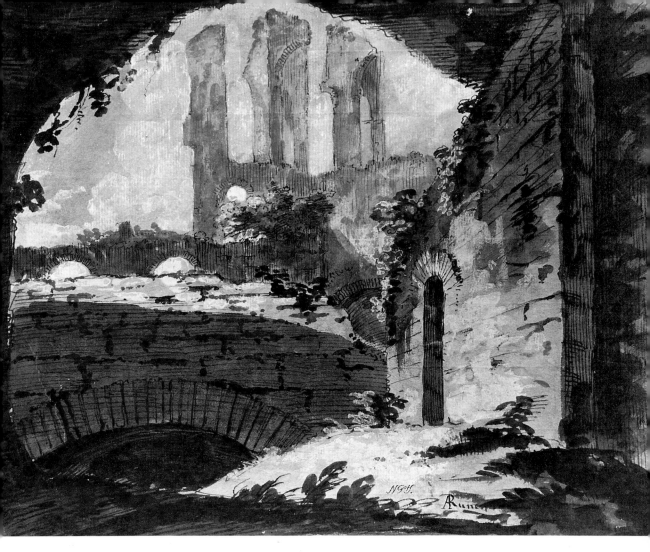

and vary from a sensitive pen-and-ink technique to a much freer and more dynamic brushwork. *View in East Lothian* (NGS) reveals Runciman's free brushwork and powerful *chiaroscuro*, a particular quality of his drawing which often made it more vibrant and exciting than that of Jacob More, despite Runciman's restrained palette. During this period Runciman travelled widely over Scotland, and in addition to painting landscape he also worked on stage designs and decorative designs for buildings, frontispieces and trade cards.

In 1767 Runciman left for Rome funded by the commission for the decorations in Penicuik House and by the help of an Edinburgh merchant, Robert Alexander. Whereas Jacob More was to go to Rome already established as an artist, Runciman went as a student of history painting, a subject which was more difficult to master in Edinburgh. In Italy he suffered financial hardship and attempted, apparently unsuccessfully, to earn money by producing views in and around Rome. The wash drawing (fig. 4) illustrated probably depicts the ruined Baths of Severus and clearly shows the influence of Piranese. To an artist already interested in *chiaroscuro*, the work of Piranese must have been

4 Alexander Runciman, *Ruins of the Baths of Severus* $9\frac{3}{8} \times 12\frac{3}{4}$ National Gallery of Scotland

most stimulating, although Runciman was already moving in this direction before leaving Scotland. This drawing also illustrates the delicacy and sureness of his penwork which is enhanced rather than swamped by the vigorous brushwork which is applied later. Runciman produced drawings of many of the famous sights including the Forum, the Appian Way, the Leonine Wall and the Tarpeian Rock, all showing his ability to organize a drawing into strong areas of light and shade using a combination of powerful washes and delicate penwork. Although most of the Roman views are vigorously handled, there are also examples of poetical drawings such as the *Italian River Landscape* (NGS). In Rome Runicman met Fuseli: there is little evidence that Fuseli influenced his drawing style (as he did John Brown's), but he did help Runciman find his feet in the complex area of history painting by directing him towards folk legends and the work of Shakespeare and Milton. Any artist involved in history and decorative painting would be fascinated by the Bolognese School and Runciman must have studied the Farnese Gallery in detail. Duncan Macmillan has shown how he continued to work on drawings for the Penicuik Ceiling while in Rome.[15] One such drawing for *The Marriage of Peleus and Thetis* (NGS) is done in a serious academic style, which he also used for *Achilles Dipped in the Styx* (BM). On the whole, however, his linear academic drawings are less successful than his freer style.

On his return to Scotland in 1772 Runciman continued to work at Penicuik and several drawings relate to this project. *The Death of Oscar* and *The Blind Ossian Singing* (both NGS) are executed in a powerful style which is effective in total, but often careless in detail – the washes hiding Runciman's weak anatomical draughtsmanship. These historical drawings do not compare in quality to his earlier landscapes and views of Rome, and it seems likely that his dissolute lifestyle affected the quality of his art. He was appointed Master of the Trustees' Academy in 1772 but had little interest in the job, seeing it as a temporary appointment until something better turned up. He remained, however, a somewhat unsatisfactory Master until his death in 1785.

The other artists working in Edinburgh in the 1760s deserve mention. **Richard Cooper Junior** (1740–1814) was the son and pupil of Richard Cooper, an English artist who settled in Edinburgh. During the 1760s Cooper was influenced by the decorative schemes of Delacour, Runciman, More and the Norie family, and there are wash studies for Rock Rooms in a light Rococo style (NGS). He studied in Paris under Le Bas and on his return worked in London exhibiting at the Royal Academy and the Society of Artists. In the 1770s he spent much time in Italy and his Italian watercolours showed fluent pen-and-ink drawing combined with vigorous brushwork and fresh colours. Although Richard Cooper was born in Edinburgh, most of his career was spent in London or abroad, and his influence on the Scottish School was slight. Between 1760 and 1767, the French artist **William Delacour** (d. 1768) held the first appointment as Master of the Trustees' Academy. After a period working in London, Delacour settled in

Edinburgh in 1757 and produced landscapes for use in stage scenery and architectural settings. John Adam commissioned a series of land-scape panels in 1758 for Lord Milton's house in Edinburgh, and a series of landscape with Roman ruins are *in situ* in Yester House, East Lothian. Delacour also worked in watercolour, using a broad style and Rococo interpretation of landscape, although he was equally capable of precise topographical views, especially when intended for engraving.

For a period in the 1780s **John Brown** (1752–1787) was one of the most original and accomplished Scottish draughtsmen. Born in 1752 in Edinburgh, he was the son of a goldsmith and watchmaker, and despite the limited means of his parents, he was given a good education studying under William Delacour at the Trustees' Academy. He was obviously a man of great charm, 'much beloved and esteemed by many men of letters, and by many women of elegance: his conversation being extremely acute and entertaining on most subjects, but particularly so on those of art'.[16]

In 1771 Brown left Edinburgh with David Erskine to visit Italy and was introduced to Roman society by Erskine's cousin, who held a post at the Vatican and was later to become Cardinal. In Rome Brown met Alexander Runciman and Jacob More and 'met with Sir William Young and Mr Townley, who pleased with some very beautiful draw-ings done by him in pen and ink, took him with them as a draftsman into Sicily'.[17] A sketchbook in the Victoria & Albert Museum shows his careful drawing of Antique Sculpture and he also did views of Rome and of Sicily. In 1774 he sent two drawings to the Royal Aca-demy, *A Cave of Dionysius at Syracuse in Sicily* and *A view of the Colosseum in Rome*; several landscape drawings from this period are known, mostly showing the influence of Claude Lorrain and Poussin, especially in the placing of murder scenes in the foreground.

Far more interesting and original than his Roman views are Brown's superb drawings of Roman women and street characters. It was here that, for a short period, Brown really excelled. The influence of Fuseli is evident in these drawings, and indeed Fuseli is known to have been friendly with Brown. Nevertheless, the drawings are by no means pas-tiches, being highly personal and original, depicting either over-dressed Roman women or evil-looking characters from the back streets. In all only some 15 have been traced and it seems unlikely that many more will turn up, but they are enough to establish Brown's position.[18] These drawings are executed in pen-and-ink with deep washes in Indian ink and bistre, creating an almost sinister sense of light and shade. *The Seller of Daggers* depicts detail in the pattern of one cos-tume to give a focal point, while the faces radiate malice. *The Three Friends* shows three elegant Roman women dressed in the latest fashion which Brown exaggerates to great effect. He again achieves a satisfac-tory delineation of patterns in the clothing. Another drawing, *The Con-gregation*, reveals the influence of Poussin in the dark brooding atmo-sphere, while Caravaggio must have inspired the handling of *chiaroscuro* as well as the choice of subjects. On the other hand a

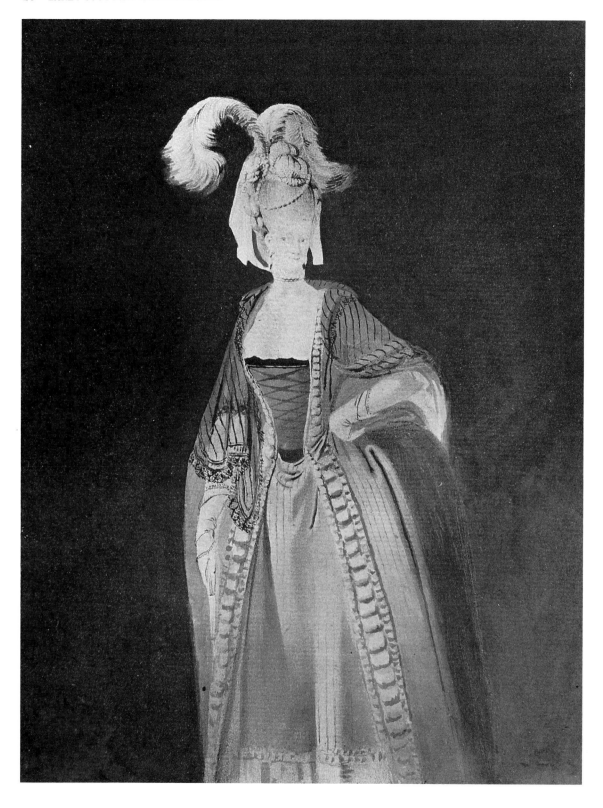

drawing, *The Holy Family*, in the Royal Academy shows the deep impression that classical sculpture made on Brown, and looks forward to the work of Flaxman.

Had Brown remained on the Continent, his work might well have developed yet further. The potential is clearly evident in the Roman drawings, but he decided to return to Edinburgh. Lord Buchan, one of the founders of the Society of Antiquaries of Scotland and the author of Brown's obituary in *The Bee* realized the error of this move:

> If he had gone to Berlin the Great Frederick II would have doated on him and his genius would have been permitted to expand. But he came to the cross of Edinburgh, from piety to his parents, and he languished in obscurity long after his return from Italy.

Although, according to Lord Buchan, 'the pencil and crayon were ever in his hand, and the sublime thoughts of Raphael and Michelangelo ever in his imagination', the quality of his work in Edinburgh never approaches that of his Roman drawings. To earn a living Brown produced many pencil portraits and Lord Buchan commissioned him to draw the members of the Society of Antiquarians in 1780 and 1781. These drawings, 31 in all, are very proficient but lack the imagination of his Roman work, possibly because the use of lead pencil prevented Brown from indulging in his real ability to use strong *chiaroscuro*. In 1786 he left Edinburgh for London having married in the same year, and exhibited for the second time at the Royal Academy – this time a portrait and a frame of miniatures. In London he was 'very much employed as a painter of small portraits in black lead pencil', but he had to return to Edinburgh on the death of his father.[19] He returned by sea and himself died in Edinburgh in September 1788 aged only 35.

John Brown was a highly intelligent artist: he mastered the Italian language, composed poems in Italian, although none now survive, and wrote *Letters Upon the Poetry and Music of the Italian Opera* which was published postumously in 1789. He is one of the most fascinating figures of his period.

David Allan (1744–1796) is an important figure in the development of Scottish painting both in oils and watercolour, for he established not only the concept of genre which was to re-appear time and time again in Scottish art, but also helped to establish the tradition of Scottish history painting. Born at Alloa near Stirling in 1744, Allan was educated at the parish school but seemed to show an aptitude only for drawing caricatures. On the advice of Lord Cathcart he was sent to Glasgow to study at the newly established Foulis Academy, where he remained for nine years from the age of 11. The next step in a young artist's education was Italy and Lord Cathcart again helped Allan. Cathcart's wife was sister to the British Ambassador in Naples, Sir William Hamilton, a noted collector and connoisseur. Thus with money from the Cathcarts and from another local family, the Erskines, Allan was sent to Rome to continue his studies. The exact date of his arrival is not known, although it was probably 1767 or 1768; he re-

5 John Brown, *Full Length Standing Female Figure* $9\frac{1}{2} \times 7\frac{1}{2}$ National Gallery of Scotland

mained about ten years but returned to Scotland, probably more than once, to paint portraits of local families. In Rome Allan made his mark as a lively and witty conversationalist; Sir William Hamilton was prompted to describe him as 'Lady Cathcart's little painter Allan, one of the greatest geniuses I ever met with: he is indefatigable'. He worked hard at his art, being greatly influenced at first by history painting in the grand manner. However his natural ability for caricature and rapid sketching enabled him to draw local scenes and figures. Thus in 1769 he began a series of drawings in pen and wash, *Evening Amusements in Rome and Naples*, and a year later he started a sketchbook of costumes and figures illustrating people encountered on his visits to different parts of Italy and France.

There must have been considerable pressure on Allan to become a history painter, especially after winning the Concorso Balestra and a gold medal at the Academy of St Luke for a baroque work entitled *The Origin of Painting*. Allan nevertheless found time to work on and develop his sketches of Italian characters and costumes. In many ways this ensured his future success. In later years, his talents as a history painter were sought after, but was always to be in demand also as an illustrator of local festivals, habits and costumes. During his ten years in Italy, Allan produced a large number of watercolours and pen-and-wash drawings. These fall into several categories. Sometimes he would concentrate on individual characters such as *A Neapolitan Sailor*, *A Roman Beggar*, *The Pope's Swiss Guard* or *Italian Mother and Child*.

6 David Allan,
A Neapolitan Dance
$7\frac{3}{4} \times 14\frac{1}{2}$ British Museum

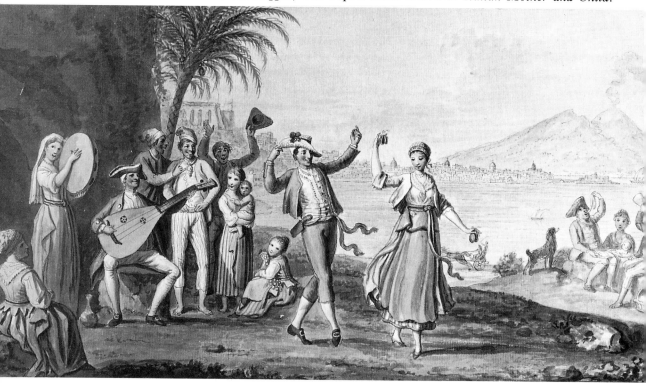

These character studies show a firm and convincing handling of the human form. Sometimes he would depict a dance or festival such as *Evening Amusements* or *A Carnival*, often drawn in a way which describes the *joie de vivre* experienced by artist and subjects alike (fig. 6). This essential happiness is possibly the result of the effortless manner in which Allan draws; there is no sign of struggle or second thoughts. His figures dance happily across the paper and even the beggars seem to enjoy their lot, and while Allan likes to depict different types of people and their social classes, the drawings make no direct social comment. His skill lies in his ability to sum up his subjects' status without verging upon caricature. David Irwin has pointed out that Allan was influenced by classical sculpture and that several of his groups reflect classical reliefs.[20] However, just as Robert Adam in his interiors used classical motifs in an essentially Rococo manner, so Allan uses classical poses for his dancers in a Rococo spirit and setting. In 1777 Allan returned to London where he spent two unsuccessful years. Joshua Reynolds was the unrivalled portrait painter and the unknown Allan had little chance of breaking in, despite exhibiting his Roman Carnival drawings at the Royal Academy. So in 1779 he returned to Edinburgh where he was to remain for the rest of his life.

In 1785 Alexander Runciman died and the post of Master of the Trustees' Academy fell vacant. Several artists competed for the post which carried a salary of £120; Allan was successful and for the first time in his life he was to enjoy a steady income. The Master was expected to concentrate upon industrial design, which invariably meant pattern drawing for local manufacture in textiles, and Allan duly produced some patterns for carpets and textiles, one of which is in the National Gallery of Scotland. But he also encouraged students to paint genre and he opened his own studio at Dickson's Close, off the High Street, where he taught many pupils, including Hugh 'Grecian' Williams. In the last ten years of his life Allan seems to have achieved financial stability and personal happiness, marrying late in life and becoming the father of five children.

Allan had always been interested in printing and had seen the success of Paul Sandby's aquatints made from his own *Sketches of the Roman Carnival*, a series of prints which had earned Allan the title 'The Scottish Hogarth'. In the 1780s Allan decided to produce a series of prints illustrating Allan Ramsay's classic *The Gentle Shepherd*, and set about raising the money for a beautifully illustrated and produced edition. Allan rode out into the Pentland Hills south of Edinburgh to visit the actual scenes described in the play and attempted to capture the character and costumes of the people involved. The 12 drawings for the book were finished by 1787 and the edition, published by Foulis, appeared in 1788, becoming an instant success. Allan's careful observation is evident and in the Letter of Dedication to Gavin Hamilton, he wrote of Ramsay:

I have studied the same characters on the same spot, and I find that he has drawn faithfully and with taste from Nature. This likewise, has been my

model of imitation, and while I attempted in these sketches to express the idea of the poet, I have endeavored to preserve the costume as nearly as possible by as exact delineation of such scenes and persons as he actually had in his eye.

The drawings reveal not only Allan's interest in landscape, but an early awareness of Scottish traditions.

In 1788 Allan began a series of watercolours depicting Edinburgh characters (NGS). They were a sequel to the Italian characters, and show such figures as *A Kilted Highland Officer*, *A Poor Father with 29 Children*, *An Edinburgh Fireman*, *A Fish Wife* and *A Beggar with a Donkey*, in which Allan wittily contrasts the elegantly dressed lady to the unfortunate beggar, but, unlike Hogarth, makes no moral comment (fig. 7). His drawing is firm, though using something of a formula for facial expressions, and his colour is fresh. At this time Allan was also embarking on a series of Scottish history paintings. Scenes from Scottish history were becoming popular with English as well as Scottish artists, but Allan was certainly the first to use watercolour for such subjects. A series in Edinburgh (NGS) depict scenes from the life of Mary Queen of Scots and probably date from the late 1780s. Allan worked on this series on the suggestion of Lord Buchan, visiting Hopetoun House and Pitfarrane House to sketch details of contemporary settings and clothes. He also produced illustrations for editions of Ossian, the hypothetical Scottish bard, in addition to scenes from Shakespeare. Allan's interest in history painting was influential amongst the following generation.

One of Allan's last projects was a series of illustrations for an edition of Robert Burns's *Scottish Songs* organized by George Thomson, the clerk at the Trustees' School. Strangely enough, the two great propagators of Scottish genre, Burns and Allan, while living in the same town, did not meet, despite collaboration in the 1790s. Allan produced 20 illustrations for this edition, but his health was failing and when he died in August 1796, less than a month after Robert Burns, the work was still incomplete and was never published. Nevertheless, Allan's drawings of Burns's images were important for artists like Geikie, Carse and Wilkie. Thus watercolours such as *The Penny Wedding*, *The Highland Wedding*, *The Cottar's Saturday Night*, *Madge and Bauldy* and *Domestic Scenes*, all drawn with great observation as well as a sense of humour, can be considered as the foundation of Scottish genre.

Throughout his life, Allan had been interested in landscape, not only as a setting for his characters, but also as a subject in its own right. He had insisted on drawing the Pentland Hills from nature, and, being a keen traveller, he made many other such expeditions. In 1793 he drew Dundas Castle and worked in and around his home town of Alloa. A view of Clackmannan Tower probably dates from this year, as does the view of Culross Abbey. In 1794 he visited North Queensferry, drawing the bay and the countryside to the north, while in the following year he was at Moffat where he drew the mineral well with tourists taking the waters. These landscape drawings were important for 'Grecian'

7 David Allan, *A Beggar with a Donkey and Children asking a Lady for Alms* $9\frac{3}{4} \times 7\frac{3}{8}$ National Gallery of Scotland

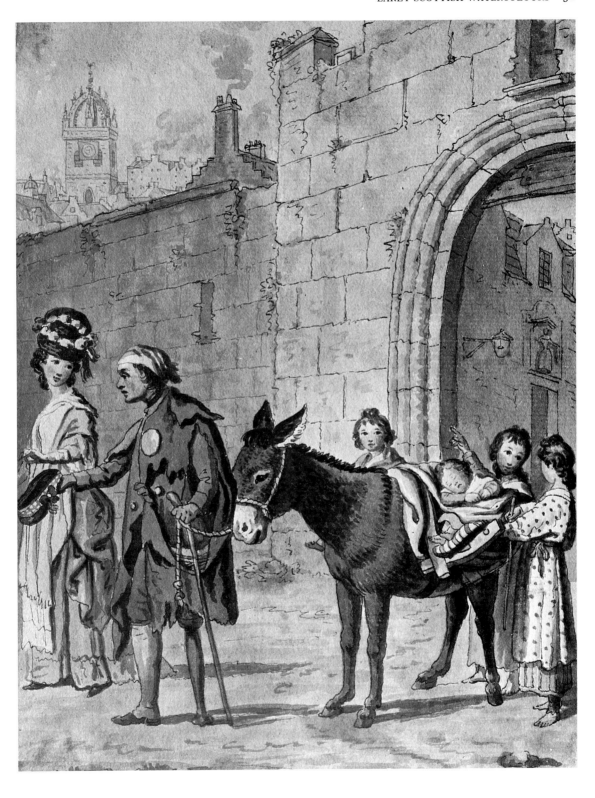

Williams in terms of the clear colours and the handling of the pen work, particularly in the foliage.

Like David Allan, **Charles Cordiner** (1746–1794) studied at the Foulis Academy in Glasgow (1763–66) before becoming Episcopal Minister in Banff. While in Glasgow he made drawings of local views including Bothwell and Crookston Castles, which were engraved by another Foulis Academy student, **Robert Paul** (1739–1770), himself a competent draughtsman, but more devoted to the art of engraving. Their joint expeditions into the countryside to sketch provides a parallel with the Edinburgh artists. In Banff, Cordiner established a reputation as an artist and received commissions to paint local views in both oils and watercolour. In 1769 he made a sketching tour of Northern Scotland which resulted in his *Antiquities and Scenery of the North of Scotland* (1780). The drawings for this book show an influence of Claude Lorraine and *Cascade in Sutherland* (BM) is complete with a Roman river god playing his lyre, suggesting that Cordiner might have visited Italy. Other watercolours, such as *Prospect of Morven* (BM), are more objective, representing an early view of Highland mountains with three bonneted figures in tartan in the foreground. Cordiner's interest in Celtic remains is revealed in his book *Remarkable Ruins and Romantic Prospects of North Britain* which appeared, after his death, in 1795.

One of the most significant features of this period was the establishment of academies to teach art.[21] The short-lived Academy of St Luke in Edinburgh (1729–31) was followed by the establishment of an academy in Glasgow in 1753 by Robert Foulis, who had built up a collection of Old Masters, sixteenth- and seventeenth-century engravings and copies after Italian High Renaissance paintings. Emphasis was placed on history painting and on copying Old Masters and Antiquity, but painting from models or landscape from nature played little part in the curriculum. The academy closed in 1775 after the death of Andrew Foulis, by which time the Trustees' Academy had been established in Edinburgh (1760) by the Board of the Trustees for Improving Fisheries and Manufactures in Scotland. Unlike the Foulis Academy, its aim was to teach industrial design – carving, gilding, textiles, cabinet making, glass-engraving and goldsmithing – but the Master appointed by the Trustees was always a fine artist, and it was often difficult to maintain a balance between design and fine art. Under the Mastership of **John Graham** (1800–1817) the emphasis moved strongly towards the fine arts, drawing from life replacing mechanical copying, and many significant artists were trained at the Trustees' Academy.[22] Apprenticeship and private schools also played a part in this period. The Norie family of decorators instructed young artists in landscape painting and both Alexander Runciman and Jacob More benefited from their experience. Two private schools existed in Edinburgh during the later years of the century: David Allan combined his role as Master of the Trustees with a small private school at his studio in Dickson's Close, while the Nasmyth family ran a successful school at York Place.

2 Towards a Scottish school 1790-1830

During the period from 1790 to 1830 the art and practice of water-colour painting in Scotland developed rapidly. Many artists used the medium for finished landscapes as opposed to preliminary sketches and much topographical work was executed in watercolour. This period also marks the spread of the professional artist in Scotland. Of the artists in the previous period, many were amateurs, or (like Robert Adam) earned their living from other professions, while others were forced to live abroad to further their art. By 1826 when the Royal Scottish Academy was founded there were a significant number of artists who survived entirely on their painting, and of these, many were watercolourists.[1] Of the 25 Foundation Members and Associates of the RSA at least ten were competent watercolourists, and there were other watercolourists, especially on the west coast, who were not members. Thus by the 1820s watercolour had been transformed from a minor art form into an important aspect of Scottish painting and art training. The watercolour artists of the period show growing concern with the technique of the medium. Colour became more important and the sophisticated colours of 'Grecian' Williams and Andrew Wilson must have made the restrained washes of Adam and Clerk seem outdated. The actual technique of applying the medium and its relationship to the original drawing was explored. 'Grecian' Williams explained how he mixed and applied his colours using brushes, sponges and even stale bread, and Alexander Nasmyth was fascinated by the potential of watercolour. Whereas his earlier works are in the controlled pen-and-ink and wash style of the eighteenth century, a watercolour such as *A View in North Wales* (BM) pushes the technique into exciting new ground. Andrew Wilson was also a fine colourist and explored ways of creating luminosity with watercolour by allowing the whiteness of the paper to shine through.

James Holloway has shown how this generation of artists was influ-enced by a new, romantic feeling towards the Scottish landscape.[2] The ruggedness of the landscape was to be admired, and Sir Walter Scott, himself a great influence upon many of the artists of the time, wrote:

> I like the very nakedness of the land; it has something bold and stern and solitary about it.[3]

English writers, artists and poets came north to savour the Romantic imagery of the Highlands. This Romanticism is possibly less evident in the watercolours than in the oil paintings of the period. This might be chance; John Thomson of Duddingston used watercolour rarely and certainly not for finished exhibition work. It might also be that watercolour was considered less suited to a Romantic interpretation of nature, and it is significant that 'Grecian' Williams's most Romantic works – his late views of Greece and Italy – are often painted in a mixture of oil and watercolour. Nevertheless Romanticism did influence the watercolourists, especially in the abandoning of eighteenth-century compositional techniques, and in the closer observation of rocks and plants. Many of the watercolourists appear to be torn between the two conventions. Often 'Grecian' Williams's views of the Highlands are decorative in colour and rely upon traditional compositional devices, yet at the same time he carefully observed flowers and rocks, and, at times, such as in his watercolour *Glencoe* (NGS), he captures the grandeur of the mountains. Andrew Wilson looks back nostalgically to the Italy of Claude, often emulating his compositional *repoussoirs*, while at the same time creating a rich colour harmony and atmospheric effect which is close to the Romantic tradition. Alexander Nasmyth, 'the Janus figure in the development of landscape painting in Scotland', is also, in his watercolours, split between a Romantic naturalism, Claudian landscape and eighteenth-century topography.[4] A slow but persistent broadening of style can be seen in almost all the watercolourists involved; from 'Grecian' Williams to comparatively minor figures like Andrew Donaldson. The tight penwork of the late eighteenth century was slowly replaced by broader sweeps of the brush, and a growing interest in nature, its moods and its details, is evident.

The long life of **Alexander Nasmyth** (1758–1840) bridges the development of Scottish watercolours from the first tentative steps in the eighteenth century to the professionalism of the early nineteenth. During his long career, his own style changed considerably but throughout his life he insisted upon careful drawing. His son, James Nasmyth, in his *Autobiography*, an invaluable source of information, wrote:

> There was one point which my father diligently impressed upon his pupils, and that was the felicity and the happiness attendant upon pencil drawing. He was a master of the pencil, and in his off-hand way that mere words could never have done. It was his Graphic Language.

This discipline enabled Nasmyth to become an excellent draughtsman capable of turning his hand to a variety of different subjects, from topography to theatre design to free landscapes.

Nasmyth was born in the Grassmarket, Edinburgh, at the house of his father who was a successful Edinburgh builder. After attending the High School, he was apprenticed to a Mr Creighton, a coachbuilder;

here Nasmyth painted decorations and heraldry, attracting the attention of Allan Ramsay who invited him to join his London studio in 1774. He als attended some classes at the Trustees' Academy under Alexander Runciman.

In London Nasmyth must have developed his skills in drawing as well as hearing about Italian painting which Ramsay knew so well, and he must have benefited from seeing Ramsay's collection which included fine seventeenth-century Italian and Dutch landscapes. On his return to Edinburgh in 1778 Nasmyth became involved with the experiments of one of his patrons, Patrick Miller, a successful baker who was developing paddle-driven steamships. Nasmyth, with his inquisitive mind, was soon making working drawings for Miller, and it is not surprising that his youngest son, James, was later to become one of the most famous of all Victorian engineers. Some years later, Alexander Nasmyth was present at Dalswinton Lock when Miller's steam ship made its maiden voyage. Miller not only commissioned a family portrait from Nasmyth, he also encouraged him to visit Italy, and helped to finance this trip which lasted from 1782 to 1784.[5]

The years in Italy left a deep impression on Nasmyth and many years later the influence of Poussin, Claude and the Antique still reappear in his work, in both oil and watercolour. He visited Florence, Bologna, Padua and Rome where he saw the work of Claude and of Jacob Moore, a fellow Scot. Little is known about this trip and James Nasmyth in his *Autobiography* makes only brief reference to it. Allan Ramsay was in Italy at the same time, and it would seem possible that he introduced Nasmyth to Scottish and English artists working in Rome. During these two years, Nasmyth came to appreciate landscape painting, and on his return to Rome he decided to turn towards landscape:

> Instead of painting the faces of those who were perhaps without character or attractiveness, he painted the fresh and ever-beautiful face of nature.[6]

Patrick Miller introduced Nasmyth to Robert Burns and Burns's enthusiasm for the Scottish landscape must have provided much inspiration. Together they walked in the Pentland Hills or along the banks of the River Nith,[7] and Martin Kemp has shown how the sparkling Burnsian enthusiasm was transcribed into pictorial images by Nasmyth's brush or pencil.[8] James Nasmyth commented upon the lack of interest in landscape painting at the time:

> In those early days of art-knowledge, there scarcely existed any artistic feeling for the landscape beauty of nature. There was an utter want of appreciation of the dignified beauty of the old castles and mansions ... There was also at that time an utter ignorance of the beauty and majesty of old trees ... My father exerted himself successfully to preserve these grand old forest trees. His fine sketches served to open the eyes of their possessors to the priceless treasures they were about to destroy.[9]

Nasmyth's enthusiasm for the Scottish landscape was conveyed not only to his patrons but also to his pupils, for at some date between 1785 and 1792 he opened a landscape school at his house in 47 York

8 Alexander Nasmyth,
Edinburgh from Dean Village
Fitzwilliam Museum,
$16\frac{1}{8} \times 18\frac{1}{4}$ Cambridge

Place, Edinburgh. At first Nasmyth ran the school himself, but later, as his children grew up and developed into competent artists they helped him with the teaching. He insisted upon drawing as a basic element of the teaching, and the students were taken on sketching expeditions to Arthur's Seat, Salisbury Crags, Duddingston Loch, Braid Hills, Craigmillar Castle, Hawthornden, Roslin Castle, the Pentlands and to the sea. We are told that 'the excursionists came home ladened with sketches'. Later the Nasmyth girls organized these trips. 'On many a fine day did my sisters make a picnic excursion into the neighbourhood of Edinburgh. They were accompanied by their pupils, sketchbook and pencil in hand.' Good drawing, or 'Graphic Eloquence' was stressed as this alone could lead to good structure in a landscape; 'this graphic eloquence is one of the highest gifts in conveying clear and correct ideas as to the form of objects.'[10]

Nasmyth's earlier watercolours, dating between 1785 and 1805, are influenced by his Italian experience. James Nasmyth recalled how his father

... would throw down at random a number of bricks, or pieces of wood representing them, and set me to copy their forms, their proportions, their lights and shadows respectively.[11]

This emphasis upon structure derives from Seicento principles of landscape composition using *repoussoirs*, framing trees and carefully receding distances. *Classical Landscape* (BM) is an example of this Italianate composition, combined with Claudean light with delicate blues in the distance. The earlier watercolours make use of a pen-and-ink outline which is not integrated with the colour washes, looking back to the drawings of Adam and his circle, although Nasmyth's penwork is freer, crisper and more incisive than that of many earlier artists. This can be seen in the landscapes set with castles and buildings around Edinburgh and painted in the later 1780s and 1790s. Nasmyth's patrons demanded views of Edinburgh and other cities and he was able to provide detailed topographical watercolours and gouaches. *Edinburgh from the Dean Village* (Fitzwilliam) is a good example (fig. 8). Edinburgh, dominated by the castle and Arthur's Seat is framed by trees to the right and a rocky outcrop to the left, while two figures stand by the river in the foreground. The oval shape, the placing of the castle in the centre middle distance, and the use of *repoussoirs* make this a happy composition. This watercolour is difficult to date, because, although it should in theory belong to the period before 1810, the *View of Falkirk from Calender Park* (Glasgow) is dated 1834, which suggests that Nasmyth could produce good topographical views to order throughout his career, and that his movement towards a more Romantic view of nature after 1810 did not influence his topographical style.

During the early nineteenth century, Nasmyth's style of watercolour painting began to broaden. It is likely that he accompanied his son Patrick to London in 1807 and he could have been influenced by the breadth of the Dutch landscapes which he would have seen there, as well as by the watercolours of David Cox and the Norwich School. He was also influenced by his son's development in both watercolour and oil painting, and the breadth and freedom of Patrick Nasmyth's *Between Bridgenorth and Much Wenlock* (fig. 9) must have been a revelation to him. The development of his Scottish contemporaries was also important to Nasmyth: 'Grecian' Williams's style was broadening and becoming less dependent upon fine pen outlines; Andrew Wilson's washes were broadening even if he retained a careful pencil outline, while the free landscapes of Nasmyth's own pupil, John Thomson, were attracting attention. Watercolour was a good vehicle for experiment and Nasmyth's *A View in North Wales* was such an experiment in the open air. He has captured the movement of the clouds and light across the hilly landscape using luminous washes applied with broad brushes. A similar breadth of handling is found in Nasmyth's seascapes, which are among the earliest watercolours of this subject in Scottish art. Working on the Firth of Forth, he captures the effects of light from a cloudy sky using a broad style and technique influenced by the Dutch School. Martin Kemp has discussed a watercolour

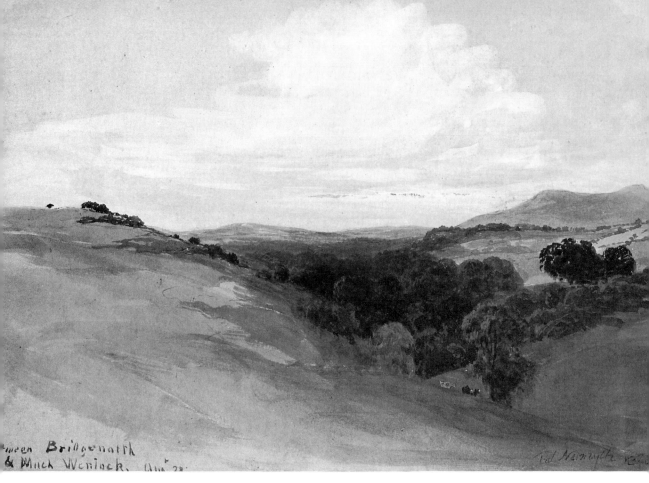

Between Bridgenorth
& Much Wenlock. Aug 28

Ped Nasmyth

9 Patrick Nasmyth, *Between Bridgenorth and Much Wenlock* August 1828 $8\frac{3}{4} \times 13$ British Museum

Branches and Foliage (NGS 1808) which could have been used as a demonstration piece in the York Place school.[12] This drawing reveals the use of washes laid down carefully over each other following the general shape of the foliage, over which strokes of opaque pigment are placed as highlights, with darker washes laid in to create depth. Such a progressive technique illustrates Nasmyth's movement towards a freer, more experimental use of watercolour. Also belonging to this period are stage designs for the Theatre Royal, Glasgow and, later the Theatre Royal, Edinburgh, and several drawings can be related to these projects.

The number of watercolours and drawings by Nasmyth known today is small compared to those of his contemporaries such as 'Grecian' Williams, and compared to Nasmyth's undoubted importance as a watercolourist. More watercolours by Nasmyth will no doubt be identified in coming years, but nevertheless, the bulk of his *oeuvre* was executed in oils. Nasmyth is important not only for his actual watercolours, but also for his dedication to the art of drawing and teaching, which artists of the earlier generation often lacked. His son, James, summed this up:

> This accomplishment of accurate drawing, which I achieved for the most part in my father's workroom, served me in many a good turn in future years.[13]

Alexander Nasmyth's elder son **Patrick Nasmyth** was born in 1787 in Edinburgh, and died in London in 1831 some years before his father. 'My father was his best and almost only instructor', wrote Patrick's younger brother James, who was 21 years his junior. Patrick Nasmyth worked with his father on Scottish landscapes before leaving for London in 1807[14] and the *View of Craigmillar Castle* (Glasgow), which was probably painted shortly before leaving for London, clearly shows the influence of his father's Italianate style. A golden Claudian light suffuses the picture, while the drawing of the castle reflects Alexander's handling of architecture. On the other hand *Gorgie Mill, near Edinburgh* (Glasgow), while still revealing his father's influence, shows Patrick's growing interest in trees and rustic details. He also became increasingly responsive to weather conditions, clouds and the changing effects of British skies. He was apparently a good meteorologist, and this is borne out by his excellent handling of skies. James comments upon his interest in nature:

> The wild plants which he introduced into the foregrounds of his pictures were his favourite objects of study. But of all portions of landscape nature, the sky was the one that most delighted him. He studied the form and character of clouds – the resting cloud, the driving cloud and the rain cloud – and the sky portions of his paintings were thus rendered so beautifully attractive.[15]

The last 20 years of Patrick Nasmyth's life were spent working in London and the south-east, although he did not achieve his father's success, being less of a businessman than his father and a more retiring personality. He continued his father's practice of sketching in the open air, producing a large number of pencil, charcoal or wash drawings of the Thames Valley, Sussex, Hampshire and the Isle of Wight. He was greatly influenced by Dutch landscape painting of the seventeenth century, being sometimes known as the 'English Hobbema'. His brother again sums up well his subject matter:

> His taste was essentially for simple subjects. In his landscapes he introduced picturesque farm houses and cottages with their rural surroundings; ... the immediate neighbourhood of London abounded with the most charming and appropriate subjects for his pencil. These consisted of rural bits of the most picturesque but homely description – decayed pollard trees and old moss-grown orchards, combined with cottages and farm houses in the most paintable state of decay, with tangled hedges and neglected fences, overrun with vegetation clinging to them, with all the careless grace of nature.[16]

There is a collection of watercolours and drawings by Patrick Nasmyth in the British Museum, including an album of sketches. *The Common* is executed in black chalk and watercolour on grey paper and depicts a flat English common with houses in the middle distance and hills beyond. The sky is cloudy and is handled in a wet, atmospheric manner. Another effective watercolour is *A View in Sussex* depicting a simple road with trees in sunlight, painted in a fresh manner. One of the most successful of these watercolours is *Between Bridgenorth and*

Much Wenlock (fig. 9). While the colours are restrained compared to his father's watercolours – tending towards browns and dull greens – the handling is free, yet well-controlled. Moreover, the balance between the detailed central areas of trees and the simple washes of the grassland is finely judged, and the influence of both Cotman and Cox can be felt. Other sketches in the album, which was assembled at a later date and comprises works of different periods, include views of the New Forest cottages by the Thames and scenes in Surrey. While sketching willows by the Thames, Nasmyth caught a cold from which he died in August 1831. He was a fine draughtsman, and although comparatively few of his watercolours exist today, he can be seen to have had more talent and originality in this medium than as an oil painter.

Had **Hugh 'Grecian' Williams** (1773–1829) lived and worked in London, he would have assumed a far greater place in the history of British watercolours than he now enjoys. He receives but two paragraphs in the third volume of Martin Hardie's classic *Water-Colour Painting in Britain*, and saleroom prices reflect his comparative obscurity.[17] He was, nevertheless, an important and prolific watercolourist who, at his best, could produce sparkling watercolours, well coloured and confidently drawn. Williams was born on board ship – his father, a Welshman, was the captain; his mother was the daughter of Colonel Lewis, Deputy Governor of Gibraltar. Williams lost both his parents when young and was brought up by his maternal grandmother and her second husband, an Italian, at Craigside House, Edinburgh. The latter encouraged him to paint, sending him to study with David Allan in his studio in Dickson's Close. James Nasmyth mentions Williams among those artists whom his father assisted and it seems that Williams attended the Nasmyth School in York Place. The influence of Allan is, however, far greater than that of the Nasmyths; in the essentially rococo quality of his colours and in his elegant penwork Williams reflects the teaching of David Allan. Williams matured quickly as an artist, for the watercolour of *Hawthornden* (NGS), painted in 1796 when he was 23, is already fluent in its draughtsmanship and sensitive in colour; *A View of Crichton Castle, Midlothian* (Glasgow) also of 1796 shows Williams using the accepted Claudian composition of framing trees and *repoussoirs*. During the 20 years before he went to Greece in 1816, Williams produced a large number of watercolours of Scotland, often of views around Edinburgh and Glasgow, including Loch Lomond and Loch Ard. He also worked in Argyllshire and on the Isle of Arran, as well as on the East Coast in Angus. By 1800 his work had developed quickly in both style and sophistication. The fact that the quality of his work varies greatly from watercolour to watercolour makes it difficult to trace his development. Thus *Bothwell Castle* of 1802 (VAM) is a fine Romantic watercolour with ruins in the foreground and well-judged blue washes, whereas *A Highland Scene with a Castle* of the following year is clumsy in its draughtsmanship and dull in its muddy greens and browns. This inconsistency is a feature of Williams's work

and is a result of a desire to produce in quantity rather than an indi-
cation of assistants or later forgeries.

From about 1810 onwards Williams's style began to broaden, pos-
sibly as a result of his work in oils, as David Irwin points out.[18]
Nevertheless there are certain characteristics which run throughout his
work. At his best, he is an elegant draughtsman with an ability to
depict figures and animals. This can be seen in the figures of the
fishermen in *Kilchurn, Loch Awe* (Glasgow) or the tartan-clad figures
in the foreground of *Loch Ranza* (BM). He could sum up the move-
ment of an animal in a few strokes, and dogs and cattle appear often in
his foregrounds. He was also excellent at touching in details of foliage,
suggesting a variety of different plants and flowers with confident and
economic brush-strokes. In certain respects he was better at foreground
details than at distances, for often his handling of more distant trees
declines into a repetitive use of banana-shaped marks of the brush, and
in some of his watercolours the difference between a well-observed and
elegantly painted foreground and a rather mechanical distance is strik-
ing. Williams certainly sketched 'on the spot' and it is possible that
many of his watercolours were executed entirely in the open. Despite
this natural observation, Williams's earlier watercolours often have a
rococo sense of colour with rather sweet russets in the foreground and
powder-blue distances. The rugged element of the Scottish landscape
is thus transformed by Williams's vision of pastoral tranquillity and
rococo elegance.

In 1816 Williams set off on his Grand Tour travelling from Rams-
gate to Ostend, through Germany and into Switzerland. Here he was
struck by the colours of the sky:

> The sky is of a pure and delicate blue, with horizontal streaks of pale grey
> inclining to purple.[19]

He later published his account of the tour as *Travels in Italy, Greece
and the Ionian Islands*, and often reveals a sensitivity to Mediterranean
colours which he had so often suggested in his work without having
seen them in nature. His views on art are typical of an educated man
of the period; he preferred Titian, Reni and Dolci to the Quattrocento,
which he never mentions. He makes few references to his own work
other than to the places he had drawn, but he seems to have followed
in Jacob More's footsteps, sketching from a carriage window in Tus-
cany:

> I attempted to make what may be called carriage sketches done when we
> were travelling at the rate of from five to six miles an hour.[20]

From Otranto he sailed to Corfu and toured the Greek Islands before
reaching Athens via Delphi. His visit to Athens was cut short by an
outbreak of the plague, but he did have time to observe the Acropolis
and suggested substituting Coade stone statues and reliefs for those
removed by Lord Elgin. The return journey was via Malta, Sicily and
Italy, arriving back in Scotland in 1818.

A highly successful exhibition of his Greek watercolours was held in Edinburgh in 1822 and this success, combined with the publication of the illustrated account of his travels as well as a series of engravings from his watercolours, *Select Views in Greece* (1827), earned him the title 'Grecian' Williams. The Greek watercolours fall into two distinct types. There are the large, well-worked pictures which sometimes combine oil and watercolour, for he found that good effects could be created 'by painting first with opaque watercolours and afterwards varnishing and finishing with oil colours'. These works have a splendour and a power that are lacking in his earlier watercolours. Williams was no archaeologist, but was highly sensitive to architecture as his description of the temples at Paestum reveals:

> The simple dignity of the Doric Order was irresistibly striking, and we could not but confess, that, though the structures are small in dimension they inspired us with higher ideas of grandeur than any building we have yet seen.[21]

This dignity and grandeur is very evident in his large Greek views and the splendid *Temple of Poseidon, Cape Sunion* (NGS) of 1828 is one of his most romantic and powerful works, executed in watercolour and oil. Although several of Williams's pre-1816 watercolours had been large, none came anywhere near the size of these Greek views. However, much of the elegance of his watercolour 'handwriting' is sacrificed to the grand effect.

The second group of Greek watercolours are much closer to his earlier Scottish works, in size, in technique and in style. *Boats on the Isthmus of Corinth* (colour plate 1) is one of the finest of his works, executed purely in watercolour and revealing a sensitivity towards colour and light which can hardly be rivalled by any other Scottish contemporary. He has moved away from schematic colouring and rococo stylization has given way to a refreshing naturalism. At the same time his elegant draughtsmanship is used to its best degree.

During the last ten years of his life he devoted most of his energies to Greek and Italian views and it seems unlikely that he produced many Scottish scenes. As a man Lord Cockburn recalled him as being warm-hearted, gentle and modest; moreover, having married into some money, he was able to move amongst the best society in Edinburgh. Wilson in his *Noctes Ambrosianae* makes the Shepherd say of Williams:

> As for the man himself, I like to look on him, for he's gotten a gran' bald phrenological head, the face o' him's at once good-natured and intelligent; and o'a'the painters I ken, his mainners seems to be the maist the mainners o' a gentleman and a man o' the world.

There is a revealing manuscript in the Victoria and Albert Museum, *Method of drawing in Watercolours as Practised by Mr Williams*, copied by T. Dick Lauder in 1811 from a manuscript written by Williams. It is worth quoting in full as it gives a good account of the watercolour technique of the period:

In preparing to draw in water colours it is proper to stretch the paper on a board, which is conveniently done in the following manner. The side to be placed next to the board must be completely damped with a wet sponge in such a manner that the paper may lie flat. You then cover about half an inch round the damped side of the paper with paste, next turn that side to the board, and with a cloth press the pasted part down, taking care not to stretch the paper in any direction if it can possibly be avoided. You then damp the upper side of the paper all except the part which has the paste underneath. The reason of this operation is that the pasted part had already received not only the moisture spread at first over the whole of the paper, but also that of the paste, and consequently was more wet than the rest. Hence if the rest of the paper were to receive no more moisture than at the first damping, it would dry sooner than the pasted part, and as it shrinks by drying, would either tear away the pasted part from the board, or make a rent at the edge of it.

Outline

It is of advantage in beginning an outline to sketch lightly the general forms of the subject; the next thing to be done is to descend to particulars, giving every object its proper character. Marking the distances with a fainter line than should be used to express the middle ground, and the middle ground with a fainter line than the foreground, and it is also an advantage to make the lines stronger towards the darkened side of the objects, it being of considerable assistance in shading, although, when the outline is done with the black lead pencil it is of no consequence to the effect, because when the drawing is finished such an outline becomes imperceptible.

Of Shading

It may be presumed that the shading now to be explained is adapted for colouring alone. The aerial hue may be obtained by mixing together Lake, Indigo and Camboge, or in other words, Red, Blue and Yellow and, according to the effect of time of day to be represented, the Yellow, Red or Blue should predominate it. With the aerial tint the distances may be done, but as the objects advance towards the eye, it will be necessary to reduce the effect of air. Indian Ink is well adapted for this purpose and should be introduced in just proportion as they approach, otherwise the harmony of the aerial perspective will be destroyed, as the effect of air upon the foreground is in general scarcely to be perceived, it may be done with Indian Ink with the introduction of a little Umber in it. In applying the brush you first lay in the great shades carefully preserving your lights and determining the general effects. This being done you proceed to shade every object in each ground with the exact tint with which you laid in the general shade. It may be proper to add that one shade should be compleatly dry before another is laid on, otherwise they will run into each other and produce confusion; and that in using a full brush, which except in a few particular cases ought always to be done, care should be taken not to overload it, as the neglect of this rule introduces harsh edges. When the effect of light and shade is produced you then begin to paint the sky.

Of the Sky

In order to allow sufficient time to manage the sky, it will be necessary to damp the paper which may be done with a sponge; but after this operation, there is generally a quantity of superfluous moisture left on the paper, it must be taken off by pressing on it a fine cloth, otherwise it would be impossible to shape the clouds properly, as the colour would run and have

a very bad effect. The sky may be done with Prussian Blue, beginning at the top farthest from whence the light proceeds, and gradually weaken it with water as you approach the horizon, but especially near the lightest part of the sky. The Blue being laid in and perfectly dry you must next shade the clouds which may be done with aerial colour according to the distance. Upon the principle of shading the landscapè – After the sky is thus far advanced, you may find it necessary to soften it, or correct any unevenness in the Blue, this may be done with a sponge and water and at the same time if you think the distances or any part of the landscape are harsh, you may apply the sponge to it also; in sponging it is best to begin to the distance, and go gradually upwards as hastily as possible, gently rubbing all over the sky, taking care not to dwell on any particular part before you have given the whole a general softening – The influence of the sponge is very great, and when judiciously used, produces the most pleasing and most delicate effects. But if it be used to excess, a sky only intended to be slightly softened is often rendered spiritless and insipid. Mist may be well represented by means of the sponge gently rubbing over part of the landscape pervaded by it carefully washing the sponge at every application and the parts mostly obscured will require the most frequent application. It is hardly necessary to mention that, when mist prevails, general forms are only discernible, and that therefore particular shading should be avoided. If the mist be very partial or if smoke or spray can be introduced, it may be done after the drawing is shaded in the following manner which is preferable to preserving it in shading. Take a clean brush moistened with pure water, and shape the mist or smoke with it, allowing it to settle. When the water is nearly eva-porated, or the paper in some degree absorbs the moisture, then rub it with a piece of stale bread which will take off the colour, wholly or indistinctly according to the force with which the bread is applied, or the time the water was allowed to remain. Should the edges of the smoke [or] mist be a little harsh, it will then be necessary to have recourse to the brush again very slightly moistened, applying it to the part to be softened, and gently use the head. Indeed it may be necessary to repeat this operation often before these objects can be done with delicacy. When the sky and distance are harmon-ized, you may proceed to lay in a characteristic horizon hue, it may be of a yellow or red complexion, according to the time of day, or effect to be expressed. If your shade or aerial colour be warm or partakes of a purple hue Burnt Terra de Sienna may be used, but if it be inclined to a Bluish cast the paper may be left white or slightly tinged with yellow. Upon what-ever atmospheric colour the general hue is to be applied, it must be washed over the whole drawing, so that every object may partake of it. It should be most vivid at the lightest part of the sky, and gradually weaken with water in advancing from it in either direction, so that the top of the sky will be slightly tinged, while that at the horizon will have a higher glow.

Local Colouring

Begin with the middle part of the landscape where the effect of impregna-tions of the air is not intended entirely to obscure the local colour of objects. If the distances be very remote they will be wholly enveloped in air and no effect of colour will be perceivable on them. The colours for the distance must be fainter than those laid on any other part, and, to prevent heaviness such colours should be used as are most transparent. On the middle grounds stronger tints may be used, and in greater variety, carefully preserving the harmony with the parts beyond it. In approaching the foreground, the

variety may be extended, and the strength and warmth of the colours increased, and this remark applies in its utmost latitude to the foreground itself. In the distance, and even in some degree in the middle ground, it will be sufficient to distinguish objects by giving each a tint expressive of its general hue. But on the foreground you must distinguish not only betwixt one object and another, but also between the different parts of the same object. For example in a tree in the foreground, it may be necessary to characterize by colour the withered or decayed branches from those that are healthy, the bark and the stains upon it, together with the parts which are stripped.

In like manner with regard to rocks in the same situation, you must represent their natural colour and the hues they may have received from external causes. The same attention must be paid to broken grounds and to various vegetation. In a word, character in colouring must be preserved with the same precision as in outlining and shading.

On the strength and variety of colouring required in a foreground the greatest care should be taken to make them harmonize not only with each other in that part but likewise with the colouring of the whole drawing – great care should be taken not to make the colours too strong at first, because there is no good remedy to remove that defect.

Signed H.W. Williams 17th June 1811.

Reproduced by permission of the Victoria & Albert Museum.

As with 'Grecian' Williams, the work of **Andrew Wilson** (1780–1840) is not widely known outside Scotland. This is unfortunate as his watercolours are always beautifully executed and evoke a feeling of tranquillity. He is an important but underrated figure in the history of Scottish watercolour painting. Wilson, born in Edinburgh, trained with Alexander Nasmyth before moving to London in 1797 aged 17. He studied at the Royal Academy Schools, then went on to Italy to complete his education. This first visit to Italy lasted nearly three years and during this period he made many sketches of Rome, Naples and the surrounding countryside. Wilson was back in London briefly in 1803, but returned to Italy in the same year, despite the problems that the war posed for British travellers. He realized that there was money to be made exporting Italian Old Master paintings to British collectors, and when he returned to London in 1805, he had with him some 50 canvases, including Rubens's *Brazen Serpent* and Bassano's *Adoration of the Magi*. During this second trip to Italy he was based in Genoa where he posed as an American citizen to avoid the suspicions of the French authorities. He continued to paint and was elected to the Ligurian Academy, where his work was exhibited.

From 1805 to 1818 Wilson worked in London, producing mostly watercolours based on his Italian sketches. His fellow Scot, David Wilkie, visited his studio in 1809, beginning a friendship which lasted for many years. Wilkie noted in his *Journal*:

Went to Andrew Wilsons's where I saw two pictures in watercolours – Italian views – very fine and much in the style of Poussin.[22]

Wilkie is referring to Gaspard Poussin, whose views of the Campagna influenced Wilson. For some of this period, Wilson taught drawing at

Sandhurst Military Academy, but in 1819 he returned to Edinburgh to become Master of the Trustees' Academy. He was not an outstanding teacher, but his knowledge of the Italian Masters must have widened the outlook of many of his students, and his enthusiasm for watercolour painting may well have kindled an interest in the medium by pupils such as David Octavius Hill and William Simson. Wilson continued to work in both oil and watercolour while in Edinburgh, choosing both Italian and local views. *Lasswade, near Edinburgh* (fig. 10) dates from the early 1820s, although dating of his work is difficult as he often neither signed nor dated his watercolours.

In 1826, Wilson resigned his post in Edinburgh and returned with his family to Italy, living in Rome, Florence and Genoa for the next 20 years. He continued his activities as an art dealer buying pictures for Lord Hopetoun, Lord Pembroke, Sir Robert Peel and many other collectors, while continuing to paint Italian landscapes. Wilson was apparently a popular figure among English and Scottish artists in Rome, and along with the Duke of Hamilton, presided over a public dinner in honour of David Wilkie in 1826. He left Italy in 1847 for a short visit to Scotland, but died in Edinburgh in November 1848.

Andrew Wilson's long absences from Britain have contributed to his comparative obscurity as a watercolourist and even during his lifetime only a relatively small number of his watercolours would have filtered back to London or Edinburgh. A fine draughtsman, he laid in his outlines in pencil, as can be seen from the unfinished *Town and Lake of Nemi* (VAM 1827). The crispness and confidence of line is not lost in the finished watercolours, which have remarkable freshness, achieved by clear washes over simple outlines. In his handling of architecture, Wilson reveals an ability to sum up the construction and perspective of a building in clear and simple pencil lines, over which he places light washes. The large watercolour *St John the Lateran, Rome* (VAM) has excellently drawn architecture – there is no hesitation, no second thoughts in the pencil outline, while the freshly applied light ochre washes create a sense of sunlight. Combined with his draughtsmanship is an ability to compose a picture, grouping his buildings well, and placing foreground features such as people or trees in happy relation to the distance.

In addition to being a fine draughtsman, Wilson has also a good sense of colour. He exploits watercolour by using the white paper beneath to create luminosity. Sometimes he evokes the mellow richness of an Italian evening, as in *A View of Nemi* (BM), creating a golden sky in a nostalgic Claudian vein. In complete contrast *Lasswade* (fig. 10) creates the freshness of morning light with crisp greens and blues: areas of white paper are left blank in the handling of the two figures in the foreground to create the intensity of the morning sunlight. By suppressing unnecessary detail, and by simplifying the architecture, Wilson often produces watercolours of surprising directness. One of his finest watercolours is the *View of Oxford from the Distance* (VAM). The architecture is handled with his usual skill, while the foreground

is created by a series of cool washes not unlike those of Peter de Wint. Such a drawing, presumably done while at Sandhurst before 1818, is the work of a highly professional and skilled watercolourist.

The work of **Patrick Gibson** (1782–1829) has been neglected by most writers on Scottish art. He was born in Edinburgh probably in 1782 and studied at the Nasmyth School in York Place before moving on to the Trustees' Academy, then under the direction of John Graham. He spent three years in London from 1805 to 1809, returning to Edinburgh to become a watercolour painter of some success and a writer on art matters. He joined the Associated Artists in 1808 and was a Foundation Member of the Royal Scottish Academy, writing several articles on the state of the pictorial arts at the time. His *View of the Progress and Present State of the Arts of Design* was published in the Edinburgh Annual Register in 1816 and provides useful notes on minor Scottish artists. In 1817 *Selected Views of Edinburgh with Historical and Explanatory Notes* appeared with etchings by Gibson, and in 1824 he was appointed Professor of Painting at the Dollar Academy. Most of Gibson's work consists of watercolours and he developed a pleasing if slightly frozen style. *Bothwell Bridge from Bothwell Park* (NGS), an early work of 1803, shows a good sense of colour in the light greens

11 Patrick Gibson, *The Priest's House, Quivig* 8 × 12½ British Museum

and blues which predominate, although the general effect is somewhat naïve. There are also in the National Gallery of Scotland some good pen-and-wash drawings of Lambeth done between 1805 and 1808. *Sailing Vessels in Harbour* (Glasgow) is a good example of his rather precise penwork which, with its silvery tones, is undeniably attractive. In 1812 Gibson accompanied Sir George Mackenzie on a visit to the Faroe Islands. A volume of 26 views by Gibson is in the British Museum and must rate as one of the earliest examples of a Scottish artist accompanying a geographical or naturalist expedition. Gibson's rather precise style was well suited to this kind of work and he has left us with a detailed pictorial account of the Islands in the early nineteenth century.

Born in Comber near Belfast, **Andrew Donaldson** (1790–1846) came to Glasgow as a boy and joined his father's trade as a spinner. A serious injury damaged his health and he turned to art as a career, beginning to sketch at the age of 20, although his earliest known work dates to 1817. His early works are views of Glasgow, but in the late 1820s and early 1830s he travelled extensively in the Highlands, North

Wales and Northern Ireland, producing landscapes which were exhibited at the Royal Scottish Academy and the Glasgow Dilettante Society. He seems to have worked almost entirely in watercolour and was noted in Glasgow for being a good pencil sketcher. For many years he taught drawing in Glasgow and died there in 1846. *Landscape with House and River* (fig. 12), dated 1819, is an example of Donaldson's earlier work. During the 1820s his style became freer as he turned away from purely topographical views towards a wider landscape. *Tantallon Castle and the Bass Rock* (NGS 1830) is looser in handling, with fresh blue washes in the sea. The Royal Scottish Academy catalogues of the 1830s suggest that he was a prolific watercolourist and titles such as *Holy Loch*, *Argyleshire*, *Iona*, *Luss*, *Lochlomond* and *Cambuskenneth Abbey* appear. It seems likely that more of his watercolours will come to light.

Little is known about the life of **Daniel Alexander** (*c.* 1800–1864), but he was probably born in or near Glasgow where he worked for most of his life. Glasgow Art Gallery has an interesting group of his works, the earliest of which date to 1818 and are executed in pencil-and-wash. They depict views around Glasgow, including views of the Clyde and Cathcart Castle. He visited Europe in the 1820s, producing fine pen-and-wash drawings of Italy and Switzerland, which he usually initialled 'D.A.' He was a fine draughtsman and his best works have a romantic quality. **William Anderson** (1757–1837) and **John 'Old Jock' Wilson** (1774–1855) both made their reputations in London, thus anticipating the regular exodus of Scottish artists to the south in

12 Andrew Donaldson, *Landscape with House and River*, probably Gilmorehill House with the River Kelvin
$16 \times 28\frac{1}{2}$ The People's Palace, Glasgow

the later nineteenth century. Anderson's work really belongs to the English School, although he was born in Scotland, and his watercolours of shipping and coastal views are carefully executed with great regard for the details of rigging and tackle. His figures are competently executed and his drawing always crisp and decisive. 'Old Jock' Wilson was also a marine artist; born in Ayrshire, and apprenticed to the Nories in Edinburgh, he attended the Nasmyth classes in York Place. He moved to London in 1798 working first as a scene painter, but later specializing in marine oils and watercolours. He visited the Flemish coast in 1818 and in 1824 accompanied his friend David Roberts to Dieppe, Rouen and Le Havre. In addition to his marine watercolours he produced some good topographical views of Ayrshire.

During this period there were a number of competent topographical artists in addition to Alexander Nasmyth. **John Heaviside Clark** (1771-1863), known as 'Waterloo' Clark from his sketches made of the battlefield in 1815, is an important topographical artist. Glasgow Art Gallery has good examples of his work. *Port Patrick* is a view of the town with its port and ships at sea in the distance, including an early steam sailer. Not only is the draughtsmanship delicate and accurate, but the colour is also attractive. From 1802 Clark was based in London, where he produced aquatints, illustrated books and wrote a treatise on landscape painting; *Practical Essay on the Art of Colouring and Painting Landscapes* (1807). He returned to Edinburgh where he died, a very old man, in 1863. **James Skene of Rubislaw** (1775-1864) is a fascinating figure in Scottish topographical art. The younger son of the Laird of Rubislaw, he was born in Aberdeen but moved to Edinburgh at the age of eight. As a boy he began to draw Edinburgh, but attended the University to study law. On the death of his elder brother he inherited the family estate while continuing to be a member of the Scottish Bar. He finally settled on the family estate at Inverie, Kincardineshire on his marriage in 1806. From then on he devoted much time to painting in watercolour, travelling regularly to paint landscapes in Belgium, Germany, France, Switzerland and Italy. In 1824 he embarked upon a project with Walter Scott to produce an illustrated description of Old Edinburgh to be entitled *Reekiena*. This never materialized, but Skene painted several hundred watercolours which are today in the Edinburgh Library. In 1829 he produced a series of sketches of Scotland illustrating places mentioned in the Waverley Novels, and as a close friend of Walter Scott, he was the organizer of the National Appeal on Scott's death in 1832. He was also involved in art education as Secretary to the Board of Trustees for Manufacturers in Scotland. In 1838 he visited Greece for the first time and was enchanted by the country, deciding to build a villa near Athens which became his home until 1845. During this period he executed many sketches of the mainland and Islands of Greece.[23] His last years were spent in Frewen Hall, Oxford.

The oils of **Robert Gibb** (1801-1837) might be, as Caw suggests, 'wholly artless', but his watercolours are effective. He exhibited

watercolours 'done from nature' at the Royal Scottish Academy in the late 1820s and 1830s attempting to obtain some element of naturalism. While a similar effort resulted in somewhat crude colours in his oils, his watercolours have an unusual freshness for the period, as can be seen in *The Grounds of Kinfauns Castle, Perthshire* (NGS). **Patrick Syme** (1774–1845), a founder member of the Royal Scottish Academy, was the leading flower painter of his time. He had a reputation as a teacher of drawing in Edinburgh and in 1810 published *Practical Directions for learning Flower Drawing*. The rather timid illustrations in this book do not do justice to his many finely detailed and carefully observed watercolours of flowers, birds and insects, in which he achieves interesting compositions. There is an album of sketches by Syme in Edinburgh (NGS) which shows his considerable skill and wide range. He was also an expert on birds, publishing a *Treatise on British Song Birds* in 1823. Syme took a leading role in the establishment of the Royal Scottish Academy, taking the chair at the first meeting in 1826, but he later moved to Dollar where he was art master at the Dollar Academy. A scandal had surrounded his marriage to the beautiful and aristocratic Elizabeth Boswell of Balmuto, who met Syme while attending his classes in Edinburgh. The couple eloped for a secret marriage and her family never forgave either partner. The marriage appears to have been successful, and Elizabeth Boswell was herself a flower painter of some skill.

William Nicholson (1781–1844) was also a founder member of the Royal Scottish Academy and acted as the Academy's secretary. Born in Newcastle, he lived in Edinburgh for many years, producing delicate portraits in pencil-and-wash, as well as some interesting watercolour landscapes. His drawing is precise and his colours fresh. **James Stevenson** was a professional artist working during the early years of the century, mostly in watercolour, painting landscapes in a style not unlike that of 'Grecian' Williams. Little is known of his work or life, except that he painted watercolours of the landscape around Newhall House, which were engraved for Robert Brown's *The Gentle Shepherd with illustrations of the Scenery* (1808).

3 Sir David Wilkie and his influence

The influence of **David Wilkie** (1785–1841) can be seen in Scottish painting right up to the early twentieth century, when the last of the genre painters died. The unparalleled success of his work, both in Edinburgh and London, took Scottish art out of its quiet provincial backwater and opened the eyes of successive generations of Scottish artists to the acclaim and wealth that a career in London could bring. Born in the Fife village of Cults, the son of the minister, Wilkie began to draw as a child, sketching local characters like gypsies, soldiers, or Highlanders in pen-and-ink or in pencil. In 1799 he was sent to the Trustees' Academy in Edinburgh where John Graham was the new Master. As a student, Wilkie was noticed for his ability to draw character studies, and he wandered in the markets of Edinburgh making sketches in his notebook. Sir William Allan later commented:

> He was always on the look-out for character: he frequented trysts, fairs and market places ... These were the sources whence he drew his best materials; there he found that vigorous variety of character impressed on his very earliest works, which has made them take such a lasting hold on the public mind.[1]

The watercolours of David Allan were important for Wilkie as a student, and he also drew inspiration from Allan Ramsay's *The Gentle Shepherd*, which had been an important source for David Allan. While at the Trustees' Academy his drawing technique became more fluent and his colours lighter. John Graham wrote to Wilkie's father on his leaving the Academy in 1804:

> He is capable of carrying through the most elevated and elegant part of his art ... the most delicacy required in the execution of a subject, the more successful he will be. In some of his first essays in painting when with me, he evinced a degree of taste which bore a great resemblance to the manner of Correggio[2]

Wilkie returned to the manse at Cults in 1804 and began work on a view of Pitlessie Fair, using local people as models. *The Visiting Chapman* (Kirkcaldy), despite its misleading inscription, 'Done as a Schoolboy at Pitlessie', is dated 1807, and is an example of Wilkie's incisive

watercolour character studies of this period. He also painted a number of portraits in Fife and later in London, using pencil, charcoal or ink. Several portraits exist dating from this period: *Charles William Henry Montagu Scott, 4th Duke of Buccleuch* (Ashmolean) shows Wilkie's sensitive and restrained draughtsmanship using black and sepia chalks. The later *Portrait of Perry Nursery* of 1823 (Ashmolean) shows an increased confidence with fluent handling of light and shade using chalk with body-colour highlights. It is thus evident that the portrait drawings which Wilkie was commissioned to execute in the years before his first trips abroad were important for his later watercolours.

After selling *Pitlessie Fair* for £25, Wilkie left for London in 1805 and enrolled at the Royal Academy Schools. In London he met many important artists including Flaxman, Fuseli, Nollekens and West, as well as his compatriot Andrew Wilson, who had returned from his second visit to Italy. This was the period of Wilkie's first successes, with paintings such as *The Jew's Harp*, *The Cut Finger*, *Rent Day* and *The Village Festival* becoming popular talking points at the Royal Academy exhibitions. Comparatively few of his watercolours date from this period, although Wilkie was making numerous working drawings in pen-and-ink, a number of which are in the British Museum. In 1814 Wilkie visited France, taking advantage of the brief respite offered by the Peace of Amiens, and with Benjamin Robert Haydon he visited Dieppe, Rouen and Paris. He was impressed by the Dutch painters in the Louvre, reinforcing his already extensive knowledge of Dutch School canvases and drawings. As usual, Wilkie was armed with sketchbooks, in which he made studies of local costumes, views of Paris and copies of paintings in the Louvre. In 1816, after peace had been re-established, Wilkie again returned to Europe, visiting Amsterdam and Antwerp. A fluent chalk-and-watercolour sketch in the Ashmolean – copying a painting by Cuyp – dates from this trip, as does a series of landscape sketches in pencil and body-colour dated September 1816 (VAM). On his return to London, Wilkie began work on the Wellington portrait, and the pen-and-ink studies (BM) show the developing virtuosity of his draughtsmanship, in which vigorous penwork is complemented by strong *chiaroscuro* washes.

Wilkie's reputation reached a high-point during this period. *The Penny Wedding*, *The Reading of the Will* and *Chelsea Pensioners* attracted crowds at the Royal Academy and, still only 35 in 1820, he was as popular as Turner. He returned at regular intervals to Scotland to refresh his memory, to carry out portraits and to make studies from nature recalling John Graham's earlier advice:

> I therefore would advise you never to paint your principal work without you have nature before you.[3]

In 1817 Wilkie made a visit to the west coast to see the Falls of Corra Linn, the Isle of Bute and Coull in Argyll, making sketches of the landscape and of local characters. He returned via Dunkeld and Blair Atholl, visiting Walter Scott at Abbotsford, where he made sketches

for the group portrait of the Scott family. A watercolour depicting Cults dated 1817 in the Ashmolean shows Wilkie's controlled technique and an approach to landscape still influenced by eighteenth-century traditions, and contrasts to his much freer approach to portrait drawing. Working drawings and watercolours for Wilkie's successful oils of this period exist in some number. The Ashmolean has a series of drawings in pen-and-ink for *The Reading of the Will* which reveal Rembrandtesque qualities in the use of the pen-and-wash, achieving facial expression with an economy of line. The pen-and-wash study for *The Preaching of John Knox before the Lords of the Congregation* (1821, Fitzwilliam) again shows Wilkie's fluency and looks forward to the almost baroque qualities of the later watercolours and drawings. These working drawings show Wilkie's variety of line, his judicious use of washes, and his extraordinary ability to capture expression with a minimum of detail.

In 1822 Wilkie returned to Scotland to work on a large oil to commemorate the visit of George IV to Edinburgh and to start an ambitious painting of Knox's arrival at Holyrood. Both pictures caused major problems and Wilkie had to return north on several occasions to study the architectural and landscape backdrops. *View of Edinburgh at Night* (BM) probably dates from this time and is an unusual nocturnal watercolour, the dark buildings pierced by light from the windows. Here Wilkie is using touches of purples, sepias and browns as his watercolour palette becomes richer. The *Interior of Pitlessie Mill* (Ashmolean) dates from a visit of 1824. In a large, powerful watercolour with areas of rich washes, Wilkie creates a sense of broken light entering the dark mill interior, and the figure of a girl is drawn with elegance. Wilkie's health suffered from the problems posed by these two ambitious paintings, and in 1824 he left for a recuperative trip abroad, reaching Italy via the Alps in the following year. He relished the scenery, but at first felt too tired to sketch:

> I am quite unable to sketch or to make memoranda, ... seeing pictures with leisure to judge, compare and reflect is more beneficial than any copies made from a few of them.[4]

Wilkie was fascinated by the technique of fresco painting and commented on Sistine Chapel frescoes in a letter to Sir Robert Peel.

> Fresco, which is clearer, less heavy and more easily lighted than oil colour, can exist only with the higher qualities of painting and cannot, like oil with its beauties of execution, supply their place.[5]

Commenting upon the frescoes by Domenichino in Sant' Andrea della Valle, he wrote:

> They have all the effect and clearness of an English watercolour drawing; and any oil picture in their place however brilliant, even from the hand of Rubens, would fail in comparison.[6]

Wilkie's stay in Italy opened his eyes to the transparency and clarity of fresco painting, and he worked continuously, drawing in chalks and

watercolour, copying the works of the Cinquecento. He particularly admired Correggio's cupola in Parma, and commented upon Correggio's warm shadows and flesh tints:

> The flesh tint, though never warmer than nature in the lights, is in the shadows hot to foxiness, giving much of it the appearance of a red chalk drawing.[7]

Several watercolour studies made in this visit exist, such as a copy of Correggio's *Adoration of the Shepherds (La Notte)* painted in Dresden in July 1826. A study of Murillo's *Virgin and Child* at Dulwich, probably painted shortly after his return (BM) clearly shows the development in his watercolour technique. The drawing in red and black chalks provides a fluent and sensitive outline for wet watercolour washes. The flesh tones and the shadows are warm and the highlights are achieved with the whiteness of the paper. Wilkie uses a wide range of colours including greens, blues, reds, ochres and his characteristic purple. Wilkie recognized the value of copying and wrote:

> I have now, from the study of the Old Masters, adopted a bolder and I think a more effective style; and one result is rapidity.[8]

Fluency and confidence is evident in the watercolours of this period and enabled him to progress from the controlled wash drawings of the earlier years to the brilliant and virtuoso watercolours of his later years.

Before leaving Rome Wilkie was honoured with a dinner given by Scottish artists and collectors living in Rome, presided over by the Duke of Hamilton and Andrew Wilson, who had become a close friend. In the late summer of 1827 Wilkie prepared to return to England, but decided to visit Spain first to see the works of Velazquez and Murillo, and to buy paintings for Sir Robert Peel. This detour was to prove crucial for his development, and while in Spain Wilkie began work on three historical canvases, based on the War of Independence. An example of Wilkie's working drawings in Spain is *The Spanish Mother* (Ashmolean) dated Seville 1828. A large and powerful drawing, it represents a mother and child before a cannon, with a soldier to the right. The fluent draughtsmanship is enhanced by a dramatic wash of rich blue. Another example of the Spanish watercolours is *Columbus at the Convent of La Rabida* (Leicester Museum) dated 13 October 1827, a subject later worked up into a full-scale oil. While in Spain Wilkie renewed his acquaintance with Washington Irving who was researching for his work on Columbus and a projected *Chronicle of the Conquest of Granada*. Together they visited monasteries, churches and houses:

> Amateurs and artists fill one's mind merely with flowers, but honest Wilkie sows in it true seeds of knowledge.[9]

Wilkie arrived back in London in July 1828 and in the following years exhibited three historical Spanish canvases at the Royal Academy, in addition to a number of Italian oils. The critics immediately disliked Wilkie's new fluent oil technique, with its virtuoso brushwork

and rich colours. An obituary written 12 years later sums up the critics' attitude towards his new work:

> We are among those who lament his change of style, although we know that there are many who do not condemn it. But this is not a question of opinion: it has long been decided – for Wilkie's fame rests upon his earlier works. Such being the case, he was wrong to risk his settled reputation by adopting another style, since in his own he was without a rival, and in that of his adoption he had many superiors.[10]

Despite the fact that both critics and the public preferred Wilkie's earlier genre paintings, the 1830s were a prolific time for Wilkie, both for his oils and for his numerous, and often superb, watercolours. In 1830, he was appointed Principal Painter in Ordinary to the King and a number of official portrait commissions followed, including the full-length *Portrait of William IV* (1832), the equestrian *Portrait of the Duke of Wellington* (1834) and *Portraits of Queen Victoria* (1837 and 1840). A fine pen-and-sepia wash drawing of the *Duke of Wellington* (1833 BM) shows Wilkie's verve as a draughtsman and the same energetic draughtsmanship can be seen in the study of *Sir Robert Peel reading to Queen Victoria* (VAM), in which Wilkie uses a pencil in repeated fluent lines, while varying their strength and intensity. One of Wilkie's finest portrait studies is that of *Pius VII* (BM), a study for the 1836 oil *Napoleon and the Pope at Fontainebleau*. Wilkie brilliantly combines watercolour and chalk, while creating vibrantly fresh tones of papal red in the clothing, which is set off against the Pontiff's black hair and white cap. In addition to portrait studies, Wilkie also painted some fluent nude studies, such as the *Nude Mounting a Ladder* (BM) and the *Penitent Magdalen* (Ashmolean 1840), in which he achieves a pearly skin colour contrasting with the dark red background.

In 1834 Wilkie returned to Scotland, staying in Edinburgh and painting watercolours of the wooded Perthshire landscape. He visited Lady Baird at Fern Tower, Perthshire and was commissioned to paint *Sir David Baird discovering the body of Tippoo Sahib*, which was finally completed, after many difficulties, in 1838. The numerous sketches and watercolours for this oil reveal Wilkie's working methods and the importance of his watercolours in the evolution of the final canvas. A number of vigorous pen-and-wash drawings are in the British Museum, while some larger chalk and watercolour studies can be found in the Victoria and Albert. In these, Wilkie's remarkable ability to capture expression and to control light and shade, while using three colours of chalk, watercolour washes, body-colour highlights and sepia, is clearly shown. Wilkie's concern over physiognomical accuracy is also revealed by a letter written to Lady Baird:

> I was told that there were three Hindoo cavalry soldiers at the India House, who had come overland, to complain of some grievance. I obtained their consent to sit to me, and they came – a Jemidar and two inferior officers – in their native dress. I explained to them, by the interpreter what I wanted, and put them on a platform in a group, the Jemidar as Tippoo, reclining with his head supported by one of his lieutenants, and his hand held by the

13 Sir David Wilkie, *Two Women*
15 × 11 National Gallery of Scotland

other, with his finger on his pulse to know if he were alive or dead. The group was magnificent, and I was all ecstacy to realize such a vision of character and colour. It was indeed a vision, and a vision only; for all of a sudden the youngest of them said, 'Me no Tippoo!' and sprung from his position, while the others repeated, 'No Tippoo I! No Tippoo I!' and to my surprise, left their places also; and no persuasion I could use could induce them to resume them.[11]

In contrast to the powerful Tippoo Sahib drawings, Wilkie was producing graceful and delicate studies of women and young girls. The various studies for *The First Earrings* (BM and Harvard) and the exquisite *Two Women* (NGS) reveal Wilkie's keen eye and felicitous technique (fig. 13) in the portrayal of elegant ladies.

In 1835 it was suggested that Wilkie would find a good source of ideas in Irish history; he spent August and September sketching in Ireland, producing portraits and genre drawings, only a few of which were worked into larger canvases. An excellent drawing for *The Peep-O'-Day Boy* (BM) was made shortly after his return from Ireland, while *The Irish Baptism* (BM) is dated 13 August and was drawn in Ireland. Other Irish sketches include studies of peasants and figures in cottage interior, such as *Peasant Family* (BM, inscribed 'West Port, August 19th 1835'). Here Wilkie shows a woman standing in the doorway of a cabin, a pig at her feet, with children indoors. Wilkie's handling of this kind of subject was to have a great influence on Scottish watercolour painting.

In the summer of 1840 Wilkie decided to visit the Middle East, not only to find new subject matter, but also to improve his failing health. The dramatic possibilities in the costumes and facial expressions of his figures for Sir David Baird had aroused his interest in the East and some of Wilkie's finest watercolours were painted during the last nine months of his life. Accompanied by a friend, William Woodburn, Wilkie travelled across Europe via Vienna and Belgrade, reaching Constantinople in October 1840. It is recorded that while in Constantinople between October 1840 and January 1841, Wilkie made over 60 sketches, some of which were engraved as *Oriental Sketches* (published by Graves and Warmsley) or appear in *The Wilkie Gallery* by Virtue.[12] In January Wilkie left Constantinople for Smyrna, making sketches of travellers and camels on the way, arriving in the Holy Land by ship in February. Here he visited Jaffa, Jerusalem and Bethlehem, making drawings of the Mount of Olives, Mount Zion and the leading Jewish rabbis. After a short stay in Alexandria, where he painted the *Portrait of Pacha Mehemet Ali*, he departed for Malta, but died at sea on 1 June 1841. The number and quality of the Eastern watercolours is extraordinary, as Wilkie delights in the facial expressions of Turks, Greeks, Persians, Arabs, Egyptians, Negroes and Jews, from princes and ladies of society to the humblest slave. His fluency of drawing, his rich use of colour, his sense of light and shade as an element in composition, and his ability to know exactly when to finish a study, capturing the essentials, but never overworking the details, place these watercolours among the finest records of the Middle East by a British artist (fig. 14).

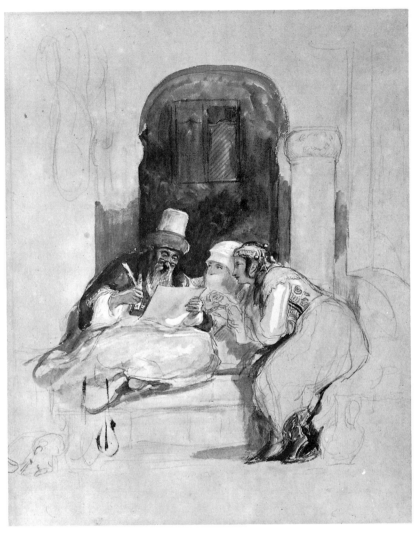

14 Sir David Wilkie, *The Letter Writer, Constantinople*
$14\frac{3}{4} \times 12\frac{3}{4}$ Ashmolean, Oxford

Wilkie's influence on numerous Scottish artists of the nineteenth century stems from the two separate aspects of his work. His earlier genre paintings in oil were reinterpreted and reworked by artists in both oil and watercolour, continuing into the early years of this century. On the other hand, the later watercolours had an influence on the work of John Phillip and W.E. Lockhart. There were also contemporaries of Wilkie whose style, although no doubt influenced by his popular success, looked back to the same sources as Wilkie himself – in particular the watercolours of David Allan. **Alexander Carse** (died *c.* 1838) was a few years older than Wilkie and had been a pupil of David Allan before joining the Trustees' Academy in 1806. He worked in both oils and watercolour in a genre style strongly influenced initially by David Allan but later by the successful formula of David Wilkie, whom he followed to London in search of a public. Carse's most important watercolour was *Oldhamstock's Fair* (fig. 15) dated 1796 (NGS)

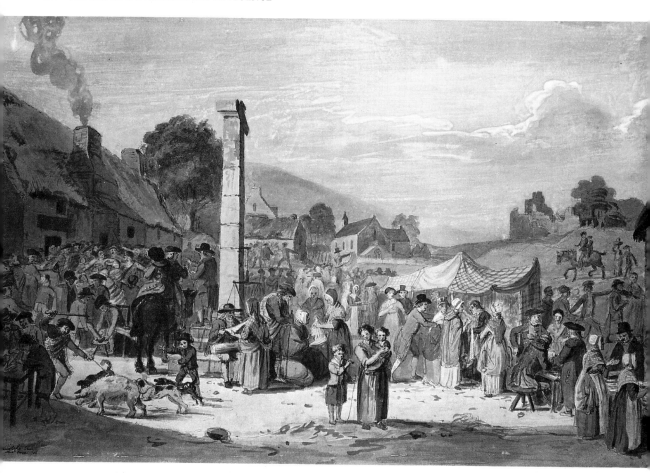

15 Alexander Carse,
Oldhamstock's Fair 1796
$15\frac{1}{2} \times 24\frac{3}{4}$ National Gallery of
Scotland

and it seems likely that Wilkie had seen this watercolour, as well as
Allan's *Muzzling Fair* of 1764, before starting work on *Pitlessie*. Many
of Carse's watercolours depict drinking and fighting scenes such as *The
Cottar's Saturday Night* and *Cockbetter's Show* (both NGS). His draw-
ing lacks the finesse and liveliness of David Allan, his figures are often
wooden and his colours tend towards brown. His oils, with their atten-
tion to detail, composition and the effects of light, are possibly more
successful than his watercolours. In 1812 Carse moved to London,
returning to Edinburgh in 1820 where he died in about 1838.

A more brilliant draughtsman is **Walter Geikie** (1795–1837) who
was both deaf and dumb, but nevertheless had studied at the Trustees'
Academy from 1812. Andrew Wilson instructed Geikie in the use of
oils and introduced him to the Earl of Hopetoun who commissioned
three canvases. He was, however, more successful in his chalk or pen-
and-wash drawings than as an oil painter. Like Wilkie, Geikie was a
perceptive draughtsman who found a wealth of subjects in the streets
and markets of Edinburgh, and a number of his sepia wash drawings
of Edinburgh are in the National Gallery of Scotland. He was also a
perceptive commentator on the Scottish way of life, and his satirical

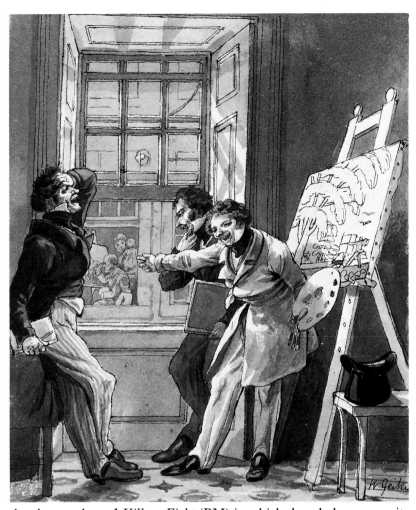

16 Walter Geikie, *Rival Artists*
6¾ × 5¾ British Museum

sketches, such as *A Village Fight* (BM) in which the whole community is at war, are effective and witty. His drawing style verges on caricature, but his figures are always full of life and character even if somewhat exaggerated. Some of his work has a poignant touch, such as *The Supper* (BM) in which five children and their parents eat a frugal meal in a garret. Other works are humorous, such as the *Rival Artists* (fig. 16) in which Geikie sums up the intense and often absurd rivalry between artists in the early nineteenth century. The victim is depicted with a particular sympathy which Geikie, himself isolated from the speaking world, feels with depth. It is the sympathy, combined with a fine drawing technique, that gives Geikie's work its particular quality.

John Burnet (1784–1868) was a fellow student of Wilkie at the Trustees' Academy under Graham. Like Alexander Carse, he was inspired by Wilkie's success in London and moved south in 1806. Trained as an engraver by Robert Scott, Burnet engraved Wilkie's early works as well as producing his own canvases. These follow

Wilkie's change in style from detailed genre scenes towards broader historical subjects. Burnet was also a draughtsman of some ability. He contributed illustrations to the first collected edition of Scott's *Waverley Novels*, published by Cadell in 1830–34, along with Wilkie, Alexander, Fraser, William Allan and others. Burnet's pen-and-wash drawings are similar in technique to Wilkie's, although they lack his skill in handling faces and expressions. This can be seen in the drawing of *Robert Burns before the Kirk Session* (NGS). At times, as in the study for *Playing at Draughts* (BM), Burnet reveals himself as a competent and energetic draughtsman, with a good control of light and shade. He also produced some attractive landscapes and seascapes in watercolour, with a firm line and a fine sense of detail. Burnet died in Stoke Newington, near London, in 1868.

William Bonnar (1800–1855) was a comparatively minor historical and genre painter whose best oils are his small portraits and studies of children, rather than his more ambitious historical canvases. He was a good watercolourist, painting portraits, genre and views of Edinburgh. *Return from Market* (NGS), a small watercolour with gouache, reveals the influence of David Allan in the faces, while *Gossips* (NGS) show that in his colours and subject matter, he has been influenced by Wilkie. **Alexander Fraser** (1786–1865) should also be mentioned as a fellow pupil of Wilkie at the Trustees'. Born in Edinburgh, he moved to London in 1813, where he painted genre close in style to that of Wilkie, who passed on commissions for which he had no time. He also painted some watercolours and an example, *The Scottish Highlander* (BM), shows that he was influenced by Wilkie's watercolour technique, especially in his use of *chiaroscuro* and rich colours. **Alexander Chisholm** (1792–1847) was born in Elgin and apprenticed to a weaver in Peterhead, before moving to Edinburgh under the patronage of the Earl of Buchan, and worked as an art teacher. In 1818 he moved to London and exhibited his genre watercolours with some success at the Royal Academy and the Old Watercolour Society. His watercolour technique is tight and well-worked, but despite the scrubbing and highly finished effect, his watercolours have life and vitality. Chisholm's drawing is good, and he uses a rich palette, as can be seen in *The Cut Foot* (VAM), one of his most popular works. There is also a fine watercolour, *Portrait of James Arbuthnot* (BM), which shows a similarity to the style of McLeay.

One of Wilkie's closest friends at the Trustees' Academy and for many years afterwards was **Sir William Allan** (1782–1850). After leaving the Trustees he moved to London in 1805, but set off in the same year for St Petersburg, in search of exotic subjects and costume. For nine years, Allan painted romantic studies of Tartar warriors and Circassian brigands, while exploring the remotest areas of Russia and Turkey. Several watercolours painted after his return in 1814 show his accurate, if somewhat outmoded handling of watercolour and his interest in detail. The influence of Wilkie is seen in his oil paintings done after his return, as both Wilkie and Sir Walter Scott encouraged Allan

to move towards subjects from Scottish history, such as *The Murder of Archbishop Sharpe*, which was shown at the Royal Academy in 1821. In 1826 Allan was appointed Master of the Trustees' Academy, following the retirement to Italy of Andrew Wilson, but as the result of problems with his eyesight, Allan made an extended recuperative trip to Italy, Greece and Constantinople, returning only in 1830.

Allan was deeply impressed by the Waverley Novels and along with many of his contemporaries, contributed illustrations for the Cadell edition. He also produced a series of watercolours of the interior of Abbotsford, to record the house in Scott's lifetime. These watercolours (NGS) show Allan's excellent draughtsmanship, although the nature of the undertaking allowed little freedom. An unusual landscape watercolour, *On the Banks of the Allan, near Dunblane* (BM), shows a much freer side to Allan's work. The fresh, sparkling colours and the relaxed use of the medium look forward to the 1870s and the watercolours of Sam Bough. In 1834 Allan was again abroad, working in Spain and Morocco and painting some of his most vibrant watercolours. *A Street in Cadiz* (BM) or *Interior of a Moorish House* (Aberdeen) have an excellent sense of pattern as well as a feeling for the heat of the south, looking forward to the street scenes of Venice by Sir George Harvey and the Spanish views of John Phillip. A series of portraits done in pencil, chalk or charcoal during this visit (BM and Aberdeen) show to what extent Allan's later work has assimilated the freedom and draughtsmanship of Wilkie. In 1838 he became President of the Royal Scottish Academy and succeeded Wilkie as Limner to the Queen in Scotland in 1841. Allan's watercolours and drawings have survived the test of time better than his large historical canvases.

The historical paintings of **William Simson** (1800–1847) were admired by David Wilkie, although today his landscapes are probably better considered. Born in Dundee, Simson studied at the Trustees' Academy under Andrew Wilson. His earlier work comprised seascapes and landscapes, but he later turned to portraiture, and, following a trip to Italy, he settled in London in 1838 and produced a number of historical canvases. Simson appears to have worked in watercolour throughout his career, using great fluency of drawing and freshness of colour. *Interior of a Cottage, Killin* (fig. 17) reveals the influence of Wilkie's watercolours, and has much in common with Wilkie's Irish watercolours of two years later. The rich colouring and vigorous brushwork, combined with strong *chiaroscuro*, make this an interesting work. There are copies in watercolour of Wilkie's oils (NGS) by Simson which show his debt to Wilkie, a debt which is also revealed in Simson's Italian watercolours, painted between 1835 and 1838. *A View of Cromarty Bay* (NGS) probably painted *c.* 1840, has a surprisingly daring use of reds, greens, and yellows, while *Eel Pots* (BM 1845), painted on the spot, has a wet watercolour technique, which looks forward to the work of McCulloch and Bough. His watercolour and pencil studies of Scottish peasants (VAM) are also most effective.

Born in Aberdeen, in humble circumstances, **John Phillip** (1817–

17 William Simson, *Interior of a Cottage, Killin* August 1833
10 × 13⅝ National Gallery of Scotland

1867) was sent by his patron, Lord Panmure, to study at the Royal Academy Schools in London. His earlier oils, although finely executed with a dramatic sense of light and shade, are of less interest than those of his later years when, inspired by a visit to Spain in 1851–52, Phillip's eyes were opened to the romantic qualities and rich colouring of Murillo and Velazquez. Phillip returned to Spain in 1856–57 and again in 1860–61, each time producing a quantity of drawings and watercolours. Caw records that be brought home some watercolours from the 1856–57 trip[13] and some of these were used, like his rapid oil sketches, as the basis of larger canvases, or more detailed watercolours. A group of watercolours in the National Gallery of Scotland show Phillip's energetic and fluent handling, combined with a deft use of charcoal outlines and body-colour highlights. His sense of light and shade is excellent, and combined with a vibrant use of blue, gives a real impression of southern heat, an impression which he achieves in his oils through a similar vibrance of colour and richness of *chiaroscuro*. *A Street Scene, Segovia* (fig. 18) for which there is a study in Edinburgh (NGS), is typical of his more finished Spanish watercolours. Phillip also drew economical and effective pencil studies of Spanish peasants, with light watercolour washes. Some watercolours of Scottish subjects also exist, showing figures in cottage interiors, painted much in the manner of

later Wilkie, with rich colours and *chiaroscuro*. Despite the fact that Phillip painted a considerable number of watercolours in his later years, comparatively few exist in public collections, and as most are unsigned, it is likely that many have been misattributed.

The landscapes of **William Ewart Lockhart** (1846–1900) are discussed in Chapter Six, but some mention of his Spanish watercolours should be made in conjunction with John Phillip. As a student at the Trustees, Lockhart was impressed by Phillip's later Spanish paintings, and like Phillip, he travelled to Spain on several occasions, becoming interested in the history and literature of the country. Although known as a history and portrait painter (especially after his work for the Royal Commission to record the 1887 Jubilee Ceremony at Westminster) Lockhart produced a number of watercolours and was elected to the RSW. His Spanish subjects – such as cathedral interiors, portraits of church dignitaries or Spanish street scenes – owe much to Phillip, with a fresh handling of washes and fluent drawing. Phillip also exerted an influence on watercolourists whose style was later to develop. Thus we find Spanish subjects and facial expressions similar to Phillip's in the earlier watercolours of Robert Herdman. It is possible to argue that Phillip 'Victorianized' Wilkie's later idiom and popularized the Mediterranean Romantic subject in a way that Wilkie had failed to do.

18 John Phillip, *A Street Scene, Segovia* 1853
9 × 13 Private collection

Whereas Phillip and Lockhart were looking towards Wilkie's later style, there were many watercolourists who found inspiration in his earlier genre oils. By the mid-century, domestic genre scenes were commonplace in Scottish art, both in oils and in watercolour, and the quality varied greatly, from poor pastiches of Wilkie to the finely executed works of the Faeds and the Burrs. The **Faed brothers**, **John** (1818–1902), **Thomas** (1826–1900) and **James** (1821–1911), established themselves in London as successful painters of Scottish genre and history. Born in Gatehouse-of-Fleet, John Faed began painting and miniatures and soon made a name for himself in Galloway. In about 1841 he settled in Edinburgh, where he became Associate of the Royal Scottish Academy in 1847 and was elected to membership of the Academy in 1851. He was also a member of the Smashers' Club, a sketching club which included James Archer, William Fettes Douglas, and his brother Thomas Faed, who had joined him in Edinburgh in 1846. Various themes, such as Evil or Death, were chosen and the members produced watercolours and drawings connected to the subject. Examples of these sketches can be found in the National Gallery of Scotland and Glasgow Art Gallery, and there is a watercolour by John Faed, depicting members of the Club, in the Scottish National Portrait Gallery. In Edinburgh, John Faed expanded his production from portrait miniatures to historical and literary themes, illustrating some of Burns's characteristic stories, while a visit to the Middle East in 1857 resulted in Biblical and Eastern subjects, often painted on a large scale. In 1864, he moved to London, following the success of his younger brother, Thomas, and his historical canvases met with considerable acclaim at the Royal Academy. John Faed was not a prolific watercolourist, and the majority of his watercolours come from the earlier part of his career, often painted on ivory.

Born two years after his brother, Thomas Faed joined him in Edinburgh in 1846, to study at the Trustees' Academy, where he was influenced by the work of Erskine Nicol and Robert Herdman. Thomas Faed's talent for painting domestic genre and subjects from Scott, combined with his good looks and natural charm, ensured his immediate popular success; and, like Wilkie, he moved to London to exploit his popularity. The subjects of his genre are sincere and moving and he avoided witty or bucolic themes. Thus, while his more famous subjects such as *The Mitherless Bairn, Home and the Homeless* or *The Last of the Clan* appeal to mid-Victorian romantic notions of Scotland, they are neither sensational nor over-emotional. Faed's watercolours depict figures in humble Scottish interiors – a mother and child, a child at play by the hearth or an old man reading by a table. Often the charm of his watercolours lies in his attention to minute detail – the texture of a wall, an old piece of furniture, a bird in a cage, a vase or a clock. At times his watercolour technique is meticulous with every item clearly stated with a judicious use of bodycolour highlights. At other times, in his less formal watercolours, Faed's handling is freer and less emphasis is given to detail, the composition being held together by broad washes of colour to achieve light and shade.

19 Thomas Faed, *The Story* 1863
$7\frac{3}{4} \times 5\frac{3}{8}$ British Museum

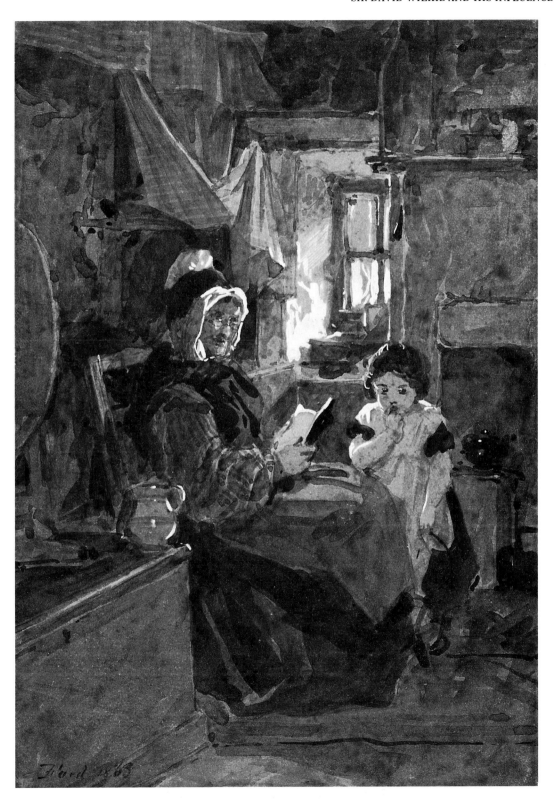

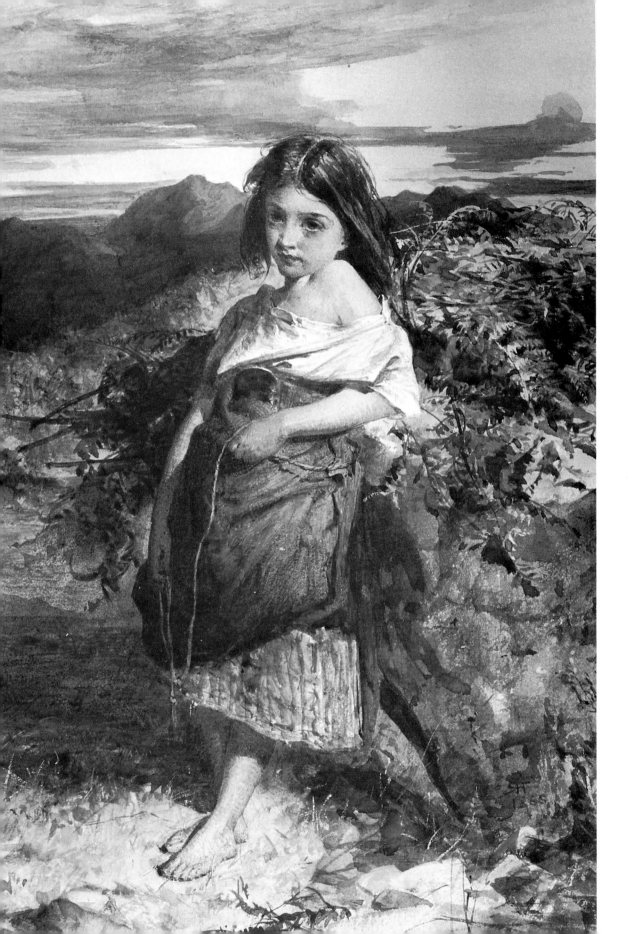

Faed was accomplished at the portrayal of feminine beauty, and some of his pictures, both oils and watercolours, depict girls standing in a landscape. In the watercolours of this theme, Faed creates rich colours and bloom, bringing to life not only the landscape, but also the face of the girl with rosy cheeks, red lips and moist eyes. Thomas Faed was not alone in this particular style of watercolour, as Robert Herdman, John Adam Houston and the Burrs were also painting similar subjects. The Pre-Raphaelite influence on Herdman and Houston are discussed in Chapter Six, but the sentimental and at times even somewhat provocative quality of their Highland maidens owes much to the success of Thomas Faed's formula, and it can be difficult to tell the artists apart. Thomas Faed gives his figures titles such as *The Reaper*, *Gipsy*, *Evangeline*; Herdman used titles such as *The Fern Gatherer* (fig. 20) or *The Berry Gatherer* – and the formula remains much the same. Both Herdman and Faed were interested in the landscape background, and Faed's watercolour sketches for landscape are exquisite. When Thomas Faed died in St John's Wood, London, aged 74, *The Times* wrote of his work:

> His taste lay in the 'homely pathetic' scenes of domestic genre, not without their moral or even religious lesson. Whereas Wilkie had been content to paint the gayer aspects of life ... Faed appealed to the graver emotions. His pictures touched the public sentiment...[14]

John Burr (1831–1893) and his brother **Alexander Hohenlohe Burr** (1835–1899) studied at the Trustees' Academy under Robert Lauder, before moving to London in the early 1860s, where John achieved success both as an oil painter and a watercolourist, becoming an Associate of the Old Water-Colour Society. John Burr's genre is closely related to that of Thomas Faed, his numerous domestic scenes painted with skill, but possibly lacking Faed's tenderness and sadness. Like Faed, he painted some fine watercolours of young girls in Highland landscapes or by the sea (fig. 21) and these works, with their rich colours and beautifully handled details, represent some of Burr's most successful watercolours. Alexander Burr was essentially an oil painter working in a similar style to his brother, but with brighter colouring.

Erskine Nicol (1825–1904) was also a leading exponent of genre during the later part of the century. Born in Leith, he trained at the Trustees' Academy before becoming Drawing Master at Leith High School. In 1845 he went to Ireland where he remained for four years, and this trip, reinforced by subsequent annual visits to Ireland, formed the basis of many of Nicol's works. He painted humorous views of Irish life, depicting the lighter side of the Irish character, and scenes of drinking, arguing and gambling are common in his work. His watercolour technique is remarkably fresh with an effective use of a coarse brown paper to which he applies his colour washes and white bodycolour with vigour. In 1862 Nicol settled in London, returning to Scotland on his retirement in 1885, and in his later years he turned more to Scottish subjects. His work should not be confused with that

20 Robert Herdman, *The Fern Gatherer* 1866
$10\frac{1}{2} \times 6\frac{3}{4}$ Private collection

21 John Burr, *By the Sea*
$5\frac{3}{4} \times 7\frac{3}{4}$ British Museum

of his son **Erskine E. Nicol** (died 1926) who painted landscapes in muted colours and broad washes, influenced by the Dutch School.

Tom McEwan (1846–1914) continued the tradition of Scottish genre into the early years of this century. He was born near Glasgow into an artistic but impoverished family, his father being a textile designer and an amateur artist, whose friendship with James Docharty was important for his son's artistic development. McEwan was apprenticed to a pattern designer in Glasgow and in 1863 began to attend evening classes at Glasgow School of Art under Robert Greenlees. During the 1860s he began to exhibit at the Glasgow Institute and in 1872 he spent six months with James Docharty, painting on Islay and Jura. This trip finally decided McEwan to turn to art as a career and over the next 40 years he produced a large number of genre and historical paintings, mostly executed in watercolour. His watercolour technique is meticulous with carefully worked areas and evidence of scrubbing; colours are rich and densely applied (fig. 22). While the influence of Wilkie's genre is still evident in McEwan's work, there is also a strong influence of mid-nineteenth-century Dutch genre, in particular that of Israels. McEwan was a popular figure in Glasgow both as President of the Glasgow Art Club, and as a member of the Glasgow

22 Tom McEwan, *The Sewing Lesson*
$15\frac{1}{2} \times 20$ Perth Museum and Art Gallery

Ballard Club, and his wide range of interests included Scottish history and literature.

The influence of the Dutch School is also evident in the genre watercolours of **Robert Gemmell Hutchison** (1855–1936) whose landscapes and seascapes are discussed in Chapter Seven. Hutchison's studies of humble people in homely interiors are painted in a loose style, quite unlike the earlier genre painters, yet through subtle tones and undefined details, Hutchison creates sympathetic, but never sentimental, images. **Hugh Cameron** (1835–1918) and **George Manson** (1850–1876) are both discussed in Chapter Six for their contribution to the development of a freer watercolour technique. Both were significant genre painters, Cameron for his studies of old people or children outside crofts or seen around the hearth, and Manson for his meticulous watercolours of children in interiors. Like Hutchison, both artists continued within the genre tradition while introducing new techniques.

One of the last genre painters in Scotland was a Glasgow artist, **John Rennie MacKenzie Houston** (1856–1932), who specialized in figures in interiors, often set in historical periods. His work was influenced by the Dutch School and can be effective with its rich colours and wet washes. Too often, however, he simply reworked the formula of the Faeds, and it is evident from Houston's work that by the 1920s genre had lost its impetus.

4 The mid-century 1830-1880

During the mid-nineteenth century the English image of Scotland moved from that of a remote, inaccessible and even dangerous province, towards that of a magnificent, romantic country rich in ancient traditions and noble architecture. The change was partly brought about by the growing interest shown by the Royal Family in Scottish affairs, starting with George IV's triumphant visit to Edinburgh in 1822. Queen Victoria began to visit Scotland north of Edinburgh, an area previously neglected in favour of the Borders. So impressed was she that she set about looking for a country residence, settling finally for Balmoral, where she spent her first extended holiday in 1848. To her English subjects Scotland meant different things. To some it meant the possibility of acquiring large estates and titles at very reasonable prices; to others it meant fashionable and healthy holidays, maybe with some deer-stalking – the sport which Prince Albert had popularized. To the more thoughtful and imaginative of her subjects, Scotland represented an unspoilt haven of natural beauty untouched by the continuing industrialization which had affected the landscape of almost every part of England. Thus the Scottish Highlands seen through the music of Mendelssohn, the poetry of Scott and the oil paintings of McCulloch, Landseer and MacWhirter became an aspect of Victorian escapism. The poverty of much of the Highlands and the misery caused by the clearances stood in stark contrast to the images created by Scott in *The Lady of the Lake* or by McCulloch, whose Highland views were thus described in 1860:

> He can make you feel through his art the loneliness of mountain sides and great glens and inspire you, if you will but open your mind to receive the impression, with the feeling of religion and wonder, which, growing out of the sense of that loneliness, has imbued his own spirit.[1]

Almost all the leading artists of this period, both landscape and historical, were good watercolourists. Many, like Roberts, Leitch, Giles and Waller Hugh Paton, were more successful in watercolour than in oils. Even the great academic artists known in their time for large historical canvases – Sir William Allan, Sir George Harvey and James Drummond – were also good watercolourists, revealing a more intimate as-

pect of their art. Watercolour was accepted as an important medium; the annual Royal Scottish Academy exhibitions had a consistently large number of watercolours on display. Watercolour drawings were also in demand by publishers, as direct lithographs. Retaining the artist's original spontaneity, they could be issued, especially following the success of David Roberts; while collectors could commission albums of watercolours as an alternative to large Academy canvases. Moreover the Queen's interest in watercolour drawing did much to stimulate the art on both a professional and an amateur level.

One of the first artists to work at Balmoral for the Queen was **James Giles** (1801–1870) who produced watercolours of the original castle to help the Royal couple decide which property to buy. Giles was a natural choice for this task, having been brought up in the area and having already worked on a similar project for the 2nd Duke of Sutherland. He was born in Aberdeen, the son of Peter Giles, a calico designer and artist who ran a small drawing school, the advertisement for which ran:

> P. Giles teaches Drawing and Painting in all their branches, either at his Academy, Boarding Schools or Private Families.[2]

James Giles followed his father and was teaching drawing by the time he was 15, later taking public classes in Aberdeen. His real development, however, came during a visit to Italy in 1824–25. This trip, which has been carefully researched by John Sparrow and Mary Herdman,[3] the artist's grand-daughter, opened Giles's eyes to the magical light of the south. His sketchbooks of 1824–25 reveal his progress through France via Toulon and Marseilles to Genoa, Florence, Siena and Rome where he spent the Christmas of 1824, moving down to Naples in January before returning via Venice and Switzerland. The numerous watercolours he made during this period show that he was an artist of outstanding potential. His sense of light on buildings, drawn crisply but with free washes, is superb, as are his views of sunsets, looking towards a golden sun while the sky turns to pinks and purples.

In *St Giovanni Laterano* (Aberdeen Art Gallery) of 1824 he uses accurate yet sensitive pencil outline, the statues on the roof being finely drawn while the windows and architectural details are summed up in a most effective shorthand. Giles's handling of architecture is quite as good as Andrew Wilson's and his handling of light is similar; it is possible that Giles had seen some of Wilson's watercolours in Scotland before leaving for Italy. A good example of Giles's more finished Italian watercolours is *Sorracte from Civita Castellana* (fig. 23) in sepia and bodycolour on blue paper. Giles's informal style and sensitivity to light result in some very advanced works which, at times, appear similar to the almost contemporary *pochades* of Corot and Henri de Valenciennes.

On his return to Scotland, Giles continued to produce some excellent watercolours, and *Kinheld Market* (BM 1827) has a freshness close to

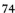

23 James Giles, *Sorracte from Civita Castellana* 1825 $11\frac{1}{2} \times 16\frac{5}{8}$ Aberdeen Art Gallery and Museums

his Italian work. In 1839 he produced an album of watercolours for the 2nd Duke of Sutherland illustrating various parts of his huge estate.[4] The watercolours capture the emptiness and desolation of the landscape following the clearances, and Giles has responded to light effects very different from those found in Italy. *Ardvreck Castle and Lock Assynt* depicts a mighty thunderstorm, the landscape dominated by a rainbow. These drawings are executed on grey paper with extensive use of bodycolour. Another aspect of this period are the worked-up watercolours and oil paintings based on his Italian sketches, but just as John Brown's inspiration seems to have deserted him in the more rational atmosphere of Edinburgh, so Giles's spontaneity slowly seems to have evaporated in the north-east of Scotland.[5] His patrons – Queen Victoria, the Duke of Sutherland and Lord Aberdeen – wanted detailed and highly finished topographical or sporting pictures, and his later work, such as *Deer Stalking* (1853 Aberdeen) lacks the verve and directness of his earlier watercolours. Giles continued to draw well and one late sketchbook (Aberdeen 1862–63) is filled with studies in pencil and pen-and-ink of deer, hounds, fish and eagles. There are also views of Arran which he visited in 1862. Obviously hard-working to the end, he wrote in 1862, 'I hope to be diligent and make a good use of my time'; and later that year, 'I must be diligent while I am able – the 4th

January makes me 62 years old.'[6] Giles's problem lay with his patrons who demanded 'finish' more than verve, subtlety or spontaneity.

Like James Giles, **William Leighton Leitch** (1804–1883) also worked for the Royal Family and derived much of his inspiration from an early trip to Italy. He was born in Glasgow, the son of a retired soldier, and was given a good education with the aim of entering the law. Leitch disliked this choice of career and spent much time with his two friends Daniel Macnee and Horatio McCulloch, who were both devoting themselves to painting. He admired the theatrical sets of David Roberts and Alexander Nasmyth and in 1824 himself became a scene painter at the Theatre Royal in Glasgow. He later wrote:

> The exquisite drawings of Roberts' architecture charmed me beyond measure, and the masses of shadows gave his work great grandeur and breadth. His painting encouraged me by its simplicity and I imitated some of his work with considerable success. Nasmyth's art was different. The perfection of the execution was wonderful. You felt as if you could pull aside the branch of a tree and find another beneath it. I never saw painting so like nature and this was its charm, I was continually studying these works, and the lessons I got from their teaching, I have never forgotten.[7]

Leitch's career in the Theatre Royal ended after little more than a year, and for a time he worked in Cumnock, Ayrshire, decorating snuff boxes before moving to London in 1830. He was to be based in London for the rest of his life, supporting his wife and three children by working again for the theatre, first at the Queen's Theatre, Tottenham Street and later at the Pavilion Theatre. He became a friend of Roberts and of Clarkson Stanfield who were both working for London theatres. Leitch's opportunity came when a wealthy stockbroker (a Mr Anderson), admiring his work, sent him to take lessons with Copley Fielding, and his career as an artist had commenced. Between 1833 and 1837 Leitch was in Italy during which time his style developed rapidly. He later described these four years:

> The most interesting part of all my artistic life – I mean the interest of my artistic progression – was in these four years of travel.[8]

Supported by Mr Anderson, Leitch travelled via the Rhine and Switzerland to Venice where he obtained a teaching post; in 1834–35 he was in Rome where he met Horace Vernet and other artists and was deeply impressed by the Campagna landscape. He moved on to Naples and later to Sicily, but returned to spend most of 1836 in Naples where the coastal views at Salerno, Amalfi, the Bay of Baiae and Ischia created a strong and lasting impression upon his work. Although he did not revisit Italy until 1854, Leitch continued to paint many Italian views in oils and watercolours, based upon these four important years.

Over the following years, Leitch's reputation grew fast. He was introduced to the Royal Family and for 22 years he taught at Windsor, Osborne, Balmoral and Buckingham Palace, having amongst his pupils not only Queen Victoria, but also Princes Arthur and Leopold and Princesses Louise and Helena. A fascinating sheet relating to Leitch's

24 William Leighton
Leitch, *Travellers in an
Italian Landscape* 1839
$6\frac{1}{2} \times 10\frac{1}{4}$ Moss Galleries

lessons exists in Dundee Art Gallery. It is a series of exercises consisting of coloured washes and overlapping planes in addition to two small views. It was bequeathed by the watercolourist Emily Paterson who wrote on the verso:

> At one time he gave lessons to Queen Victoria and it is possible that this was a demonstration lesson to her, illustrating the construction of a drawing and the juxtaposition of a colour scheme as laid down by Chevreuil in 1830...

Leitch disliked bodycolour and showed his pupils how to benefit from the luminosity and transparency which watercolours could achieve. He also encouraged his pupils to paint in the open air, capturing a specific time of day or atmospheric effect. He believed in hard work as a necessary complement to pure talent:

> In art, whatever talent the student may possess, he must have knowledge to express it... All the best masters, all the geniuses in art, were the hardest workers, and laboured most ardently at the practical part.[9]

In 1854 Leitch returned to Rome with an old friend and distinguished pupil – Sir Coutts Lindsay. He was again impressed by the Roman Campagna and the Alban Hills, and on this trip he returned via the Italian lakes, admiring the effects of the sunlight on water and the sun setting behind the Alps. He had always admired the work of Turner and wished to experience at first hand those views which had influenced Turner so much. After his return in 1855 he never again

visited Italy, although he continued to make regular sketching expeditions to Scotland (fig. 25). His watercolours were admired and he was invited to join the Royal Society of Painters in Water-Colours, but declined in favour of the Royal Institute, of which he became Vice-President in the year of his death. On his death Sir Coutts Lindsay wrote:

> He possessed not only the creative faculty of the poet, but the familiar knowledge necessary for its expression – a wealthy memory, an accurate perception and a fervid imagination.[10]

Although Leitch was respected in his time, later critics have tended to dismiss him lightly. Martin Hardie wrote of him:

> Although he was a skilful draughtsman, with intimate knowledge of what pencil and brush could accomplish in capable hands, his outlook was neither original nor emotional; he was insensitive to atmosphere; and was apt to clutter his work with a profusion of details and incidents rendered with painstaking accuracy.[11]

This criticism appears harsh today. Leitch's work has a considerable charm and poetry which, although not totally original, is certainly very individual. His watercolours of the Italian lakes, painted in fresh blues,

25 William Leighton Leitch, *Mr Muir's House on the Gareloch*
$24 \times 40\frac{1}{4}$ Fine Art Society

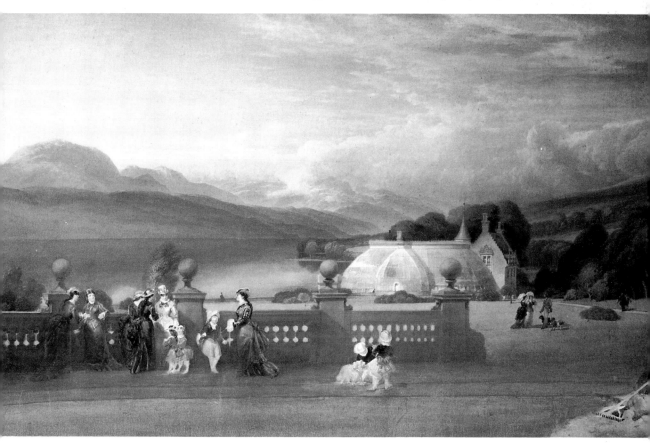

purples and greens with sensitively drawn figures and buildings in ochres and reds in the foreground, can be exquisite. They are sometimes small, compelling the viewer to go close to examine the details and thereby entering the pictorial depth (fig. 24). He was not insensitive to atmosphere. His Scottish views are different from the Italian landscapes: he captures the damp mists and subtle colours of the Highlands in a watercolour technique which is less incisive and precise than that used for the Italian views.

David Roberts (1796–1864) became, after Wilkie, the best known Scottish artist of the mid-nineteenth century. His reputation has remained comparatively unaffected by changes in taste; while the work of many of his contemporaries like Leitch and Giles was to drop into relative obscurity early this century, the watercolours, lithographs and oils of Roberts have always remained popular. He was born in humble circumstances as the son of a shoemaker in Stockbridge, then a village on the outskirts of Edinburgh. After an apprenticeship with an Edinburgh decorator, he moved on the scene painting first with a circus, and later in the theatre. In 1818, after a short period at the Trustees' Academy, he joined the Theatre Royal in Glasgow and saw the scenes of Alexander Nasmyth which included palace interiors, street scenes and views of the Clyde. He later wrote in his *Journal:* 'These productions I studied incessantly, and on them my style, if I have any, was originally formed.'[12] In 1820 he returned to Edinburgh to work at the Theatre Royal in that city and at the Edinburgh Pantheon where he first met Clarkson Stanfield, who was to become a life-long friend. Stanfield probably encouraged Roberts to turn to easel painting; in 1822 Roberts exhibited three oil paintings at the Edinburgh Institute, and in the same year he moved to London with his wife and daughter Christine, to find work in the theatre. He was again successful, designing and painting sets at both Drury Lane and Covent Garden, and creating several dioramas to satisfy a growing demand. However, he also began exhibiting easel paintings at the newly founded Society of British Artists and the British Institution, and by 1830 he had left the theatre for good. To what extent his theatre experience influenced his later work is open to discussion. The need to have total understanding of complex perspective must certainly have helped him with the often complicated views of towns and buildings. Moreover, in some of his works, especially his views of European towns, he creates a theatrical space composed of churches, palace façades and fountains into which he projects his figures, rather like actors upon the stage. His experience of the theatre taught Roberts how to depict a building in a three-dimensional manner – both interior and exterior. This he achieves time and time again, making his architecture far more tangible and real than that of his contemporary 'Crimean' Simpson, who had no experience of the theatre. Roberts's use of such devices as a set-square and ruler also derived from his practice of stage design. On the other hand, Roberts never uses theatrical devices in an obvious or crude way; his *chiaroscuro* is played down and the poses of his figures are subtle and individual.

In 1824 Roberts made his first trip abroad, visiting Dieppe and Rouen with another Scottish artist, John Wilson, while in 1829 he was in Paris with Alexander Fraser. He remained close to Scottish artists who were erecting a memorial to Patrick Nasmyth in Lambeth New Churchyard in 1831. The others included David Wilkie, Andrew Geddes, John Wilson, William Kidd, John Burnet and Alexander Fraser. Wilkie's expedition to Spain in 1828 was probably the inspiration for Roberts's own visit to Spain in 1832–33 and on stylistic grounds there is a strong similarity between the figures in Roberts's watercolours and oils from the 1830s onwards, and those which Wilkie developed from the late 1820s. Wilkie's ideal of a Spanish beauty with fine aquiline features and rich dark hair appears in many of Roberts's sketches both in Spain and later in the Holy Land. The use of rich colours and strong contrasts of reds, blues, blacks and whites in particular, which are evident in the watercolours of Wilkie from the early 1830s, became a characteristic of Roberts's figures. His apparent lack of interest in the effects of sunlight and atmosphere upon his figures has been a constant point of criticism from Ruskin onwards, but its roots lie in the influence of Wilkie's later watercolours. Equally important to Roberts were Wilkie's subtle and naturalistic poses and in many sketches by Roberts one feels the suggestion of Wilkie's seated or resting figures.

Late in 1832 Roberts set out for Spain, crossing the Pyrenees early in January 1833 and reaching Madrid by the middle of the month. He sketched out-of-doors around Cordova and Granada and also crossed over via Gibraltar to Tangiers where he drew Arabs and their costumes for the first time. He was greatly impressed by the sensations offered by the country:

> The fabled perfumes of Arabia were here realized; the scent from the orange and citron groves surpasses anything that we sons of the cold north can imagine. This, with the singing of birds, their beautiful plumage, the rich vegetation of the plains, and the wild and picturesque grandeur of the chain of the Atlas mountains, make the whole seem an earthly paradise...[13]

He failed to meet J. F. Lewis in Spain, but on return in October 1833 found himself frequently working in competition with Lewis, whose *Sketches and Drawings of the Alhambra* appeared in 1835. Roberts's Spanish drawings were reproduced as engravings in *Jenning's Landscape Annuals* between 1835 and 1838 and a group of 26 drawings were reproduced lithographically as *Roberts' Picturesque Sketches in Spain*, some plates being lithographed by Louis Haghe who was subsequently to lithograph most of Roberts's watercolours. This volume, which appeared in 1837, was highly successful and encouraged Roberts to embark upon a more ambitious project.

When Roberts set out for the Middle East in August 1838, he was recognized as one of the leading landscape and architectural painters of the day, his reputation having grown immeasurably during the 1830s. He travelled like a prince with servants in attendance, but still

found time to produce innumerable drawings, and to keep a journal which is full of sensitive, sometimes poetical comments. A few days after arriving in Alexandria in September, he saw the Pyramids for the first time: 'What sensations rush through us at first sight of these stupendous monuments of antiquity',[14] he wrote, and later he commented upon the stillness of the landscape:

> The sun was setting, and beaming full upon the hills – deep broad shadows on one side of the amphitheatre, a purple glow on the other – long lines of green maize here and there broken by the palm and accacia – the solitary ibis stalking lazily along the banks; altogether the scene was imbued with a serenity and beauty I have never seen equalled.[15]

He was moved by the sense of past achievements which contrasted so strongly with the contemporary squalor of Egypt:

> I reached my boat overcome by melancholy reflections on the mutability of all human greatness, and the perishable nature of even the most enduring works of human genius.[16]

For the best part of a year Roberts worked in Egypt, before setting off in January 1839 for Petra and Jerusalem accompanied and guided by a tribe of a hundred Bedouins. Petra he found fascinating for its combination of man-made architecture with a landscape of natural drama. He worked hard in and around Jerusalem painting several views of the town from a distance as well as its famous buildings, and he also visited Nazareth, Bethlehem and Galilee. Baalbek inspired Roberts to some of his most famous watercolours:

> The celebrated temple ... It is still by far the most perfect as well as the most beautiful in its proportions I have ever seen. ...
> The beauty of its form, the exquisite richness of its ornament, and the vast magnitude of its dimensions are altogether unparalleled.[17]

Some of Roberts's views of towns on the coast are also among his most successful works. Here he was able to incorporate the blue sea, white beaches and details of boats into his compositions, making them pictorially more interesting than the somewhat dry views of Jerusalem. *Tsur, Ancient Tyre, from the Isthmus* (fig. 26) illustrates his superb handling of a difficult subject, while the views of St Jean d'Acre and Sidon are equally successful. The journey ended with a return trip via Egypt, Malta and Spain, arriving at London in June 1839.

Roberts had now to work up his drawings and sketches into finished oils and watercolours for exhibition and lithographic reproduction. *Views in the Holy Land, Syria, Idumea, Arabia, Egypt and Nubia* appeared in parts between 1842 and 1849, and were an immediate success. Despite the pressure of producing some 250 watercolours, Roberts continued to travel. In 1843 he was back in Normandy and Brittany, in 1845 he was drawing churches in Belgium, in 1849 he returned to Paris, Brussels and Holland, and in 1851 and again in 1853 he visited Italy. While in Venice in 1851 he met Ruskin and a mutual

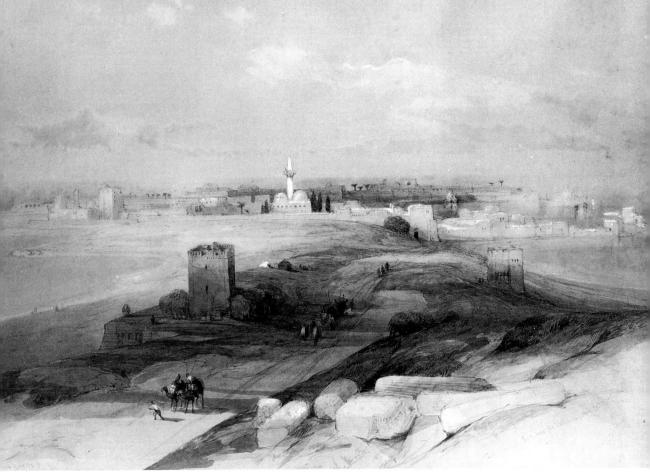

antipathy appears to have been quickly established. Ruskin wrote to his parents:

> I saw David Roberts today ... Venice has been used to all kinds of libels and must put up with it. Nobody could draw her but John Lewis.[18]

26 David Roberts, *Tsur, Ancient Tyre, from the Isthmus* April 27th 1839 $9\frac{1}{2} \times 13$ Fine Art Society

and later:

> Mr Roberts left us last night.... He is hurried away from Venice to go to paint the Great Exhibition for the Queen. However, Venice does not lose much. He has been what he calls sketching.... He sketches the Ducal Palace this way (very rough sketch) and says it is quite enough. How he is ever to work up his sketches I cannot imagine.... I am the more sorry to see him failing in this way, for he is thoroughly kind, upright and good-natured – upright at least in all but pretending to draw things which he does not.[19]

Roberts, described by a contemporary as 'a big powerful Scotsman who spoke his mind fearlessly on all occasions',[20] had little time for Ruskin's criticisms and is reputed to have countered:

> Who are ye to attack me? Ye are just a damned scribbling snob! Ye tried to paint yerself and ye couldna![21]

Roberts continued to visit Scotland regularly and retained many Scottish friends, especially D. O. Hill, and produced drawings for *Scotland Illustrated* although this was not a commercial success. His last

visit abroad was to Belgium in 1861, but he continued to paint views of the Continent from previous sketches. His last project, a series of views of the Thames, was left incomplete on his death in 1863.

David Roberts's watercolours appear surprisingly modern to our eyes; his approach is cool, unemotional; his pencil lines are precise, his colours restrained and his composition balanced. It was this dispassionate quality that Ruskin temperamentally disliked and which Martin Hardie, a sensitive critic, mistook for emptiness:

> Many of his drawings and oil-paintings, however accurate in technical mastery of detail, are uninteresting just because they are so empty and monochromatic.[22]

Nor can it be argued that Roberts's work was repetitive: he was highly sensitive to the patterns and colours of architecture and its relationship to natural surroundings, such as the mountains of Spain and the Middle East. At times he emphasized the natural drama of snow-clad peaks; or dwelt upon the harsh dryness of the Middle East, while in other watercolours he placed ruined classical temples romantically against a setting sun. The success of Roberts's watercolours does not depend upon the grandeur of the architecture or landscape before his eyes, as some of his most exquisite works are intimate views of churches or streets in France or Belgium. Roberts's popularity has resulted in many fakes, especially as so many of his watercolours were lithographically reproduced. Poorly drawn figures or a mechanical handling of architectural details distinguish these forgeries.

William 'Crimean' Simpson (1823–1899), some 20 years younger than Roberts, made a reputation as a traveller in much the same way as Roberts. He was born in Glasgow, the son of a marine engineer, and was apprenticed to a lithographer, but he preferred to go into the countryside with his friend Robert Carrick to paint from nature in watercolour. In his autobiography he points out that Andrew Donaldson was an early influence:

> I looked carefully at Donaldson's pictures, which were often in a shop window in Queen Street, and tried to do something like them at home.[23]

Simpson was one of the first part-time students at the Glasgow School of Design when it opened in 1845, but in 1851 he left for London where he continued to work as a lithographer, becoming a close friend of Louis Haghe. His opportunity came in 1854 when he was sent by Colnaghi's to cover the Crimean War, thus becoming one of the first war artists expressly commissioned to record a campaign. His drawings of the Crimea were skilfully lithographed and have become popular with collectors, although they are far less poignant than the photographs of the same campaign by Roger Fenton and James Robertson.

In 1866 Simpson joined the *Illustrated London News* and travelled extensively, recording important events. In 1859 he visited India after the Mutiny. He stayed for three years and covered some 22,500 miles including expeditions to the Himalayas and Kashmir. He returned

several times to India recording the Prince of Wales's visit in 1875–76, the Afghan expedition of 1878–89 and an Afghan Boundary expedition in 1884. Among other foreign trips were a visit to Moscow in 1866 to cover the marriage of the future Alexander III to Princess Dagmar, the opening of the Suez canal in 1869, the start of the Franco-Prussian War in 1870 (when he was arrested by the French in Metz as a German spy), the Paris Commune and its fall in 1871, and the coronation of Alexander III as Czar in 1883. He also found time to sketch Greece, Mycenae and Ephesus in 1877. This fascinating life is recorded in his autobiography with interesting comments on a variety of subjects including the amount of blood to be seen on a battlefield. Caw's comment, that 'it is the romance of his career, rather than the quality of his art that makes appeal', is somewhat harsh.[24] Forced at times to produce watercolours to a commercial deadline, Simpson inevitably produced some ordinary and uninspired works, but at his best, he painted imaginative and romantic views which reflect his love of adventure and travel (fig. 27). He later made an interesting series of watercolours based on earlier sketches depicting Glasgow in the 1840s, which are today in the People's Palace (Glasgow). They provide a fascinating view of Old Glasgow before dramatic alterations in the late nineteenth century.

The watercolours of **Charles Heath Wilson** (1809–1882), the eldest

27 William 'Crimean' Simpson, *Parnassus and Helicon from Corinth* 1870 $14\frac{7}{8} \times 23\frac{1}{2}$ Fine Art Society

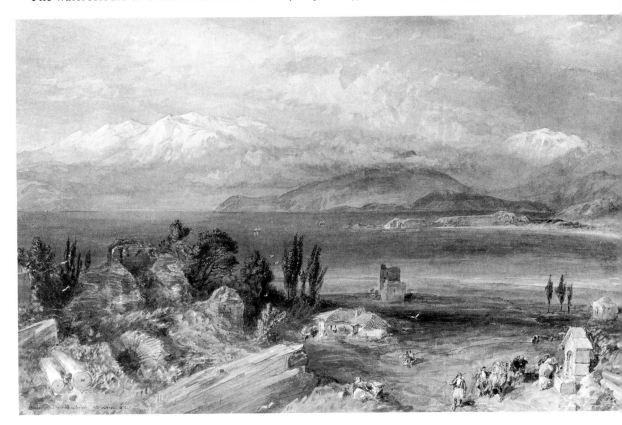

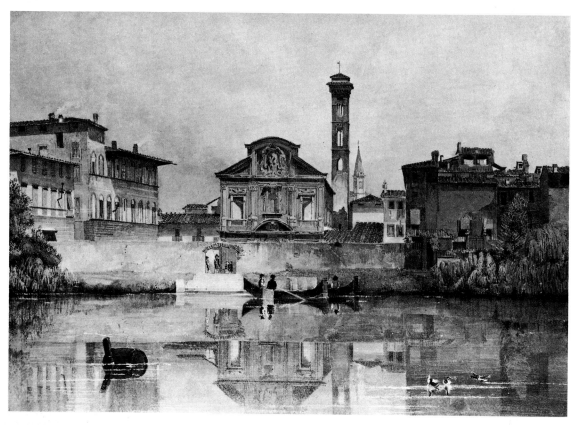

28 Charles Heath Wilson, *The Church of the Ognissanti, Florence* $13\frac{1}{2} \times 19$ Formerly with Spink and Son

son of Andrew Wilson, deserve greater recognition, for Wilson is today known more as a writer on, and administrator of, art education than as a painter. Born in London, he studied under his father and accompanied him to Italy in 1826. Wilson stayed there until 1833, when he returned to Edinburgh to practise as an architect and teach at the School of Art. He held several administrative posts in the government design schools – first as Director of Edinburgh School of Art, then of the Somerset House School on the resignation of Dyce in 1843, and finally as Headmaster of the new Glasgow School of Design in 1849. He was in addition an expert on fresco painting and stained glass. No doubt his active administrative life impinged upon his career as an artist, but, like Dyce, he found time to paint. In 1869 he retired from Glasgow School of Design and moved to Florence with his family to devote himself to the study of Italian art, publishing a life of Michelangelo, and to watercolour painting. *The Church of Ognissanti, Florence* (fig. 28) illustrates Wilson's firm draughtsmanship and the influence of his father's teaching. The buildings are well handled, and at the same time, he has achieved his father's ability to create transparent effects in flat watercolour washes.

The artists discussed so far in this chapter found their greatest inspiration abroad. There were, however, many good watercolourists during the mid-century who lived and worked in Scotland, such as

Octavius Hill (1802–1870) – better known as Robert Adamson's partner in the making of early calotypes of Edinburgh and of the fishermen and women of Newhaven, than as a painter. Born in Perth, he studied at the Trustees' Academy and was elected to the Royal Scottish Academy in 1829, having earlier attended the inaugural meeting of the Academy in 1826 as an Associate. From 1830 he was the Academy's energetic Secretary. His landscape painting in oils varies considerably in quality, although Caw's comment that he is more successful in black-and-white is born out by his fine illustrations for *The Land of Burns* (1840). His handling of watercolour could be effective; his pencil drawing is sharp and precise and he had a feel for the effects of clouds and light on water. This is illustrated by a series of sketches in the National Gallery of Scotland showing views in and around Edinburgh and the Firth of Forth. *The Tomb of Burns, Dumfries* (fig. 29) illustrates his firm handling of architecture and sensitive touch with watercolour washes. He also produced much less successful watercolours of Highland scenery and lochs where the handling is heavy and bodycolour greatly over-used. Although Hill probably visited Italy in 1842, it had little influence on his watercolour painting.

Sir George Harvey (1806–1876) was also closely associated with the Academy as a Foundation Associate in 1826 and later as President from 1864 to 1876. Like D. O. Hill, Harvey is little known for his watercolours, having made his reputation as a painter of large historical works and genre. He was, nevertheless, an exceptionally fine

29 David Octavius Hill, *The Tomb of Burns, Dumfries*
$7\frac{7}{8} \times 13\frac{3}{8}$ National Gallery of Scotland

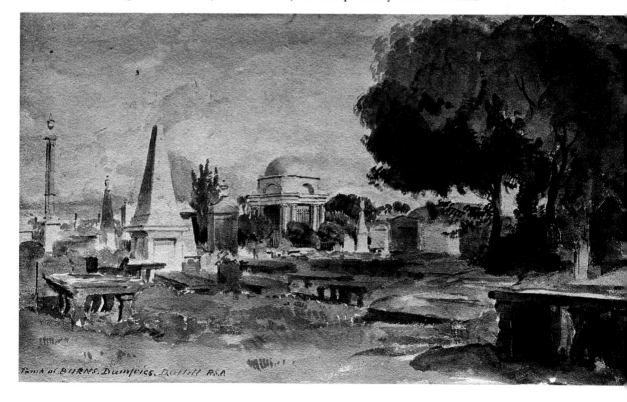

watercolourist. As a pupil of Sir William Allan, he would certainly have been introduced to watercolour painting and Allan's insistence upon drawing must have helped Harvey become an accomplished draughtsman. His landscape watercolours are beautifully executed with attention both to detail and to the mood of the location. *Glenfalloch* (fig. 30) captures the desolation of the Highlands as well as the dampness of the atmosphere, while at the same time highlighting the foreground details. Caw's comment that Harvey 'realized the pensive charms and pastoral melancholy of the Highland staths and the Lowland hills with ... insight and sympathy'[25] is fully born out in his watercolours and oils. Although he worked mostly in Scotland, Harvey visited Italy in the early 1850s and several watercolours exist as a record of this trip, such as *A Canal in Venice* (NGS). In his Italian views he tends towards the sunlit tones of Leitch although his handling is more vigorous.

Arthur Perigal (1816–1884) began to exhibit watercolours at the Royal Scottish Academy in 1837. The son of a successful miniaturist from Edinburgh, he quickly established himself as a landscape painter both in oils and watercolour, being elected Associate of the Royal Scottish Academy aged 25. In many respects he did not fulfil his early promise, his later views of the Highlands often appearing dull, overworked and repetitive. The *Art Journal*, reviewing the 1868 RSA summer exhibition, well summed up the appearance of Perigal's work:

There are half-a-dozen of his landscapes all with the same hard, cold, solid sky, and serrated ridges of mountains.

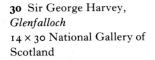

30 Sir George Harvey, *Glenfalloch* 14 × 30 National Gallery of Scotland

On the other hand, his more delicate watercolours painted in Italy in the 1840s can be charming, and occasionally he revived this delicacy in his later watercolours of the Highlands. At his best, he produced exquisite skies with silvery blues, pinks and yellows, while his fore-

grounds have mellow greens and browns. At their worst, his water-colours are oversized and mechanical.

Until recently **Jessie Cassie** (1819–1879) has been under-rated. The 1979 exhibition of his work at Aberdeen Art Gallery has restored him to his position as an interesting mid-century painter of seascapes, beaches and harbour scenes in both oils and watercolour.[26] He was born at Inverurie near Aberdeen, but his family moved into Aberdeen itself in the late 1820s. As a child, he was seriously injured in a street accident and suffered physical disabilities for the rest of his life. Having trained under Aberdeen's leading artist and drawing-master, James Giles, he made a living as a portrait and animal painter. During the 1860s he turned more towards seascapes and his work became known in Edinburgh and London, where he exhibited at the Royal Academy. He was elected Associate of the Royal Scottish Aca-demy in 1869 and in the same year moved to Edinburgh where he could sell his works at a better price. He nevertheless returned to the north-east coast to paint its harbours, beaches and shoreline. Cassie was not himself a sailor and his views of the sea tend to be taken from the land. He loved brilliant colours and often painted the summer sea with a sharp clarity of detail. This he contrasted with powerful storm

31 James Cassie, *On the East Coast*
$5\frac{1}{4} \times 7\frac{1}{8}$ National Gallery of Scotland

scenes, nostalgic views of beaches at low tide, or romantic views of the setting sun or morning mists. He used watercolour both as a means of recording on the spot and in finished works which he exhibited in the RSA watercolour room. His watercolours tend to be small, but their handling and unworked simplicity make them striking (fig. 31). Although he was fascinated by detail, and probably made use of photographs as an *aide-mémoire*, his watercolours never became laboured. James Cassie produced a large number of watercolours during his career, but there are few today in public collections. The bulk, signed with a monogram, must still be in private collections, their author possibly unknown to the owners.

John Wilson Ewbank (1799–1847) was born before the other artists in this chapter and died of typhus at the comparatively early age of 48. Born in Gateshead, Durham, he was brought up in Yorkshire before studying under Alexander Nasmyth in Edinburgh, which became his adoptive home. His oils were strongly influenced by Dutch marine painting, but he also developed a fresh and personal style of drawing in pencil, using fine detail in which he balances areas of light and shade. He combined pencil and wash in a series of vignettes depicting Abbotsford and its neighbourhood, and his views of Edinburgh were engraved by W. H. Lizars for Dr James Browne's *Picturesque Views of Edinburgh* (1825). While he drew in the Trossachs and around Loch Lomond, his best works were seascapes. His last years were spent in decline as an alcoholic. A contemporary of Ewbank is **Edmund Thornton Crawford** (1806–1885), who was also best at marine painting and was likewise influenced by the Dutch School. Born at Cowden near Dalkeith, he studied at the Trustees' Academy where he became a close friend of William Simson. In 1831 he visited Holland to study Dutch seventeenth-century painting in public collections. His watercolours can be fresh, with a good sense of movement. *Marine View with Dutch Fishing Vessels* (fig. 32) is an example of his style with fluent pencil drawing and wet washes. He often worked on coloured paper, either light brown or blue, using bodycolour for the highlights. **William Clark** (died 1883) lived and worked in Greenock painting sea pieces in oil and watercolour, having possibly been influenced by the marines of Robert Salmon who was working in Greenoch. His output was large but of a consistent quality, his knowledge of boats and shipping giving his work a mark of authenticity. He exhibited both his oils and watercolours in Glasgow at the West of Scotland Academy and in the RSA. Although he exhibited watercolours over many years, they are today rare.

Despite the development of photography during this period, there remained a considerable demand for drawing of Scottish towns. The most sensitive topographical watercolourist was **Thomas Fairbairn** (1820–1884) who had studied in Glasgow under Andrew Donaldson. He became a friend of Alexander Fraser and Sam Bough, painting with them in the wooded landscape of Ayrshire. Like Fraser he was interested in detail and some of his landscapes have an almost Pre-

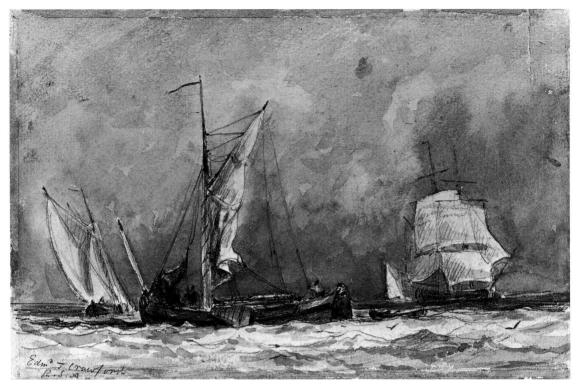

32 Edmund Thornton Crawford, *Marine View with Dutch Fishing Vessels* $6\frac{1}{4} \times 9\frac{3}{4}$ National Gallery of Scotland

Raphaelite exactitude. He also painted views on the west coast and Arran as well as in Cadzow Forest, with occasional visits to the east coast. Among his best work is a series of watercolours of Glasgow painted between 1844 and 1849 and published first in 1849 with a later reprint of 1884. A substantial number of these drawings are today in the People's Palace, Glasgow, and illustrate along with those of his friend, William 'Crimean' Simpson, the fascination of that city in the nineteenth century. *Stockwell Bridge* (fig. 33) shows Fairbairn's light touch in watercolour painting. He uses the medium to create a fine sense of sunlight with lightly applied washes. At times the figure drawing can be weak, but the overall effect is always charming.

Edinburgh was also well supplied with topographical artists. **James Drummond** (1816–1877), who was one of the leading history painters of the mid-century, was in addition an interesting watercolourist of Old Edinburgh. Born, appropriately, in the House of John Knox, he became obsessed with Scottish archaeology, history and antiquities. On leaving school, he worked as an illustrator for the ornithologist Captain Thomas Brown and the surgeon John Lizars, before studying under William Allan at the Trustees. He made his name with the large historical canvas, *The Porteous Mob* (NGS) but found time to continue his study of Scottish history and legends. During the 1840s and 1850s many parts of Old Edinburgh were either demolished or threatened with demolition. Drummond recorded in watercolour many of these old buildings and lanes before they vanished. His observation is accu-

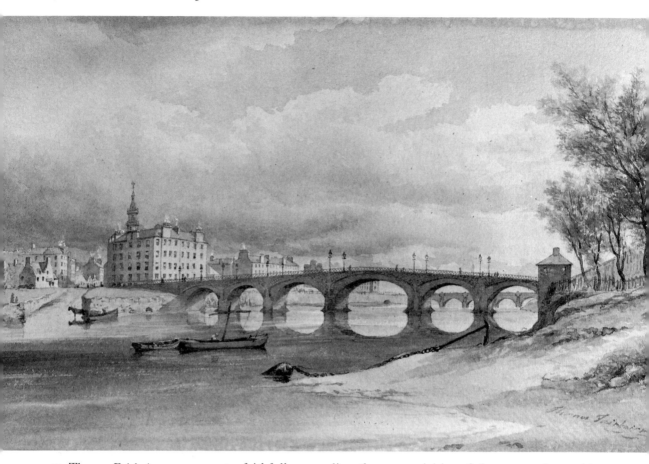

33 Thomas Fairbairn,
Stockwell Bridge 1848
$8\frac{1}{2} \times 14\frac{1}{2}$ People's Palace,
Glasgow

34 Kenneth MacLeay,
*Portrait of William Ord
Mackenzie IV of Culbo*
$10\frac{3}{4} \times 8\frac{1}{8}$ National Gallery of
Scotland

rate, faithfully recording the eccentricities of the vernacular architec-
ture, although the overall effect of his drawings is less appealing than
that of Fairbairn. *The Old Mint* is an example of Drummond's water-
colours of Edinburgh. In addition to painting, he collected antiquities
and was Curator of the National Gallery of Scotland and of the
Museum of the Society of Antiquaries of Scotland.

John Le Conte (1816–1887) also recorded the buildings of Edin-
burgh and a number of his watercolours can be seen in the City of
Edinburgh Museum and Art Gallery. He had studied under Robert
Scott, the engraver, before setting up on his own as a watercolourist
and engraver. While his style is freer than that of Drummond, espe-
cially in his energetic penwork, he does at times tend to be clumsy and
his drawing is often technically weak. Little is known about **Henry
Duguid** who was working from the early 1830s to about 1860. He was
an Edinburgh teacher of drawing and of music, and produced many
topographical views of the city. His style is controlled and always com-
petent, being similar to that of Drummond, but usually stronger in
colour and smaller in size. He also painted views in the Highlands and
still-lifes which were exhibited in the RSA watercolour room. **Joseph
Woodfall Ebsworth** (1824–1908) was primarily a lithographer who

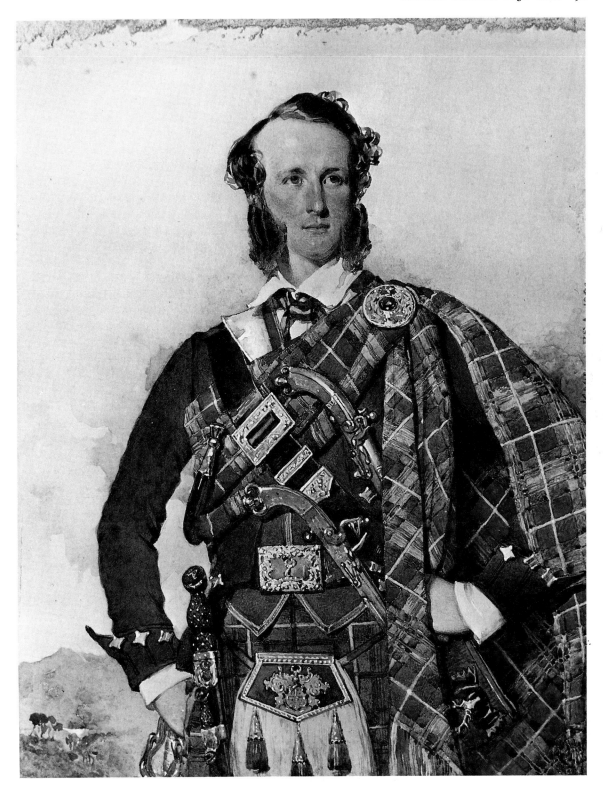

became Artistic Director of the Manchester Institute of Lithography and later a Professor at the Glasgow School of Art. He produced some fascinating views of Edinburgh from the newly erected Scott Monument in the late 1840s, four of which are in the City Art Gallery.

There are few Scottish portrait painters who worked in watercolour, **Kenneth McLeay** (1802–1878) being the most interesting. He was born in Oban, the son of a doctor and antiquarian, and after studying in Edinburgh at the Trustees, was involved with the formation and early years of the Royal Scottish Academy. He produced a large number of watercolour portraits which vary greatly in size from miniatures on ivory or paper, to large full-length portraits of Highland chiefs. Like Giles, Leitch and Roberts, he worked for the Royal Family producing a series of watercolours of costumes of the Highland clans, later lithographed and published as *Highlanders of Scotland* in 1870. He painted portraits of Prince Albert and the Royal Family at Balmoral, and had a large clientele for his very competent watercolour portraits – it was severely eroded by the development of photography in the 1850s and 1860s. McLeay was a fine draughtsman, capturing not only the sitters' likeness, but also the details of their clothes, jewellery or ceremonial costumes (fig. 34).

By the end of the 1860s, the watercolours of most of the great mid-century figures were beginning to look outmoded, as a new generation of artists emerged from the Trustees' Academy and as the Pre-Raphaelite movement, which had shaken the London art world in the 1850s, spread its influence to Scotland. The idyllic Italianate scenes of Leitch and Giles and the immaculately executed architecture of Roberts were to be challenged, on the one hand, by an obsession with a detailed study of nature, and on the other by a movement towards a freer, looser approach to watercolour painting.

5 The influence of Pre-Raphaelitism

Although the Scottish landscape played an important part in the development of Pre-Raphaelite painting in England, the influence of the movement on Scottish artists has never been systematically traced. Established artists who, until the 1850s, still preferred, in Ruskin's words 'flourishes of brush better than ferns, and dots of paint better than birch leaves'[1] begin to move towards precision and detail, and young artists, such as MacWhirter or McTaggart, whose style was to move towards freedom in later years, passed through a period of Pre-Raphaelite influence. Both in England and Scotland, this influence lasted much longer than the existence of the Brotherhood itself, especially upon the more minor artists whose style, once formed in the mid-century, had changed little by the late 1880s. Thus, just as Impressionism was to persist for decades after the original group had dispersed in the early 1880s, so Pre-Raphaelitism influenced aspects of Scottish watercolour painting almost until the end of the century.

Some direct links between the Pre-Raphaelite movement in London and its Scottish followers can be established. In the summer of 1853 Ruskin visited Scotland for the first time. At first he found the Highlands rather wet:

> Scotland is immeasurably inferior to Switzerland in her sponginess. The hills are *never* dry ... it is always squash, splash, plash, at every little indentation where morass can form itself.[2]

However, he soon came to admire the scenery which he saw in the Trossachs while staying in a schoolmaster's house in Brig o'Turk. The Ruskins were accompanied on this trip by John Everett Millais and his brother William, and the famous portrait of Ruskin was started at Glenfinlas that summer. While at Brig o'Turk Ruskin himself produced drawings of landscape details, but devoted most of his time to preparing his lectures to be delivered in November at the Philosophical Institution in Edinburgh. His parents were not pleased at the thought of their son giving public lectures, but Ruskin reassured them:

> ... I have many friends and admirers in Edinburgh, and am in some respects far better understood there than in London. The Edinburgh artists – Harvey, D. O. Hill, Noel Paton etc. are all eager to meet me.[3]

The Edinburgh Lectures, which are amongst Ruskin's most lucid comments on painting, were a great success, and must have had a far greater influence than Ruskin could have hoped.

> Pre-Raphaelitism has but one principle, that of absolute, uncompromising truth in all that it does, obtained by working everything down to the most minute details, from nature and from nature only. Every Pre-Raphaelite landscape background is painted to the last touches, in the open air, from the thing itself. Every Pre-Raphaelite figure, however studied in expression, is a true portrait of some living person. Every minute accessory is painted in the same manner. And one of the chief reasons for the violent opposition with which the school has been attacked by other artists, is the enormous cost of care and labour which such a system demands from those who adopt it, in contradistinction to the present slovenly and imperfect style.[4]

In the following spring, Effie Ruskin returned to her parents in Perth, awaiting the annulment of her marriage, and in July 1855 she married John Everett Millais. Millais had come to love Scotland and many of his paintings, especially in later years, were based on the landscape around Perth. He became a close friend of Noel Paton and his ideas must have had a considerable influence on Waller Hugh Paton. Scottish artists were able to see Pre-Raphaelite paintings which began to appear in the Royal Scottish Academy exhibitions in the late 1850s. Moreover the important Art Treasures Exhibition held in Manchester in 1857 enabled both artists and critics to reassess what had somewhat contemptuously been called 'Primitive Painters' including the Flemish and Italian Quattrocento masters. Art criticism was becoming more important in the 1850s following the publication of Ruskin's *Modern Painters* and the establishment of art magazines.

William Dyce (1806–1864) was born in Aberdeen, the son of a lecturer in medicine at Marischal College.[5] He originally intended to study theology at Oxford, but soon turned towards art as a career and in 1825 entered the Royal Academy Schools in London. He was soon disillusioned with the teaching at the Schools and, in the same year, he left to go to Rome where he stayed until 1827. His earliest known watercolour *Bacchus Nursed by the Nymphs of Nysa* was painted in 1827 in Aberdeen and shows the influence of the painterly style of the early seventeenth century which Dyce had admired on his first visit to Italy. He returned to Italy in the summer of 1827, probably meeting the Nazarenes who aroused his interest in the Italian Quattrocento, both in style and technique. He was again back in Scotland from 1829 to 1832, establishing a successful practice as a portrait painter in Edinburgh and found time to paint in watercolour; *Glenair* (VAM) is the result of a holiday spent in Dumfriesshire. In this watercolour, Dyce is alert to the textures and colours of the Scottish landscape, which he painted on the spot. In 1832 he returned to the Continent, staying for a time in Venice in the company of David Scott who painted a watercolour of him in a gondola (SNPG). For Dyce this relaxed and enjoyable trip, which included Paris, the Rhone Valley and Northern Italy, was an important factor in the development of his watercolour

technique. He produced many watercolours of rivers, valleys, coastal scenes and architectural studies, most of which are today lost, but were catalogued in the Dyce Sale of 1865. *The Rhone at Avignon* (BM) comes from this trip and Dyce shows himself here to be a fluent watercolourist, using a low horizon, light washes and a broad style which could well have been influenced by Bonington.

Dyce's output of watercolours was limited as a result of his many official duties. In 1837 (jointly with Charles Heath Wilson) he became Master of the Trustees' Academy, being followed shortly by a further appointment as Superintendent of the Government Schools of Design. He was also involved with the Ecclesiological Movement, becoming a friend of William Butterfield, taking an interest in the revival of stained glass and other Ecclesiological matters, and helping in the decoration of All Saints, Margaret Street, the Movement's showpiece. He was, in addition, a good musician, a founder member of the Motet Society and a composer in that form. Much of his time in the 1840s was devoted to official duties and to fresco painting, at which he became an acknowledged expert, producing a government report on its technique. With five other artists, Dyce was selected to present full-scale cartoons for the frescoes in the new Palace of Westminster. In 1846 Prince Albert commissioned him to paint a fresco *Neptune Resigning his Empire of the Sea to Britannia* in the staircase of Osborne House. While working on it Dyce found time to paint the surrounding countryside in watercolour. *Osborne House, Isle of Wight* (BM) was painted in July or August 1847 and shows the relaxed, natural style that he had evolved for his landscapes. He also painted views of Puckaster Cove and Culver Cliff. Although Dyce also used watercolour for preliminary sketches for his frescoes (in the case of the Queen's Robing Room at Westminster he was specifically requested to produce watercolour sketches for each compartment), it is the *pleinair* landscapes of the 1830s and '40s which are, in watercolour terms, the most striking. In Marcia Pointon's words, 'The watercolours of the forties are of crucial importance in a chronology of Dyce's landscape painting for, without them *Pegwell Bay* and *A Scene in Arran* appear as a sudden and unpremeditated blossoming of outdoor naturalism.'[6]

From the point of view of Pre-Raphaelitism, the last seven years of Dyce's life were the most important. In 1857, aged 51, he completed *Titan Preparing to Make His First Essay in Colouring*, a painting admired by Ruskin, and over the next years painted a number of oils and watercolours upon which his reputation as an artist rests. Although not a member of the Pre-Raphaelite Brotherhood, he knew the group well and it is interesting to speculate whether, during his extended stay in Edinburgh in 1857, he discussed their ideas with his Scottish contemporaries. In 1859 he spent a holiday on Arran where he painted several exquisite watercolours, following the Pre-Raphaelite custom of painting landscape backgrounds and details during the summer, while adding the figures in the studio during the winter months. Apart from the known watercolours of *Goat Fell* (VAM), *Glen Rosa* (Private

35 William Dyce, *Ben Nevis from Glen Rosa* 9 × 14 Ashmolean, Oxford

Collection) and *Ben Nevis from Glen Rosa* (fig. 35), several watercolours of the island appeared in the Dyce Sale of 1865, including *Glen Sannachs, Rocks and Foliage, Arran* and a further view of *Glen Rosa*, but they are today untraceable. These watercolours show a new obsession with detail – the fluid washes of the 1840s have given way to thickly applied colour and careful observation of detail in the central areas. They are not, however, overworked, as can be seen in *Ben Nevis from Glen Rosa*. For many years, Dyce had urged a return of careful observation, and in the Sixth Report of the Commission on the Fine Arts of 1846 had written: 'I suspect that we modern painters do not study nature enough in the open air, or in broad daylight.'[7] The two oils which followed the Arran trip, *Man of Sorrows* and *David in the Wilderness*, both show the results of this outdoor naturalism, being set in authentic west coast landscapes, and it is evident that the Arran watercolours played a large part in these two canvases.

One year earlier, in 1858, Dyce had spent a brief holiday on the Kent coast, and had made a detailed watercolour of Pegwell Bay. This is similar in effect to the Arran drawings, revealing an interest in geology. The famous canvas based on the watercolour appeared at the Royal Academy two years later, in 1860. In the same year, Dyce made a visit to Wales and Devon, where again he produced landscape watercolours, known to us only from the Dyce Sale Catalogue. He was fascinated by the geological structure of the Welsh mountains:

> In Scotland the granite mountains, by process of disintegration became rounded and their asperities smoothed down ... but in Wales, the material being slate rock, it does not crumble ... but splits and tumbles down in huge flakes which leaves the peaks from which they have fallen as sharp and angular as if they had never been acted upon by the atmosphere at all.[8]

Thus Dyce reveals himself close in spirit and interest, not only to Ruskin, Holman Hunt and Millais, but also to Scottish contemporaries

such as John Adam Houston and Robert Herdman, who were also painting the rock formations of Arran, Skye and the west coast.

Like William Dyce, **William Bell Scott** (1811–1890) spent most of his working life in England, and was also occupied with a career in art education and administration. Born in Edinburgh, the son of the well-known engraver, whose large workshop in Parliament Square had produced many fine books and illustrations, and the younger brother of David Scott, William Bell Scott grew up surrounded by works of art. He was influenced at an early age by John Burnet, a former apprentice of Scott's father who continued to work in the family firm: 'It appears to me now that Burnet was one of the ablest and most accomplished men in art criticism I have known.'[9] As a young man, Scott produced a set of etchings of Loch Katrine and the Trossachs, and it is evident that his father's insistence upon the fine details of ferns, plants and foliage in his engravings was to have a lasting influence on his work. He probably began working in oils around 1830, exhibiting at the RSA for the first time in 1833, but apart from some part-time classes under William Allan at the Trustees' Academy, his artistic education was based upon the practical knowledge gained while working for his father.

In 1837 Scott left Edinburgh to settle in London where he made a living from etching. Here he came to know artists such as Richard Dadd, Augustus Egg and William Frith, and, like many aspiring artists of the day, including his own brother David Scott, he entered cartoons for the Houses of Parliament competition. Scott also painted landscapes in and around London, often using watercolour, a medium which he appears to have discovered and enjoyed during these years. In October 1839 he married Letitia Margery Norquay, whom he later described as 'the most difficult human creature to understand'. Unable to make his mark as an artist in London, Scott took up the post of Head of Newcastle School of Art in 1844, and in this capacity he came to know William Dyce, who was acting as the Government Inspector of Design Schools. His job allowed him the time to continue painting, working on landscapes in watercolour, historical subjects in oils, and cycles of fresco decorations. He retained links with London, and in the late 1840s met Rossetti and Holman Hunt, thus seeing the progress of Hunt's *Oath of Rienzi* and Rossetti's *The Childhood of the Virgin*; but despite his sympathy for the Movement, Scott was not involved with the establishment of the Brotherhood. In 1853, he met Millais and Ruskin in London, but like Roberts, took a dislike to Ruskin and his theories on art and art education. Some years later he wrote of Ruskin's hopes for the development of his Working Man's College:

> I came away feeling that such a pretence of education was in a high degree criminal; it was intellectual murder; not one of the young men who attended at the Working Man's College ever acquired any power of drawing.[10]

When, in 1854, Scott was invited by Sir Walter Trevelyan to decorate Wallington Hall at Morpeth with scenes from local history, he con-

sulted Ruskin with some considerable misgivings. They consisted of eight scenes from Northumbrian history: *St Cuthbert on Farne Island*; *The Building of the Roman Wall*; *The Death of Bede*; *The Danes descending on the Coast of Tynemouth*; *The Spur in the Dish*; *Bernard Gilpin taking down the Gage of Battle at Rothbury Church*; *Grace Darling*; *Iron and Coal*. Before being installed, the panels, painted in oil on canvas, were exhibited at the French Gallery, London in June 1861. Drawings and watercolour studies played an important part in the cycle, as can be seen in the studies at the Victoria and Albert Museum. Particularly successful is the highly finished study for *Grace Darling* (fig. 36) with its interest in detail and its freshness of colour. As in the larger watercolours of Waller Hugh Paton, Scott uses watercolour more like oil, applying the colour densely and reworking areas in detail. The study for *Bernard Gilpin* reveals Scott's debt to the Brotherhood, with its interest in medieval details, rich colours and precise drawing, while at the same time showing Scott's weak handling of facial expressions and figures. This weakness, often overcome in his oil paintings through reworking, is most noticeable in some watercolours and in his larger decorative schemes – Scott was not a natural draughtsman, his success depending upon careful observation and meticulous studies, rather than that instinctive *brio* which so many Scottish watercolourists possessed. This does not, however, justify Professor Fredeman's assertion that Scott was 'a disgruntled second-rate painter-poet'.

Scott's model for *Grace Darling* was Alice Boyd of Penkill Castle, Ayrshire whom Scott had met in 1859. Born in 1825, Alice Boyd had attracted the attentions of Scott whose own marriage had proved unsatisfactory, and following their meeting in Newcastle in 1860, she modelled for Scott's *Una and the Lion*. In 1860, Alice Boyd invited Scott to Penkill Castle and commissioned him to paint the spiral staircase. Together they chose a theme based upon the poem *The King's Quair* written by James I, probably while in captivity in Windsor in 1423. Ironically, despite Scott's knowledge of wall-painting techniques, and his criticism of the Oxford Debating Chamber decoration – 'It was simply the most unmitigated *fiasco* that ever was made by a parcel of men of genius' – his own use of encaustic was unable to withstand the dampness of the walls. Only one panel, repainted by Scott on zinc, is in good condition, although a series of watercolours painted to record the cycle gives an idea of the richness of colour and medieval flavour that Scott created. The cycle was painted during the summer months between 1865 and 1868. Scott, who had resigned his Newcastle post in 1864, was living in London, still with his wife; but he was visited regularly by Alice Boyd, who accompanied the Scotts on trips to Italy and spent many of the winter months in their house in Notting Hill. The landscape around Penkill was a constant source of inspiration to Scott. He wrote in his *Autobiography*:

> The glen below the house was most interesting to me, and revived my ancient landscape proclivities. Every summer for nearly ten years I painted there.[11]

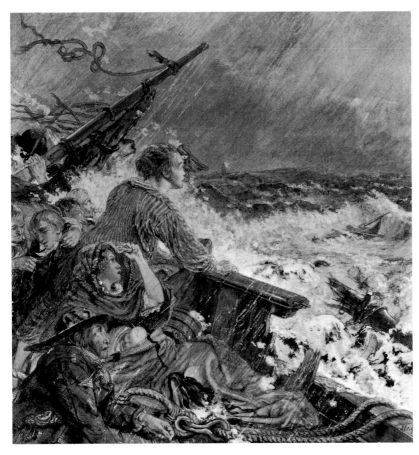

36 William Bell Scott,
Grace Darling
$4\frac{3}{8} \times 4\frac{1}{2}$ Victoria and Albert
Museum

After Scott's death, Alice Boyd wrote:

> Fortunately his love of Penkill was so great that he never tired of it; and the
> enjoyment he had in the change of seasons ... was always a delight.[12]

Some of Scott's finest watercolours are landscapes based on careful
observation, often painted towards evening, a glowing sky casting a
warm light across darkening trees and fields. Although he painted de-
tailed architectural views in Venice and broader views of the Alps, his
most successful works are more humble subjects – the manse garden
at dusk, light through trees or studies from nature around Penkill. His
large watercolours of figures, based on biblical or classical themes, such
as *The Temptation of Eve* (VAM), are generally less successful than the
watercolour studies for his decorative cycles. William Bell Scott, known
in his lifetime more as a poet, an educationalist and an art historian
than as a painter, died in London in November 1890.

David Scott (1806–1849), who was five years older than his brother,
died young, without achieving the recognition he deserved.

> He had no power over female beauty in his art, and in every other feature
> he repudiated modern taste.... Faith in himself and in the old masters, and
> blindness to the modern position of art, killed him[13]

Thus his brother explains his commercial failure, yet his illustrations to *The Ancient Mariner* and *Pilgrim's Progress*, as well as many of his historical canvases, often possess a dark foreboding of evil and death, which is more convincing than many of the more contrived Symbolist works that appeared later in the century. The main body of his work, being book illustrations and oils, lies outside the scope of this book, although some watercolours do exist mostly executed as studies or experiments for larger works. *The Murder of Rizzio* (NGS) and *Moses, Aaron and Hur* (NGS) both display powerful draughtsmanship and strong colours, although in *The First Born* (NGS) a certain crudeness of both colour and drawing is evident. His monochrome sepia or Indian ink drawings are often striking in effect, but are again mostly used as preliminary studies. A particularly fine watercolour is *Hercules Driven Mad in the Act of Murdering his Children* (Huntingdon Library and Art Gallery, San Marino) which was owned by David Octavius Hill.

Both **Sir Noel Paton** (1821–1901) and his brother **Waller Hugh Paton** (1828–1895) are of importance to the Scottish Pre-Raphaelite Movement, the former for his fantasies in oils, the latter for his landscapes, primarily in watercolour. They were born in Dunfermline to talented and inquisitive parents – their mother was a great teller of traditional fairy stories, and their father, in addition to designing damasks for the local textile companies, was an antiquarian and collector of armour. He was also a religious mystic, eventually becoming a Swedenborgian, and transmitted his love of the mystic art of William Blake to his elder son.

Noel, who during his lifetime outshone his younger brother, studied for a year at the Royal Academy Schools in London where he moved into the circle of S. C. Hall, editor of the *Art Journal* and patron of Richard Dadd. From then on, his work moved towards the illustration of ballads, literary texts and fantasies. He was not, by nature, a watercolourist and only a few watercolours can be attributed to him, but his close friendship with Millais and Ruskin, and his contact with the Pre-Raphaelite Brotherhood are of importance to Scottish watercolour painting. *A Study from Nature, Inveruglas* (Sotheby's, Belgravia, 29 June 1976, Lot 205) is a rare example of Noel Paton's watercolours. It is a highly worked landscape with a figure seated on rocks by a tributary of Loch Lomond. The colours are fresh greens and yellows, and the medium is highly worked. In 1858, Waller Hugh Paton exhibited *Wild Water, Inveruglas* at the RSA and it seems likely that the two brothers worked side by side on Loch Lomond, as they had worked together on Arran in 1854 and 1855.

Although **Waller Hugh Paton** is less known than his brother, he was a landscape painter of great skill, and his work is today being revalued. Having spent some years designing patterns for the textile industry in Dunfermline, he turned towards fine art and received some lessons in watercolour painting from John Adam Houston. He was, however, essentially self-taught and his method of working – painting the whole landscape from start to finish in the open air – reveals an

artist unencumbered by academic theory. Ruskin attacked the accepted landscape formulae in his letter *Generalization of the Scottish Pre-Raphaelites* of 1858, and defended Waller Hugh Paton's *Wild Water, Inveruglas*:

37 Waller Hugh Paton,
Sundown, Brodrick Bay, Isle of Arran
$26\frac{1}{4} \times 49\frac{1}{2}$ Private collection
Photograph, Christie's London

> Such a lovely picture as that of Waller Hugh Paton's must either speak for itself, or nobody can speak for it. If you Scotch people don't know a bit of your own country when you see it, who is to help you know it? If, in that mighty wise town of Edinburgh, everybody still likes flourishes of brush better than ferns, and dots of paint better than birch leaves, surely there is nothing for it but to leave them in quietude of devotion to dot and faith in flourishes.... I don't say therefore – I never have said – that their (the Pre-Raphaelites') pictures are faultless – many of them have gross faults; but the modern pictures of the generalist school, which are opposed to them, having nothing else but faults: they are not pictures at all, but pure daubs and perfect blunders; ... they are mere emptiness and idleness ... whereas the worst Pre-Raphaelite picture has something in it ...[14]

In later years, Sir James Caw was far less enthusiastic about Waller Hugh Paton, and his criticism in *Scottish Painting* reflects the reaction against Pre-Raphaelitism in the early years of this century:

> ... like several of the Pre-Raphaelites in their earlier years he was passionately fond of purple, and the purple chords in colour were always, and often disagreeably emphasized in his pictures, for he had little appreciation of the atmospheric envelope which in Art as in Nature means harmony.... Worst of all, the great relationships on which the moods of landscape depend are not observed.... Therefore it is to the unobservant and the prosaic that Paton's art appeals.[15]

As a watercolourist, Paton was one of the most prolific artists of his period, but despite the number of his landscapes, his quality remains very steady. He is, at times, repetitive, but his drawings always demand attention for the quality of their light, their composition and their

detail. Like many other artists influenced by Pre-Raphaelitism, Paton is not a pure watercolourist, making extensive use of bodycolour and stippling in order to build up a highly detailed finish, which often looks deceptively like an oil. Purists, who insist upon the virtues of using white paper to create highlights and luminosity, will be disappointed by Paton's use of bodycolour for highlights and depth. Moreover, he often works on a scale more reminiscent of an oil painting. *Sundown, Brodrick Bay, Isle of Arran* (fig. 37) measures 26 × 49 inches and is one of the larger watercolours of the Scottish School. It has a strong romantic element – a young couple is set against the bay, over which the sun is setting. It was Paton's love of evening views which earned him Caw's rebuke for using too much purple, but his use of rich, even solid colours, is typical of much Pre-Raphaelite painting.

Paton's subjects are invariably Scottish, usually mountains and lochs on the west coast, but he also painted architectural subjects, such as Stirling Castle and views of Edinburgh. He enjoyed varieties of scale, from tiny, almost miniature watercolours to huge works, the size of large oils. Many of his watercolours have arched tops – a device often used by the Pre-Raphaelites, especially for oils. His tendency to use bodycolour mixed into watercolour has caused some of his drawings to fade, in particular the skies. *Near Glen Cloy, Arran* (fig. 38) is a fine example of Scottish Pre-Raphaelite watercolour painting. The contrasts created by the *contre-jour* composition looking up the stream into the light are striking, while the intensity of the shadows is offset by the delicacy of the details of grasses and plants. Although dated 1878, it shows no sign of the decline in Waller Hugh Paton's work that Caw alleges.

John Adam Houston (1813–1884), who produced some of the finest Scottish Pre-Raphaelite landscape watercolours of the 1860s, has been almost totally ignored by historians of Scottish art. Caw devotes one paragraph to his paintings of battles between Cavaliers and Parliamentarians, although he does add that his designs are frequently effective, particularly when carried out in watercolour.[16] Houston was born in Wales of a Scottish family, but studied art at the Trustees' Academy in Edinburgh, becoming known as a painter of historical genre on a large scale, for which he was elected Associate of the Royal Scottish Academy in 1842 and a Member of the same body three years later. He also worked extensively in watercolour and from the early 1840s was exhibiting views of France, Germany and Italy as well as Scotland and England in the watercolour room of the Academy. By the 1850s he seems to be working mainly in watercolour, painting Highland views, and it was during this period that Waller Hugh Paton took lessons in watercolour painting with him. How and when Houston moved towards a Pre-Raphaelite style is difficult to establish. Possibly Paton's connections with Ruskin and Millais influenced him; it is likely that he attended Ruskin's Edinburgh Lectures in 1853 and he might well have seen Millais' Glenfinlas portrait or even Ruskin's own sketches of rock formations and plants. In 1858 he moved to London

for health reasons enabling him to study the Pre-Raphaelite movement at first hand, but he continued to paint in the Highlands, exhibiting both in Edinburgh and London, where he became a member of the Royal Institution.

Ben Blaven from Ord (fig. 39) illustrates Houston's precision. The rocks in the foreground are painted in a careful dry technique, and in the mountains behind every ridge and crag is delineated. Even the water of Loch Eishort is meticulously worked. Like Paton, Houston works his watercolour more like oil, using bodycolour and stippling, and in some places scratching out the colour to reveal the paper beneath, thus creating a different-toned white and texture from the bodycolour highlights. The overall effect is fine; the colours are rich and the technique ideally suited to one of the most impressive views in Skye. Houston worked much on Skye, the ruggedness of the mountains appealing to his obsession for detail. At times he painted the mountains from a distance, at others he produced meticulously detailed views of streams flowing through lichen-covered rocks. In some drawings, he

38 Waller Hugh Paton, *Near Glen Cloy, Isle of Arran* 1878 $14\frac{1}{2} \times 21\frac{3}{4}$ Private collection

39 John Adam Houston,
Ben Blaven from Ord 1863
$9\frac{1}{2} \times 13\frac{1}{4}$ Private collection

provided a historical subject, such as an encounter between the English and Highlanders of the '45, but often this only provides an excuse for a highly dramatic landscape setting. Houston also painted single figures, usually young girls standing in a Highland landscape, executed in both oils and watercolour. These sometimes sentimental studies have little to do with the Pre-Raphaelite Movement other than in their attention to a detailed background, and the genre is discussed in Chapter Three. He continued painting large historical oils until his death, but they are often tedious and overblown – it was as a watercolourist that John Adam Houston excelled (fig. 40).

The work of **Robert Herdman** (1829–1888), like that of Houston, has not been fully appreciated. Born in Rattray, Perthshire, the son of a minister, he studied at St Andrews University before moving to the Trustees' Academy in 1847, where he studied under Robert Scott Lauder and John Ballantyne. He won a prize for history painting as a student, and for the rest of his life he produced competent historical canvases, often distinguished by a rich colour. He was also in demand as a portrait painter, especially of the ladies of Edinburgh society in whose company this cultured and apparently charming artist felt at home. As an oil painter he is probably best known for his canvases of young girls standing in pastoral or Highland landscapes, often almost

40 John Adam Houston,
Loch Long 1867
12 × 17½ Private collection

sensuous in style in terms of both the handling of the rich colours and the pose of the models. Throughout his life, Herdman worked in watercolour, starting with a series of watercolour copies of Italian Renaissance Masters painted for the Royal Scottish Academy on his first trip to Italy in 1855–56. Italian light and colour had a considerable effect upon Herdman, and he obviously enjoyed the details of Quattrocento painting as well as the richer colours of the Seicento. An early watercolour, *The Mandolin Player* of 1856 (Perth) reveals the influence of the Seicento in Italy in his handling of colour and even in the pose. A further visit to Italy in 1868–69 resulted in watercolours of Venice.

It was during the 1860s that Herdman turned more towards the minute details and intense colours which link him with the Pre-Raphaelite Movement, although his subject matter does not change. It is difficult to trace his links with the movement, but he appears to have been a friend of both Houston and Waller Hugh Paton, and he may well have sketched with them on Arran, an island which features much in the Scottish Pre-Raphaelite Movement. Herdman produced some of his finest watercolours on Arran during his regular holidays there. Recently several of these Arran drawings, which Caw singled out for praise, have come to light. The National Gallery of Scotland has acquired a finely detailed watercolour study of plants at Corrie and other finely drawn works dating into the 1870s have appeared in the salerooms. The freshness of colour is outstanding, as is the confident and

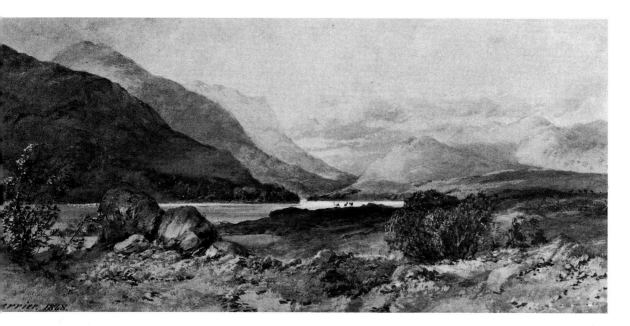

41 James Ferrier, *The Kyles of Bute* 1868 $6\frac{1}{2} \times 14$ Private collection

skilful draughtsmanship. As a draughtsman Herdman was versatile, being capable of dealing equally with figures, costume details, landscapes, rock formations and plants. An unusual monochrome drawing *Waverley and Rose Bradwardine at their Studio* (Hunterian) of 1864 shows his exceptional power of drawing.

An interesting example of Herdman's watercolours is *The Fern Gatherer* (fig. 20). It is closely related to the oil now in the National Gallery of Victoria, Melbourne, which was exhibited at the Royal Scottish Academy in 1864 (although the watercolour is dated 1866, making it a copy after, rather than a sketch for, the oil – the copying of a successful oil was common enough for Pre-Raphaelite artists). The watercolour is a combination of Herdman's somewhat romantic, even sensual, subject-matter with a Pre-Raphaelite obsession for detail.

James Ferrier, who first exhibited at the Royal Scottish Academy in 1843 and probably died in 1883 or 1884, was well known in his lifetime as a landscape artist, but has since slipped into comparative obscurity. He worked mostly in watercolour, often painting on quite a large scale, and exhibited regularly at the Academy. He painted mostly in Scotland, often on the west coast and on Arran, but also in Perthshire and in Cumberland. His watercolours are full of detail and incident, and, while lacking the grandeur and discipline of Dyce or Paton, they have considerable charm. He often chose landscapes influenced by human endeavour – often with castles, harvesters, hunters or bridges, but at other times he depicted a winding river or a windswept bay: His colours are strong and his compositions intricate, but the results are usually pleasing. Whether he actually knew of the existence of the Pre-Raphaelite Movement is debatable, but he was certainly influenced by the mid-century obsession with detail (fig. 41).

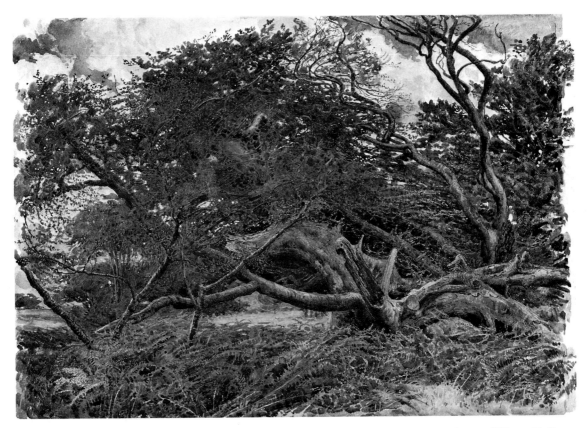

42 George Wilson, *Fallen Trees* $9\frac{1}{2} \times 13\frac{1}{2}$ National Gallery of Scotland

The work of **George Wilson** (1848–1890) also deserves greater recognition. Born near Cullen in Banffshire, he was educated at Aberdeen and Edinburgh University before turning to painting which he studied in London at Heatherley's, at the Royal Academy Schools and finally at the Slade. He died young, probably of cancer of the stomach, and his work is today very rare. Nevertheless, he established a reputation in London as a follower of the Pre-Raphaelites in both figure and landscape painting, and his work was bought by Halsey Ricardo. As a watercolourist he can be effective, painting landscapes in great detail. *Fallen Trees* (fig. 42) shows his interest in the details and patterns of nature – ferns, leaves, bark and grasses. *On the Bogie* (Aberdeen) is a watercolour which shows his often quite daring use of colour.

Charles Woolnoth (1815–1906) was born in London and trained at the Royal Academy Schools, but moved to Scotland where he remained until his death in Glasgow. A founder member of the Royal Scottish Society of Painters in Water-Colours, he painted intricately detailed landscapes in watercolour, using the medium almost as oil. He first exhibited at the Royal Scottish Academy in 1850 and from then on was a regular contributor. His work varies in quality: at times his large, well-worked views of the Highlands have an undeniable grandeur, but in other works, his style appears heavy-handed and his colours pedestrian. **John Finnie** (1829–1907) can also be considered a minor

Pre-Raphaelite watercolourist. He was born in Aberdeen, but moved to London in 1853 before taking up the post of Headmaster of Liverpool School of Art from 1856 to 1896. He painted detailed watercolours of the mountainous North Wales landscape, and was also an etcher. Very little is known about **Harriet Bruce**, although the watercolour by her in Dundee Art Gallery suggests that she was also strongly influenced by Pre-Raphaelitism, as was **John Cairns** who produced highly detailed landscapes of Scotland and France from 1845 to the 1860s. Amongst other minor watercolourists to be influenced by Pre-Raphaelitism are the Edinburgh artists **Jessie Frier**, **Robert Frier** and the Glasgow painter **John James Bannatyne** (1836–1911). The last-named, at his best, painted delicate views of the Highlands and Iona, with good effects of sunsets and moonlight, often reflected in water.

Most of the Scottish artists to be influenced by Pre-Raphaelitism were landscape painters, apart from William Bell Scott and **George Clark Stanton** (1832–1894), who is an interesting and underrated figure. Born in Birmingham, he trained at Birmingham School of Art, studying silversmithing, and later worked for Elkington's, who sent him to Florence to study Italian Renaissance sculpture and metalwork. Always a romantic at heart, he joined up with Garibaldi and his Red Shirts; several drawings of Garibaldi date from the late 1840s and early 1850s. In Italy he fell in love with Clara Gamgee and when her family returned to Edinburgh, Stanton followed her back. Despite parental opposition, the couple were married and Clark Stanton settled down to a precarious life as an artist in Edinburgh. He produced statues and designs for decorative friezes on buildings, as well as watercolours which can often be richly coloured and imaginatively conceived. His subjects cover romance, history and often literary themes, many taken from Shakespeare. His heroines wear richly coloured dresses and his backgrounds are finely detailed, yet, unlike those of T. R. Lamont, his pictures carry great conviction and never appear like theatrical charades. A close friend of Sam Bough, Clark Stanton was a fine draughtsman and produced anatomical drawings for John Gamgee's books on the horse, as well as teaching at the Life Schools. Unfortunately he sold little and was constantly in debt.

Whereas some established artists like Herdman and Houston were influenced by Pre-Raphaelitism late in their careers, some younger men passed through a period of Pre-Raphaelitism early in their lives, before moving on to a broad style. The most significant of these is **John MacWhirter** (1839–1911) who was born in Slateford, Edinburgh and at the age of 15 ran away from his job in a bookshop to take up art as a profession. The following year he made the first of many Continental trips visiting Germany, Austria, Italy and the Alps, travelling mostly on foot. He also spent two summers in Norway making detailed studies of wild flowers which were to attract the attention of John Ruskin. Ruskin, who was introduced to these sketches by E. Fox White, art dealer and publisher, wrote:

I must state how much I am obliged to you for forcing me to see this wonderful work. I have never seen anything like it.[17]

Ruskin certainly did not know MacWhirter personally, and in fact even made a mistake over his initials, but he admired his flower studies so much that he used them as examples for teaching at Oxford Art School. Several of these early flower drawings can be seen in public collections. Some were bequeathed by Ruskin to the Ashmolean, an album dated 1861 is in the National Gallery of Scotland, and a further study is in Glasgow Art Gallery. MacWhirter later joined the Trustees' Academy, and under the influence of Robert Scott Lauder moved away from his detailed style. Nevertheless, he retained an interest in detail:

Begin at the beginning – I mean study the parts before attempting the complete picture. Study flowers and trees – stems and stones and clouds ... Be ready at any moment in town and country to note the form of a cumulus cloud, any fleeting effect, a branch of a tree....[18]

and

I think it is most important for all landscape students to fall in love with flowers and the details of nature ... I remind the student that it is absolutely necessary to study and note all kinds of foreground material....[19]

His later watercolours often provide a fascinating combination of foreground details and broad distances. John MacWhirter began exhibiting watercolours at the Royal Scottish Academy in the mid-1850s and his sister **Agnes Eliza MacWhirter** also exhibited highly detailed watercolours mostly of still-life, flowers and plants, but she died young in the 1870s, having already established a reputation.

Edward Hargitt (1835–1895) is not usually considered a Scottish artist – he was born in Edinburgh and studied with Horatio McCulloch, but moved south as a young man. His earliest watercolours, from the 1850s, are strongly influenced by Pre-Raphaelite detail and his views of Scottish streams and coasts, which he continued to paint throughout his life, have a great concern for construction and detail. Unlike MacWhirter he was a poor colourist and many of his watercolours appear pedestrian. **Keeley Halswelle** (1832–1891), like Hargitt, has become associated with the English School, but some of his crispest and most impressive work was done as a young man in Scotland before moving south.

6 Towards a freer style

During the nineteenth century, a new spirit of naturalism in art began to develop as more artists turned their backs on studio subjects and lighting, and moved towards the practice of painting in the open air. For centuries artists had made sketches from nature – Claude Lorraine's pen-and-wash drawings of the Campagna being some of the earliest – but during the nineteenth century *pleinairism* was to become a purposeful movement, developing simultaneously in France and England. The movement was not co-ordinated nor organized; *pleinair* artists in France knew little of the Norwich School or Cox and Constable in England; McCulloch painting in the open on the west coast of Scotland knew little, if anything, of the Barbizon School; McTaggart, a leading exponent in Scotland, apparently had no knowledge of Monet and the Impressionists until late in his career. Groups of artists in other countries including Holland, Spain and Italy also abandoned the studio in favour of the open skies. *Pleinairism* took many forms; the Barbizon painters tended to stress the golden or pink light of evening, choosing pastoral and romantic views, the Pre-Raphaelites attempted to depict the details of nature with painstaking accuracy, while the Impressionists sought the dancing effects of light on water or snow. *Pleinairism* was thus an attitude rather than a style.

In Scotland, watercolour played an important part in the development of *pleinair* painting. The medium itself, requiring speed, spontaneity and dexterity, was ideally suited to sketching in the open air, as was the small size of the normal watercolour; its speed of drying made it easy for the artist to travel at home and abroad. And thus, while English watercolour painting in the later century was often a restatement of the lessons of Cox, or a development upon Pre-Raphaelitism, in Scotland the watercolours of McCulloch, Bough, McTaggart and MacWhirter were breaking new ground, and are unique in this period of British painting. It is at this time that the individual quality of Scottish watercolour painting becomes apparent, with the extraordinary development from Sam Bough to Arthur Melville taking place within a few decades.

Horatio McCulloch (1805–1867) was known during his life as a painter of large, often romantic landscapes in oil, and his watercolours

are comparatively unknown. He was, nevertheless, an interesting water-colourist, using the medium both for recording views on the spot and as finished works in their own right. Born in Glasgow in 1805, and named in memory of Horatio Nelson, he was apprenticed to a house-painter, but managed to attend lessons, along with William Leighton Leitch and Daniel Macnee, with the Glasgow landscape painter John Knox. In about 1824 he left Glasgow and spent a period with Leitch and Macnee decorating snuffboxes in Cumnock before joining the famous Edinburgh firm of engravers, W. H. Lizars; here he was employed in colouring prints by hand, including the illustrations to Dr Lizars' *Anatomy* and Selby's *Ornithology*, thus gaining experience in using watercolour washes. He was introduced by Lizars to the water-colours of 'Grecian' Williams, and also came to know the oils of John Thompson of Duddingston, whose free style and keen interest in nature were to influence McCulloch. After about five years in Edinburgh, McCulloch returned to Glasgow, but in 1838 he settled in Edinburgh New Town, where he remained until his death.

McCulloch loved the Highlands and Western Isles and after his marriage in 1848 to Marcella McLennan of Skye, he spent many summers painting on the island. He also enjoyed the tranquil rivers and valleys of Perthshire, Stirlingshire, Renfrewshire and the Borders. Apart from one visit to the English Lakes, Wales and London in 1840, he never left Scotland and, unlike many of his contemporaries, he never sought recognition in London. This devotion to the Scottish scenery made his work popular in his own country, although very few of his landscapes were seen in the South. It is difficult to assess his output of watercolours. His friend and biographer, Alexander Fraser, states that he did many careful watercolour studies as preparations for larger oils, as well as spending many evenings working on sepia drawings. He must also have had a market for finished watercolours and in recent years more of these have appeared in the salerooms. Thus, whereas Martin Hardie, while appreciating the few watercolours by McCulloch that he had seen, was unable to judge the extent and importance of McCulloch as a watercolourist, it is today possible to argue that he was both influential and productive in this medium.

The dominating feature of a McCulloch watercolour is a sense of freedom. He walked miles across the Highlands to capture remote and inaccessible views, and this unencumbered freshness penetrates his watercolours possibly even more than his oils. His favourite views are those dominated by powerful mountains with boulders, streams or lakes in the foreground – landscapes where the human figure is dwarfed by nature and where even the softer greens of trees and foliage are overwhelmed by dramatic skies and rugged crags (fig. 43). His colour is surprisingly strong, creating a symphony of rich blues, browns and greens set against cloudy skies through which flashes of sunlight appear. His use of the medium was unconventional for the time, making extensive use of bodycolour to create rich effects and strong contrasts. He also achieved a rhythm in his watercolours by spontaneous and clearly visible brushstrokes. Unfortunately McCulloch rarely dated

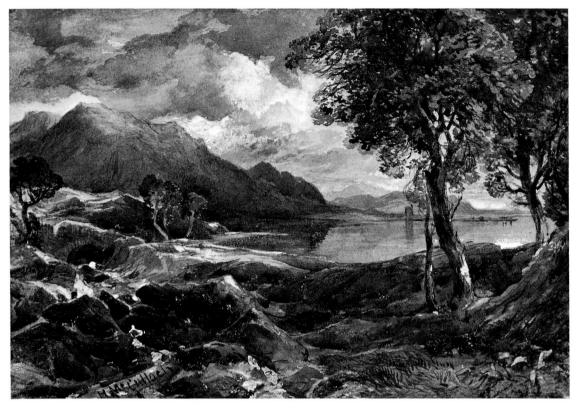

43 Horatio McCulloch,
Near Glencoe 1864
$15\frac{1}{2} \times 23\frac{3}{4}$ National Gallery of
Scotland

his watercolours, but it seems likely that his freer style developed in
the late 1830s and early 1840s. Thus, *In the Wood*, an accurate and
detailed watercolour in the Orchar Gallery, which has resemblance to
the work of Alexander Fraser, probably dates from the mid-1830s and
could belong to a series made in Cadzow Forest. On the other hand,
not all McCulloch's more detailed watercolours are early, as through-
out his life he made special sketches of landscape details as studies for
larger oils. When he died in 1867, the movement towards a freer style
of watercolour painting was only beginning, and thus Horatio McCul-
loch must be seen as a pioneer, many years ahead of his time.

The watercolours of **Sam Bough** (1822–1878), along with those of
William McTaggart, dominate the development of Scottish water-
colour painting towards a freer, broader style. Bough was born in Carlisle,
the son of a shoemaker who came from Hereford, and thus, although
he came to be associated with the Scottish School, he was not a Scot
either by birth or by family. His mother was a vivacious character, and
seems to have imparted a restless energy to her son. As a youth, Bough
rebelled against any attempt at a formal education. Aged 15, he became
a lawyer's clerk, but disliked the post so much, that his parents agreed
to send him to London to study engraving under Thomas Allom. Again
Bough rebelled against the discipline and returned to Carlisle on foot,
settling for a period in Penrith where he taught drawing in the local
school. The main features of Bough's character were already visible –

he loved to walk for mile after mile seeking out interesting views to sketch in the Lake District and later over the border. On these trips as a young man, he was often accompanied by an old Highland soldier, John McDougal, who had fought at Corunna and Waterloo, and who told Bough about the Highlands and its legends. Bough had a propensity for wearing unusual clothes including a cloak and a red Turkish turban. His Bohemian lifestyle was also evident at an early age. Often in debt, he would sell paintings for very little to raise money. He worked irregular hours and, unlike most craftsmen, he kept his studio in Carlisle in a state of constant untidiness, with unwashed paint-brushes scattered around. Despite his later success his way of life remained to his death relaxed, informal and Bohemian.

In 1845 Bough left Carlisle having decided that there was no real chance of selling his work:

> There is little chance of ever growing fat by landscape painting in Carlisle. Indeed, all the painters have talk of departing from a shabby place that cannot afford an Exhibition: and does hardly support a drawing school.[1]

Moving south to Manchester, Bough became a scene painter at the Theatre Royal, and soon became successful, particularly at painting woodland and landscape, rather than interiors or architecture. While in Manchester, he attended life classes at the Manchester Academy and continued to paint, mostly in watercolour, winning the Heywood Silver Medal for the best watercolour in the 1847 Manchester Exhibition, with a view of Askham Mill, Westmorland. Most of the watercolours from this period are of the Lakes, although he also painted a large view entitled *Tanziermunden on the Elbe* in 1848. Bough had never been abroad, but contemporary engravings combined with studies on the Bridgewater Canal enabled him to produce a composite view. His main preoccupation, however, was his lack of money, made worse by the failure of the Queen's Theatre, for which he had done much work, still unpaid. It was thus as a disappointed and penniless artist that he moved to Glasgow in 1848 to become scene painter at the new Princess Theatre. Here he met an opera singer, Isabella Taylor, a former student of the Royal College of Music, whom he married in 1848, within three months of first meeting. Bough was to move yet again, this time after a row with the Theatre, taking up a similar post at the Adelphi Theatre in Edinburgh, which he was to leave, once more after a disagreement.

Despite his inability to settle happily into a job, Bough was developing as an artist in the late 1840s. While in Glasgow he established a relationship with the publishers Blackie and he was commissioned to produce illustrations for them for over 20 years. At the same time, he sold several watercolours of Glasgow and its surrounding countryside to A. G. Macdonald who was to become both a friend and a patron in the years to come. Another friend of his Glasgow days was John Milne Donald, a landscape painter in oils, and in 1850 he met Alexander Fraser, an artist in both oils and watercolour, who became a life-long friend. In the same year, Bough visited the Western Hebrides and Skye

with A. G. Macdonald, following McCulloch's practice of working in the open air. Bough was also acquiring a wider patronage – Lady Belhaven bought several watercolours as did Lady Ruthven, herself an amateur watercolourist.[2] Finally, in 1853, Bough met Thomas Fairbairn, who became a neighbour in Hamilton. Together with Fraser, they painted in Cadzow Forest enjoying the wooded landscape and the views of Borthwick Castle. Thus, although this period presented many financial difficulties to Bough, it also marked the beginning of important friendships and patronage. During the 1850s Bough's reputation grew fast and he was able to live entirely from his painting, being elected Associate of the Royal Scottish Academy in 1856. He was painting many topographical views both of Edinburgh and of Glasgow at this time, and a series depicting Victoria Bridge, Jamaica Bridge, Glasgow Cathedral and Kelvingrove Park, all dating to the early 1850s, is in the People's Palace, Glasgow. Other topographical views of the 1850s include *The Clyde at Govan during widening Operations* (1859), *The Clyde from Dalnottar Hill* (both in Glasgow Art Gallery) and a rather unusual view *Snowballing Outside Edinburgh University* (1853, NGS). After the 1850s, Bough very rarely painted townscapes. In this decade, he developed an interest in marine painting and spent much of 1853 in Port Glasgow studying boats, rigging and marine architecture. This interest in coastal scenes was to grow over the years and some of his best work was done in the fishing villages of the east coast – Dysart, Crail, St Andrews, Anstruther, St Monance (fig. 44) and Pittenweem. In Edinburgh from 1855, he was able to make regular visits to the Fife coast, as well as painting the Bass Rock in the mouth of the Firth of Forth, which he often viewed from Canty Bay. Bough was at home with the fishing folk of these villages, who came to recognize this extraordinary figure, often armed with a multicoloured umbrella, painting in the open air. At times he asked local boatmen to take him out, so that he could sketch at sea. His many watercolours of coastal scenes vary from fresh, salty wind-swept views to placid, carefully composed and drawn scenes of shipping in habour. *Pittenweem* (1874, VAM) is an example of the former: a large watercolour full of movement, with the paper cut and scraped to produce waves and motion, the emphasis being upon overall effect rather than on detail. In such works his technique it close to that of David Cox, as, at times are his colours. The second type of harbour view is well represented by *West Wemyss* (colour plate 5), where he creates a different atmosphere of tranquillity using subtle colours and lighting. *Early Morning at Sea* (1877, Glasgow Art Gallery) is a pure study of light on water and cloud effects, revealing Bough's great powers of observation, the mackerel clouds being particularly delicately handled.

Another group of watercolours shows landscapes near the sea with figures working in fields or on the beach set against a distant sea. Some of Bough's most effective works are those with figures on a beach collecting seaweed or loading carts. He captures the light off the wet sand with great skill and a fresh, salty wind can be felt. His figures

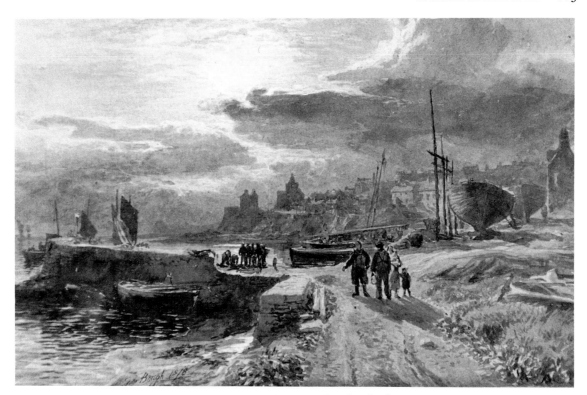

44 Sam Bough, *Moonlight, St Monance* 1878
16 × 21 Moss Galleries

often appear 'dumpy' and were probably influenced by Cox's figure drawing. Bough always depicted working people – fishermen, harvesters and labourers – for whom elegance of clothes or pose had no relevance, and much of the appeal of Bough's work lies in his closeness to, and feeling for, his subjects.

Although probably most at home with coastal scenes, Bough had a wide range of subjects. Some of his views of castles by lochs can be romantic, the view depicted at sunset or in the moonlight, looking towards the moon. Bough was one of the few Scottish watercolourists to paint night scenes, a subject often more suited to oils and technically difficult in watercolour. He also had a particular ability to paint skies. His cloud formations, often with his favourite anvil-shaped cloud, suggest a hidden sun or moon behind, the whole sky appearing to be moving before our eyes. He often placed his subject directly in front of the light source, with horses, carts, figures and buildings silhouetted against the sky.

Bough continued to work in the Lake District, painting not only by the Lakes, but at Morecambe Bay and Lancaster Sands, where the wide expanse of sand and sky appealed to him. He travelled abroad, once to the Rhineland and three times to Holland, but preferred, on the whole, to stay at home:

> I wonder at folk going away so much on foreign travel in search of the picturesque, when we ourselves have such fine and varied scenery on every hand.[3]

He made many trips to Southern England, working in East Anglia and London where he enjoyed painting the Thames. He worked quickly and would finish all but the most complex of his watercolours on the same day. He believed strongly in painting from nature:

> Why the devil don't you get out into the green fields and woodlands, my lad, and study Nature for yourself, instead of poking and grubbing on so much within doors? There's nothing like meeting Nature face to face.[4]

In later years, Bough's work was appreciated in Scotland. He was elected to the RSA in 1875, just a few years before his premature death aged 56 in 1878, and was also Vice-President of the newly formed Society of Scottish Watercolour Painters, later the Royal Scottish Society of Painters in Water-Colours. His works fetched good prices, and he was able to buy a large house in Morningside, Edinburgh in 1866. His main regret was being turned down by the Old Water-Colour Society in London, to which he had sent the necessary number of drawings to gain admission. Although no reason was stated, the council probably disliked his Bohemian way of life and might also have objected to his repeated use of bodycolour. Perhaps too they criticized his occasional lapses in drawing, arguing that this revealed his lack of a formal art training. In retrospect, these 'faults' seem insignificant compared to his achievements as an energetic, yet sensitive watercolourist, who more than anyone else, influenced Scottish watercolour painting away from the conventions of the mid-century, towards a fresh, *pleinair* style.

A close friend of Bough, and an admirer of McCulloch, **Alexander Fraser II** (1828–1899) was the son of Wilkie's associate and fellow artist. He was born in Linlithgow, but spent much of his childhood on the Argyll coast, where he took an interest in painting from an early age:

> My father painted for his own amusement in both oils and watercolour, and had always by him a supply of materials, palettes and brushes. They were the toys of childhood, and became my manhood's tools.[5]

Although he studied at the Trustees', he believed that he had learnt most from sketching in the open, going on painting expeditions with his contemporary at the Trustees', Fettes Douglas, and with Sam Bough, making rapid pencil and watercolour drawings in Cadzow Forest and on the banks of Loch Lomond.

> Though attending the classes of the School of Design, of any teaching from a master I had little or none. The best teaching a student of art gets comes from the criticism of his brother-artist, and the education and training of his eye by constant work and ceaseless observation.[6]

Although Fraser was influenced by the broader style of Bough and McCulloch, as well as by his admiration for David Cox and William Muller, he continued to enjoy the details of a landscape. *November's Workmanship – Fine as May* (fig. 45) depicts a garden in autumn in harmonies of russet and beige and, despite the concern for details such as

individual branches and leaves, the overall effect is free. In many of
his oils, Fraser shows the influence of Pre-Raphaelitism, but his water-
colours tend to be more loosely handled. In later years they become richer
in colour and somewhat heavier in technique. He worked not only in
Scotland, but also in East Anglia, the Fens and Surrey, depicting
scenes of rural England, often at sunset, with figures and buildings
dark against a pink sky. Influenced, no doubt, by the English Ruralists,
he produced glowing watercolours in rich tones. Some of his later
works, from the later 1880s and 1890s, show a decline due largely to
illness and partial paralysis.

William McTaggart (1835–1910) stands out with Sam Bough as a
leading figure in the development of a freer style in watercolour paint-
ing. Like Bough, he was born in humble surroundings, the son of a
crofter with a smallholding near Campbeltown, but unlike Bough,
McTaggart enjoyed a formal art education at the Trustees' Academy

which he entered in 1852. Much has been written both recently and last century about the brilliance of the students at the Trustees' during the 1850s and 1860s when Robert Scott Lauder was Master. Not himself a first-rate artist, he appears to have been an excellent teacher:

> The Lauder method was not Scholastic, but educative. He made no attempt to impress himself upon his pupils, to fetter them by rules. . . He took them as he found them, however fashioned and endowed, and directed his efforts to the development of such gifts as they possessed. He encouraged them in the search for means and ways of self-expression.[7]

McTaggart found himself studying alongside Hugh Cameron, John MacWhirter, George Paul Chalmers, Tom Graham and others who were to establish considerable reputations in later life. Contact with his talented fellow-students was almost as important to McTaggart as the formal training, for in 1857 he visited the Manchester Art Treasures Exhibition with Chalmers. The Pre-Raphaelite Movement influenced his work in the 1860s, and his oil *The Thorn in the Foot* was later reproduced by Percy Bates in *The English Pre-Raphaelite Painters* (1901). During this period watercolour did not play an important part in McTaggart's work, although his first pictures at the Royal Scottish Academy in 1855 were watercolour portraits, painted in Campbeltown during the summer vacation.

The sea was important to McTaggart, and each summer as he returned to the west coast, his mind was refreshed by the wide expanse of the Atlantic. Although McTaggart was still working in studio conditions for his principal oils, he was also sketching the sea in watercolour, and often like Bough working from a small boat. After his marriage in 1863, he moved to Fairlie near Largs from where he could see the Peaks of Arran. Here he made watercolour sketches of the beach and the sea, sketches which are very different from his finished oils. In 1866 he visited Lochranza, and again made extensive use of watercolour for sketching out-of-doors, and in 1868 he made a trip to Tarbert on Loch Fyne, where he worked with Colin Hunter. McTaggart's use of watercolour was beginning to influence his oils, for the freedom and movement which he obtained in this medium becomes apparent in the oils of the early 1870s, in which Pre-Raphaelite 'finish' is less important. Caw stressed the importance of the watercolours in this period:

> One may say that it was in watercolour, rather than in oil paints, that he began to liberate his hand to express the sparkle and flicker of light, the purity and brilliance of colour and the dancing and rhythmical motion which mark all the work of his full maturity.[8]

By the early 1870s McTaggart was in the fortunate position of making a good living from his art. He had received early recognition, being elected Associate of the Royal Scottish Academy in 1859, aged 24, and was able to support a family and a substantial house in Edinburgh. During this period he discovered Carnoustie on the east coast near Dundee. Here he was able to paint the North Sea and figures on the foreshore, as well as the inland landscape. Carnoustie is liable to

dramatic storms and gales, and in the autumn of 1875 McTaggart witnessed and painted such a storm. He also spent periods on the west coast at Machrihanish, working largely in watercolour, two of which were exhibited at the Royal Academy, London, in 1877. It was common for McTaggart to spend the spring or early summer in Carnoustie and move to Machrihanish for August, September and October. In the 1880s he often worked on the east coast of Kintyre at Carradale, always painting outside and often producing a large number of watercolour sketches. From Carradale he could paint Arran and Kilbrannan Sound.

That McTaggart took watercolour painting seriously cannot be disputed. Whereas in the 1860s watercolour had been an *aide-mémoire*, from the 1870s onwards it became for him an important technique in its own right. His friendship with Sam Bough had aroused his interest in the medium, and in 1878 he was elected Vice-President of the newly formed Society of Scottish Watercolour Painters. Whereas most of the 1870s watercolours were small, McTaggart began in the later 1870s and 1880s to work on a larger scale. Sir James Caw, who knew McTaggart, has provided a description of his technique:

> Always frankly a wash, laid swimmingly with a big brush, and modulated in colour and tone as it was floated in, his actual handling was so swift and flexible, so delicate and yet so decisive, that it seems to exist only as tone, colour and atmosphere. His finest drawings have the look of having been breathed rather than painted upon the paper, and appear the result of easy, half-careless playfulness rather than what they are – the issue of finely controlled and expressive craftsmanship.[9]

McTaggart used double-thick rough-surfaced Whatman paper, which he neither mounted nor strained. He apparently placed his paper under a thin iron frame, which was attached to his sketching folio. While working in the open air, he used a light easel for watercolour painting, which, because of the small size of the folio, did not need anchoring in the ground as did larger easels used for oils. He made preliminary sketches lightly in charcoal, and never pencil, avoiding any detail. While working on the spot, McTaggart used only one size of brush – an eagle sabre mounted in a quill. Figures and the occasional detail he left until he was in the studio where he had brushes of differing sizes. Thus he employed an unconventional watercolour technique, with no hard-and-fast rules about the use of bodycolour which he used where he wanted to create a different type of highlight. He was, in short, a spontaneous and natural watercolourist who greatly enjoyed the medium: 'There is nothing so beautiful as watercolour ... One associates freedom and charm of expression with it.'[10]

McTaggart continued to paint many watercolours during the 1880s, but in the following decade he concentrated more on oils, and after he moved to a house in Broomieknowe, Midlothian, landscape entered his painting after almost two decades of seascapes and coastal views. Exhibiting less in the Royal Scottish Academy and Glasgow, he remained interested only in the Royal Scottish Society of Painters in Water-Colours where he continued to exhibit. His pattern of summer painting also

changed, visiting Machrihanish in midsummer to capture the clear blue skies and brilliant white sands. For a period his output of watercolours declined, but from about 1905 onwards, as he began to find painting large oils in the open-air increasingly tiring, he turned back towards watercolour. Thus, during his last visit to Machrihanish and Carnoustie in 1908, he appears to have worked almost entirely in watercolour.

McTaggart's watercolours arouse differing views. The main criticisms are often those of repetition and lack of form, although neither is fully justified. There is considerable variety in his subjects – at times he shows figures by the sea, children lying in the sand, shrimping or fishing; at other times he depicts harvest scenes or quiet rural lanes in midsummer; rarer subjects include views of the Highlands, such as *Sketch at the Trossachs* (Orchar) or views of fishing villages. In each watercolour there is a freshness and a sense of movement achieved by his unusual technique and colour. Using a rough paper, he drags his brush across the surface in places to create a textured effect; in other places he floods the paper with wash; while in yet other areas he cuts or rubs the surface of the paper for different effects. Often the whole watercolour is pulled together by the use of Chinese white, and by the use of rhythmical brushstrokes. McTaggart used colour very freely, combining subtle pinks, purples, reds and blues in a patchwork of brushstrokes, merging effectively in the eye, and his unconventional technique had no counterpart in English watercolours of the period. Many of his watercolours were experimental or intended simply as *aides-mémoire*. Some of these, such as the rather formless cloud studies or seaviews, should be seen as such, and not as finished works. His more complete works, intended for exhibition, are finely controlled and resolved. *Girl Bathers* (colour plate 2) is such an example. Watercolours of this quality reveal McTaggart as one of the truly original and progressive watercolourists of the nineteenth century. Moreover, McTaggart's direct, unacademic approach to the medium was to have a great influence on the younger generation of Scottish artists. This approach is well summed up in McTaggart's hint to young artists: 'The simpler and more direct the method, the finer the picture.'[11]

John MacWhirter (1839–1911), whose early Pre-Raphaelite-influenced watercolours are discussed in Chapter Five, was a close friend and contemporary of McTaggart. He studied at the Trustees' with McTaggart, where Robert Scott Lauder's idea of colour made a lasting impression on his work. Unlike McTaggart, he did not stay in Scotland, moving to London in 1869, from where he unsuccessfully urged his friend to join him. A natural colourist, he searched out views in which unusual and dramatic colour combinations could be exploited:

> If Italy is the land of light, Scotland is certainly the land of colour. The grey olive, the vine, and the stone-pine and white walls of Italy require sunshine to show them to advantage; but Scotland has colour when there is no sun, and gloom and cloud often aid the beauty and grandeur of the Highland landscape.[12]

In Scotland, MacWhirter captured the rich blues, purples and greens of the Highlands, creating vivid effects, while on other occasions he depicted clear blue skies with crisp white clouds. He also enjoyed sunsets and the afterglow over water and mountains. Having visited Skye aged 15, he retained a love of the island and the Kyle of Loch Alsh, while also spending many autumns either on Arran or in the Trossachs or in Glen Affric. Some of his most romantic watercolours are moonlit views of Loch Ailort or Loch an Eilan, where he was able to exploit his exquisite use of rich blues, managing to stop before descent into vulgarity. *On the Coast near Dunoon* is an example of MacWhirter's freedom of technique in his Scottish subjects and shows his affinity to McTaggart (fig. 46).

During the spring and summer months, MacWhirter worked abroad, enjoying in particular the Italian and Swiss Lakes, the Tyrol and the South of France. Here he could depict the pink and white of fruit blossom set against the rich blues of water and distant mountains. His foregrounds are freshly painted, with fine touches of detail, but never overworked. *Pink Blossom – Looking down in the Harbour of Toulon* (VAM) captures the freshness of spring in the South of France. He made extensive use of bodycolour to create three-dimensional effects

46 John MacWhirter,
On the Coast near Dunoon
$9\frac{1}{2} \times 13\frac{1}{2}$ Private collection

in the foreground, using a technique employed by watercolourists of the Pre-Raphaelite School, including Waller Hugh Paton and Robert Herdman. He also made use of coloured paper on many occasions, floating gouache across the surface in a direct and unorthodox manner. Like many travelling artists, he made use of a notebook and quick sketches:

> Always carry a notebook. You cannot begin to train your memory too soon. The finest effects will vanish before you have time to copy them. They must therefore be noted down and afterwards reproduced from memory.[13]

Also notable was his ability to recall colour and effects from memory:

> As he advanced in age he gradually developed a habit of making a rapid sketch, and colouring it from memory.[14]

47 John MacWhirter, *A Watermill by the Sea* $12\frac{1}{2} \times 18$ Private collection

MacWhirter's combination of a romantic sense of colour and a Pre-Raphaelite awareness of detail results in many fine watercolours,

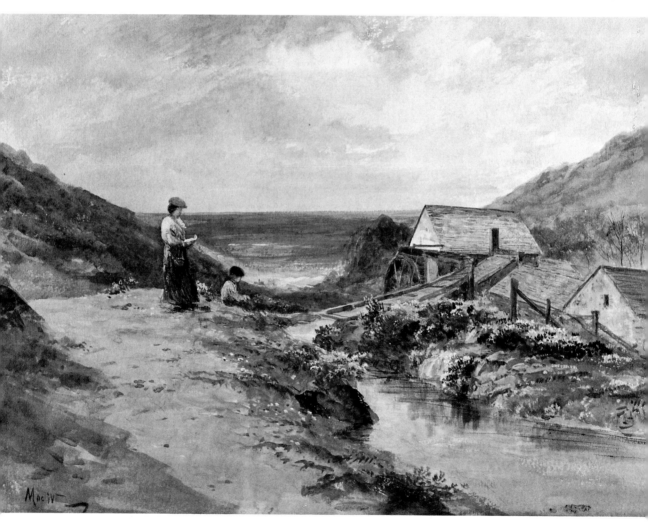

ranging from tiny, Turneresque views of lakes, mountains and build-
ings to large, powerful watercolours executed with great panache in
vivid colours.

During his lifetime, MacWhirter gained a considerable reputation
both as an oil painter and as a watercolourist, and several books were
published containing his advice on watercolour painting – *The
MacWhirter Sketchbook* (1906), *Landscape Painting in Watercolour*
(1907), and *Sketches from Nature* (1913). These illustrated books, com-
bined with his easily copied signature, have led to a large number of
copies, many no doubt dating to the nineteenth century, which appear
regularly in the salerooms. The poor quality of these copies should
distinguish them easily from the works of one of the most charming of
Scottish watercolourists (fig. 47).

A friend and associate of McTaggart was **Colin Hunter** (1841–
1904), best known for the large oils of coastal scenes which he exhibited
with great success at the Royal Academy in London. Born in Glasgow,
he trained as a clerk in his father's business in Helensburgh before
turning to painting. He had no formal art training, but was able to go
on painting expeditions with Milne Donald, the Glasgow oil painter,
and also spent a few weeks in Bonnat's studio in Paris. Hunter worked
in the open air, sketching coastal views on the west coast from nature,
aided by his knowledge of sailing, enabling him to create a vigorous
sensation of the sea in his work. He became a friend of McTaggart and
sketched with him at Tarbert for several summers in the late 1860s,
but in 1872, like many of his contemporaries, he settled in London,
returning to Scotland most summers to sketch. In 1882, while work-
ing on a large canvas, *Waiting for the Homeward Bound*, he chartered
a small steamer and for two months he painted at sea, in order to be
in direct contact with nature – in a similar fashion to the English
marine artist, Henry Moore. Colin Hunter's watercolours are rare,
although he did exhibit at the RSW, being elected in 1878. His
watercolours were primarily working sketches for his oils, and most
take the form of freely painted *pleinair* sketches. The handling is loose,
and the colours are pure but the majority were not intended as finished
works.

Joseph Henderson (1832–1908) was a friend of McTaggart, later
becoming his father-in-law – in 1886 after the death of his first wife,
McTaggart married Henderson's daughter. Although born in Perth-
shire and trained at the Trustees' in Edinburgh, Henderson lived for
much of his life in Glasgow, becoming a well-known figure in the
Glasgow Art Club. His earlier work was mostly genre subjects in oils,
but during the 1870s he came under McTaggart's influence and began
painting marine and coastal views in lighter colours. He worked in
both oils and watercolours, often exhibiting the latter as finished works
at the Glasgow Institute and the RSW. His watercolours, although less
adventurous in terms of colour and technique than those of McTaggart,
are usually successful in their sparkling colours and light-handed tech-
nique, which allows the white paper to show through, creating great

luminosity. His subjects are often figures by the sea – children playing on the foreshore, fishermen mending or drying their nets on the sand, and views of beached boats. He captures the changing mood of the sea, at times grey and threatening rain, at other times delighting in the vivid contrast of deep blue water and pearly white sand which can be found on the west coast of Scotland.

Hamilton Macallum (1841–1896) worked at Tarbert on Loch Fyne along with McTaggart and Colin Hunter. Like Hunter, he was a good sailor and cruised around the west coast in his own small yacht painting views of the sea, coastal scenes with boys bathing or fishing and vessels under sail. Having been born on the Kyles of Bute he knew the west coast well, and his work in both oil and watercolour has a freshness and sparkle similar to that of Henderson. He settled in London in 1865, but never achieved the recognition accorded to Hunter, and when he died, rather young, in 1896 his work had not been fully appreciated. His watercolours are comparatively rare, and although he was a founder member of the RSW and a member of the RI, his output appears to have been limited. In addition to views of the west coast, he painted some watercolours of southern Italy, Capri and Salerno in the 1880s. **W. F. Vallance** (1827–1904) should also be mentioned as a friend of McTaggart, with whom he had studied at the Trustees'. Later, in the 1860s, they worked together in Cadzow Forest. His oils are of genre and topical subjects, such as *Reading the War News* or studies of the Irish problems, but he also painted many seascapes in both oils and watercolour, often in close tones of grey with an effective use of body-colour highlights. His larger watercolours tended to become rather heavy, often with sombre colours and clumsy drawing. He also drew humorous sketches of Irish characters in watercolour.

The influence of McTaggart is evident in the work of **Hugh Cameron** (1835–1918) who studied at the Trustees' at the same time as McTaggart, but whose reputation is based on oils of children and cottage interiors, painted in a somewhat 'sweet' style. He was also a fine watercolourist with a delicate sense of colour, using a technique based on careful painstaking stippling and reworking. Although his technique is far from 'free', his use of colour is often original, even daring. In the 1870s he began to travel abroad working in southern France and Italy, where the purity of light and colour appealed to him. *Venice 1877* (Perth) is a limpid view of a gondola with the city in the distance. **George Paul Chalmers** (1833–1878) was also a student at the Trustees' under Lauder and a friend of McTaggart. Like Cameron, he is today known for his oils, but some mention of his rare watercolours should be made. He was a founder member of the RSW in the year of his death, so he must have had some reputation in the medium during his lifetime. *The Legend* (Aberdeen) is a watercolour sketch for the oil, freely executed, but showing a great feeling for the medium. An irregular and erratic worker, it seems likely that Chalmers used watercolour for preliminary sketches, and that, as in the case of McTaggart, these sketches came to influence his use of oils.

There were other watercolourists moving towards a more adventur-
ous and freer style of painting who had not been associated with
Robert Scott Lauder and his pupils. **John Smart** (1838–1899) had
been a pupil and friend of Horatio McCulloch, and his style and
method of painting were greatly influenced by his friend's technique
and subject matter. An ardent Scottish nationalist, Smart loved the
rugged West Highlands, painting mountains and lochs in the open air.
His work varies greatly in quality: at times his robust technique and
strong colours combine to produce effective landscapes, in which a wet
handling of washes creates a sense of freshness. On other occasions, his
strong colours become too dark and brooding and his technique over-
worked. A founder member of the RSW, he produced a considerable
number of watercolours in Scotland and Wales.

The influence of John Phillip upon the watercolours of **William
Ewart Lockhart** (1844–1900) has been discussed in Chapter Three.
In addition to his Spanish subjects, Lockhart also painted views of
Scottish east coast fishing villages, including St Monance, Crail, Largo
and St Andrews. For these subjects, his style was strongly influenced
by the watercolours of Sam Bough. Using a free style with light washes
and often luminous colours, he captures the fresh wind and lively sea
of the east coast. Like Bough, he also painted views of harvesting or
peat gathering in which the closeness of the sea can be felt. His main
weakness lies in his figures, which at times appear stiff and lifeless.

Alexander Kellock Brown (1849–1922) also contributed to the
development of a 'wet' watercolour technique. He was born in Edin-
burgh; his family moved to Glasgow when he was three, and he was
associated with that city throughout his life, becoming President of the
Glasgow Art Club. He had no formal art training, having worked as a
textile designer before turning to painting, coming under the influence
of James Docharty. He worked in both oils and watercolour, paint-
ing romantic views of Highland moors and mountains, with 'wet'
washes and rich but luminous colours. Edward Pinnington described
his work:

> He works largely in semitones, in russets, grey, green and soft shades of
> blue. A leaning towards low tones is accompanied by a frequent choice of
> evening, moonlight and winter effects. He loves to look dreamily across
> moorland when the sun is low, when the clouds absorb the dying light and
> the world reposes in shadow.[15]

Brown worked hard to encourage watercolour painting in Scotland and
was an active supporter of the RSW. The same romantic, almost nos-
talgic quality can be felt in the watercolours of **John Crawford Win-
tour** (1825–1882). Born in Edinburgh, he studied at the Trustees'
when Sir William Allan was still Master. Wintour's earlier watercol-
ours owe much to Leitch with warm colours and considerable detail;
however his best watercolours, dating from the 1860s, have a relaxed
informality with broad brushwork held together by pencil and charcoal
drawing. Choosing simple views of water framed by trees or brooding

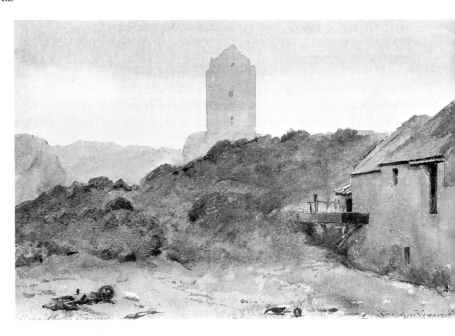

48 George Manson, *Smailholm Tower and Sandy-Knowe Farmhouse* $4\frac{1}{2} \times 6\frac{3}{4}$ National Gallery of Scotland

sunsets, he masses areas of light and shade, avoiding specific detail. His mellow colours produce close harmonies of yellows, browns and quiet greens, giving a restrained yet intense mood. Although he never became a popular artist in his time, his work was important for the Glasgow School and the watercolours of Walton and Macaulay Stevenson owe something to Wintour.

Although **George Manson** (1850–1876) died tragically young, his works are significant in the development of Scottish watercolour painting. Trained as a wood engraver, he turned to watercolour only five years before his death. His work falls into two types. Today he is known for his studies of young children such as *The Cottage Door* and *What Is It?* (both in the Orchar), painted in great detail with much stippling, but never becoming overworked. But he was also a fine landscape painter. *Smailholm Tower and Sandy-Knowe Farmhouse* (fig. 48) illustrates the combination of detail and 'wet' washes in his work. *Castle by Moonlight* (VAM) is a very small watercolour in which the deep blue washes combine with fine detail to produce a work of great intensity. Possibly his greatest achievement, however, lies in his understanding of children, whom he portrays with great sensitivity, which never descends, as with so many of his English counterparts, into Victorian sentimentality. **Peter Walker Nicholson** (1856–1885) also died young, the result of a boating accident on a Highland loch. His watercolours, which are rare, depict children and peasants in landscapes, painted in a poetical and lyrical style similar to that of Wintour and Manson.

The watercolours of some artists are difficult to fit into any category. This is true of those by **Sir William Fettes Douglas** (1822–1891) and **Sir George Reid** (1841–1913) who were both known in their day as

academic artists and leaders of the artistic establishment, and both became Presidents of the Royal Scottish Academy. Compared to their formal canvases, their watercolours come as a surprise. **Fettes Douglas** was a recognized painter of historical canvases usually displaying great concern for exact detail and historical accuracy, but in later life he began to paint landscapes both in oil and in watercolour, displaying a new sense of freedom. His first watercolours date from the late 1870s when serious ill-health prevented him from working on large oil paintings. His watercolours are quiet, subdued and controlled, but they contain a quality of concentration and precision which makes them unforgettable. *Lundin Tower* (fig. 49) illustrates this combination of fluid washes and precise drawing. Fettes Douglas's use of colour is restrained, with a palette of subtle greys, greens and blues, but at times he creates rich *contre-jour* effects with deep-green trees and dark buildings against a pearly sky, possibly reflecting a knowledge of the Barbizon School and the Dutch School which he had seen on a trip to Holland and Belgium in 1878.

 Sir George Reid was a leading portrait painter and a somewhat reactionary President of the Royal Scottish Academy, who disliked the innovations of the Glasgow School. He was a landscape painter whose

49 Sir William Fettes Douglas, *Lundin Tower* $7 \times 10\frac{1}{2}$ National Gallery of Scotland

restricted palette and sombre lighting effects resulted in powerful, if not superficially attractive, canvases. He was also a watercolourist – or, more accurately, a draughtsman in pen and monochrome washes – of some note. *Traquair House* (fig. 50) painted in monochrome, shows his fine draughtsmanship and excellent sense of light. Here, as in many other wash drawings, he chooses views looking towards the sun, exploiting *contre-jour* effects and his ability to create a remarkable range of different lighting conditions out of simple washes.

The watercolours of **Robert Thorburn Ross** (1816–1876) should be mentioned, although he was older than other artists in this chapter. A genre painter whose oils are described by Caw as 'merely trivial and commonplace'[16], he was, nevertheless, a talented watercolourist who chose subjects beyond his genre repertoire. His watercolour landscapes are broadly handled with verve and with dramatic colours, in a style not unlike that of Lockhart at his best. *Cornfield near Cheltenham* (NGS), dated August 1874, is a fresh and vivid work, as is *Study of Ferns, Grasses and Stones* (plate 51) in which fine detail is combined with fluid washes and rich colour.

51 Robert Thorburn Ross, *Study of Ferns, Grasses and Stones* September 1865 $10 \times 14\frac{1}{8}$ National Gallery of Scotland

50 Sir George Reid, *Traquair House* $11\frac{5}{8} \times 9$ National Gallery of Scotland (opposite)

7 The Glasgow School and its influence

In recent years the history of the Glasgow School has been extensively investigated, not only in standard reference books, but also by means of exhibitions devoted both to individual members and to the group as a whole.[1] While the emphasis has been given mostly to oil paintings, the significance of the watercolours of Melville, Walton, Paterson, Crawhall and Henry have also been recognized. Most of the group painted in both mediums; one or two of the leading figures like Guthrie and Lavery produced virtually no watercolours, whereas others like Melville, Alexander and Crawhall were at their best in watercolour. Just as the oils of the Glasgow School are among the most progressive in Britain at the time, so the watercolours with their fluid technique, assured draughtsmanship and uncluttered composition, have few parallels in the English School.

One of the characteristics of the School is a bold, direct use of oil, eliminating detail and delighting in rich surface textures. In watercolour this finds a parallel in the 'blottesque' technique, in which carefully calculated 'blobs' of colour are placed on the paper to merge at a distance into a coherent image. The technique, effectively used by Melville, Paterson, Herald and Allan, was influenced by the mid-century Hague School. The loose 'wet' watercolours of Israels, Maris, Weissenbruch and Roelofs were seen by Scottish artists in Glasgow and Edinburgh galleries and the RSW invited Dutch artists to exhibit at their annual exhibitions. In addition many Scottish artists visited Holland to paint coastal scenes, and saw galleries showing both historical and contemporary Dutch art. A further source of the 'blottesque' style lies in the direct influence of French Impressionism. It had been common for Scottish artists to study in Paris from the 1870s onwards, and the ateliers of Constant, Laurens, Dagnan-Bouveret, Carolus Duran and Jacquesson de la Chevreuse were often frequented by younger Scottish artists. Although none of these teachers had links with the Impressionists, the students themselves sought out the more progressive aspects of French painting. Robert Weir Allan later recalled discussions with the avant-garde in cafés in Paris, and James Paterson gave a vivid account of student life in the ateliers.[2] Impressionist perception of form in terms of light, and the move away from

the highly finished picture surface, had a direct influence on the 'blott-esque' style of the group. Finally, the 'wet' technique which Scottish artists of the 1870s were pioneering, seen in the work of McTaggart, Henderson, MacWhirter and others, was an important stimulus to the younger artists.

A second and different aspect of the Glasgow School watercolours is the emphasis upon pure draughtsmanship. This is particularly evident in the watercolours of the animal and bird painters like Crawhall and Alexander. While the two techniques remain distinguishable, they were by no means incompatible; at times Crawhall adopts a wet technique, while Melville in his later work appears to be taking a more linear approach, and a combination of the two techniques can be found in the work of George Henry and E. A. Walton. The root of the more linear approach lies in the contemporary craze for Japanese art. A large num-ber of Japanese colour prints were reaching Europe in the 1870s and 1880s and their simplicity and emphasis upon linear design was influ-encing progressive artists throughout Europe. Several of the Glasgow School were to visit Japan – Hornel, Henry and, after the turn of the century R. W. Allan – while in London, Whistler and his circle had achieved much public interest, and some ridicule, for their obsession with things Japanese. Whistler's move towards thinly applied paint, achieved with simple and direct brushstrokes was important for the Glasgow School – both for the oil painters like Guthrie and Lavery and for the watercolourists like Crawhall and Alexander. A further aspect of Glasgow School watercolours is the interest in new and ori-ginal techniques of watercolour painting. Melville's technique of using soaked paper to achieve a 'blottesque' effect and his use of glass to try out his next brushstrokes before committing himself, is matched by Crawhall's experiments with different grounds including coloured paper and linen. E. A. Walton was also highly innovative in his use of rough paper and cardboard as a ground, and his use of charcoal and bodycolour to create textures and depth makes his watercolours amongst the most interesting of the period.

'Melville was unquestionably the most brilliantly audacious water-colour painter of his time.' Frank Rutter's view of the Melville Mem-orial Exhibition of 1906 is still valid today, unlike most art criticism of the period. **Arthur Melville** (1855–1904) is one of the great masters of British watercolour painting, a figure comparable to Cox or Girtin, not only for his originality of style and technique, but also for his influence on a generation of watercolourists. His work is not only ori-ginal by British standards, but also compares favourably with develop-ments in Europe during this period. His watercolours of the Middle East and Spain point towards Fauvism and in particular towards Der-ain's daring use of the bare canvas. However, like that of McTaggart, his work was little known outside Britain, despite Glasgow School exhibitions in Germany, Russia and the United States. In many re-spects Melville worked within the Scottish tradition of watercolour painting: his free technique and pure colour was foreshadowed in the

work of McCulloch and McTaggart, and like many Scottish artists, he achieved an immediacy and transparency in his watercolours which always appears spontaneous. Melville was an indefatigable traveller, like Wilkie, Roberts and 'Crimean' Simpson before him, and his *Journal* reveals him as being alert to new sensations, new places and new combinations of colour. This quality is reflected in his art and was noted in *The Studio* 1906:

> Melville had the supreme painter's gift of conveying not atmosphere only of air and sunlight, but also the psychic atmosphere, shall we say, of a scene – its effect upon his own mind, the glamour, the romance, for instance of the East as affecting a Western stranger.... Beyond his imitation of the scene, he succeeded in conveying a sense of its reality as happening.[3]

Born into a large family in Angus and moved as a child to East Lothian, Arthur Melville enrolled for evening classes in art in Edinburgh while working in a local shop, and each evening he walked the eight miles into town. His employer, James Annandale, persuaded his parents to let him study art full-time and he joined the Edinburgh School of Art under John Campbell Noble. In 1878 he made his first trip abroad, going to Paris where he met Robert Weir Allan, who had been studying at the École des Beaux Arts and in the Atelier Julian. Melville learnt little from the ateliers in Paris, preferring to study modern French painting, and it is likely that he was introduced to some of the Impressionist painters at 'La Nouvelle Athènes' in Place Pigalle. He stayed for a while at Grez-sur-Loing where several of the 'Glasgow Boys' were working, and it was here that he began to experiment with the transparent qualities of watercolour. *The Kingcup Meadow*[4] of 1879 with its pearly light and muted tones shows the influence of Corot and Bastien-Lepage, and there is a foretaste of his later watercolour style in the handling of the foreground and the luminous white ducks, using the whiteness of the paper. Rather more vigorous in its handling is the larger watercolour *Honfleur* (Dundee) dated 1880, in which Melville uses a restrained palette of greys, browns and blacks and some bodycolour, and its strong brushwork is related to Glasgow School oils of the same period. In the autumn of 1880 Melville set out for the Middle East, visiting Istanbul, Cairo, Baghdad and Karachi. It was a journey full of danger and near Baghdad he was attacked by bandits and left for dead.

The brilliance of the light in the Middle East impressed Melville and during the course of the trip, which lasted until August 1882, his palette lightened and his style became more incisive. Thus earlier watercolours from this trip, such as *The Grand Bazaar, Muscat*[5] and *The Waterseller* (Glasgow) are painted in russet tones with much rubbing of the paper. In later watercolours, a more sparkling effect is achieved with greater use of bare paper and watercolour equivalent of the *alla prima* technique. Melville often kept unfinished watercolours for many years before reworking them and inscribing the final date and signature. Despite the problems of dating, it is clear that Melville's style developed rapidly during these two years, and his signature also

changed to the neater script that he retained to his death. Throughout the 1880s, Melville continued to produce Eastern scenes, and although he made two trips to France with members of the Glasgow Group in 1886 and 1889 to look at contemporary developments in art, he did not visit a southern climate again until his trip to Spain and Algiers in 1890. Thus, working from sketches, he depended upon his vivid memory of places and scenes to re-create the atmosphere. He also painted some fine views in Scotland, working in Orkney in 1885 where he produced the superb *West Front of St Magnus Cathedral, Kirkwell* (Dundee). *The Lawn Tennis Party at Marcus* and *The Shieling Brig O'Turk* (both in private collections) also date to the 1880s; the former is particularly fine in its use of space and placing of the figure, while the latter records a favourite spot of the 'Glasgow Boys'. Scottish views, however, are less numerous than Eastern subjects which, during this decade, reach a high level of skill. By 1883 his style and technique had fully matured; his technique was later described by Theodore Roussel, Melville's close friend (who later married his widow):

> Melville's method was pure watercolour, but watercolour applied on a specially prepared paper. This paper was soaked in diluted Chinese White, till it was literally saturated and impregnated with white. He worked often into a wet surface, sponging out superfluous detail, running in those warm browns and rich blues and reds which he knew so well how to blend and simplify. His colour was often dropped on the paper in rich, full spots or blobs rather than applied with any definite brush-marks. The colour floats into little pools, with the white of the ground softening each touch. He was the most exact of craftsmen; his work is not haphazard and accidental, as might be rashly thought. Those blobs in his drawings, which seem meaningless, disordered and chaotic, are actually organized with the utmost care to lead the way to the foreseen result. Often he would put a glass over his picture and try the effect of spots of different colour on the glass before applying them to the surface of his paper.[6]

In 1890 Melville visited Spain and Algiers for the first of several visits: he returned in 1891 and 1892, this time with Frank Brangwyn, who described his trip in the first volumes of *The Studio* in 1893. Melville kept a journal and we have his descriptions of the countryside:

> All the beautiful valley which now lies on our left is before us. A gorgeous panorama of green dark olive trees, mountains of opal blue and sky otherwise shaded with great white clouds rolling and changing ceaselessly.

Melville had complete mastery of his technique, achieving a balance between the firmness of his composition and a solidity of his architectural setting on the one hand, and movement and drama within this structure on the other. This can be seen in *A Moorish Procession* 1892 (NGS) in which the colourful, spontaneous and impressionistic figures contrast with the architectural setting which is painted in thin washes, nevertheless giving a three-dimensional effect. Melville was making greater use of areas of white paper within each watercolour, balancing areas of activity and drama with wide areas of flat, light washes. *The Capture of a Spy* (Glasgow), combines areas of movement (the central

group of spy and horseman) with areas of flat washes (the courtyard and the white walls). The movement of the horse's tail contrasts with the frozen fear of the kneeling spy, while subtle contrasts are created between areas of pure white paper for the horse and seated Arabs' clothing and the pale cream of the architecture and courtyard.

Awaiting an Audience with the Pasha (colour plate 3) reveals another aspect of Melville's work – a sense of suspense and drama, which his bullfight watercolours also share – *Banderillos a Pied* (Aberdeen) and the well-known *Bravo Toro – The Little Bull Fight, Madrid* (VAM). The excited and expectant crowd await the moment of destruction, while in the ring, the toreadors goad the bull into fury. The compositional balance is excellent – a colourful crowd, an area of bare paper for the sandy ring, the dramatic black bull as the pivotal point within the picture. Melville had the rare ability to build up psychological tension within his watercolours, effectively re-creating the charged atmosphere of the scene.

In 1894 Melville visited Venice for the first time; this trip resulted in a series of watercolours which show a new complexity of technique and composition. *The Rialto* (private collection) has rich and varied colours in the water foreground and a new use of bodycolour. The technique seems looser and this is more evident in *The Music Boat* (Glasgow) in which Melville creates a luminous night scene contrasting the bright lanterns of the gondola with the dark canal water. There could well be some influence of J. S. Sargent in these paintings: the broad handling and rich colours reflect his brilliant watercolour style, and Melville, moving in the artistic circle around Graham Robertson in London, would have come into contact with Sargent. In 1899 Melville married Ethel Croall and moved to Redlands, a cottage with a large studio in Witley, Surrey. Here he began to experiment in oil painting. Maybe he felt that he had reached a technical mastery in watercolour painting and wanted to develop something new; maybe he was afraid that his watercolour style would lead to slickness; maybe his friends encouraged him to use oils. Whatever the reason, he embarked upon a series of large oil paintings which he never completed and which absorbed most of his energy. Few watercolours can thus be dated to the last six years of his life. He continued to travel in search of new subjects: 1899 saw him in Spain, 1902 in Italy and in 1904 he and his wife made a final visit to Spain where they both contracted typhoid. They returned to England early in August, but Melville died at Redlands on 28 August 1904.

Although **Robert Weir Allan** (1851–1942) was not a 'Glasgow Boy' his watercolours must be discussed in conjunction with Melville. Born in Glasgow, he moved to London in the early 1880s, but his close association with Melville during the development of the latter's 'wet' style is of great importance to Glasgow School watercolours. It has been assumed that Allan's technique was based on that of Melville, but there is evidence to suggest that the opposite is true. In an article in *The Studio* of 1909, Martin Wood wrote:

The painter Melville, after he had seen some of Mr Allan's work, painted as one who had received a revelation and thereafter himself built up a method of his own, remarkable for its strength, its freedom and its luscious execution. This should be remembered by those who ... have thought that such a method as Mr Allan's had its inception at the easel of Melville.[7]

Further evidence comes from Nancy Bell who knew Allan when he was in Paris in the late 1870s. In an article in *The Studio* in 1901 she wrote:

... the watercolours of Robert Allan soon began to exercise an influence, still maintained, over other works in the same medium; he inaugurated, in fact, something of a new style and has made an indelible impression on the watercolour art of Scotland.[8]

Allan had begun painting in Glasgow in the 1870s – his father, an amateur artist, had encouraged him to paint and he had exhibited for the first time in Glasgow in 1873. In 1875 he moved to Paris to study at the Beaux Arts and in the Atelier Julian. Whereas many British artists spent a few months, or at most a year, in Paris, Allan remained based in Paris for five years, until 1880 when he appears to have returned to Scotland for a brief stay, before settling in London. During his five years in Paris, Allan came to admire developments in French painting, with a particular admiration for Bastien-Lepage. It is likely that he also knew of Impressionism, and that he met various Impressionist painters at cafés such as 'La Nouvelle Athènes.' His watercolour style developed fast and by 1879 he had achieved a 'blottesque' technique. A watercolour dated 1879, *Market in Brittany*,[9] shows clearly that he had created a 'wet' technique before Melville, who at this time was still influenced by a heavier Dutch technique. An interesting watercolour of the harbour at Le Havre (private collection, London) dated 1879 shows a marked similarity to Monet's harbour scenes, the boats dark against luminous water, suggesting that Allan had seen Monet's oils of St Adresse and Le Havre. It is reasonable to assume that Allan's sparkling 'blottesque' watercolour style was based upon his knowledge of the broken brushstrokes and fragmented colour of the Impressionists; moreover his choice of subject – market scenes and views of the Seine in Paris – is closer to the Impressionist townscape than the rural views of Lepage or the beaches of McTaggart. Allan is thus interesting as one of the first British watercolourists to be directly influenced by French Impressionism.

For the next 60 years Allan was to produce many watercolours and oils, outliving Melville by many years and still working in London in the late 1930s. He found considerable success, exhibiting regularly in London and Scotland, and becoming a member of the RSW and Vice-President of the RWS. He continued to travel abroad – in 1891–2 he was in India where he produced some fine watercolours capturing the sparkle of sunlight on the white stone mosques set against clear-blue skies. He visited Japan where he painted figures outside the temples and in 1911–12 he visited North Africa. This pattern of regular

52 Robert Weir Allan,
Oudepore, India
14 × 20 Private collection

trips abroad continued throughout his life; he returned often to Italy,
Belgium, Holland, France and North Africa. His output was large and
usually consistent, with only the occasional lapse when his 'blottesque'
technique overpowers the subject. Allan was not a draughtsman of
Melville's talent – his figures are often rather 'dumpy' in a Dutch
manner and his handling of architecture is less economical: he did not
have Melville's eye for a striking composition, nor Melville's ability to
stop working on a watercolour as early as possible; nor was he inter-
ested in psychological tension. Although their technique is similar,
their watercolours are very different in intention. Allan was essentially
a painter of landscapes and townscapes with a sense of composition
influenced by the Impressionists. To him the human figure was an
element of a composition but never a central feature. He was, in short,
a *petit maître* of great skill and charm – sensitive towards atmosphere,
he sometimes chose grey days and muted colours, in addition to bril-
liant sunshine. One of the attractions of his watercolours is their var-
iety, not so much in terms of composition and technique, but in terms
of subject-matter. He travelled widely and his watercolours are lively
and interesting, taking us from Cairo to Taormina, from St Andrews
to the Punjab and from Tokyo to Bruges (fig. 52).

Born in Glasgow, the son of a successful manufacturer with a strong interest in the arts, **James Paterson** (1854–1932) was allowed to leave the family business in order to attend watercolour classes given by A. D. Robertson at Glasgow School of Art. In 1877 he was sent to Paris where he spent five years in the studio of Jean-Paul Laurens, where Henry Tuke was a fellow student. During the summer months he either returned to Scotland, or made visits to countries such as Switzerland, Italy and Egypt. In 1878 he spent some months working in the studio of W. Y. MacGregor in Bath Street, Glasgow which had become the centre for the Glasgow Group. Paterson finally left Paris at the end of 1882, having had a wide experience of the ateliers in Paris and the contemporary developments in French art. He recalled these years in an article published in the *Scottish Art Review* entitled 'The Art Student in Paris':

> The often dirty, and even squalid, surroundings in a Paris atelier, the almost constant noise and inevitable tobacco smoke, frequently disturb the equanimity of youths gently nurtured in the prim proprieties of British Art Schools; but a few months' inoculation generally accustoms the most particular to the change, and one gets quite to like it. Very earnest work is pursued in this dirty, comfortless room....[10]

On his return to Scotland, Paterson lived for a while in Glasgow but after his marriage in 1884 he settled in the Dumfriesshire village of Moniaive. Here he painted many watercolours in the open air, combining careful observation with a strong sense of decorative design. Some interesting photographs exist showing Paterson painting in the open air around Moniaive, with a large umbrella to protect him from direct sunlight. Some of his finest watercolours date to this period of his career: idyllic rural views are painted in rich and imaginative colours in broad dashes of colour. These works are very much in the 'wet', 'blottesque' Glasgow style although their peaceful, rural feeling is quite different from the excitement of Melville. Some of his finest watercolours of this period were reproduced in a book entitled *Nithsdale*, written and illustrated by Paterson and published in 1893. Although Paterson spent very little time in Glasgow, he nevertheless kept in touch with members of the Group, and in 1888 he helped found the *Scottish Art Review* which was to be the mouthpiece of the Group for a short period. He was also active in establishing the Glasgow Group's reputation in Scotland and England.

In 1905 Paterson and his family moved to Edinburgh where he became Librarian of the Royal Scottish Academy and, in 1924, its Secretary on the death of W. D. Mackay. Edinburgh began to feature in his work – views of the city from Arthur's Seat and the Salisbury Crags, as well as from more distant viewpoints; studies of the old City and Leith, often painted in restrained tones of greys and browns reflecting his enduring admiration for Corot, in terms of both colour and elegance of technique. During the 1880s and 1890s Paterson had travelled little, but from 1900 onwards and especially after the death of

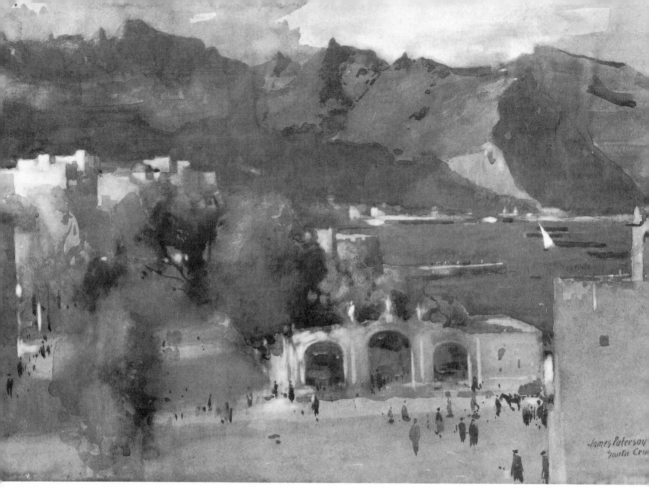

53 James Paterson, *Santa Cruz*
14½ × 21 Glasgow Art Gallery

his wife in 1910, he began to paint abroad, visiting France, Corsica, Italy, and the Canary Isles. His colours, which had become more restrained in Scotland, grow vivid and his handling more daring (fig. 53). Commenting on *Winter in Teneriffe* in 1903, *The Studio* wrote: 'He is a colourist by instinct, but, more he is an individualist.' Teneriffe, Oratava and Santa Cruz feature in many later watercolours, but at times the colour, especially his deep blues, becomes forced and his watercolours sometimes lack the subtlety and elegance of his earlier works. Paterson's watercolour technique is not unlike that of Melville. Broad, swiftly floated washes were laid in large masses; details were later added and areas worked up. Like Melville, Paterson used sponging and retouching as a means of creating texture, but on the whole, he is more restrained in the use of the individual brushstroke, preferring a broader area of wash. Paterson was a fine colourist, with a particular ability to use browns and russets, often set off against striking blues. His work had great variety both of subject and of mood, and it was appropriate that in 1922 he succeeded E. A. Walton as President of the RSW (fig. 54).

Edward Arthur Walton (1860–1922) was an important Glasgow artist, equally at home in both oil and watercolour. Born in Renfrewshire in 1860, he studied for a year in Düsseldorf before returning to Glasgow to enter the School of Art. In 1878 he met Guthrie, became

a life-long friend, and in the same year, his brother Richard married Joseph Crawhall's sister, and the two artists became close friends. During this early period of the Glasgow Group Walton painted with several colleagues in very different areas of the country: with A. K. Brown in Surrey, with J. D. Taylor, a minor Glasgow artist, at Ballantrae, with W. Y. MacGregor at Stonehaven and with Guthrie in Lincolnshire. In 1883 Walton and Guthrie spent the summer at Cockburnspath, a Berwickshire village near the coast and they were joined by Crawhall and Whitelaw Hamilton: in the following year they were joined at Cockburnspath by George Henry, Arthur Melville and Corsan Morton. Walton also worked on the other coast, at Helensburgh, where, in the early 1880s, he produced some of his most striking watercolours. In these Helensburgh watercolours Walton combines brilliant, clear colours with charcoal drawing to reinforce the depths, creating highly realistic effects. Their clarity of image and colour are extraordinary. Walton continued to look for variety in landscape, and was attracted by the more intimate views of Worcestershire and Somerset (fig. 55). The quality of his work was recognized by the RSW

54 James Paterson,
Springtime, Moniaive 1887
$20\frac{3}{4} \times 27\frac{3}{4}$ Private collection

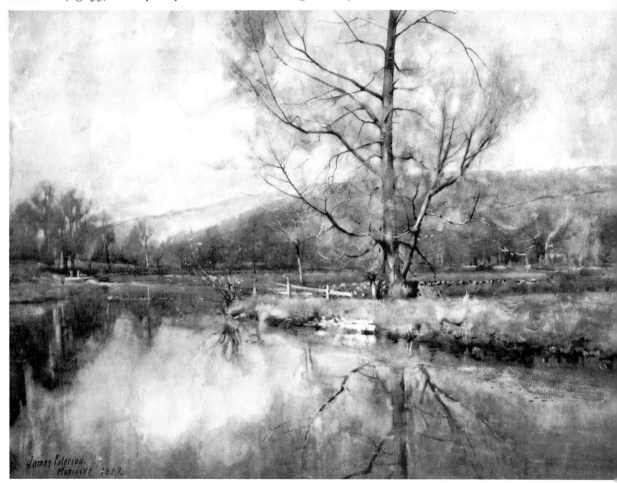

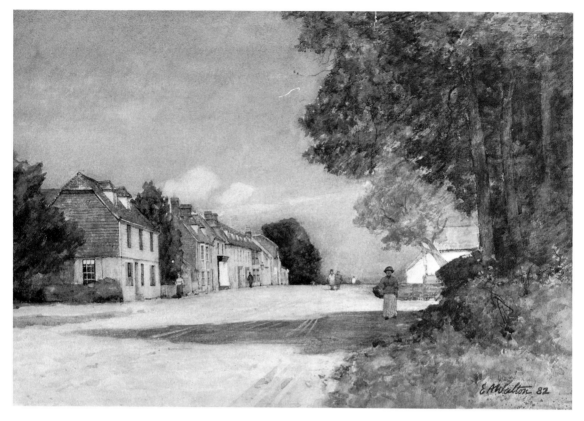

55 Edward Arthur Walton,
Winchelsea 1882
$13\frac{1}{2} \times 21$ Private collection

and he was elected a member in 1885. In the following year, Walton set up a studio at Cambuskenneth near Stirling where many of the Glasgow School worked, and it was here that their plans for the *Scottish Art Review* were discussed. Walton's links with Melville continued throughout this period, and in 1889 they visited Paris, accompanied by Sargent. Despite his friendship with Melville, Walton did not move towards a 'blottesque' watercolour technique, preferring broader washes and a tighter framework of drawing.

In 1893 Walton settled in London, attracted by the developments of the group around Whistler and by the success of the New English Art Club. He also wished to escape from the rivalry between Glasgow and Edinburgh artists. He moved to 73 Cheyne Walk, a house designed by Ashbee, where he had Whistler, Wilson Steer and Theodore Roussel among his neighbours. Whistler had come late to watercolour, probably encouraged by another Chelsea artist, Charles Holloway, but by the 1890s he was interested in the technique. Contact with Whistler broadened Walton's approach to watercolour, encouraging him to experiment with transparent washes, decorative understatements and fluent, almost calligraphic brushstrokes. During this period in London he spent many holidays at the Old Vicarage, Wenhaston, Suffolk where Fra Newbery and his family were neighbours. The Suffolk landscape became important to Walton and quiet pastoral scenes painted on buff paper with

transparent washes in low tones, heightened by bodycolour, became characteristic of his work. He continued to paint people and the local gamekeeper's daughter appears in some of his most charming works (colour plate 4).

Walton returned to Scotland in 1904 to become a full member of the Royal Scottish Academy, taking up residence in Edinburgh. He continued to travel regularly to Suffolk and abroad. In 1907 he visited Algiers and Spain with Guthrie and in 1913, again with Guthrie, he visited Brussels and Ghent. During World War I he discovered the Galloway landscape which begins to appear in his watercolours. His work was greatly admired by members of the RSW and he was elected President in 1914 on the death of Sir Francis Powell, a post he retained until his death in 1922.

The subject matter of Walton's watercolours is often simple – cattle by a river or near the sea, pastoral views with figures and farm animals, village street scenes or a single figure in a landscape. Occasionally, as during World War I, he painted anecdotal watercolours such as *Tales from the Front*, but these are exceptions. Whereas the earlier works tend to have strong blues, greens and purples, his later watercolours tend to be restrained in palette, with soft greens, blues and pastel shades. As with Crawhall and Edwin Alexander, Walton experimented with new grounds, using silk or rough paper and card of different shades, and even trying out the effects of watercolour on cork. Walton creates interesting textures within his watercolours at times using charcoal for definition, at other times using washes of bodycolour to create depth. David Martin in his important book *The Glasgow School of Painting* published in 1897 recognized the significance of Walton's watercolours:

> In his earlier drawings he finishes his work more according to accepted conventions, covering the whole surface of the paper; but in his later acquarelles he has invented the design and imbued his selection with a more personal style. In fact, he selects his subject, a roadway with figures, a group of animals, or a pastoral, with especial reference to the medium, as he now treats it. In some drawings the surface of the paper (of varied tints as required) is left uncovered, and the drawing is carried through with great dexterity and truth and with the least touch and detail, consistent with the motif of the picture.[11]

George Henry (1858–1943) worked closely with E. A. Walton and Arthur Melville in the early 1880s and his watercolours, while possibly lacking the individuality of his colleagues, are often well composed and beautifully executed. Born in Ayrshire, he studied at Glasgow School of Art for a short period in the early 1880s and began exhibiting at the Glasgow Institute at this time. Henry attended the informal classes at W. Y. MacGregor's studio in Bath Street and in 1881 joined Guthrie, Walton and Crawhall at Brig o'Turk in the Trossachs, thus becoming a central figure in the Group. In 1884 he joined Walton and Guthrie at Cockburnspath along with Arthur Melville, and it seems likely that his interest in watercolour was stimulated at this time. *The Girl*

56 George Henry, *The Girl in White* 1886
25 × 15 Glasgow Art Gallery

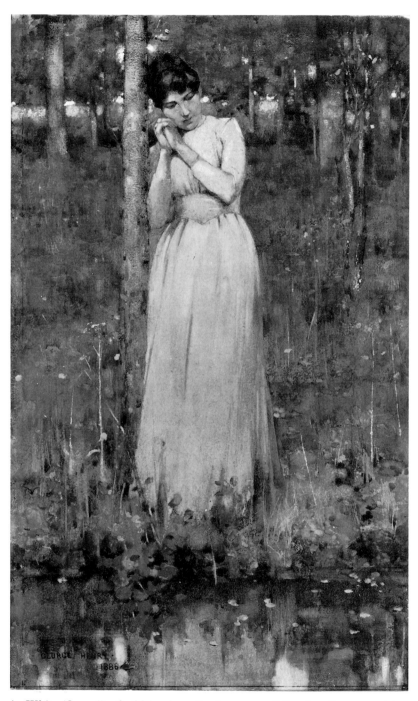

in White (fig. 56) of 1886 mixes the imagery of Bastien-Lepage with a broad 'wet' handling of watercolour, while *At the Window* (Glasgow) contrasts areas of flat washes with areas of more energetic 'blottesque' technique. A later watercolour, *The Feather Boa* (illustrated in *The Studio* of 1896) looks forward to Henry's later portraits, painted with

great panache which shows influence of France, although it has not been established whether Henry had visited France by this time.

In February 1893, accompanied by Hornel, Henry departed for an extended visit to Japan, although both artists, in keeping with most of the Glasgow Boys, had already been influenced by Japanese art, and their joint canvas *The Druids* reveals this influence. During the visit, which lasted until May 1894, Henry produced mostly watercolours, many of which were used as the basis of larger oil paintings after his return. These canvases are often less fresh and spontaneous than their original watercolours, which are painted in fluid washes with a strong sense of decorative design. Henry's Japanese watercolours are amongst the finest works produced by British artists in Japan, for, whereas Alfred East, Mortimer Menpes and Alfred Parsons remained entirely embedded in the Western tradition, Henry was deeply attracted by the composition and directness of Japanese art. His apparently effortless watercolour technique has those qualities of simplicity and freshness which the West admired. Van Gogh had written: 'I envy the Japanese the extreme clearness which everything has in their work.... Their work is as simple as breathing', and, to a certain extent, Henry did achieve these qualities in some of his Japanese watercolours as in *The Koto Plater* (fig. 57). *The Goldfish Bowl* (Dumfriesshire Educational Trust) is also influenced by Japanese design in the placing of the figures and even the vertical inscription; other watercolours depicting certain street scenes or pottery sellers are entirely Western in perspective and composition; yet others, such as *Salutations* (Glasgow), have an almost photographic exactitude combined with rather obvious composition. Henry had a tendency to be eclectic, and the influence of other artists, in particular Lavery and Crawhall, can be seen in the brushwork and drawing of many of these watercolours, while both Melville and Walton influenced his application of colour washes.

On his return to Britain, Henry continued to produce Japanese subjects, although these were mostly in oils and pastels. Some watercolours were painted after his return but these share with the later oils a lack of originality. Having settled in London, Henry turned to portraiture and soon became a respected, if somewhat dull, Academician. During his later years he rarely worked in watercolour.

If Arthur Melville typifies the 'blottesque,' fluid approach of the Glasgow School, **Joseph Crawhall** (1861–1913) represents pure draughtsmanship. The two elements were not incompatible; at times there is in Crawhall's work a Melvillian 'wetness' and a use of the 'blottesque' brushwork, but on the whole Crawhall was looking towards the draughtsmanship and design of the Japanese and their European admirers – in particular Whistler and his circle. Crawhall was not in fact a Scot, having been born in Morpeth, and later living the life of a country squire in Yorkshire. He was, however, a close friend of Lavery and the Glasgow Boys, and has always been considered part of the Glasgow School.

Born into a wealthy family, Crawhall was able to devote his life to

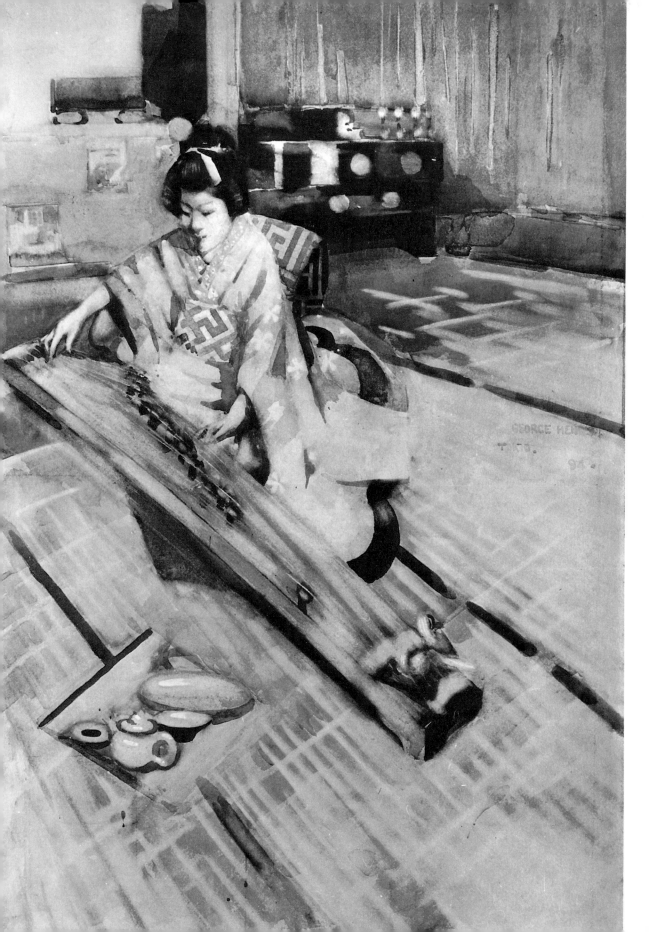

his two passions – hunting on horseback and painting. Crawhall's father was a cultured man, a close friend of the cartoonist Charles Keene; himself an amateur artist, he is remembered today for his book on fishing, *The Compleatest Angling Book that ever was Writ* with illustrations by himself, his son and James Guthrie. Being brought up in an artistic family, Joseph Crawhall junior was encouraged to draw and had lessons both from his father and Keene. After a period in London at King's College School, he was introduced to E. A. Walton through his brother Richard Walton, who married Crawhall's sister. Crawhall moved to Glasgow to continue his art studies, and here he met James Guthrie. In 1880 Guthrie, Walton and Crawhall worked together at Garelochside and at Brig o'Turk, thus forming a nucleus of the School, and in the following year they again worked together, being joined by Sam Fulton and Harry Spence. In 1882, in order to change the scenery, Crawhall, Guthrie and Walton visited Crowland in Lincolnshire. Thus through marriage and friendship, Crawhall was deeply involved in the formation of the Glasgow School. During this period Crawhall had been working in oils, but in 1882 he was sent to Paris to study under Aimé Morot, the animal and battle-scene artist. This, combined with his father's enthusiasm for pen-and-ink drawing, turned him towards drawing in ink and watercolour. Moreover, while in Paris, he met Paterson, Melville and presumably Robert Weir Allan, all of whom were working in watercolour. On his return to Britain, Crawhall turned almost exclusively to this medium. In 1883 he was again with the Group at Cockburnspath and in the following year he joined Guthrie at the house which Guthrie had taken at Dunglass, near Cockburnspath. Here they were visited by Henry, Melville and Whitelaw Hamilton, whom Crawhall had met in Paris. In the following year Crawhall visited Morocco for the first of many such visits, staying with Lavery in his villa in Tangier. He enjoyed the social life and the excellent horse riding which was available.

The best description of Crawhall's approach is given in a personal recollection by his sister:

... most of his serious work was done in watercolour, though his black and white early drawings and his later pastel work show that he had a mastery in each medium that he used. His control of materials is shown by the experiments that he tried. He knew exactly what he wanted to get his effects. At one time he tilted the paper to allow the paint to run just as he wished. Another time, he drew (with a broken wrist) with a stationary pencil and twirling paper; ... He was most particular in his choice of materials and finally seems to have been happiest painting watercolour on brown holland, but he cared nothing for paraphernalia of artistry, his easel was the back of a chair. He owed nothing to teachers and imitated no one. He was a sincere admirer of Whistler ... and the Glasgow School ... but his work was intensely individual and its main features were apparent even in his earliest work. The creative and decorative tendency of his art seems to have been the result of artistic kinship with the Japanese artists whom he greatly admired, rather than direct or indirect imitation. He had a photographic

57 George Henry, *The Koto Player* 1894
28 × 19 Glasgow Art Gallery

memory, but it was only after studying his subject in minute detail that he painted it....[12]

Crawhall was an unorthodox artist in every respect. He had a small room for a studio and worked in short bursts, during which he would lock himself away; these bursts of creativity would be followed by long periods in which he hunted or sketched in a desultory way. He did not work directly from nature, but preferred to remember what he had observed. His visual memory was outstanding, and the accuracy of his drawing remarkable. He certainly did not lead the life of an artist, preferring that of the landed gentry. In the 1890s he built a house Dale End near Bransby, Yorkshire which became a popular meeting place for Guthrie, Walton, Walter Russell, James Pryde, William Nicholson and one of Crawhill's best friends, George Denholm Armour, the *Punch* cartoonist and animal painter. He avoided the 'art world' and had little interest in either selling or exhibiting his work. A figure more at home in the country than in the Chelsea studios, Whistler described him as 'going about with a straw in his teeth'. He was also unorthodox in his technique. Much of his best work of the later 1880s and 1890s was done on holland – a thinly sized canvas-like material. Adrian Bury, himself a watercolourist, has pointed out how difficult it must have been to work on such a material – unlike paper, it does not absorb washes and would remain wet for some time. Moreover Chinese White had to be used for the highlights. The texture obviously appealed to Crawhall and, although he seems to have come across the material by accident in his sister's sewing box, he must have been aware of Japanese painting on silk.

Crawhall's work falls into several distinct 'types' corresponding roughly to each period of his development. There is a group of watercolours painted in the 1880s on white paper using a fluent almost Melvillian style, such as *The Aviary* of 1888 (Burrell Collection) in which the technique of flooding the paper and washing out is visible. The North African watercolours of the late 1880s also have great freedom and fluency as in *An Arab Raid* (Burrell). *Horses Eating – Picketed Horses, Tangiers* (Burrell), is close in feeling and technique to Robert Alexander's *Donkeys in Front of an Arab Tent, Tangiers*, of 1888 (fig. 59) and shows how Crawhall himself influenced both Robert Alexander and his son, Edwin, when they visited Tangiers together in 1887–8. While painting these free watercolours, Crawhall was also working in a style strongly influenced by the cartoonist's technique. Throughout his life Crawhall retained a love for the art of cartoon – quick, perceptive sketching in pen-and-ink. *Girl on a Bicycle* (Burrell) is an example of Crawhall's ability to capture an everyday scene with great economy of line and a marvellous sense of humour, not unlike the later witty sketches of Matisse and Marquet. Crawhall also used a cartoonist's technique for some of his hunting scenes in which strong black outlines are filled in with flat areas of wash.

During the later 1880s and 1890s Crawhall became increasingly influenced by the Aesthetic Movement and by Japanese prints, and his

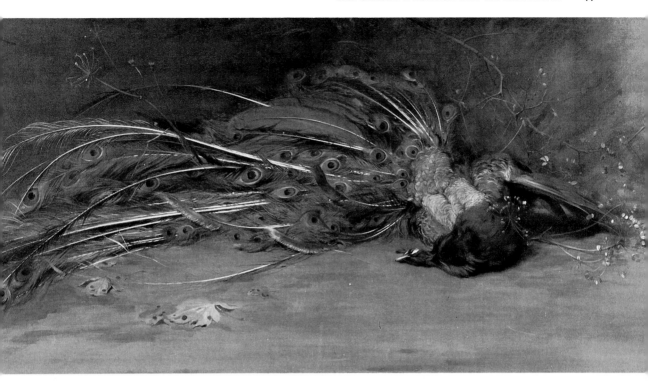

58 Edwin Alexander, *The Dead Peacock*
$37\frac{7}{8} \times 78$ The Fine Art Society

interest in Whistler's later work becomes evident. *The Jackdaw* (National Gallery of Victoria, Melbourne) is one of his finest watercolours, summing up Crawhall's brilliant draughtsmanship, his bold use of colour, his ease with the watercolour medium. *The Flower Shop* (Burrell Collection) reveals a further aspect of Crawhall's work – his ability to record everyday life around him, balancing observation with carefully planned composition. These drawings appear to have spontaneity and directness, but these were not achieved through speed, as his technique of working on cambric required sustained work and areas of reworking. During this period, Crawhall also worked in pastels. He was greatly admired during his lifetime both by the public and by fellow artists. Whistler appreciated his virtuoso skills, while Lavery wrote:

> I believe Crawhall to have been the truest artist of the Glasgow men, and, as far as I know, the best in England.[13]

and

> No artist I have known could say more with fewer brush strokes.[14]

Joseph Crawhall was a natural artist of unusual talent and must rank, along with Arthur Melville, as one of the most significant watercolourist of his generation in Scotland (colour plate 6).

Edwin Alexander (1870–1926) was not a member of the Glasgow School, but his close links with Joseph Crawhall, both personally and stylistically, require that his work be discussed at this point. A quiet, retiring man, he lived for most his life in, or near, Edinburgh seeking

little publicity. His unerring sense of line and total command of the medium combine in simple, yet very complete watercolours. The son of the animal and history painter Robert Alexander, he learned much from his father, although in later years the influence was reciprocal. In 1887 Edwin, aged 17, visited Tangiers with his father and Joseph Crawhall, who at the age of 26 had already developed a distinctive style. The simplicity of Crawhall's line and his skilful balancing of detailed subject against comparatively unworked areas, made a great impact upon both father and son. During this trip, Edwin acquired a taste for the desert with its wide expanses of sand punctuated by Arab settlements and solitary flowers. Watercolours from this first trip illustrate finely drawn flowers and grasses (which he called his 'weeds') and studies of camels and donkeys.

After a short period with Robert Burns studying art in Paris in 1891, Alexander returned to the Middle East, which, like Melville, he had come to love. Between 1892 and 1896 he was based in Egypt, either on a houseboat on the Nile or in tents in the desert, living much of the time with Erskine Nicol Junior. As Caw points out, Alexander was not attracted by the bustle of the market place or the dazzling colours of the mosques, but preferred to live amongst the Arabs in a simple style, learning to speak fluent Arabic. While Melville and Allan exploited the glamour and drama of the East, Alexander diligently recorded the way of life of his Arab friends, their tents, their animals and their immediate surroundings. He avoided the famous views such as the temples at Thebes or the Pyramids at Gaza, preferring to paint simple views of the banks of the Nile, the desert stretching into dusty infinity, and uncultivated flowers and grasses. While shunning the brilliant colours associated with the East, Alexander nevertheless managed to achieve a great sense of heat and sunlight by means of tonal modulation, understatement and close observation. Often working on buff or grey paper, where possible with an interesting texture such as packing paper, Alexander kept to a restricted and subtle palette.

In 1904 Alexander married and settled near Edinburgh, continuing to paint birds, animals, flowers and landscapes, not only in the immediate vicinity, but also travelling to the west coast, in particular Kirkcudbright, and the Western Isles. He kept owls and peacocks in the garden of his house and they appear in many of his watercolours. He also liked to paint dead birds, studying the plumage in great detail. His best watercolours of this period retain the simplicity and directness of his earlier works, and he continued to use unorthodox materials like sugar paper, packaging paper and linen. He also painted some very large watercolours which, in their technical control of the medium, are remarkable on such a scale. He was often reluctant to start a new picture until he felt that he had thoroughly examined every possible aspect, and his output was not great. On the outbreak of war in 1914 he virtually ceased painting, involved as he was in voluntary work and in teaching at Edinburgh College of Art in place of David Alison. He suffered a stroke in 1917 and was unable to paint during his later years.

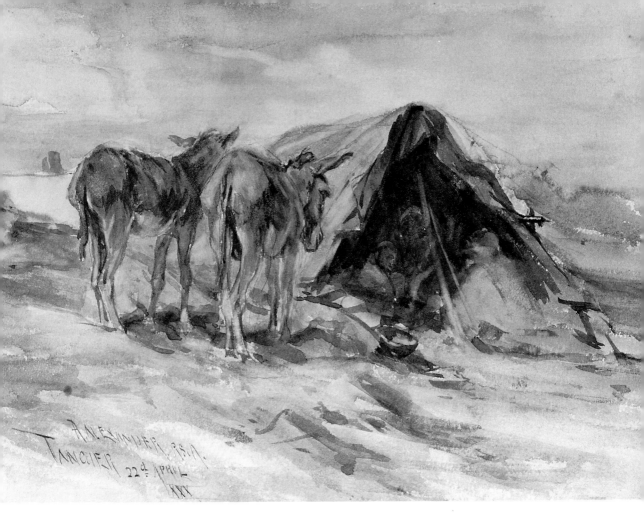

Edwin Alexander was in contact with members of the Glasgow Group: Crawhall was a close friend, and Alexander Roche married Alexander's sister Jean; the Edinburgh animal painter, William Walls, married Alexander's wife's sister. *The Dead Peacock* (fig. 58) is a monumental watercolour; a good example of Alexander's work shows to what extent he remained a close observer of nature and never substituted a formula for careful observation: 'The more one goes on – or rather as one gets older, the less one cares to make definitive statements.'[15]

Another friend and colleague of Crawhall, although not a member of the Glasgow School, was **George Denholm Armour** (1864–1949), whose work has been neglected, although he produced some fine watercolours of animals and hunting scenes. Born in Lanarkshire, he studied at St Andrews University. In the 1880s he was a regular visitor to Tangiers, where he sketched and rode horses with Crawhall; while for a period in the 1880s he lived with Crawhall first in the New Forest and later at Wheathampstead. Like Crawhall, George Denholm Armour was an excellent horseman and enjoyed hunting and the open air. *A Bull Fight* (VAM) reveals his ability to capture movement and drama in watercolour while working in an almost monochrome palette. From 1894 Armour devoted most of his energies to cartoon illustrations,

59 Robert Alexander, *Donkeys in front of an Arab Tent, Tangiers* $9 \times 13\frac{1}{4}$ National Gallery of Scotland

working for *Punch*, *Tatler* and *The Graphic*, while continuing to produce hunting and shooting watercolours and wash drawings, as well as illustrations for *With Rod and Gun* published by Hodder & Stoughton in 1912. Armour's work was popular with the public and critics, and *The Studio*, reviewing a group of his drawings at the Leicester Gallery in 1905, commented: '. . . he is, unlike most men who deal with sporting subjects, an artist of taste and skill.' During World War I, Armour served as Lieutenant-Colonel in the Dardanelles and Salonika, and after the war, he settled for many years in Wiltshire. **Robert Alexander** (1840–1923) should also be mentioned in this context, as a close friend and admirer of Crawhall and as the father of Edwin Alexander. Born in Ayrshire, he established a reputation in Edinburgh as a painter of rather sentimental oils of domestic and farm animals. His trip to Tangiers with Crawhall and his son changed his outlook and he began to work in watercolours, with a 'wet' technique and a fluent style, as revealed in *Donkeys in Front of an Arab Tent, Tangiers* (fig. 59).

There is no hard and fast categorization of membership of the Glasgow School; although David Martin's list of 21 painters is fairly accurate, despite the surprising omission of Arthur Melville and the inclusion of George Pirie who was never closely linked with the Group. Of this list the main watercolourists have been discussed, leaving one group who worked primarily in oils but also produced some interesting watercolours, and a further group who rarely worked in the medium. Of the latter, James Guthrie should be mentioned; a central member of the Group. He worked in oils and was a fine pastelist, but he did not use watercolour. Likewise John Lavery rarely used watercolour, the exception being a group of watercolours painted in 1885. E. A. Hornel, David Gauld, William Kennedy and J. E. Christie were essentially oil painters, as were Stuart Park, the flower painter, and Alexander Roche. Other members of the Group did produce some watercolours and were elected to the RSW probably as much for prestige as for their occasional watercolour. **Robert Macaulay Stevenson** (1854–1952) was known for his evocative oils depicting rivers and trees at dusk or in moonlight. His rich impasto and reliance upon the effects of oil paint did not suggest that he could be a successful watercolourist, but he was elected to the RSW in 1906, on the strength of his rich, sonorous watercolours, small in scale. He chose similar subjects as for his oils – trees at dusk with the setting sun or moon behind; figures around a camp fire at night or dark river scenes.

Grosvenor Thomas (1856–1923) also produced some richly coloured nocturnal landscapes in watercolour. **James Whitelaw Hamilton** (1860–1932) is primarily known for his canvases, but he also worked in pastel and watercolour. His best watercolours have subtle tones and an almost Whistlerian delicacy, especially in his nocturnal views or pastoral scenes. He also produced a number of chalk and body-colour drawings of landscapes in Scotland and Yorkshire.

William York MacGregor (1855–1923) played an important part in

the development of the Glasgow School, producing significant oils such as *The Vegetable Stall* of 1884. At that period he appears to have worked only in oils but on his return from an extended visit to South Africa from 1888 to 1890, he turned more towards watercolour as a medium. His style is powerful and individual, quite unlike either the 'blottesque' Glasgow style or the more draughtsmanlike approach of Crawhall. Using strong black charcoal outlines, he created a powerful framework for watercolour washes, producing a strong sense of design rather than atmospheric effects. Kirkcaldy Art Gallery has two of these large and powerful watercolours – *Chepstow Castle* and *Arques la Bataille* in which MacGregor creates patterns of strongly drawn trees and rooftops behind. At times rather lifeless and even grim, the watercolours of William York MacGregor nevertheless look forward to some watercolourists of the 1920s.

Of the four remaining artists in Martin's book, neither Harrington Mann nor Corsan Morton need be discussed in detail. Both produced some watercolours, but they tend to be rather heavy. On the other hand, the work of D. Y. Cameron and T. M. Dow deserves attention. Although **Sir David Young Cameron** (1865–1945) was Glasgow born and trained, and although he knew the Glasgow Boys, his work stands outside the mainstream of the Glasgow School. He was less interested in the decorative aspects of painting than many of his contemporaries, and he appears to have been unaffected by many of the influences which helped to form the Glasgow style. It is possible that his interest in etching helped to put Cameron's work apart – with Strang he was the leading etcher of this period in Scotland – an interest which encouraged him to draw both accurately and factually. His personality also placed him apart from many of his contemporaries – a quiet, intellectual man, the son of a clergyman, he was himself a keen churchman and, like Dyce, was interested in church music and ceremony. He studied at the Academy in Edinburgh and finally settled at Kippen in Stirlingshire. From 1924–1933 Cameron was Limner to Scotland, acquiring the knighthood which normally accompanies this post. Cameron's watercolours are based upon a careful pencil or ink framework; his sense of line is highly developed – at times powerful and dynamic; at other times delicate and sensitive. Cameron knew instinctively what to exclude and his watercolours are uncluttered and direct, having an economy and delicacy of line not unlike that of David Roberts. Many of his watercolours depict the hills and mountains of Scotland, with a loch or river in the foreground. He rarely accentuates the drama of the mountains, preferring to depict from a distance in a cool, unemotional way. His colours, although restrained, have magic as in *Hills and River at Claunie* (BM) in which he captures rich autumnal browns, beiges and purples, or *Winter in Menleith* (BM) in which a primrose yellow foreground with a light blue river is set against purple trees and light mountains in the background. There is often a sense of loneliness in Cameron's work – he rarely portrays people and his landscapes are usually devoid of signs of human habitation such as

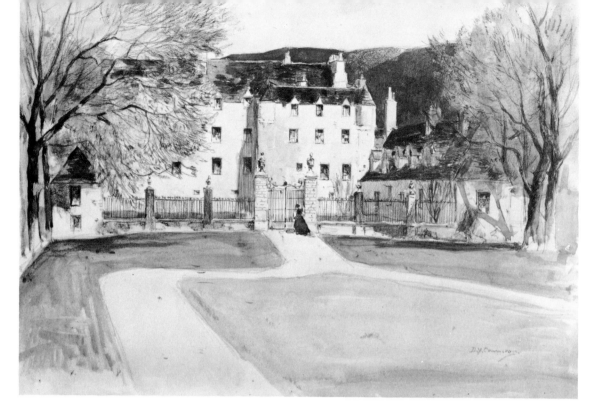

60 Sir David Young Cameron, *Traquair House* $10\frac{1}{2} \times 14\frac{1}{2}$ Fine Art Society

crofts or farmhouses. There is, it is true, an element of repetition in Cameron's watercolours. His subjects and their format are often similar, but there is nevertheless a refinement of line and colour which is most satisfying. He was also a fine architectural draughtsman and produced drawings of buildings in Scotland, France and Italy (fig. 60).

Thomas Millie Dow (1848–1919), although associated with the 'Glasgow Boys', produced watercolours which have little in common with the 'blottesque' or the linear style of the group. Born in Fife, he began to study law in Edinburgh before going to Paris to study art. From the 1880s he began exhibiting at the Glasgow Institute and was based in Glasgow between 1887 and 1895, when he moved to St Ives in Cornwall. A keen traveller, he spent winters in Canada, Italy and Tangiers, painting landscapes and some portraits. His watercolours are closely related to his oils in technique, subject matter and colour; and he was known for his watercolour studies of flowers painted in transparent washes but with care for their details and structure. His landscapes are more imaginative and subjective than most of the Glasgow School painters, with a stillness and dream-like quality which suggest a knowledge of Puvis de Chavannes.

> Mr Dow is not occupied with the topographical facts of landscape, except for his own purposes of design, but each picture portrays some exquisitely seen scheme of colour and effect, some opalescent morning, some evening of amber and gold, some twilight of shimmering blues and violets.[16]

Dow's close association with William Stott of Oldham is evident in his oils and pastels, but his watercolours with their flat washes, decorative construction and soft colours are both original and personal.

Many artists, while not being part of the Glasgow School itself, were influenced by its watercolour technique. The wet 'blottesque' style, in particular, had many adherents some of whom used the method with great skill and understanding, while others concealed their lack of draughtsmanship and composition behind a façade of colourful 'blobs' and wet washes. The influence of the Hague School is evident in many Scottish watercolours of the 1880s and 1890s. **Robert McGown Coventry** (1855–1914), who was closely associated with much of Glasgow's artistic activity throughout his life, had taken evening classes at the Art School under Robert Greenlees before studying in Paris under Bouguereau and Fleury. He painted in both oils and watercolour, often choosing subjects which included waterways, boats or quayside views; although he did paint the occasional Highland landscape. Coventry enjoyed the bustle of everyday life, and most of his works have a number of figures painted in a rather 'dumpy' style similar to that of Robert Allan. He worked much in Holland and Belgium, painting market and fishing scenes, and views of Dordrecht and Amsterdam appeared regularly in the RSW, while in the 1890s he made a trip to the Middle East. His watercolour style is fluent and 'wet' with carefully judged 'blobs' of colour contrasting with larger areas of simple washes. A subtle colourist, he occasionally surprises with touches of strong colour. His best works show an original sense of composition as *Kircaldy* reveals (fig. 61).

John Terris (1865–1914) was born in Glasgow, but his family moved to Birmingham in about 1880, where he studied at Birmingham School of Landscape Art. At the age of 26, Terris was elected to the RSW, as a result of his total dedication to watercolour painting, which

61 Robert McGown Coventry, *Kirkcaldy* $11\frac{1}{2} \times 19\frac{1}{2}$ Private collection

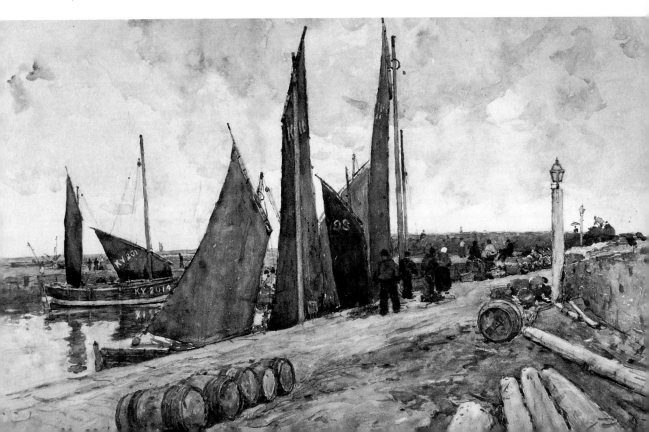

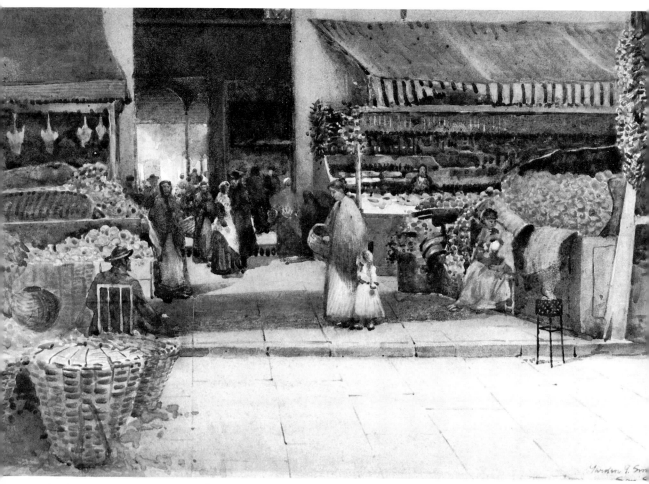

62 Garden Grant Smith,
The Market, San Sebastian
14 × 20 Private collection

he pursued in Scotland, England, France and Holland. Many of his watercolours are large with an almost square-brush approach, which creates a bold, yet decorative effect. He particularly enjoyed the effects of dark buildings and boats against a sunset sky, creating dramatic contrasts of colour. The size of many of his watercolours leads to inconsistency of quality, but at their best, they represent an interesting aspect of the Glasgow School. His early death in 1914, aged 49, deprived the Society of one of its most dedicated landscape artists.

Alexander Nisbet Paterson (1862–1947) was the younger brother of James Paterson and although an architect by profession, he produced some fine watercolours. Like his brother, he studied in Paris and throughout his life he painted in watercolour, becoming a member of the RSW. At times his work resembles that of his brother in colour, technique and even subject matter, in particular his watercolours of Teneriffe, but in other works his technique is softer, with more rubbing of a rougher paper, and the overall effect is more romantic. He often chose views with architectural subjects and had a particular love of France, as well as the Highlands.

Garden Grant Smith (1860–1913), an Aberdeen artist, should be mentioned as an artist greatly influenced by Melville who nevertheless achieved a style of his own. A dedicated traveller, he painted water-colours in North Africa, Spain and Southern France. Unlike Hans Hansen, whose pastiches of Melville's Middle Eastern views are often crude in colour and poor in draughtsmanship, Smith's watercolours have individuality and charm. His colour might lack Melville's sparkle, but he had an eye both for detail and intricate composition (fig. 62).

William Fulton Brown (1873–1905), who died at the early age of 32, should also be mentioned as a Glasgow watercolourist of great promise. He was the nephew of **David Fulton** (1848–1930), a Glasgow painter who worked both in oils and watercolours, the latter often being successful sun-dappled landscapes with figures beneath trees or by rivers. William Fulton Brown studied under his uncle and at Glasgow School of Art. He specialized in costume and character pieces, also producing some highly competent 'swish' portraits in watercolour, no doubt influenced by Sargent. He painted, too, a series of high-summer landscapes with rich foliage, in a full 'wet' style, with considerable attention to detail without ever becoming laboured. *Woodland Scene* (fig. 63) shows Fulton Brown's mastery of the 'wet' Glasgow watercolour technique, and we can only speculate as to what he might have achieved with maturity.

James Watterston Herald (1859–1914) is among the most fascinating Scottish watercolourists, an exceptionally talented artist whose progressive alcholism led not only to an early death, but also to an inconsistent and ultimately repetitive output. Born in 1859 in Forfar, the son of a shoemaker, he attended school in Dundee, returning to Forfar as an apprentice housepainter and then clerk in a local textile mill. His parents soon realized that his only talent lay in art and gave up their objections to his pursuit of painting as a career. In 1884 his family moved to Edinburgh, but instead of joining the RSA Schools, Herald painted views of Edinburgh, in particular tenement blocks and grey views of roofscapes. His only formal training came when he spent a period at Hubert von Herkomer's school in Bushey, Hertfordshire where he came across William Nicholson and James Pryde. Pryde's use of pastel on brown paper influenced Herald, and he continued to use this technique as an alternative to watercolour for many years. It is also possible that he met Arthur Melville at Bushey and was deeply influenced both by Melville's technique and his subject matter. Although Herald never went abroad he painted several Eastern subjects which were probably borrowed from Melville (fig. 64).

During the 1890s Herald lived happily in Croydon. During this period he worked hard and had considerable success in selling his work. He held at least one exhibition in London in the 1890s and found several patrons, one of whom, a wealthy solicitor named Horace Pym, bought a large number of his watercolours and invited him regularly to his country house near Sevenoaks. Had Herald remained in London he might have achieved financial success, but in 1901 he returned to

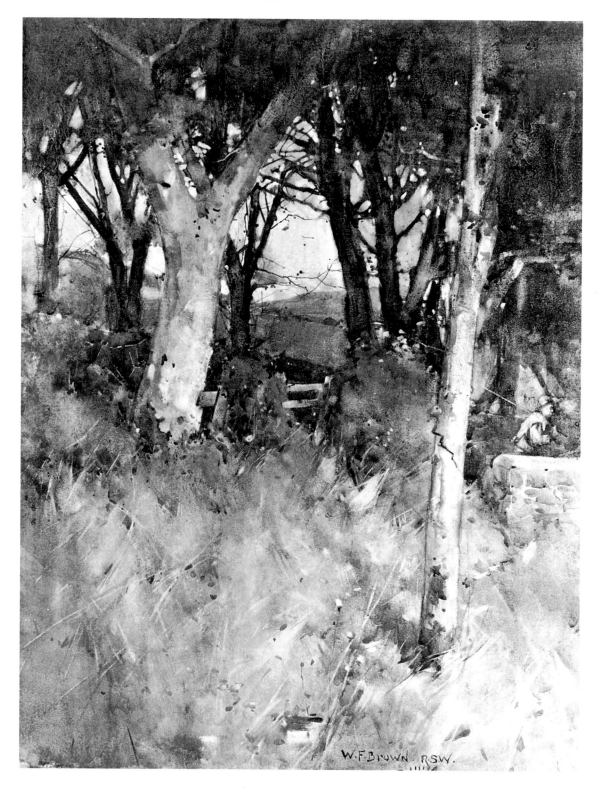

Arbroath, apparently with the intention of a short visit, for he kept his studio in Croydon. He was not to return to the south, and progressive drinking combined with artistic isolation in Arbroath made it virtually impossible for him to achieve eminence as an artist. His Bohemian ways were already apparent on his return to Arbroath in 1901. A colleague, Henry Wyse, art master at Arbroath High School, wrote;

> I went to Arbroath railway station to meet the evening Aberdeen express from King's Cross bringing back James to his native country. When the train pulled up, out he stepped, a small stocky man, in one hand an old cigar box containing pastels, his entire luggage.[17]

Herald held two exhibitions in London after his return to Scotland, both at the Baillie Gallery, an important gallery for contemporary artists, in 1910 and 1912. The first was successful and the art critic of *The Connoisseur* wrote:

> ... a new artistic star, of whom many nice things have been said by the critics, showed much individuality in his ... watercolours and pastels. He has an eye for colour and tone, and, while sufficiently realistic, his outlook on Nature is dominated by her decorative aspects.

The second exhibition, however, sold badly and Herald became depressed and disillusioned. Already isolated from artistic circles in Glasgow and Edinburgh, he continued to paint views around Arbroath and Forfar with little concern for his public. On his early death in 1914 of cirrhosis of the liver, the local newspaper wrote:

> His unassuming disposition and innate modesty prevented him from putting himself forward in any capacity. He coveted no distinction and was content to earn no more than his daily bread.[18]

Although Herald's style was influenced by Melville he was not simply a follower of Melville, for Herald achieved a highly individual and unusual style which stemmed from his eccentric and isolated way of life.

> He lived in a dream world of his own ... his works the outcome of his inner musings.[19]

Thus he used the 'blottesque' technique to create highly subjective works which contrast strongly with the essentially objective nature of the Glasgow School. Herald had a wide range of subjects, although one of his favourites was seaside towns – Arbroath, Hastings, Auchmithie. He loved to capture the patterns created by fishing boats' sails and rigging set against cloudy skies. He was interested in colour for its own sake rather than in direct observation of nature, as some colour notes suggest:

> yellow sundown sky reflected in water; houses and shipping tones of black – sepia and purple black, relieved by touches of green and red.

Arbroath in particular features in his work, the streets leading to the harbour, or ships in port. At times his sense of pattern suggests a

63 William Fulton Brown, *Woodland Scene* 1894 $19\frac{1}{2} \times 15\frac{1}{2}$ Glasgow Art Gallery

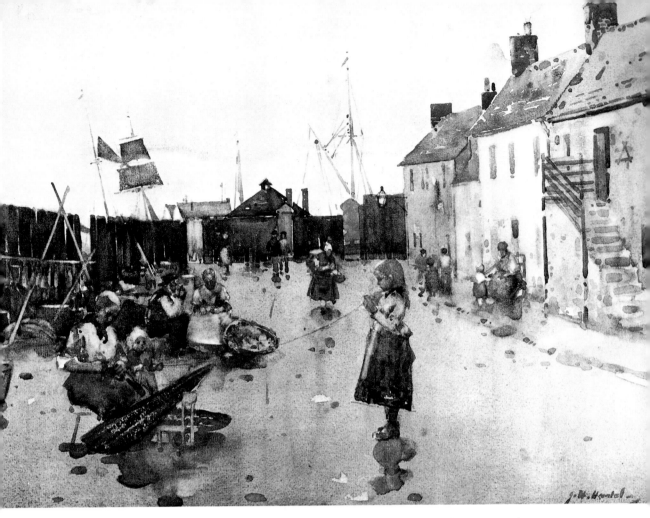

64 James Watterston Herald, *Old Shore Head, Arbroath* 1889
$13\frac{1}{8} \times 18$ Dundee City Art Galleries and Museums

knowledge of Japanese prints, while in other watercolours we see experiments with different coloured papers and varied textures. He also enjoyed town scenes. In the 1890s London features in many of his watercolours with magical views of elegant figures on wet pavements in front of buildings, figures walking in a park towards dusk, or a street party. Herald was also able to capture the play of sunlight through trees and produced a number of views of figures in orchards often executed in pastels on coloured paper. A very different aspect of Herald's work is revealed in *The Saint* (VAM) in which he enters the realms of religious mysticism. This theme is reflected in other watercolours and pastel drawings depicting Mephistopheles and single saint-like figures. Unfortunately the quality of Herald's work varies considerably. His sketchbooks show that he was a draughtsman of skill – elegantly dressed women drawn in a French *fin-de-siècle* style appear alongside designs close to the Beggarstaff Brothers – but at times, especially in his later years, his handling of watercolour became somewhat loose and unstructured, and the colours tend towards repetitive shades of browns.

One of the most extraordinary artists working in Glasgow at this time was **John Quinton Pringle** (1864–1925). Born in the East End

of Glasgow he opened an optical and general repair shop at 90 Salt-market in 1896 and remained there until his retirement in 1923. Be-tween 1885 and 1896 Pringle attended evening classes at the Glasgow School of Art where Fra Newbery quickly recognized his talent and regretted that Pringle never devoted himself full-time to painting:

> My one regret, and it is a deep and lasting one, is that he absolutely refused to abandon his daily trade work.[20]

Pringle, however, refused to abandon his business and to become de-pendent upon selling his pictures to survive. His shop became a meet-ing point for artists and friends of Pringle, who painted at weekends and after hours. Professor Sir Denis Brogan has described Pringle's shop:

> It was a rendezvous for many people who came to talk to Johnny Pringle....
> It was probably not only the worst run shop in Glasgow, but perhaps the worst run shop in Europe. It was hard to pay Pringle anything and he always undercharged; but it was also hard to get anything out of him if you had committed it for repair.[21]

Pringle's life was uneventful. In 1910 he made his only trip abroad, staying in Caudebec in Normandy, and several paintings relate to this visit. From 1911 to 1920 he worked entirely in watercolours, but re-turned to oils during his later years. Despite his small output, Pringle was admired during his lifetime both by artists and, after his only one-man exhibition in 1922, by the public. In 1914 he was represented at an important exhibition *Twentieth Century Art: A Review of Modern Movements* at the Whitechapel Art Gallery, an exhibition which in-cluded works by Sickert, Stanley Spencer, Wyndham Lewis and Paul Nash. His three exhibits included a watercolour of Hampstead Heath and a miniature painted in watercolour on ivorine, a technique which he particularly enjoyed. It seems likely that his former teacher, Fra Newbery, had ensured a place for his work in this exhibition. In 1919 he met Hunter and Peploe who were both impressed by his work, and in 1922 his one-man exhibition was held at Glasgow School of Art, organized by his friends William Somerville Shanks and Andrew Law. The exhibition was praised by the critics and in the following year, partly as a result of ill-health and partly in response to the encourage-ment of his friends to paint full-time, he sold his business and moved to Ardersier in Inverness-shire. He had visited Whalsay in the Shet-lands in 1921 and he returned there for a final painting trip in 1924. He died of cancer of the liver in the following April.

The watercolours and oils of Pringle are unlike those of any other Glasgow artist of the period, although he was influenced by his con-temporaries. In particular the use of the square-brush technique, as developed by Bastien-Lepage, Guthrie and Hornel, was important both to Pringle's watercolours and oils, but he uses the technique in a highly individual and original way. Whereas his earlier watercolours and oils are somewhat heavy and wooden, his work from the mid-1890s be-comes colourful, delicate and individual with small touches of almost prismatic colours – greens, blues, purples and reds. His watercolours

combine a square-brush method with the 'blottesque' technique of the Glasgow School and Pringle creates a highly personal, even whimsical, tapestry of colour. His favourite subjects are figures, often young girls, in a landscape painted in an ethereal style, and he also painted portraits in watercolour as well as on ivorine in miniature. While he was aware of the need to keep watercolours simple, he nevertheless devoted much time to each work, achieving freshness through calculation rather than through spontaneity. In a letter to James Meldrum written in 1924 from Whalsay he said:

> I have been working on four small watercolours most of the time and just feel at times that I have not kept them simple enough but one learns by taking care and I have not tired while working weeks on them...[22]

Some mention should be made of those Glasgow artists who specialized in views of the Clyde and the west coast and who are linked together by Caw in a chapter entitled *Pictures of the Sea*. The leading painter of the Clyde was **James Kay** (1858–1942) who was brought up in Arran and studied at Glasgow School of Art. He was close to members of the Glasgow School although his work lacks the decorative and design elements found in both the watercolours and oils of 'The Boys'. Kay shared a studio for a time with David Gauld and Stuart Park and was a well known figure in Glasgow Art Club. He loved the bustle of the Clyde with its frequent steamers and ferries, its docks and cranes, and although he painted some river scenes in Brittany and Normandy, views of the Thames and the fishing villages of the west coast, he returned inevitably to the drama of the Clyde. His watercolours are powerful rather than beautiful, with dramatic clouds and strong contrasts of light and shade, worked with a mixture of pastels, gouache and watercolour on paper of differing colours. **Patrick Downie** (1854–1945) was also a painter of the Clyde, born in Greenock and for many years a resident of Glasgow. His watercolours lack the drama and power of James Kay, capturing instead the sparkling effects of light on the water with the distant peaks of Arran behind. Like Kay, Patrick Downie was knowledgeable about the vast variety of steam and sailing vessels on the Clyde, and his watercolours are accurate in their details, enabling the viewer to identify the actual type of fishing boat (fig. 65) or class of steamer.

Charles James Lauder (1841–1920) was also a Glasgow artist, although he worked extensively abroad. He was a particularly elegant draughtsman, with an ability to paint townscapes in watercolour. He lived in Glasgow and painted views of the Clyde, but he also travelled extensively, painting the Thames, the Seine and the Italian towns of the Sorrento peninsula. His watercolours are executed with great panache, for not only was he a proficient draughtsman, but he also had a feel for the textures and effects of watercolour. **Robert Clouston Young** (1860–1929) worked mainly on the Clyde and in the villages around the Firth of Clyde, painting seascapes which capture different weather and cloud effects. His colours and technique flow freely, pro-

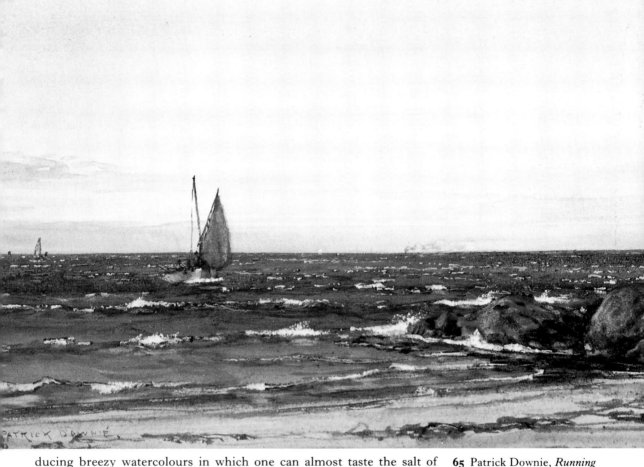

ducing breezy watercolours in which one can almost taste the salt of
Kilbrannan Sound. He also painted children shrimping or fishing by
the sea or by country streams. Not a great artist, he is nevertheless an
example of the consistent quality which even quite minor Glasgow
watercolourists of the period were achieving. **James Garden Laing**
(1852–1915) should also be mentioned in this context. Born in Aber-
deen he trained and practised as an architect for many years before
settling in Glasgow as an artist. Working much in Holland, he came
under the influence of the Dutch School and his best work, his coastal
and marine views, reveal the influence of Maris, Weissenbruch and
Roelofs, in their 'wet' technique and restrained colours. He shows a
preference for subtle browns, ochres, and greens highlighted with body-
colour. Laing painted fishing villages with fishermen at work collect-
ing the catch or mending nets, river scenes or views of Dutch canals,
or bustling market places. As an architect he was also attracted to
cathedral or church interiors, but these watercolours often lack the
sparkle of his marine views. **Andrew Black** (1850–1916), **James Mac-
Master** (1856–1913) and **James McNiven** (died 1895), all worked in
a style similar to that of Clouston Young, with a 'wet' technique, often
depicting coastal and fishing scenes.

The watercolours of **Robert Little** (1855–1944), once quite popular,

have fallen into obscurity. Born in Greenock, the son of a wealthy Glasgow shipping merchant, he studied at the RSA Schools. His father encouraged him to study abroad, and he spent 1882 at the British Academy in Rome and 1886 in Paris working under Courtois and Dagnan-Bouveret. As a child he had travelled with his father visiting Europe, Egypt, Palestine and Turkey and had acquired a taste for the Mediterranean coastline. His early work is tight and influenced by Pre-Raphaelitism, but he soon turned towards a broader, 'wetter' style in which he established lively rhythms in the clouds and foliage, producing bold effects. Some of his large Scottish landscapes appear empty and unresolved, and his more successful watercolours are intimate views of Italian hill towns or French villages, painted in a softer, almost romantic style.

The watercolours of **William Wells** (1872–1923) stand outside the mainstream of the Glasgow School, as does Wells's own career. Born in Glasgow, he studied at the Slade before moving to Sydney, Australia where he lived and worked for five years. He returned to Europe and worked for a time in Paris and rural France where he acquired an admiration for the Barbizon School with its rich tones and glowing colours. He returned briefly to Glasgow before working as a scene painter in Preston, Lancashire, for seven years. He finally settled in Appledore, Devon where he lived and painted until his early death at the age of 51. Wells's watercolours have a particular quality which cannot be found in his contemporaries' work. Using a rough paper, he constructs a framework of charcoal and deep grey washes, into which he adds rich colours in watercolour and pastel. The effects are romantic and even ethereal despite the overall darkness of the watercolour. He was particularly good at figures in gardens or streets or farmbuildings seen at dusk, and although his output was small, his watercolours are memorable (fig. 66).

The late nineteenth century represents a high point in Scottish watercolour painting, not only in the quality of the masters of the period such as Crawhall or Melville, but also in the wealth of talent shown even by numerous lesser artists. Some were directly influenced by the 'Glasgow Boys', while others took their place in the progression of a looser style which had begun in the 1870s. The RSA, RSW and the Glasgow Institute all mounted annual exhibitions, while there were exhibiting societies in most of the larger towns, including Perth, Stirling and Dundee, as well as in many smaller towns. Most of the leading artists in Glasgow and Edinburgh submitted to these societies where their work mingled with local artists, both professional and amateur, thus quickly spreading the influence of the new watercolour techniques. The artists discussed in this section were connected more with Edinburgh than with Glasgow.

The watercolours of **Tom Scott** (1854–1927) have always had a considerable following. Born in Selkirk, the son of a tailor, he began painting in watercolours as a child and remained faithful to the medium all his life, working exclusively in watercolour. He was essentially self-

66 William Page Atkinson Wells, *Peggy Bowker* 10 × 10¾ City of Edinburgh Art Collection

taught and when in 1877 he joined the Trustees' Academy he was already a proficient watercolourist. Sam Bough can be considered as Scott's principal influence, having encouraged him and introduced him to the watercolours of Cox, Muller, Constable and Fred Walker. Scott was an interesting man: he assembled a large collection of archaeological relics, including knives, arrow-heads and axes, and was an authority on local archaeology. He was also interested in the classical past, making studies on site while visiting Rome and other Italian towns. Scott gained a considerable reputation even in his own lifetime and has remained one of the most popular landscape watercolourists of Scotland. Much of his work was based on the Borders, where he painted the richly coloured hills and valleys in an intimate, and yet

intense, style. He achieves great depth of colour with rich blues, browns and greens in the foreground set off by luminous skies. He had a feeling for the seasons and weather conditions which give his water-colours, even his small works, authenticity and presence. At times he paints figures working in winter fields with patches of snow, deep purple distances and a clear, cold sky; at other times he captures the richness of full summer, with deep green foliage and warm, if cloudy, skies. His intimate knowledge of the Borders and their litera-ture, in particular Sir Walter Scott, gives his watercolours conviction and intensity. Although he worked in other areas of Scotland, includ-ing Caithness and the Shetlands, as well as in Italy, North Africa and Holland, his most memorable watercolours are of the Borders (fig. 67).

The watercolours of **Robert Buchan Nisbet** (1857–1942) have much in common with those of Tom Scott. Both artists were primarily devoted to watercolour, both painted landscapes and scenes from rural life, and both were appreciated during their lifetime. Nisbet was born in Edinburgh and studied at the RSA Schools being influenced by Sam Bough and the English tradition of Cox, Girtin and de Wint. After leaving the RSA Schools, Nisbet worked for a time in both oils and watercolour, but he soon abandoned oils. He settled in Crieff, work-ing in Perthshire and on the east coast. His best watercolours are his small landscapes in which he achieves rich, sonorous tones which radiate light. His sunset views are particularly striking and suggest some knowledge of the Barbizon School just as his watercolour tech-nique reveals an influence from the Dutch School. His larger water-colours are often less successful than his smaller works, and for these he adopted a technique of rubbing and scrubbing, often destroying the bloom of the paper and thereby losing the transparency of the medium.

John Campbell Mitchell (1862–1922) is known for his landscapes and seascapes in oils but he was also a watercolourist of some merit, although it was not a medium that he used frequently. Born in Camp-beltown, he studied at the RSA Schools and settled in Edinburgh where he remained throughout his life. He painted wide expanses of moorland and rolling countryside seen under changeable skies – some areas are bathed in strong sunlight, while others turn to shades of blue and purple as the clouds obscure the sun. He also painted by the sea with great expanses of sands seen in the afternoon light.

Sir David Murray (1849–1933), like J. Campbell Mitchell, is known for his landscapes in oils, but he was, particularly as a younger man, a fine watercolourist. Born in Glasgow, he attended Glasgow School of Art under Robert Greenlees, who did much to encourage younger artists. Greenlees's meticulous style influenced Murray, whose early work shows great concern for detail and precision. As a young man, Murray visited France and the watercolours from these French trips are amongst his best work in the medium. *Roadside in Picardy* (for-merly Fine Art Society) dated 1865 is a good example of his detailed

67 Tom Scott, *The Border Hunt*
$24\frac{1}{2} \times 18\frac{1}{2}$ Fine Art Society

yet delicately handled French watercolours, with fresh colour and no evidence of overworking. In 1883 Murray moved to London and to a successful career as an 'Establishment' artist. He was elected Royal Academician in 1905 and President of the Royal Institute of Water-colour Painters, being knighted in the following year. The quality of his work, like that of George Henry, whose career followed a similar pattern, declined and his later watercolours are less convincing, with much use of bodycolour, laboured details and metallic colours. His adoption of tempera for larger works seems to have damaged his earlier fresh watercolour technique.

The career of **Sir James Lawton Wingate** (1846–1924) as a water-colourist is not unlike that of Sir David Murray – as a young man he painted some exquisite, detailed and delicate watercolours, but later in life he worked almost entirely in oils. Born in Kelvinhaugh near Glasgow he entered business before realizing that art was his true *métier*. In 1876 he spent a year in Italy devoted entirely to painting and, according to a later article in *The Studio*,[23] he produced some 150 watercolours during that year. On his return to Scotland he lived for five years in Hamilton painting Cadzow Forest, again working in watercolour in a detailed yet charming manner. He later moved to Edinburgh to study, as a mature student, at the RSA Schools, and it was there in 1873 that he met Hugh Cameron, who argued that his work was too literal:

> I feel the work to be wrong, and art is not an affair of argument; it is an affair of feeling.[23]

From the mid-1870s onwards, Wingate's style developed breadth and detail was replaced by atmospheric effects. Wingate's later oils are most effective, especially his beach scenes with their great expanses of sky, but by the late 1870s he had ceased working in watercolour.

The watercolours of **Robert Gemmell Hutchison** (1855–1936) have some of the *pleinair* freshness found in Wingate's oils. Born in Edinburgh, he studied at the RSA Schools and was influenced by the genre paintings of the Dutch School and the Faeds. Apart from his genre watercolours, mentioned in Chapter Three, he also produced breezy beach scenes with children playing by the sea or amongst the sand-dunes. He was influenced by McTaggart who had more effect upon his art than contemporary developments in Glasgow, and his best watercolours capture the exhilaration of the seaside on a windy summer's day (fig. 68).

Emily Paterson (1855–1934) produced some fine watercolours in a style which was influenced by the Glasgow School, although she had no direct contact with the 'Glasgow Boys'. Born in Edinburgh of Ayrshire parents she studied in Edinburgh where she remained until after World War I. She worked mostly in watercolour choosing subjects from abroad – Holland, Venice, France and the Swiss Alps. She was a person of great character and a keen Alpinist, undertaking long walking expeditions in the Alps and the Tyrol, usually followed by an exhibition at London's Alpine Club Gallery. She became well known in London

68 Robert Gemmell Hutchison, *Sunlight and Shadow – The artist's daughter*
$10\frac{1}{2} \times 8\frac{1}{2}$ Bourne Fine Art

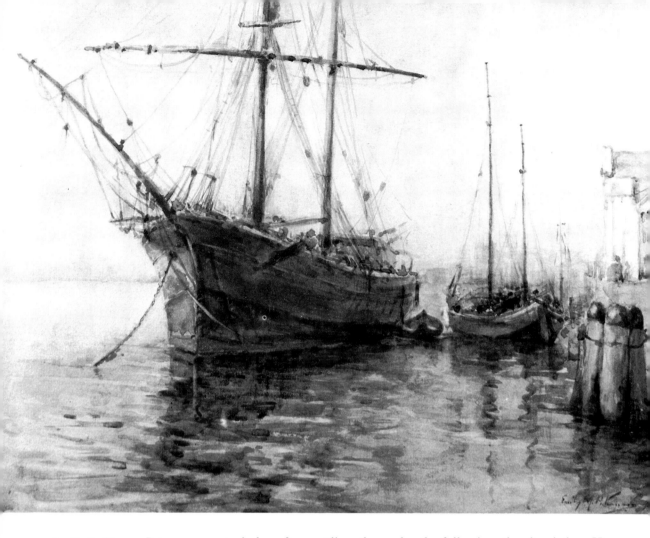

69 Emily Murray Paterson,
Venice
10 × 13¼ Private collection

art circles after settling there shortly following the Armistice. Her watercolours are effective and constant in their quality, using the 'wet' technique which suited her love of water and snow subjects, and often having bodycolour mixed in to vary the textures. Her luminous studies in the Bernese Oberland and her sparkling views of Venice often incorporate unusual and striking colour combinations (fig. 69).

Thomas Marjoribanks Hay (1862–1921) was an Edinburgh-based artist who worked extensively in watercolours, and was particularly good at creating atmospheric effects in landscape painted in a 'wet' and fluent style. Hay's earlier works have a precision which suggests some Pre-Raphaelite influence, but he soon broadened his style. He worked on the east coast painting views of fishing villages, in Perthshire and the Central Highlands. He enjoyed hills and mountains shrouded in clouds or mist, which he painted in a palette of restrained colours. While many of his watercolours are successful, he also produced some 'pot-boilers' in which the drawing and the technique are weak. A close friend of Hay was **James Douglas** (1858–1911), a Dundee artist, who also worked extensively in watercolour. His style is fresh and loose, not unlike that of his friend although his palette is lighter and more colour-

ful. He was more influenced by the 'blottesque' style than Hay and several of his views of figures in orchards or under trees are based upon an effective use of this technique.

Henry Wright Kerr (1857–1936) was known for his watercolour portraits which often show a combination of technical virtuosity and close observation. Born in Edinburgh, he studied at the RSA Schools but his main influence came from the Dutch School which he first seriously studied on a sketching trip to Holland. The watercolour technique of Israels, Mauve and Maris and their subject matter – studies of peasants, figures by the sea and church interiors – was a more important influence than the Glasgow School. He painted portraits of Scottish fishermen, crofters and elderly ladies in a loose 'wet' technique, often with touches of rich colour, and always creating a sense of life. He also painted scenes of Scottish life such as church interiors and rural views with crofters at work. Popular during his lifetime, he was elected to the RSA and RSW, and his work in Ireland earned him a reputation as a successor to Erskine Nicol, although his many studies of Scottish people would suggest that he was really a successor to Kenneth Macleay.

James Cadenhead (1858–1927) was an Aberdeen artist, although he lived for most of his life in Edinburgh. He studied at the RSA Schools and in Paris under Carolus Duran. His main artistic influence came not from Glasgow, but from Whistler and the Aesthetic Movement in London, where Cadenhead was a founder member of the New English Art Club in 1886. He worked in the area around Edinburgh and in the Grampians, painting richly coloured watercolours in which a strong sense of decorative pattern emerges. He enjoyed the effects of twilight, and a romantic and mystical feeling emerges from his carefully arranged landscapes. At times he worked on a very large scale, as can be seen in the huge *Moorland* (fig. 70) in Edinburgh City Art Collection.

The chapter concludes with two highly successful animal and bird painters, who, while possibly lacking the brilliance of Crawhall and Alexander, both achieved acclaim during their lifetime and both produced a substantial volume of work.

Archibald Thorburn (1860–1935) was born in Edinburgh, the son of a miniaturist who worked for Queen Victoria. His father taught him to paint and observe nature, and Thorburn first exhibited at the Royal Scottish Academy aged 10. During the 1880s Thorburn's reputation grew fast with a number of successful publications, culminating in the appearance of Lord Lilford of Northampton's *Coloured Figures of the Birds of the British Islands* (1888) in which 268 out of the 421 plates were Thorburn's. He continued to illustrate books and his *British Birds* which first appeared in 1915–16 met with huge popularity. Like many successful Scottish artists Thorburn was drawn to London where he settled in 1885, moving to a country house at Hascombe near Godalming in 1902. Here he lived a peaceful life, returning each year to Scotland to refresh his memory and obtain working drawings, which

70 James Cadenhead,
Moorland
$44\frac{1}{2} \times 54$ (on parchment)
Edinburgh City Art
Collection

he worked up into full-scale watercolours in his studio. He was particularly attracted to the Forest of Gaick in Inverness-shire in all seasons. Thorburn rarely worked in oils, as he preferred the delicacy of watercolour for plumage and finer details. Nevertheless, his highly finished watercolours often have the appearance of oils – he made extensive use of Chinese White and many are painted on a large scale.

Thorburn's watercolours have a large following today as they did in his lifetime, and they fetch considerable sums in the salerooms. His observation and concern for detail is extraordinary, as was his knowledge as a naturalist. His compositions are pictorially successful with a happy combination of bird, plant and landscape. The landscape ele-

ment is often remarkable with freely drawn grasses and flowers which capture the colours as accurately as the form, and are also highly sensitive to seasonal differences. Some of Thorburn's watercolours of ptarmigan in winter plumage seen in a snow landscape are outstanding for the subtleties of colour and tonal values. Although he is best known for his birds, Thorburn produced some fine watercolours of deer, stags and other Highland animals. His sketchbooks show his ability to draw freely in watercolour from life, and for those who find his finished watercolours somewhat over-complete, his sketches with their 'wet' and fresh washes combined with subtle drawing are an interesting alternative.

The long and active life of **William Walls** (1860–1942) spans two periods of Scottish watercolours. He was influenced in his earlier career by Joseph Crawhall and Edwin Alexander who became his brother-in-law, and in later years he was a respected teacher at Edinburgh College of Art, seeing many of the new artistic generation emerging in the 1920s and '30s. Born in Dunfermline, Walls studied at the RSA Life Schools and later, in the 1880s, at Antwerp Academy. While in Antwerp he began to draw in the Zoological Gardens becoming known, on his return to Edinburgh, as an animal painter. He worked both in oils and watercolours having an economy of line and simplicity similar to those of Edwin Alexander. He also tended to use tinted and often rough paper, creating highlights with bodycolour. At times he leaves his watercolours comparatively unfinished, but nevertheless showing complete understanding of animal physiognomy. In other watercolours he achieves a far greater finish with rich colouring and close attention to detail. He often worked in Hamburg and London Zoos and was one of the founders of Edinburgh's Zoo which was established near his home in Corstorphine. Many of his watercolours are concerned with zoo animals such as lions, tigers and jaguars. Walls was also a good landscape painter in watercolours. Throughout his life he carried sketchpads with him and recorded views while on holiday or even while travelling in the train. Done with verve, these landscapes are fresh in colour and technique and show his ability as a draughtsman.[24]

8 Art Nouveau and Symbolist watercolours

During the last decade of the nineteenth century there developed a strong reaction to the materialism which had predominated since the 1850s. The realism of Bastien-Lepage, with its following throughout Europe, was challenged by an inward-looking, unworldly, even obsessional, art. The Glasgow School had been largely concerned with its immediate surroundings – townscapes, views of rural life, accurate observation of animals and flowers; and whilst decorative elements often played a major part, the paintings of the Glasgow School were firmly rooted in the here-and-now, an objective rather than a subjective view of life. There were, of course, exceptions: Herald, Pringle, Gauld and Millie Dow at times lead us towards a personal world in which fantasy plays a more important role than observation, but it was not until the 1890s that a real reaction against naturalism came about in Scotland.

The Symbolist artists in Europe created mood rather than depicting actual places or events. Odilon Redon wrote:

> My drawings inspire and are not to be defined. They do not determine anything. Like music, they take us into the ambiguous world of the indeterminate.[1]

Certain themes recurred in Symbolist art – an obsession with death and the macabre, the image of the 'femme fatale', an interest in the more obscure aspects of classical mythology and in the late medieval mysticism of the Rosecrucians, and in Scotland, a revival of interest in national ballads and Celtic themes. In most cases the subject is not depicted literally, but is used as a medium to create atmosphere and mood. A further aspect of Symbolism is its close links with the Art Nouveau movement in design. Not only were many motifs shared, but in many cases Symbolist paintings were used to decorate Art Nouveau buildings and interiors. Mackintosh's work as an architect was closely linked to his own paintings and those of the Glasgow Four, as well as to his interest in both the designs and the paintings of the Vienna Secession.

The watercolours of **Charles Rennie Mackintosh** (1868–1928) span two periods of Scottish art; earlier works up to the turn of the

century belong to the Symbolist period, whereas his later landscapes are much closer to the progressive movements of the twentieth century, and are discussed in the next chapter. It is largely due to the work of Roger Billcliffe that Mackintosh's importance as an artist as opposed to an architect has been recognized,[2] and that the equally interesting watercolours of Herbert MacNair and the Macdonald sisters have been brought to light. The sources of Glasgow Symbolism include a reappraisal of the Arts and Crafts Movement and the closely related Pre-Raphaelite style, an interest in Whistler, a rejection of Realism and a knowledge of developments in France, Belgium and Austria. Several of the older Glasgow artists were also influenced by the same sentiments, and paintings such as *The Druids* by Hornel and Henry of 1890, and David Gauld's *St Agnes* also of 1890 reveal a radical departure from Glasgow Realism. David Gauld was a close friend of Mackintosh and there must have been a considerable exchange of ideas. In addition, lengthy discussions, the reading of the newly published magazines like *Ver Sacrum, Evergreen, The Studio* and *Jugend* also played a part in the development of Glasgow Symbolism.

The Four – **C.R. Mackintosh, Herbert MacNair** (1868–1955), **Frances Macdonald** (1874–1921) and **Margaret Macdonald** (1863–1933) – first came together at the Glasgow School of Art when Fra Newbery introduced Mackintosh and MacNair to the Macdonald sisters. Mackintosh's watercolour style developed quickly between 1891 and 1892: in 1891 he had travelled to Italy, France and Belgium on the Alexander Thomson Travelling Scholarship and many watercolours from this trip survive. They show an architect's interest in the great Italian buildings such as the Ca d'Oro in Venice, Orvieto Cathedral and the Palazzo Pubblico in Siena. In the following year he painted *The Harvest Moon* (fig. 71) which, with its sense of linear pattern and its rich colours is an important step towards Symbolism. This watercolour was the first of a series which culminated in drawings for the *Glasgow School of Art Magazine*, which was circulated among the students of the School. Mackintosh produced three watercolours depicting the Seasons, as well as illustrations on other themes. As with the figure in *The Harvest Moon*, Mackintosh's figures for *Winter* (1895) are restrained, even naturalistic, and avoid the stylization of MacNair and the Macdonald sisters. Billcliffe points out that each of the figures used in *Spring* and *Winter*:

> ... is shown living below ground, stretching as if wakening from a long sleep and thrusting a hand through the soil. Other buds and stems have just broken through and their long underground stems reach down to bulbs and tubers at the bottom of the picture.... Mackintosh was to use similar motifs elsewhere; the awakening bulb, with its long green stems and unopened flower buds became a favourite motif and was used even on posters and designs for furniture.[3]

Mackintosh developed his own symbolic language, with motifs reappearing in various forms in different designs. In the watercolour *The Descent of Night* painted for the 1894 *Magazine*, he uses nocturnal

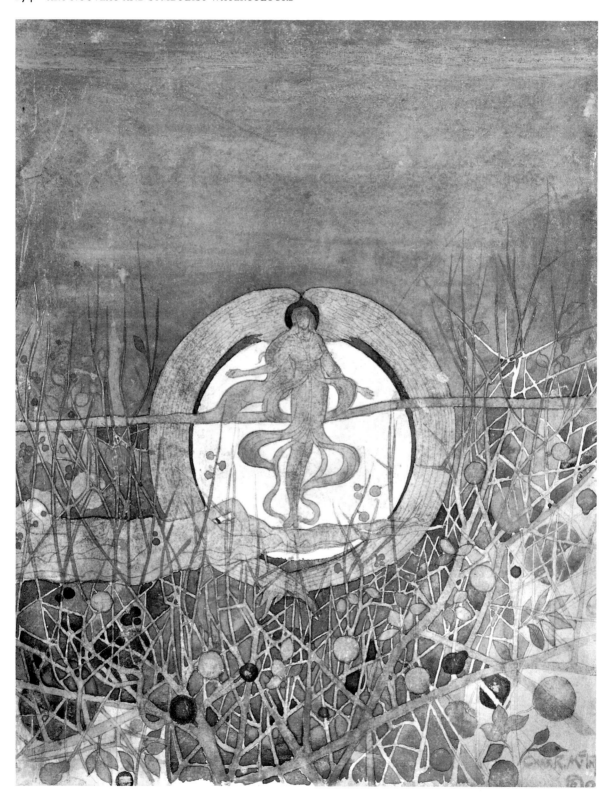

birds of prey seen flying towards the viewer. These stylized birds reappear in different guises in many of his watercolours and designs. Night is symbolized by an angel with outstretched arms and long flowing hair, seen above the setting sun. Here, as in *The Harvest Moon*, Mackintosh uses a rich palette of unnaturalistic colours.

The watercolours which Mackintosh painted in 1895 for the *Magazine* are far more complex in their symbolism, and were probably based upon theoretical discussions held by the students. *The Tree of Personal Effort* and *The Tree of Influence* (Glasgow School of Art) are both based upon natural forms combined with a geometrical construction. Not only is Mackintosh using his most complex and inaccessible symbolism, he is also using watercolour in a free way, bringing him close to some of the French Symbolist ideas – that the formal elements of a work (line, colour, technique) were as important as the symbolic language itself. The works of 1895 are the most personal of Mackintosh's watercolours, but from 1896 onwards his Symbolist works are based on architectural projects which he had in hand. Thus *Part Seen, Imagined Part* of 1896 is related to the Cranston Tea Room frieze in Buchanan Street which opened in 1897, while the concept of a figure entwined in decorative, organic tendrils and flowers appears in other designs of the period as well as in watercolours such as *In Fairyland* (private collection) 1897. *The Wassail* of 1900 (Professor Howarth) is a study for the gesso panel in the Ingram Tea Rooms, and shows not only what extent Mackintosh's architectural and poster work was dominating his watercolours, but how far he had moved away from a complex personal symbolism towards a more decorative style.

Whereas most of Mackintosh's Symbolist watercolours tend to be restrained and retain links with naturalist drawing, the works of the other three members of the Four are often stylized and somewhat exaggerated, earning for the group the derogatory title Spook School. Herbert MacNair was born into a military family living at Skelmorlie outside Glasgow. His first artistic training came in Rouen where he spent a year studying watercolour painting under a local artist. On his return to Glasgow he joined John Honeyman, the architect, as an apprentice, but architecture did not suit him and the main benefit he gained were the evening classes at Glasgow School of Art. In 1885 Francis Newbery had been appointed Headmaster of the School, and during his period of office the school developed rapidly from a provincial art school providing mostly evening classes into an important and significant centre of art training with a style and reputation of its own, and memorable buildings by Mackintosh. Fra Newbery married Jessie Rowat in 1889, herself an expert on embroidery with a strong sense of design: she had been teaching embroidery, enamelwork and mosaics at the school since 1886. Jessie Rowat's designs influenced the development of the Four just as Fra Newbery, who was not an important artist in his own right (although he worked both in oils and watercolours) was to have great influence through his international contacts and knowledge of the developing Art Nouveau style. In 1902

71 Charles Rennie Mackintosh, *Harvest Moon* 1892 14 × 10⅞ Glasgow School of Art

Newbery organized the Scottish section of the Turin International Exhibition, one of the high points of the Glasgow style. The Macdonald sisters were pupils of Jessie Newbery and it was the idea of the Newberys to bring them together with MacNair and Mackintosh, probably in 1892, thereby creating the basis of an energetic and creative association.

One of the earliest Symbolist watercolours of the Four is *Summer* by Margaret Macdonald; in it a grimacing couple are seen kissing, painted in sections like a stained glass window, and the fragmentation and stylization is quite different from Mackintosh's *Harvest Moon*. Frances Macdonald's *Ill Omen* of 1893 (also known as *Girl in the East Wind with Ravens passing the Moon*) (Glasgow University) has a morbidity and fascination with death and, as Roger Billcliffe suggests, 'the twilight world of Celtic or, more simply, northern legend'. There is a Munch-like quality in the sad figure, her flowing hair and the symbolic ravens (Glasgow University). Frances Macdonald's figure is more emaciated than those of her sister, and death and suffering play an important part in her work at this time. On several occasions between 1893 and 1897 the two sisters worked together and it is at times impossible to identify their separate hands. By the end of the decade, however, Margaret's work had become more whimsical, more decorative and less tortured. An important series of four watercolours, two by Frances and two by Margaret, depicting the seasons were painted in 1897–98, and were framed in elaborate beaten lead frames which they designed and made. All are on vellum and are now in Glasgow Art Gallery. There is a new delicacy of drawing and an elegance of design which is not so evident in earlier work. Both the drawing and the sense of pattern relate to Mackintosh's work of the same year, in particular *Fairies* of 1898. The magnificent large watercolour *Ophelia* by Frances Macdonald (private collection), also dating to 1898, follows in the same delicate style. An overall curvilinear design is enriched with fine details of bluebells, daisies, butterflies and decorative patterns, as can also be seen in *The Sleeping Princess* (fig. 72).

In the following year Frances married Herbert MacNair, a move which was to have a dramatic effect upon her life and her art. MacNair suffered much bad luck during the 1890s – he disliked architecture and ended his apprenticeship with Honeyman and Keppie, devoting himself to watercolour painting and design. In 1894 he set up his own office as a designer and decorator, but as an artist he never achieved recognition, and his work, although innovative in some respects, was strongly influenced by the Macdonalds.

> Their work as the Four is very similar in style, although Mackintosh's individuality and his more masculine draughtsmanship kept him slightly apart. MacNair, however, seems to have accepted wholeheartedly the mysticism and feminine naivety of the Macdonalds's work. As Mackintosh grew away from the Four, MacNair became more and more obsessed with its Celtic and Medieval imagery; melancholy and the sinister gradually pervading his later work.[4]

In 1897 a fire destroyed MacNair's office in Glasgow and with it many of his watercolours, his existing *oeuvre* is thus very small. He produced illustrations to poems and legends, such as *Border Ballads*, which exist today only as photographs, and *The Legend of the Birds*, but his main work was in design. As a result of Gleeson White's articles 'Some Glasgow Designers and their Work' in *The Studio* of 1897, MacNair was offered a job at Liverpool University as Instructor in Design in the School of Art and Applied Art, and was able to produce architectural schemes, decorative panels, furniture, posters and book-plates. The job ended with the closure of the school in 1905, and after a short period teaching art in Liverpool, he returned penniless to Glasgow with his wife, who was greatly affected by her husband's plight, and by the fact that he was disowned by her family. She continued to produce watercolours, but the lightness of touch, and decorative skill of the late 1890s gives way to a return to introspective, symbolist brooding. The titles of many of Frances MacNair's later work indicate her own personal problems – *The Choice* and *'Tis a long path which wanders to desire*, appear to depict herself, isolated, despite her many friends, in Munch-like introspection. Herbert MacNair also continued to do watercolours, and they held a joint London Exhibition in 1911 at the Bailie Gallery, which had promoted other Scottish artists including J.W. Herald. The exhibition was not, however, a success, and when Frances died in 1921, Herbert, who was shattered, destroyed most of his own watercolours; although he lived until 1955, he almost totally abandoned painting.

72 Frances Macdonald, *The Sleeping Princess*
$5 \times 17\frac{3}{4}$ (on vellum) Private collection

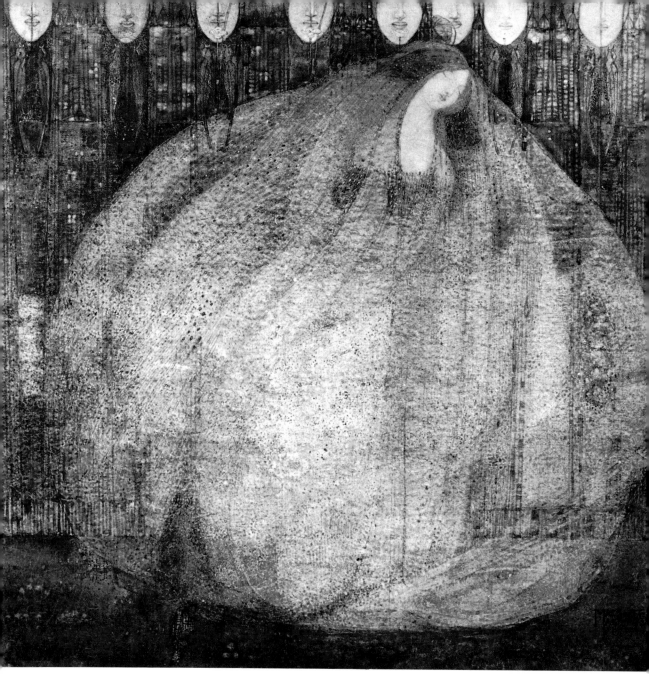

73 Marqaret Macdonald,
The Mysterious Garden 1911
$18\frac{1}{8} \times 19\frac{1}{8}$ (on vellum) Private
collection

Margaret Macdonald's marriage to Mackintosh in 1900 also influenced her art. Mackintosh became a partner in Honeyman and Keppie in 1901 and his wife was quickly drawn into the decorative aspects of his work, helping him with gesso panels and painted murals. Thus many of her watercolours between 1900 and 1910 are related to commissions that her husband was undertaking. *The Mysterious Garden* of about 1905 is related to a series of gesso panels installed in the Music Room of the Warndorfer Villa in Vienna, based upon Maeterlinck's story *The Seven Princesses*. Compared to her sister's work of this period, Margaret's watercolours are elegant, decorative and meticu-

lously designed, as can be seen in *The Pool of Silence* 1913 (private collection) and *The Mysterious Garden* of 1911 (fig. 73). Margaret began to exhibit larger, finished watercolours from 1910 onwards, the time of her husband's growing disillusionment with his life as an architect, and Roger Billcliffe has suggested that these watercolours influenced Mackintosh's determination to become a full-time water-colourist. Between 1900 and 1914 Mackintosh continued to paint watercolours, but they were mostly studies of flowers, rather than Symbolist or decorative works. Many of these flower drawings were done during summer holidays taken with the MacNairs in the Scilly Isles, East Anglia, Holy Island and Portugal. Their strong design combined with careful observation look forward to the second phase of Mackintosh's career as a watercolourist in the 1920s, as does the strength of colour in one or two more finished works, such as *Faded Roses* (Glasgow). In 1914 the Mackintoshes left Glasgow amidst recriminations, having resigned from the partnership in 1913. He was accused of arrogance, idleness and drunken behaviour, but at heart he longed for the liberty and independence of an artist. For him it was a bold step, and the resultant watercolours of the 1920s must be considered amongst the most progressive Scottish paintings of the period: for Margaret it spelt the end of her career as an artist, as she produced no watercolours after leaving for France in 1923.

The Four were not the only artists in Glasgow working in a Symbolist manner: many other students from Glasgow School of Art worked in a similar vein, and several of these achieved considerable recognition. **Jessie M. King** (1875–1949) was born at Bearsden near Glasgow and, after opposition from her father, a Presbyterian minister, she was allowed to enrol at Glasgow School of Art, where, like many other students of the 1890s, she was deeply influenced by the work of Jessie Newbery and the Four. Her style developed rapidly and by 1898 she had achieved a personal illustrative language, which was recognized in 1902 by a full-length article in *The Studio* by Walter Watson. It is a style very different from the Four, being based more upon exquisite drawing in pen-and-ink, using lines and dots in a manner reminiscent of Beardsley, whom she admired. Her work is devoid of the anguish and introspection of Frances Macdonald, and lacks the rich colours of Mackintosh. In their place, she creates a delicate fabric of line and pattern, of figures set about with flowers and tendrils. Unlike the Four, her subjects are mostly taken from literature, and it was as an illustrator that she was primarily known (fig. 74). Her earliest work, done in 1897, while still a student, was for *The Jungle Book*, and in 1904 she was commissioned to produce 95 illustrations for William Morris's *The Defence of Guenevere and Other Poems*. Even when not working on commissions, most of her drawings at this time were illustrations of literature which had caught her imagination. Thus were find illustrations for *Pelleas and Melisande*, Hans Christian Andersen's *Fairy Tales*, *La Belle Dame Sans Merci*, *The Little Princess*, *The Defence of the Holy Grail* and Oscar Wilde's *House of Pomegranates*. The concept of the

74 Jessie Marion King,
*Good Fortune Spin her
Shining Wheel Right Merrily
for Thee*
$9 \times 5\frac{1}{2}$ (on vellum) Fine Art
Society

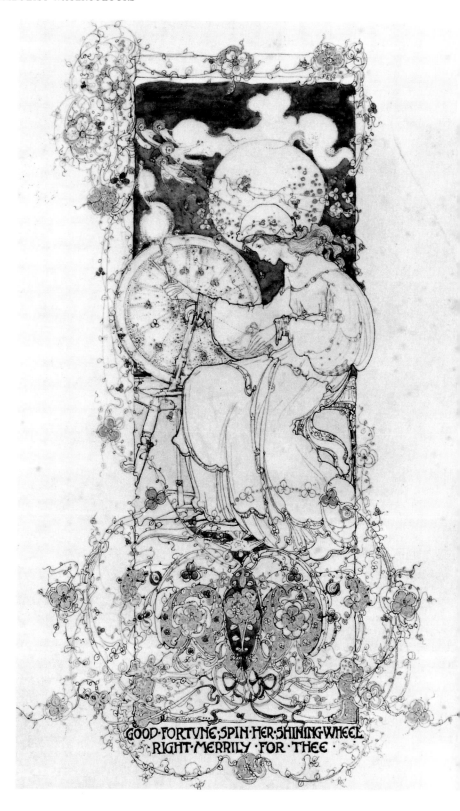

total work of art, or the unity between the various branches of art, was a feature of the late nineteenth century, bringing music, literature, and the visual arts together, and in this respect Jessie King is very much part of the Symbolist movement. Her work as a craftsman is also important. She designed jewellery, tiles, fabric and wallpapers, in addition to being an accomplished decorator of book covers, a subject which she taught at Glasgow School, and for which she won a gold medal in the 1902 Turin exhibition.

In 1906 a short note in *The Studio* discussed Jessie King's pen-and-ink drawings of landscape including views of Avignon and some German towns, a departure from her more imaginative work, and in 1909 an exhibition of some 40 watercolours and drawings was held at T. and R. Annan in Glasgow. Critics mentioned the Japanese and Whistlerian influence, and her use of a subdued palette of grey, green and blue. She also included drawings of Old Culross and Kirkcudbrightshire and, during the period from 1905 to 1911, she painted several landscapes in which realistic observation is combined with a decorative handling of trees. In 1908 she married E. A. Taylor and together they moved to Paris in 1911 where they established an art school – the Shealing Atelier. Like many artists in Paris at this time she was deeply impressed by the Ballets Russes and by Bakst in particular; her designs tended to become stronger and more colourful; and she found in batik a new and exciting form of fabric design. She also produced many drawings of Paris, which, while having considerable charm, lack the magic of her earlier work. These drawings, like her earlier works, are sometimes on vellum, and are only lightly coloured. The war forced their return to Scotland, and she later set up a summer sketching school at her cottage at High Corrie on the Isle of Arran, as well as working from their home near Kirkcudbright. Her later watercolours were influenced by her husband, and show a bold approach, often experimenting with acid dyes to produce more brilliant colours. These later works are less consistent; at times they are somewhat garish and poorly composed, while on other occasions she achieves an almost Fauvist energy and verve.

A close friend of Jessie King was **Annie French** (1872–1965) who was a fellow student and then a fellow teacher at Glasgow School of Art. She was primarily an illustrator of fairy tales and poems, but also had a reputation for designing postcards and greeting cards. Her style is often similar to that of Jessie King although she exaggerates the curvilinear patterns to a greater extent and at times her overall composition is weaker (fig. 75). Another associate was **Ann Macbeth** (1875–1948), whose reputation lay in embroidery which she taught at the Glasgow School, becoming the Head of Department on the retirement of Jessie Newbery in 1908. She was also an illustrator and an article on her work appeared in Volume 27 of *The Studio* written by Jessie Newbery, with illustrations of her drawings. Her style is less delicate than that of Jessie King and Annie French, with more emphasis upon outline and less variation in the use of the pen, while figures

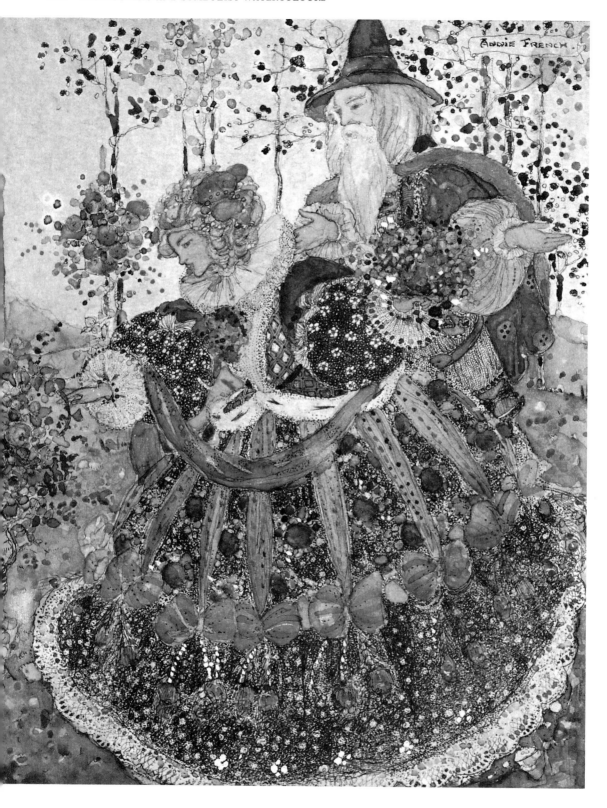

are more solidly drawn than the ethereal figures of Jessie King. An influential teacher, she remained Head of Department until 1928, having published *Educational Needlecraft* in 1911 in which she discusses the value of needlecraft in art education, followed by *The Playwork Book* in 1918. The role of embroidery in the development of the Glasgow Style has been examined by Elizabeth Arthur, and various decorative devices first used by Jessie Newbery such as the Glasgow Rose, the heart motif and other stylizations of natural forms, can be seen to have had an influence on the painters of the school.[5]

Norah Nielson Gray (1882–1931) studied at the School between 1901 and 1906, the period during which Jean Delville, the French Symbolist painter, was teaching there. In 1906 she joined the staff as a fashion designer, while also teaching art at a school in Kilmacolm. During the period prior to World War I she established a reputation as a portrait painter in both oils and watercolours, and at the same time painted some fine Symbolist watercolours in a style which owed little to the Glasgow Four. Her watercolours were quickly recognized, and she was elected to the RSW in 1914, her most imaginative and original work being done in this medium. She was influenced by both Maxfield Parrish and Adrian Stokes, especially in her nocturnal landscapes. *The Missing Trawler*, probably painted in 1914 (fig. 76), is typically elegant, yet haunting. The subtle greys, blues, pinks and greens are combined with elegant draughtsmanship and a painstaking hatching technique which never appears heavy or overworked. A further Glasgow illustrator was **Annie Urquhart** (b.1879), who was also a student at the School, graduating in about 1909. Many of her fellow students were using the formula of decorative drawing evolved by the Four and the Glasgow staff, and many were producing poor plagiarisms with stiff, stylized figures and flowers. Annie Urquhart, however, produced some delightful illustrations of children and young girls in landscape settings. She used ink for her outlines, then stippled in the colour with dry brushes, usually working on parchment.

A further student at the School was the sister of D. Y. Cameron, **Katie Cameron** (1874–1965) who later married the artist Arthur Kay. Her early water colours are much influenced by the Glasgow Symbolists, although her technique is wetter and more painterly, and her drawing less stylized. *There Were Two Sisters Sat in a Bower* (fig. 77) of about 1900 reveals her full drawing and wet technique. The Binnorie illustrations were discussed in 1900 in an article by H. C. Marillier which appeared in *The Art Journal* entitled 'The Romantic Watercolours of Miss Cameron'. She appears more influenced by the late style of Rossetti than by the Glasgow Four. It was, however, as a flower painter that Katie Cameron was best known. Her earlier flower pieces from the 1890s and early 1900s tend to be rich in colour and technique: this gives way to a more delicate style with careful drawing and restrained colour, influenced by the work of Edwin Alexander and Joseph Crawhall. Whereas the earlier flower pieces tend to depict cut flowers in bowls, the later work is usually set in the open with bees or

75 Annie French, *Gather Ye Rosebuds While Ye May* $8 \times 6\frac{1}{2}$ (on vellum) Fine Art Society

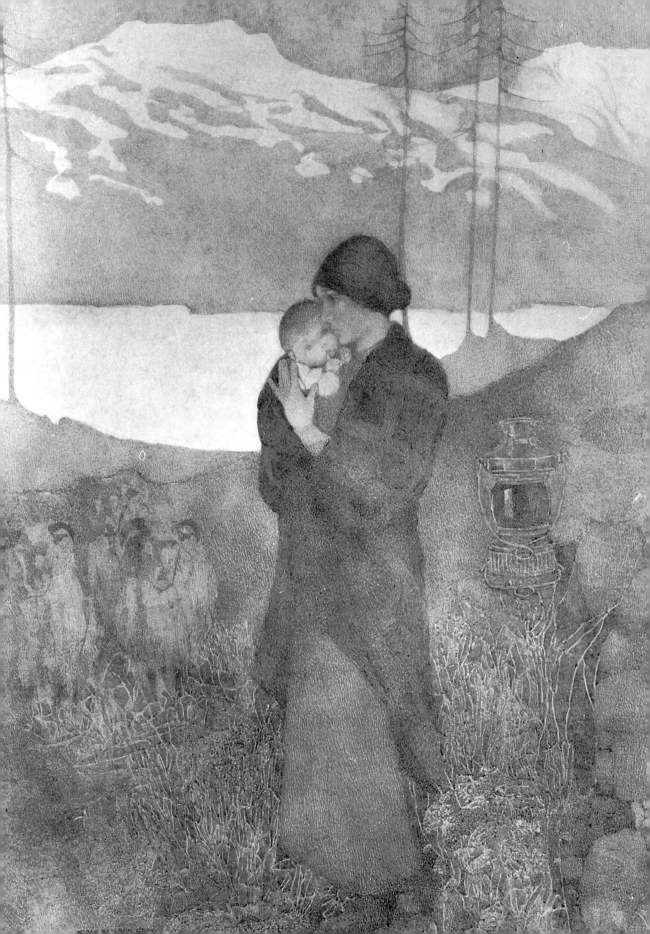

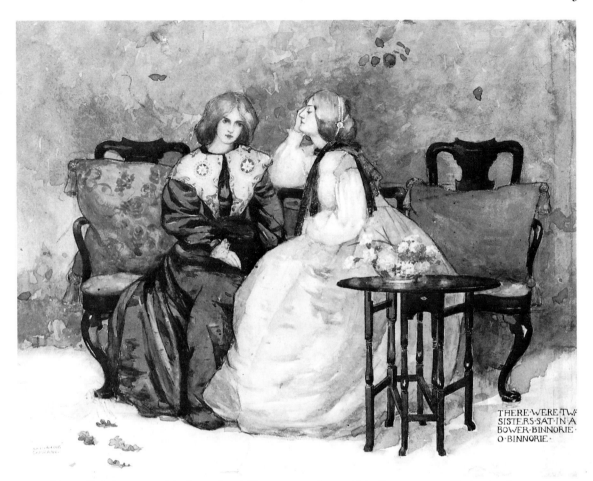

THERE·WERE·TWA
SISTERS·SAT·IN·A
BOWER·BINNORIE·
O·BINNORIE·

butterflies alighting on thistles, dandelions or other wild flowers (fig. 78). She also experimented with watercolour or very thinned oils on silk. During the 1920s and 1930s she painted landscapes influenced by her brother's restrained and economical style, but which during the 1950s became closer to the work of the Edinburgh school, especially Gillies.

Jessie Keppie (1868–1951) should also be mentioned as the sister of John Keppie, Mackintosh's partner. She was originally engaged to Mackintosh although the engagement fell through when he met Margaret Macdonald. She never married, and devoted herself to watercolour painting, choosing flowers and architectural subjects. Her style is 'wet', perhaps influenced by Melville, and by **John Keppie's** own watercolours (fig. 79). Jessie Keppie's flowers are most effective, with rich, fresh colours and a full handling of the watercolour.

Ernest Archibald Taylor (1874–1951) was, like many of his generation in Glasgow, an artist and designer of many talents, painting in oils and watercolours, etching, designing furniture, interiors and stained-glass windows. His early watercolours have much of the delicacy of line and originality of design which mark the best of this period.

77 Katharine Cameron, *There Were Two Sisters Sat in a Bower, Binnorie - O - Binnorie*
$15 \times 18\frac{3}{4}$ Formerly Sotheby's

76 Norah Nielson Gray, *The Missing Trawler*
$17\frac{1}{4} \times 12\frac{3}{4}$ Glasgow Art Gallery (opposite)

78 Katharine Cameron,
Butterflies
19 × 10 (on holland) Perth
Museum and Art Gallery

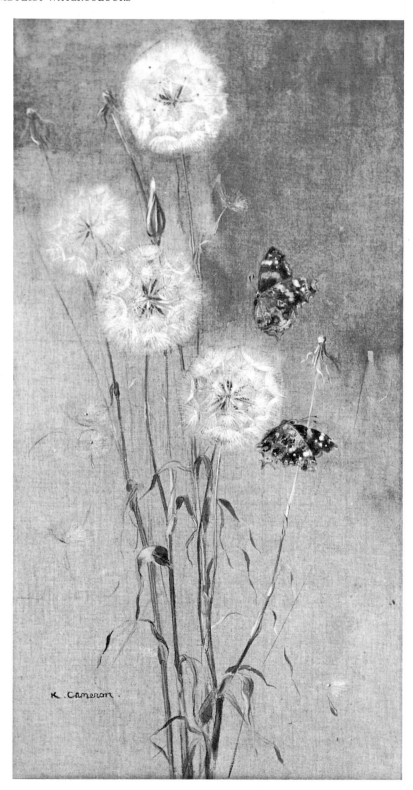

79 John Keppie, *Interior of
St Mark's, Venice*
$27\frac{1}{4}$ × $19\frac{1}{8}$ Glasgow Art
Gallery

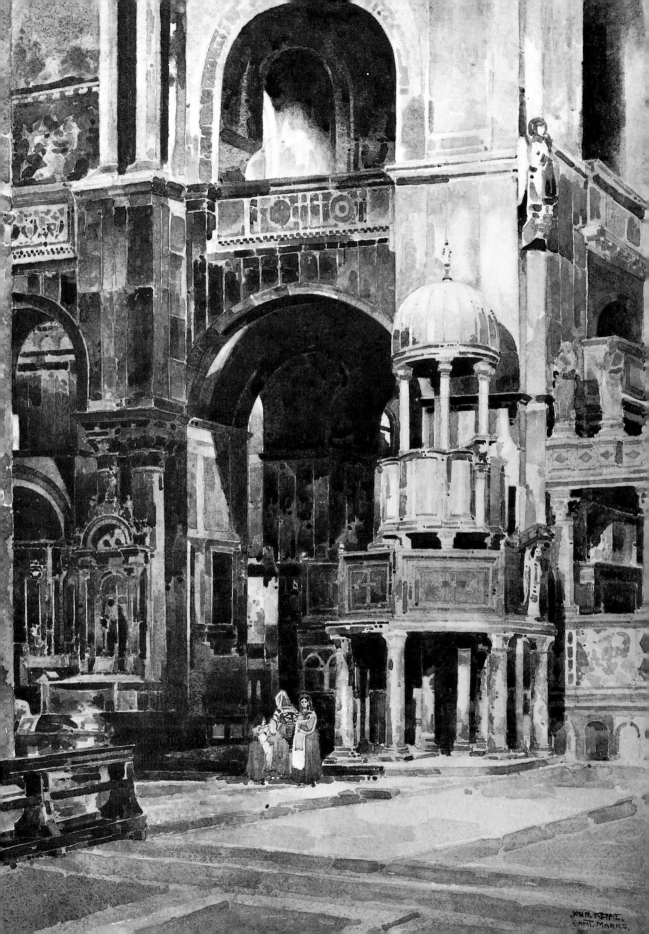

JOHN KEPPIE
SAINT MARKS

An article in *The Studio* in 1905 discussed and illustrated his work showing a combination of stylization of nature and bold design. His best watercolours date from 1900 to 1910 when he was often painting on Arran, and also working with Wylie and Lochhead, the Glasgow cabinet makers, whose work was internationally acknowledged. In 1908 he was married to Jessie King and moved to Manchester to manage and design for George Wragge Ltd, and he produced many designs for stained glass. Between 1911 and 1914 the Taylors lived in Paris, returning on the outbreak of war, later establishing a summer school on Arran. Taylor's work in the 1920s and 1930s is more dramatic, powerful and less delicate than his earlier style with black charcoal outlines and strong colours, a style closer to the Colourists than to the earlier Symbolist group. It should be noted that other Glasgow designers also worked occasionally in watercolours, including **George Logan**, **James Salmon** and **John Ednie**. **James Torrance** (1859–1916) was an illustrator and portrait painter by profession; he was born in Glasgow but worked for many years in London. His works include illustrations for *Scottish Fairy and Folk Tales* edited by Sir George Douglas (1893) for which there are originals in London (VAM) and Glasgow. These monochrome gouaches have considerable style and drama.

The Symbolist Movement in Edinburgh owes little to Mackintosh and the Four despite its proximity to Glasgow. Whereas the Glasgow Group were essentially visual in their approach, those working in Edinburgh were closely involved in current literary and philosophical discussion. This was largely due to the influence of Patrick Geddes, botanist, philosopher and historian of Scotland's Celtic past. Between 1887 and 1899 Geddes ran four-week summer meetings in Edinburgh devoted to drawing, design, psychology, biology, literature and history, and lecturers were invited from throughout Europe. To complement these summer schools, Geddes published a quarterly review, *Evergreen: A Northern Seasonal*, which ran for only four issues between 1895 and 1896. The first issue included an article by Geddes *The Scots Renascence* in which he argued for a revival of Celtic tradition in design and literature. This Celtic Revival, vital to the Edinburgh Symbolists, has its parallels in other countries, in particular in Ireland in the 1890s, although we can also find parallels in Gauguin's interest in the Celtic traditions of Brittany. Geddes also published novels and poems relating to the Celtic Revival. The illustrations to *Evergreen* were provided by John Duncan and Robert Burns, while the cover was designed by Charles Mackie, thereby linking the main artists of the Celtic Revival.

John Duncan (1866–1945) was born in Dundee where he worked as a newspaper and book illustrator before moving south to study art in Antwerp and Düsseldorf. He returned to Dundee where he remained until 1901, but he belonged not only to the small but interesting group of Dundee Symbolists, but also to the Celtic Revivalists in Edinburgh. Closely involved with Professor Geddes, Duncan was commissioned to paint a frieze in the hall of Geddes's Edinburgh apartment representing *The Evolution of Pipe Music* and in 1897 Geddes commissioned him to

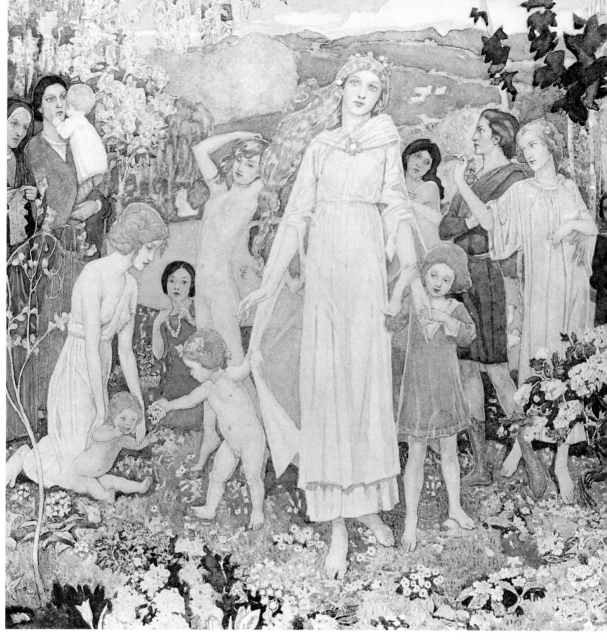

produce panels depicting Celtic and Scottish history for the Common Room of Ramsay Lodge. Duncan was becoming increasingly fascinated by the Italian Quattrocento, and Celtic influences were now mixed with classical criteria, suggesting an admiration for Puvis de Chavannes. During this period, Duncan cannot be considered a watercolourist. His work for *Evergreen* was in pen-and-ink, and his work for Geddes consisted of large murals. From 1901 to 1904 Duncan was in Chicago as Associate Professor of Art, and after his return to Edinburgh, where he settled in 1904, his style moved even further towards the classical. His most famous canvas, *Riders of the Sidhe* of 1912 (Dundee) reflects not only a knowledge of his English contemporaries, like Walter Crane, but also his extensive art-historical knowledge.

80 John Duncan, *The Coming of Bride* $22\frac{1}{2} \times 22\frac{1}{4}$ Dundee City Art Galleries and Museums

Whereas most of the Symbolists had changed their style and intentions by the post-war period, Duncan continued to work in a Symbolist manner in oils and watercolours throughout the 1920s and 1930s. His studio was a meeting point for many young Edinburgh artists, and he became something of a leader of the avant-garde in the city. During this period, he turned more towards watercolours, both for finished Symbolist works and as studies for stained-glass windows. Religious subjects appear in many of his pictures as do classical allegories, and Duncan's watercolours of the 1920s are interesting examples of late Symbolism – the flowing forms of the earlier period have given way to straighter lines and flatter planes of colour, reflecting the development of Vorticism, which had possibly been introduced to John Duncan by Eric Robertson. A combination of personal fantasy, dramatic colours and good detail, makes many of his later watercolours both original and highly individual, and it is appropriate that his later work is currently being re-assessed. There are good examples of his later watercolours in Dundee Art Gallery including *St George and the Dragon* and *The Coming of Bride* (fig. 80).

Robert Burns (1869–1941) also worked for Patrick Geddes's *Evergreen*, first making his mark with a remarkable illustration, *Natura Naturans*, which accompanied Geddes's article 'Life and its Science'. The pen-and-ink drawing was, in fact, executed in 1891, placing it amongst the earlier examples of Art Nouveau, being, for example, of the same year as Victor Horta's Hotel Tassel. A young woman with flowing hair stands amidst tendril-like waves which incorporate fish and birds. This illustration remains one of the most striking of its period and was certainly the most memorable to appear during the short life of *Evergreen*. Born in Edinburgh, Burns studied art in Paris from 1890 to 1892, working in the Academy Delecluse and, more significantly, drawing from life in the Jardin des Plantes. On his return to Edinburgh, Burns worked broadly in commercial art, producing designs for graphics, stained-glass windows, interiors and even for the early motor-car, and as a result of this activity, his output of easel paintings and watercolours was restricted. Elected to the RSA in 1902, his relationship with the Academy was never happy and he soon resigned. Likewise his position as Head of Drawing and Painting at Edinburgh College of Art was also terminated due to his unorthodox methods of teaching. Despite this unsettled background, Burns painted both watercolours and book illustrations.

Robert Burns had inherited a love of the Scottish Ballads from his family:

> My interest in Scots Ballads began at an early age, for my father ... had inherited from his grand-uncle ... a very complete collection of the earliest printed editions. I had the freedom, uncensored, of my father's library from the time I learned to read, and this, added to an hereditary interest in poetry and history, developed a love for romantic literature which has lasted well over sixty years.[6]

During the 1890s Burns studied and collated the various versions of

the ballads with the intention of compiling a hand-written and illustrated book. Lack of money and time caused the postponement of the project, but in 1929 after a severe illness, and still confined to bed, Burns began to paint watercolours on a small scale. Paul Stirton points out that in 1929 Burns returned to his illustrative style of the 1890s, and some watercolours, such as *The Border Widow's Lament* are close to the drawings of the 1890s of the same subject. Most of these illustrations are painted on vellum, using watercolour, gouache, ink and gold leaf, his unorthodox technique providing interesting textures, including burnished and tooled gold, as well as rich colours. Burns had the time to achieve highly finished illustrations and, thanks to the financial support of his friend Alexander Hunter Crawford, he also had the necessary funds. The original illustrations on vellum were bound with handwritten text into two volumes for Hunter Crawford, but Burns also arranged for good photographic reproductions to be made, bound and sold in a limited edition of twelve. In 1936 he began to rework the illustrations in pen-and-ink, and these were published in 1939 under the title *Scots Ballads by Robert Burns, Limner*. The ballads which Burns originally illustrated include *The Battle of Otterbourne*, *The Twa Corbies*, *Helen of Kirkconnel*, *William and Margaret*, *The Bonnie Erle O'Moray*, *The Twa Sisters*, *The Border Widow's Lament*, *The Wyfe of Usher Well*, *Sir Patric Spens*, and *Thomas the Rhymer*. He also produced illustrations to *The Song of Solomon*. Burns's skill as an illustrator lies in his ability to provide an accurate account of the text, sensitively interpreted, with a striking design and bold colours. His strong sense of design is reinforced by the diptych format which he often used, as in *Whe doun before Erle Douglas Speir, She saw proud Persie fa'* (fig. 81). The illustrations to *The Song of Solomon* are very different in style, reflecting an interest in contemporary developments, *The Army of Bannes* (Chapter 6 verse 10) being indebted to Vorticism, while *I am black, but comely* (Chapter 1 verse 5) appears to owe something to Bakst and the Ballet Russe. These illustrations, which, until the Fine Art Society exhibition of 1976, were comparatively unknown, reveal Burns as one of the great modern Scottish illustrators.

Landscape has an important place in Burns's work. In 1918 he held an exhibition of watercolours in Edinburgh depicting Scottish moorlands, heaths, mountains and rivers, while in 1921 he had an exhibition of views of Morocco at the Leicester Galleries, based on a trip to the country in 1920. This journey was also the subject of an article in *The Studio* in 1921 written by E. A. Taylor with several illustrations in colour. Burns used a dramatic, lively watercolour style; bright colours combined with a strong sense of pattern, and some of the landscapes have a great exuberance of light. These Moroccan landscapes are among Burns's best and are more interesting that his often rather dull views of barren moorlands and snow-swept heaths.

The reputation of **Charles Mackie** (1862–1920) rests largely on his work for *Evergreen*, his design for the embossed leather cover being, in many ways, the trademark of the Scottish Symbolist movement outside

81 Robert Burns, *Whe doun before Erle Douglas Speir, She saw proud Persie fa'* $11\frac{1}{2} \times 7\frac{1}{2}$ (Gouache on vellum) Fine Art Society

Glasgow. Born in Aldershot, Hampshire, the son of an army officer from Edinburgh, he was brought up and trained in Edinburgh. His early work was based upon the current pastoral Realism, and it was in the 1890s that he first turned towards a more theoretical approach to art. Professor Geddes was an important influence, as was a visit to Pont-Aven where he met followers of Gauguin – Le Sidaner and Serusier – whom he invited to contribute to *Evergreen*. He also became a friend of Maurice Denis, and the influence of the Nabis can be seen in his small oils, watercolours and woodcuts of this period. Synthetist theories played an important part in Mackie's work during the 1890s and several interesting landscape watercolours from this period exist, showing a vivid sense of colour and design. Although he retained a strong sense of colour, his Symbolist period had ended by about 1905. In 1908 he was in Venice with Adam Bruce Thomson, and several large and powerful watercolours resulted from this trip (fig. 82). This bold, wetly painted style with its rich colours and *chiaroscuro* is typical of his later work. Mackie had a large circle of artistic friends in Edinburgh; he was brother-in-law of William Walls and collaborated with him on lithographs, and a close friend of Laura and Harold Knight. Mackie was a deeply religious man; his career was prematurely terminated by cancer.

Eric Robertson (1887–1941) is one of the most interesting of the Edinburgh Symbolists, a flamboyant and often outrageous personality,

1 Hugh 'Grecian' Williams, *Boats on the Isthmus of Corinth* 7¾ x 11¾ National Gallery of Scotland

2 William McTaggart, *Girl Bathers* 13½ x 20½ J. G. Orchar Art Gallery

3 Arthur Melville, *Awaiting an Audience with the Pasha* 26¼ x 39¾ Mr and Mrs Tim Rice

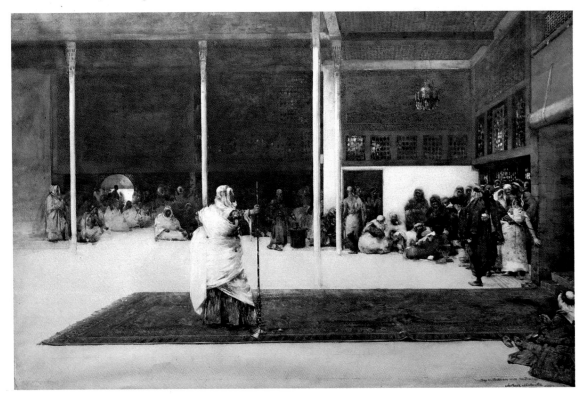

4 Edward Arthur Walton, *The Briony Wreath* 26 x 20 Bourne Fine Art

5 Sam Bough, *West Wemyss Harbour* 15 x 25½ J. G. Orchar Art Gallery

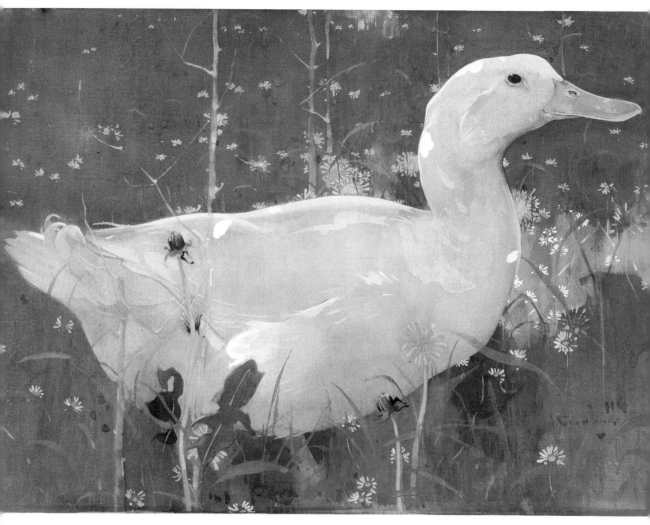

6 Joseph Crawhall, *The White Drake* 16 x 22½ (on Holland) Private Collection; on loan to the National Gallery of Scotland

7 Charles Rennie Mackintosh, *The Village of La Lagonne* 18⅛ x 18⅛ Glasgow Art Gallery

8 Sir William Gillies, *St Monance from the Harbour* 9½ x 15¾ Scottish National Gallery of Modern Art

he nevertheless produced some of the most striking images of his period. He studied at Edinburgh College of Art, where he was described as 'one of the most brilliant art students of his period', gaining for himself some notoriety for his drawings of nudes and his affairs with young girl students. While at college, he was impressed by the work of Burne-Jones and Rossetti, but above all, he admired the work of John Duncan, some eleven years older than him, and an established artist in Edinburgh. Through Duncan, he met **Cecile Walton** (1891–1956), the daughter of E. A. Walton, whom he married much against her parents' wishes. For a period the Robertsons were at the centre of a group of progressive artists, including J. R. Barclay, D. M. Sutherland, Dorothy Johnstone and Spence Smith who exhibited as the Edinburgh Group. The marriage was not, however, to last, and in 1923, as a result of Robertson's eccentric behaviour, they parted. For Robertson this parting was to prove disastrous; most of his friends in Edinburgh ostracized him and he found himself barred from the stimulating companionship of other artists. Robertson moved to Liverpool, where he remarried, but he continued to drink heavily, and despite an attempt at commercial art he was barely able to make ends meet. Apart from a few schemes for murals, he produced little work in Liverpool and his

82 Charles Mackie, *St Marks, Venice*
$16\frac{3}{4} \times 22\frac{1}{4}$ Perth Museum and Art Gallery

last known work, a watercolour entitled *The New God on Mount Olym-pus*, drawn as a study for an unknown decorative project, was painted no later than 1930, after which he produced no further work until his death in 1941.

Robertson's work is both rare and variable in style. He worked in many media, including oils, watercolour, chalk, pastel and often pencil, producing fine Blake-like images, such as *Dreamers* of 1911. *The Two Companions* (fig. 83) of 1913 is one of Robertson's most striking water-colours, painted on a large scale, and illustrates not only his debt to Burne-Jones, but also the very individual nature of his art, combining introspection with sensuality. In his post-war work, the influence of the Vorticists and Wyndham Lewis in particular can be seen in many of his oils, as well as Art Deco styles of design.

Eric Robertson's wife, Cecile Walton, is also an artist of interest, born in Glasgow and trained in Edinburgh, Florence and Paris. She was interested in illustration from an early age, and her first exhibits at the RSW in 1909 included an illustration from Hans Christian An-

83 Eric Harald Macbeth Robertson, *The Two Companions* 1913 26 × 26 Mr and Mrs John Kemplay

84 Cecile Walton, *The Truant Wife is Captured* $9 \times 8\frac{3}{4}$ From *Polish Fairy Tales* by Maude Ashurst Biggs, published in 1920. Mr and Mrs John Kemplay

dersen and Tannhäuser's Farewell. In 1911 an edition of Hans Christian Andersen's *Fairy Tales* was published by T. C. and E. C. Jack with illustrations by Cecile Walton. They show a strong Glasgow influence, in particular that of Jessie King. She married in 1914 despite the strong disapproval of her parents who sent her to Florence in a vain attempt to prevent the marriage. In 1917, when Eric Robertson was in France with the Friends' Ambulance Unit, Cecile Walton began work on a series of illustrations to *Polish Fairy Tales* which were to be published in 1920 by John Lane at the Bodley Head (fig. 84). She was influenced by John Duncan and Caley Robinson in these illustrations, casting off her earlier affinity to the Glasgow School. Her visit to Florence had also left an impression, combining with her interest in Burne-Jones and Rossetti. Twenty watercolours illustrating *Polish Fairy Tales* were exhibited at the 1920 Edinburgh Group exhibition, and they had considerable strength both in composition and colour, revealing a developed artistic personality. Sadly her talent was not to develop further for in 1923 her stormy marriage finally broke up and she moved to Cambridge to work on theatre designs for Tyrone Guthrie, returning in 1933 to Edinburgh to organize BBC Children's Hour. Although she took up painting again in the late 1940s, her most interesting work had been done in the 14 years between 1909 and 1923.[7]

85 Robert Traill Rose, *The White Peace or The Garden of Memory* 36 × 16 City of Edinburgh Art Collection

Robert Traill Rose (1863–1942) should be mentioned in connection with the Edinburgh group. A native of Newcastle, he settled in Scotland and produced illustrations, mostly to Biblical subjects including the *Book of Job* and *Old Testament Stories*. While working mostly in a bold black-and-white technique, he also did some watercolours (fig. 85).

The third group of Symbolists was based in Dundee. **George Dutch Davidson** (1879–1901) is the most significant of this group, despite a very short life. Born in Yorkshire, the son of a marine engineer from Dundee, he was at school in Dundee, intending to follow his father's profession. Following a severe attack of influenza, he was forced to abandon engineering, and after a period of convalescence, enrolled at art classes at Dundee High School in 1897. During this formulative period, he was greatly helped by other Dundee artists, in particular, John Duncan, David Foggie, Stewart Carmichael and Frank Laing. In 1898–99 he shared a studio with John Duncan and was aware of his illustrations for *Evergreen* and the growing interest in Celtic decoration. Davidson had a particular interest in ornament, and had an inquisitive intellect which enabled him to assimilate many different styles. John Duncan wrote:

> He was the most ardent student, assimilated everything that came his way, Celtic ornament, Persian ornament, Gothic architecture, early Renaissance art, 17th Century tapestries, and wove every new influence into the tissue of his style.[8]

86 George Dutch Davidson, *The Hills of Dream* 1899
17 × 27 Dundee City Art Galleries and Museums

In 1898–99 Davidson did a series of decorative watercolours based on patterns of Celtic origin. This group is amongst the most interesting products of Scottish Symbolism; the strong colours and sharply defined patterns look forward to Art Deco and the designs for the Ballet Russe, while their abstract nature links them with Mackintosh's more introspective work, as well as Synthetist theories in France, and even to Kandinsky's experiments of 1911–14. *Envy* (Dundee) is related to these abstract experiments, with a spooky green creature entwined with Celtic decoration, while *Self-Portrait* (also Dundee) follows this combination of rich colours, abstract decoration and figurative elements. This particular watercolour is interesting for its links with Munch, with its haunted face and flowing background.

In September 1899 Davidson left Dundee with his mother to travel for nearly a year via London, Antwerp and Florence. While in Antwerp he produced some important watercolours and drawings, in addition to some delicate pencil sketches and an unusual landscape in watercolour. *The Hills of Dream* (fig. 86) dates from this period, and is one of Davidson's most successful compositions. It illustrates a Celtic Revival poem and displays not only his sensitive draughtsmanship, but also his ability to organize a complex illustration. The influence of the Italian Quattrocento is also evident, an interest which, prior to his arrival in Florence, had no doubt been stimulated by John Duncan. While in Antwerp he also did two illustrations to *The Rubaiyat of Omar Khayyam*, *The Tavern Door* and *The Tomb*, the latter being a highly detailed and delicate pen-and-ink drawing, revealing his combination of strong design and sensitive draughtsmanship. The Glasgow Symbolists used their stylization of forms and distinctive pen-and-ink technique to mask often somewhat weak drawing, but Dutch Davidson's draughtsmanship is particularly fine. Davidson and his mother visited France, Ravenna and Venice, returning to Scotland in August 1900. During the last year of his life, his work shows a strong Italian influence and an increasing technical sophistication. His early death removed one of the most fascinating of the Scottish Symbolists (fig. 87).

Frank Laing (1862–1907), a close friend of Dutch Davidson, is better known for his etchings than his watercolours. Born in Dundee, he studied in Edinburgh and then in Paris, a city in which he was to spend much time both as a student and as an artist. He made a considerable reputation in Paris as an etcher and his many views of Paris were much sought after. He also produced etchings of Edinburgh, St Andrews, Dundee and Tayport, as well as Antwerp and Venice. His etchings are refined and understated, a quality which Whistler admired, and his watercolours follow this 'swish' style. His sophisticated townscapes in watercolour are painted with control and confidence, with restrained colours and an elegant line. His style is close to some French painters of the 1890s like Helleu, and his portraits are effective in a *fin-de-siècle* manner (fig. 88).

David Foggie (1878–1948) shares with Frank Laing a smooth, unlaboured style. A native of Dundee, he was also a friend of Dutch Davidson, although appears to have been little influenced by his work.

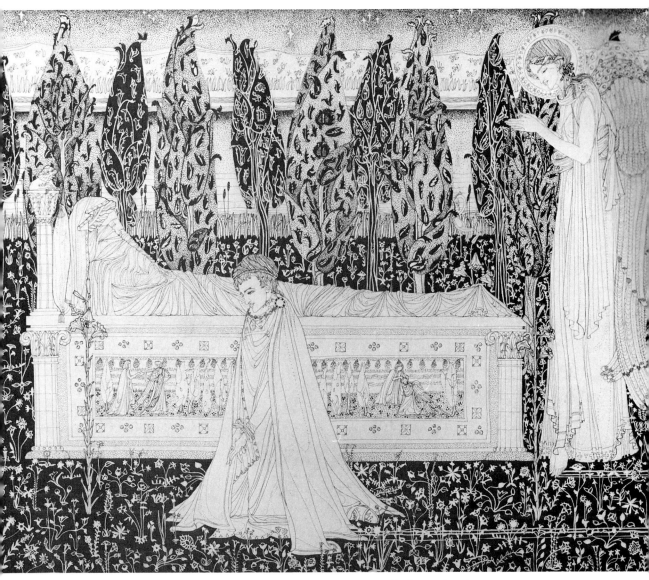

87 George Dutch
Davidson, *Ullalume*
$9\frac{1}{8} \times 11\frac{1}{2}$ Dundee City Art
Galleries and Museums

Like Laing, Foggie studied abroad in Paris, Antwerp and Italy, and
was aware of Continental developments. *Getting Up* of 1911 (fig. 89)
reveals his ability as a draughtsman, which was to make him popular
as a painter of elegant portraits in the 1920s and 1930s when he was
living in Edinburgh and teaching at Edinburgh College of Art. His
many watercolour landscapes of Scotland appeared regularly at the
RSW. Like other Dundee artists in this section, **Stewart Carmichael**
(1867–1950) also reverted to more conventional styles in later life. His
reputation was first established with his decoration of public buildings
in Dundee including *The Leaders of Scottish Liberties* for the Liberal
Club. Carmichael's later work is less original, often depicting architec-
tural subjects, but handled in a somewhat crude manner.

The Symbolist Movement in Scotland is not coherent, nor is it

88 Frank Laing, *The Yellow Girl* 1894
27 × 15½ Dundee City Art
Galleries and Museums

89 David Foggie, *Getting Up* 1911
$26\frac{7}{8} \times 20\frac{7}{8}$ Dundee City Art Galleries and Museums

linked by style or technique; it was an art in which individual talents were brought together by broad theories and sentiments, rather than by specific styles. In England Art Nouveau and the Symbolist Movement were often attacked for their eccentricity, obsession with fashion and style, and lack of moral content, as Ashbee's rhyme reveals:

I'm in the fashion – non controversial,
And the fashion is nothing – if not commercial,
Pre-Raphaelite once, with a tiny twist
Of the philosophical hedonist,
Inspired by Whistler – next a touch,
Of the 'Arts and Crafts' but not too much.
Then Impressionism, the daintiest fluke;
Then the German Squirm, and the Glasgow Spook,
A spice of the latest French erotic,
Anything new and Studiotic . . .

9 The twentieth century

Scottish watercolour painting of the twentieth century deserves greater recognition. Whereas in the previous century most leading Scottish artists ensured that their work was shown in London, the Edinburgh artists of the 1920s and '30s were unconcerned about their wider reputation, and in certain respects this isolation was healthy, contributing towards the strong sense of 'Scottishness' in many watercolours of this period. Several interesting artists have only recently been rediscovered, and the process of re-assessing and re-interpreting the inter-war years will continue.

The year 1900 brought with it no sudden change of direction. Many of the Glasgow School were still in full production, and the peak of Symbolism was not yet past. James Paterson, E. A. Walton, Robert Weir Allan and John Duncan, to name but a few established watercolourists, were to continue working for many years, and styles established before the turn of the century were to survive until the late 1930s. Combined with this chronological overlapping comes a mixing of influences. While developments in France were important, especially to the Colourists and for many of the Edinburgh Group, the traditions of Scottish watercolour painting continued to influence the younger generation. Arthur Melville was an important influence on the Colourists: the work of John Duncan and his circle was important to many Edinburgh artists in the 1920s, and the spirit of McTaggart can be felt in many landscapes of the period.

An important development was the growth of Edinburgh as the centre of artistic innovation at the expense of Glasgow. During the previous century, Glasgow was usually the centre of new artistic ideas, while Edinburgh, with its established societies, remained more conservative – the home of the established artists. Glasgow School of Art with its new buildings by Mackintosh had become the leading art school in Scotland, but by 1914, the predominance of Glasgow had been challenged. Edinburgh College of Art was attracting great talent, both as staff and students, and during the inter-war years Edinburgh eclipsed Glasgow as the centre of innovative artistic ideas. The decline of Glasgow had many causes. The School had become too closely associated with a particular style, which did not prepare students for

the sudden reaction against Art Nouveau which began around 1910. The departure of Mackintosh and his circle deprived Glasgow of a driving force and Mackintosh's dramatic and innovative new water- colours were produced in the isolation of France. No doubt the eco- nomic decline of Glasgow after World War I, leading to a fall in patronage, also played a part, whereas Edinburgh suffered less from the Depression.

The later watercolours of **Charles Rennie Mackintosh** are among the most remarkable in modern Scottish art. The important landscapes of the 1920s are preceded by the flower studies painted between 1901 and 1915. Each study has a cartouche in which Mackintosh inscribes his initials and often those of his wife or friends who were present at the time, in addition to the place, date and type of flower. These cartouches are an important factor in the overall design. The culmi- nation of these flower drawings came in 1914–15 when Mackintosh left Glasgow for good and moved to Walberswick, where he produced some 30 flower drawings, probably intended for publication. The assured pencil drawing combined with striking design and a most accomplished use of watercolour to give a feeling of texture, has made these studies popular today, and it is a measure of Mackintosh's genius that these studies, which started almost as a relaxation, are now among the best- known flower studies of this century.

Mackintosh left regular employment in 1914 and was determined to devote himself to painting, a desire which he had nurtured for two decades. In order to sell his watercolours, he realized that he would have to turn to landscape in addition to producing more highly finished flower pieces. This change can be clearly seen. The flower paintings of 1915–20 are no longer studies of single stems, but compositions of flowers in bowls or vases set against decorative backgrounds. They are striking compositions with powerful patterns in the vases or back- grounds, painted in rich colours, with the overall effect looking for- wards to the French decorative style as represented at the 1925 Paris Exhibition. *A Basket of Flowers* (Glasgow University Collection) with its stylized flowers is close to contemporary designs by Ruhlmann or Maré, while other watercolours such as *Pinks* (Glasgow) or *Begonias* (private collection) have strong hints of the Vienna Secession style in the patterned, Hoffmann-like vases. More evidence of this Viennese influence and of Mackintosh's forward-looking sense of design can be found in his textile designs of this period. He also produced some landscapes between 1900 and 1920, but it was not until 1920, when on holiday in Dorset with Randolph Schwabe, that he began to work seriously on landscapes. In these Dorset watercolours the strong sense of pattern so evident in his flower painting emerges. *The Downs, Worth Matravers* (Glasgow School of Art) is a striking composition, the fields, roads and hedgerows becoming instruments in a complex design. He paints distant objects in as much detail as those close to and thereby tilts the picture plane towards us, rather in the manner of the first phase of French Cubism. Very few of Mackintosh's architectural pro-

90 Francis Campbell Boileau Cadell, *View of Iona* $10\frac{1}{4} \times 12\frac{1}{2}$ The Scottish Gallery, Edinburgh

jects of this period had been accepted, and in 1923 he decided to take a long holiday in France, a visit which was to last until 1927, and which was to produce some extraordinary watercolours. The Mackintoshes settled in the South of France on the Mediterranean near the Spanish border, staying at various times at Ille-sur-Tet, Collioure, Amélie-les-Bains, Mont Louis and Port Vendres, where they settled in 1927. The dramatic countryside of this area, dominated by the Pyrenees, appealed to Mackintosh's sense of design.

Mackintosh's French watercolours bring together many aspects of his work both as an architect and as a painter. In most of them there is a strong architectonic sense, not only in the buildings which often feature, but also in the handling of rocks and mountains. Mackintosh's grasp of three-dimensional form gives these watercolours conviction and never allows them to become simply coloured patterns. In *The Village of La Lagonne* he creates a complicated, yet convincing space (colour plate 7).

Combined with his unerring grasp of construction is a dramatic sense of design; the fields and distant black mountainside not only create space, but also a striking pattern. In the *View of Felges* (Tate) rocky fields in the foreground also act as eye-catching designs, while areas of water work to create both space and pattern. Mackintosh's long experience working in two-dimensional forms within three-dimensional areas enables him to combine flat patterns within fully resolved spaces and part of the excitement of his French watercolours lies in this dramatic and unexpected combination. His sense of colour, developed during the 1890s, also plays an important part. Brilliant blues and turquoises are set against unexpected yellows and greens, but at the same time, the greyness of the Pyrenean stone is retained, and his imagination never pushes the landscape into pure fantasy. Unlike many Cubist landscapes, a sense of place is never lost in Mackintosh's watercolours. Moreover, his awareness of detail remains, combined, as in the earlier flower studies, with a distinctive sense of pattern. We know that Mackintosh worked slowly, often taking many days or even weeks on the spot to finish a watercolour. He used a Whatman paper laid down on board, working in a 'wet' technique with ample washes which he soaked into the paper, which was then scrubbed, at times with a toothbrush.

The work of the Colourists has been appreciated in Scotland for many years, although somewhat more recently in England, and several books and exhibition catalogues have been devoted to their work. Their best known works are their oils and their vigorous brushwork, rich impasto and intense colours – the hallmarks of the Colourists' art – are more suited to oil than watercolour as a medium. Nevertheless both Cadell and Hunter worked in watercolours throughout their careers and Fergusson produced some watercolours of great quality, especially during his earlier years.

Francis Campbell Boileau Cadell (1883–1937) was born in Edinburgh and was encouraged to paint by Arthur Melville. A close friend of the family, Melville persuaded them to send Cadell to Paris where he studied from 1899 to 1903, being influenced particularly by the Impressionists. It was in Paris that Cadell first exhibited, successfully entering a watercolour at the Paris Salon of 1899, and from then on watercolour played an important part in Cadell's art, as a medium suited to his spontaneous and fluent draughtsmanship. He continued to work abroad in Paris and Munich until 1909, when he returned to Edinburgh, but visits abroad, particularly to Paris and Venice, continued until the outbreak of war when Cadell volunteered, fighting on the Somme in 1916 and being twice wounded. After the war, Cadell resumed his practice of working in Edinburgh during the autumn and the winter months, while spending his holidays in the Highlands and on Iona, an island he particularly liked and where he acquired a croft (fig. 90). Here Cadell was able to capture the whiteness of the sand and the subtle blues, purples and pinks of the water and hills in a fresh and spontaneous watercolour technique. He avoids heavy outlines and

charcoal is used very sparingly, if at all. These scintillating views of Iona, usually painted on a fairly small scale, represent the majority of Cadell's watercolours.

Venice and the South of France also appealed to Cadell's sense of colour and light, and before World War I he painted a number of watercolours of figures in the piazzas, buildings reflected in canals of Venice, or the old harbours of Provence. Possibly the most original of all Cadell's works are the studies in oil of people in interiors. Often taking white as the predominant colour, he creates elegant spaces with subtle touches of black, red and yellow. Although these interiors are most successful in oil, he also worked on similar themes in watercolour, in which his fluent drawing was shown to its best advantage. Cadell enjoyed painting elegant ladies in formal garden settings, and several watercolours deal with this theme in great style, including several from his early years in Munich. Cadell's superb brush drawings in ink and coloured chalks should also be mentioned. With broad sweeps of the brush, in an almost calligraphic manner, Cadell captures the character and pose of people with a fluency and accuracy not unlike the pen drawings of Albert Marquet. Cadell was the only Colourist to be elected to the RSW.

George Leslie Hunter (1879–1931) also produced many watercolours, although possibly of a less consistent quality than those of Cadell. Born in Rothsay, Hunter was taken as a boy to California where his parents had settled, and Hunter became an illustrator working for various magazines in San Francisco. A visit to Paris in 1904 led him to turn to painting (a watercolour, *The Poultry Market, Paris* dates from this year, and shows Hunter's ability as a draughtsman) but he continued to illustrate for many years, working for the publishers Collins, the *Pall Mall Magazine* and *The Graphic* after his return to Glasgow. Hunter's training as an illustrator is revealed in his firm handling of pen-and-ink, and his best watercolours have a strong sense of design. In 1914 Hunter's work was brought to the attention of Alexander Reid, the Glasgow dealer, who encouraged him to work towards a one-man show. Hunter visited France in that year to gather ideas and to re-acquaint himself with the work of the Post-Impressionists, Cézanne, Van Gogh and Gauguin, whose work he particularly admired. On the outbreak of war in 1914, he moved to his uncle's farm in Lanarkshire where he worked, while continuing to paint, and in 1916 a one-man exhibition was held at Alexander Reid's gallery in Glasgow.

In 1922 Hunter visited the Continent producing drawings of Venice, Florence and the Riviera. The Venetian drawings are executed in a quick pen-and-ink outline with bright touches of red, green, yellow and blue in a style not unlike the Fauves, and can be compared in particular to the drawings of Matisse and Dufy, in which the pen-and-ink framework exists independently from the coloured washes. From 1924 to 1927 Hunter worked mostly in Scotland, in particular in Fife where he painted landscapes in both oil and watercolour. Watercolours painted in Largo show Hunter's more controlled drawing

which is often lost in the more sketchy French or Venetian water-colours. During this period, Hunter painted some of his most convincing watercolours in Fife and on the banks of Loch Lomond. He was, however, unsettled, and decided to return to France in 1927, remaining there until 1929. He moved from village to village, drawing on the spot in places like St Paul, Vence, Villefranche, St Tropez, Antibes, Cassis and Monaco, producing a large number of drawings which he intended to work into finished canvases. Some are executed in charcoal, others in pen-and-ink with either watercolour washes or pastel, while others are broadly drawn with a loaded brush (fig. 91). He returned to Glasgow in poor health, and was cared for by his sister. His last years were spent working by Loch Lomond and in London where he produced a number of drawings and watercolours of Hyde Park in preparation for a series of canvases of the city which were never realized. Leslie Hunter's watercolours are inconsistent in quality. He was a fine

91 George Leslie Hunter, *Road in Provence* 15 × 20 (Ink and crayon) Sir Norman Macfarlane

draughtsman and his free use of pen-and-ink, and his quick sketches with the brush, can be outstanding in their vitality and quality and economy. At times, however, his drawings lack substance and form, and were certainly intended as *aides-mémoire* rather than finished water-colours in their own right.

Samuel John Peploe (1871–1935) painted comparatively few water-colours, although he did produce drawings in charcoal and coloured chalks which are strong in construction and colour. Peploe was born in Edinburgh and began to study law at Edinburgh University before turning to art, studying at Edinburgh College of Art and Julian's in Paris. France left a great impression on Peploe, and he returned with his close friend, J.D. Fergusson, working in the north-coast ports and eventually settling in Paris for a period before World War I. Here Peploe had a wide circle of friends including Fergusson, E. A. Taylor and his wife Jessie King. The rapid development of art during this period excited Peploe and he moved towards brighter colours. After the war Peploe continued to visit France, although he also worked in Iona after Cadell had introduced him to the island's landscape. He was self-critical, often leaving canvases unfinished, and he made extensive use of drawings as studies for his oils. These studies were often exhibited alongside the oils at his one-man shows. Peploe's chalk drawings, often executed on brown paper, share the same robust energy as his oils.

Peploe's close friend, **John D. Fergusson** (1874–1961) was a water-colourist of some importance. Born in Leith, he studied to be a doctor, before turning to art. As a young man he was excited by the work of Arthur Melville, and some of his earliest watercolours such as *The Last Boat to Leith* (Glasgow) and *Morocco* (Hunterian) show a debt to the 'blottesque' technique of the Glasgow School. Fergusson's first water-colours were painted in Edinburgh where he had a studio and where he saw the work of the Glasgow School which he so much admired:

> By painting I mean using oil paint as a medium to express the beauty of light on surfaces. What we used to call in Scotland 'quality of paint' – with solidity and guts! – not drawing a map-like outline and filling in the spaces with an imitation of the colour of the object with paint. That is the difference between the Glasgow School paintings and academic paintings.[1]

In 1905 Fergusson, accompanied by Peploe, went to Paris where Fergusson was to remain until the outbreak of war. Fergusson had visited Paris briefly in 1897, but now he was to become deeply involved in the development of Cubism and Fauvism and became a personal friend of such painters as Picasso, Braque, Vlaminck, Friesz and de Segonzac. During this period in Paris, he painted some of his most individual watercolours, depicting elegant ladies in fashionable dress, painted in a style which owes much to the more decorative aspects of Fauvism, but with a more subtle use of colour. Fergusson had long been interested in the theatre, music halls and ballet, and the colour and drama of the Ballet Russe, both visually and musically, fascinated

92 John Duncan Fergusson, *After the Concert* $15\frac{7}{8} \times 12\frac{7}{8}$ University of Glasgow

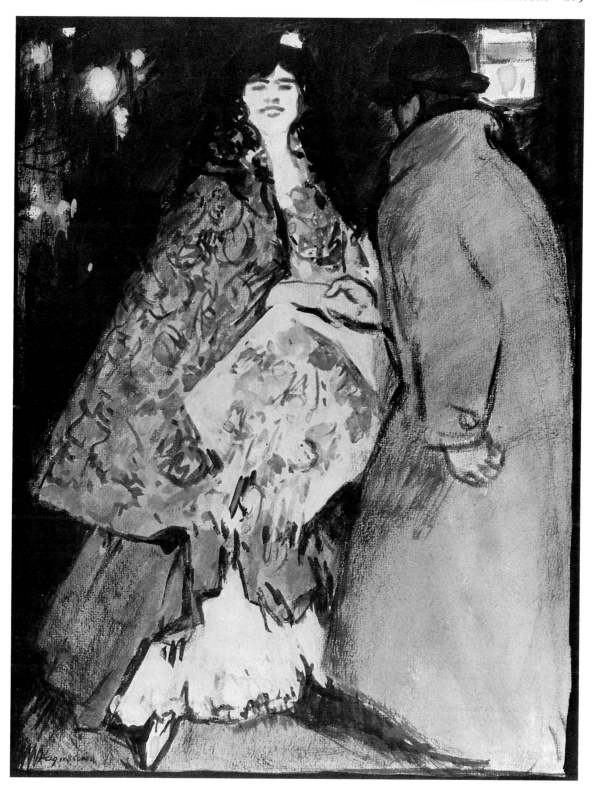

him. *After the Concert* (fig. 92) is typical of the stylized portraits of the period 1905–1913, and looks forward to the stylized watercolours of the 1920s. Fergusson sat in the cafés on the Paris boulevards, sketching the latest fashions, and many of his watercolours of the period combine Fauvist ideas with contemporary fashion. During this time he also painted highly constructed landscapes in watercolour and charcoal such as *The Church at Royon* (1910 Hunterian) and portraits influenced by Cubist theories, such as *Mrs Peploe and Willie* (1911 Hunterian).

While in Paris Fergusson had visited the Northern French ports, often accompanied by Peploe, but he longed for the South, and in 1913 settled in Cap d'Antibes. The colours of the South were important for Fergusson, but on the outbreak of war, he was forced to return to Britain, where he worked in London and Edinburgh. After the war, Fergusson went on a sketching tour of the Highlands with John Ressich, producing drawings and watercolours, which he later worked up into larger canvases. In these Highland landscapes, his elegant watercolour style gives way to a more powerful vision, based on strong charcoal outlines and colour washes, although he continued to paint stylish watercolours of women throughout the 1920s. Examples of these can be found in the Hunterian – *At the Serpentine* (1921) and *Blonde, Bourne End* (1926). In 1923 Fergusson returned to Antibes for a holiday, settling in Paris two years later, and remaining there until 1939. During this time he became a well-known figure among both French and foreign artists in the city. While his interest in dance and the female form persisted, the bulk of his work was now in oil rather than watercolour. The Second World War again forced Fergusson to return to Britain and he settled in Glasgow, returning to France from 1950 onwards for an annual holiday. Although Fergusson produced many powerful drawings in his later years, the bulk of his watercolours were painted before 1930.

Although **Stanley Cursiter** (1887–1976) was not considered as one of the Colourists, he was a friend and biographer to members of the Group. Born in Kirkwall, Orkney, he studied at Edinburgh College of Art and was inspired by the 1912 Severini Exhibition in Edinburgh, producing, as a result, a series of Futurist oils and watercolours. Having been gassed in World War I, he was sent to Cassis to recover, where he began to paint the landscape and architecture of the South of France. His watercolour style of the 1920s is elegant and fluent with vibrant colours and virtuoso brushwork. He also painted more subdued watercolours of the East Lothians, Shetlands and Orkneys. Cursiter was appointed keeper of the National Gallery of Scotland and King's Painter and Limner in Scotland. **Peter Wishart** (1852–1932) is an unusual and interesting watercolourist who was older than the other artists discussed in this chapter, and yet whose style looked forward to the twentieth century. He was influenced by the later work of Mc-Taggart and developed his own individual style which has Expressionist tendencies. Wishart painted entirely in Scotland, capturing windy days by the sea or storm-swept mountains with energy and gusto, using

long sweeps of the brush with deep blues and greens predominating. Wishart lived in Edinburgh, painting right up to his death in 1932 aged 80.

The work of the Edinburgh Group of artists has received much attention in recent years with exhibitions devoted to William Gillies, John Maxwell, Ann Redpath, Penelope Beaton and others; they have done much to show the vitality, verve and originality of these artists, who have no real counterparts amongst English watercolourists of the period. **Sir William Gillies** (1898–1973) must rate with Mackintosh as the leading Scottish watercolourist of this century; an artist most at home in watercolour and devoted to the Scottish landscape. Born in Haddington, East Lothian, his interest in art was encouraged by his uncle William Ryle Smith, an art teacher and watercolourist who worked at Broughty Ferry. Ryle Smith had a number of watercolours by Scottish artists including two by J. W. Herald, which Gillies particularly admired. He was also encouraged to look at those nineteenth-century east coast Scottish artists who had been inspired by the Dutch School, and possibly Gillies's outstanding ability to paint skies derives partly from these early influences. In 1916 Gillies enrolled at Edinburgh College of Art, but was called up in 1917. On his return from the war he found himself amongst a group of students and staff sympathetic to developments in modern art in Scotland and France. The Head of School was David Alison, a portrait painter whose handling of oil was important to Gillies, while his assistant, D. M. Sutherland, had a direct influence on Gillies, which he acknowledged: 'There was something exciting about him and his brilliant handling of colour'.[2] Adam Bruce Thomson and Donald Moodie were also on the staff, while amongst his fellow students were William MacTaggart and William Geissler. In 1922 Gillies graduated from the college and was given a one-year post-graduate grant, and in 1923 he received a Travelling Scholarship which enabled him to visit France and Italy. He travelled to Paris with William Geissler and enrolled in André Lhote's studio, an atelier where students from throughout Europe could learn a middle-of-the-road decorative Cubism. To Gillies this stylized approach had little appeal, and he soon moved on to Florence. Shortly after his return to Scotland, Gillies was appointed art master at Inverness Academy, but in 1926 he was offered a part-time post at Edinburgh College of Art and he returned to Edinburgh to join the staff which now included John Maxwell and William MacTaggart, in addition to D. M. Sutherland, Adam Bruce Thomson and Donald Moodie. The stimulus of both talented staff and students was vital to the development of Gillies's art, and in 1922 a 'ginger group' of young artists was formed consisting of Gillies, William Crozier, Herbert Gunn, Geissler and George Wright Hall.

During the late 1920s and early 1930s, Gillies developed a powerful and unique watercolour style. Until about 1929, the structure of his paintings was formalized and even Cubist in inspiration, but he was moving towards a more Expressionist, freer style. The 1931 Munch

exhibition at the Society of Scottish Artists may well have influenced this movement towards greater freedom, but the main development came from within himself. In 1929 he visited Kirkcudbright with John Maxwell, who had studied at Edinburgh College from 1921 to 1927 and had joined the staff in 1929. In the following year he spent a holiday in Morar, on the west coast opposite Skye, again with John Maxwell, and throughout the 1930s worked on the west coast, including Ardnamurchan, Morar and the Kyle of Lochalsh. He worked quickly in the open air making spontaneous sketches from nature. Gillies's love of the Scottish landscape, and his determination to paint directly from nature, unencumbered by studio techniques and formalized styles, were the basis of his art. The changing weather, the great skyscapes and the natural power of the uninhabited coastline were essential to Gillies's watercolours. Some have blotches which bear witness to a passing rain storm:

> I have always enjoyed weather, always seen landscape pictorially; and I've
> got immense pleasure from recording swiftly in drawings and watercolours
> the fugitive, the subtle and the grand . . .[3]

This close communication with nature possibly finds its closest comparison in watercolours by Emil Nolde, although Gillies's rich blues, browns and greens are more sonorous and less strident than Nolde's Expressionist palette. Gillies rarely used precise outlines for landscape watercolours of the 1930s, preferring to work with a fully charged, long hogshair brush, and it was only towards the end of the decade that he began to adopt a more linear style. An unusual watercolour, *In Ardnamurchan* (SNGMA), includes three figures, those of his mother, sister and aunt with whom he had visited the peninsula. Figures rarely appear in Gillies's work, either in this period or during the post-war years.

The 1930s were a productive period for Gillies. He enjoyed the companionship and inspiration from members of Edinburgh College to which he was appointed a full-time lecturer in 1934, and he also benefited from exhibiting with the Society of 8. In 1939 he moved to Temple, a village outside Edinburgh, which was to become his home for many years. He chose often to repeat certain views in different moods and the landscape around Temple came to appeal to him as much as the west coast. The villages of Temple, Haddington, East Linton, Howgate and Gifford appear in his watercolours, their stone houses set against the undulating countryside, visited by Gillies on his motorcycle. He was developing a tighter, more linear style in which a pen-and-ink or pencil outline is set against an Expressionist handling of watercolour. The more complex landscapes which he chose after 1940 are ideally suited to this technique – intricate patterns on roofs, clearly defined winter trees, roads winding up hills, around corners and back into view. The power of the earlier watercolours is not lost: stormy skies dominate landscapes devoid of figures, but with brooding atmosphere. Gillies's mastery of skies develops with attention to the

structure of clouds, and, not surprisingly, he found it difficult to paint on clear summer days: 'Weather almost too good for painting – no clouds at all – so subject not as big as I'd like'.[4] In addition to the Lothians and Border landscapes, he also painted in the east coast fishing villages, the haunt of so many Scottish watercolourists, like Bough or Herald. In these often complex watercolours, Gillies faithfully depicts the topography so that one can today identify the view exactly as in *St Monance from the Harbour* (colour plate 8). Gillies handles the intricate foreground of lobster nets and ropes with skill, while the buildings behind are an accurate account of what exists today. Still water also attracted Gillies's attention as a subject, and several fine watercolours exist depicting reservoirs and lakes with their reflections. Gillies's magnificent pen-and-ink drawings should also be noted, with their varying and subtle lines combining with his acute eye for architectural detail.

After the war, appointments and honours were heaped upon Gillies. In 1946 he was made Head of Drawing and Painting at Edinburgh College of Art and a full RSA in the same year. In 1960 he became Principal of the College and in 1963 President of the RSW. He also received recognition from London, being made C.B.E., a member of the Royal Academy and, finally in 1970 receiving a knighthood. He remained modest and hard-working, dedicated to both painting and teaching, and despite spending much time at the College, his art never suffered, as has been the case of many artists too involved in the administration of art schools. The directness of his watercolours, his lack of formulae or theories, his firm draughtsmanship combined with a fluent watercolour technique, and his understanding of the Scottish landscape, combine to make Gillies one of the most memorable of Scottish watercolourists.

John Maxwell (1905–1962) was a close friend and colleague of Gillies. Born in Dalbeattie, Kirkcudbright, he began to study at Edinburgh College of Art in 1921, where he met Gillies who was in his last year as a student. Like Gillies, he won a Travelling Scholarship and spent a period in Paris in 1925 working under Leger and Ozenfant. Wheres Gillies had been largely immune to French influences, Maxwell's stay in Paris was important to his development, as he came to admire the work of the French Symbolists, in particular, Odilon Redon. He was also deeply impressed by the vivid, evocative work of Marc Chagall. In 1929 he joined the staff of Edinburgh College of Art and benefited from a stimulating and talented environment. He worked for a period with Gerald Moira, Principal of the College, on the murals for St Cuthbert's church and he saw Moira's fluent handling of watercolour and his vivid sense of colour.

Maxwell and Gillies went on painting trips together, the first being to Kirkcudbrightshire in the late 1920s, followed by visits to Morar, Ardnamurchan, and the Kyle of Lochalsh in the 1930s. Gillies respected Maxwell's painting, although their approaches were radically different, and he wrote an appreciation of Maxwell's art after his early

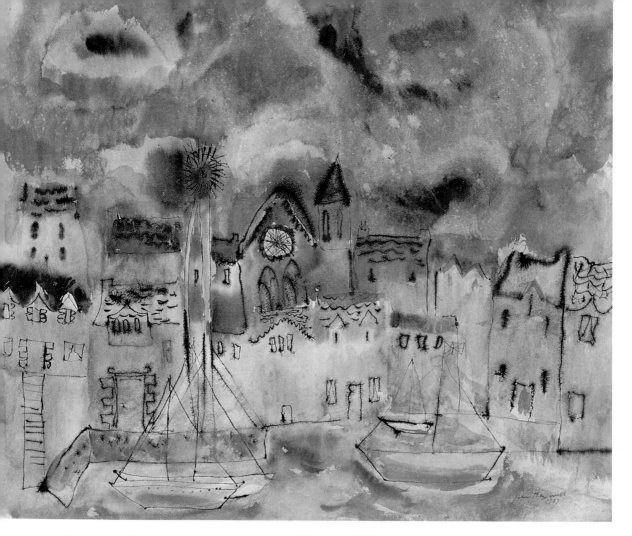

93 John Maxwell, *Harbour with Warning Light* 1937 20 × 24½ Aberdeen Art Gallery and Museums Photograph, The Scottish Gallery, Edinburgh

death in 1962. Whereas Gillies worked fast, often producing as many as five or six watercolours a day, Maxwell painted slowly and painstakingly, revising certain areas and worrying about every passage. Spontaneity is the essence of Gillies's watercolours, but it played little part in Maxwell's carefully considered and introspective work. Whereas Gillies aimed at capturing the mood and feeling of a place, Maxwell created his own personal vision, based upon, but not dominated by, the view in front of him. His interest lay in the quality of line or in experiments with mixed media of watercolour, pen-and-ink, chalk and gouache (fig. 93). Working outside in the 1930s he produced fascinating pen-and-ink drawings coloured with strong washes in which he explores the details of grasses, flowers and hedgerows, rather than concerning himself with the overall mood of the place. Maxwell's watercolour technique became increasingly complex in the 1930s and was not suited to working out-of-doors. He saturated his paper in water, then placed it on a sheet of glass, working into the paper with pen and ink, while observing the bleeding between the ink and areas of wet colour. The watercolour, when dry, could be heightened with chalks.

During the later 1930s Maxwell moved away from landscape towards figures, in which the influence of Chagall can be seen, as well as that of Dufy. Single heads or figures in imaginary landscapes are depicted in Maxwell's extraordinary combination of a rich, wet watercolour technique combined with delicate pen-and-ink added later. His drawing of figures, although never academic, is always convincing, having a natural sense of movement. In 1943 Maxwell left the college on grounds of poor health and retired to Dalbeattie where he continued to work in watercolour. In 1955 he returned for a period to Edinburgh College, but died aged 61 in 1961. Maxwell's watercolours are unique in Scottish art – although influenced by his contemporaries in Edinburgh and by developments in Paris, he created a personal dream-like world through an individual technique.

Anne Redpath (1895–1965) joined Edinburgh College of Art in 1913 and was immediately impressed by the work of her tutors, in particular D. M. Sutherland and Adam Bruce Thomson. In 1919, as soon as possible after the war, she visited Brussels, Bruges and Paris, before moving on to Italy where she stayed in Florence and Siena. Here she was particularly struck by the work of the Sienese 'Primitives' – the Lorinzettis and Simone Martini. In the following year she married James Michie, an architect working with the War Graves Commission in France, and settled in the Pas-de-Calais, moving South to St Jean, Cap Ferrat in 1925. During this period she continued to paint and held two exhibitions in France as well as sending works to the RSA exhibitions, but most of her energies were devoted to bringing up her family, and she remained isolated from the developments taking place in Edinburgh.

In 1934 Redpath returned to Scotland and was soon exhibiting at the RSA, RSW and Society of Scottish Artists. During the 1930s she produced many watercolours in a highly constructed, but never overworked, style. These watercolours are cool in colour and are carefully, almost architecturally, composed. Quite different from the Expressionist tendencies of Gillies or the soft lyricism of Maxwell, they come closest in feeling to the watercolours of William Crozier. Redpath uses careful pencil or charcoal outlines which are filled with flat washes of pale colours, and it is possible to see the influence of her husband's architectural work in this approach. Her subjects at this time include views of Southern France and landscapes painted around Hawick in the Borders. During the 1940s, Redpath continued to work in both watercolour and oils, her oils showing a debt to Matisse in terms of colour and composition, while her watercolours remain individual and largely uninfluenced by Gillies. Some of her best works date to the 1940s, when in addition to landscapes around Hawick, she painted still-lifes, flowers and figures in interiors. Various objects, such as Venetian glass vases, a Worcester jug and simple ceramic dishes with folk designs, are included in works executed both in watercolours and in oils.

After the war, Redpath was able to return to France, staying in

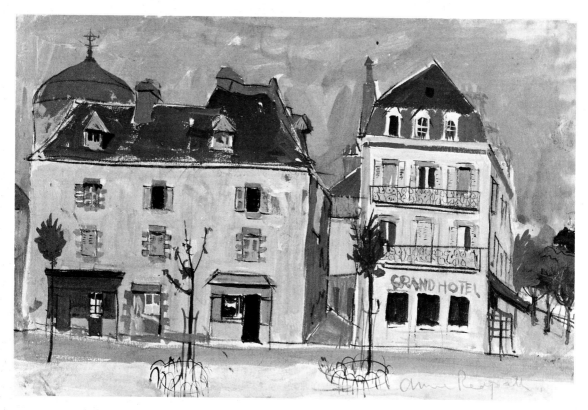

94 Anne Redpath, *The Grand Hotel, Concarneau* 10 × 14 Bourne Fine Art

Menton and Paris in 1948 and visiting Spain the first time in 1951. She was also working in many areas of Scotland including the east coast fishing villages, and on Skye. Her love of travel took her to Italy, Portugal, Corsica and the Canary Isles on almost annual painting trips in the 1950s and '60s. During her later years, Redpath developed a rich impasto technique of oil painting, and her watercolours also became stronger in colour and freer in handling. Some of her watercolours of Italy with figures in strong sunlight capture the intensity of colour and light to great effect, although it is probably true to say that the earlier watercolours are more individual in style, composition and colour. Anne Redpath, like Gillies, met with considerable critical acclaim. She was elected a full RSA in 1952 and was awarded an OBE in 1955.

Willie Wilson (1905–1972) was also closely involved with Gillies, Maxwell and the Edinburgh College of Art, and his watercolours clearly show the influence of Gillies's powerful style. Wilson's large watercolours of Scotland painted in the 1930s are close to the prevailing Expressionist tendencies of the Edinburgh Group, although he made greater use of constructive outlines and used a more vigorous framework of pen-and-ink in his drawing. Wilson's interest in architecture is a feature of his watercolours and in many of his works a church or a group of houses predominates, as in the views of Dean Village or the many views of French hill-towns or squares with their churches; he

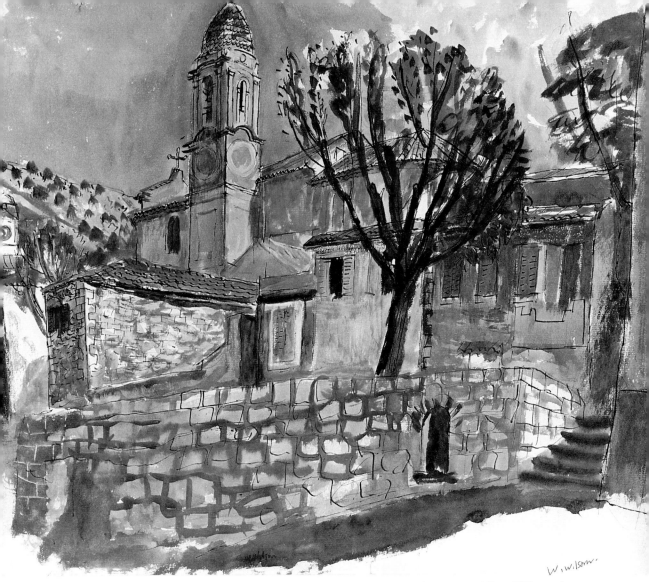

W. Wilson.

painted some of his best watercolours in Provence (fig. 95). He also painted some powerful views in the Italian Dolomites in the mid-1930s. Wilson's watercolours are more restrained than those of Gillies, being based on a pen-and-ink construction, but they retain the fluency and power associated with the Group.

Sir William MacTaggart (1903–1981) is known for his bold oil paintings and as a successful President of the RSA rather than as a watercolourist, but as a younger man he worked in watercolour; and throughout his life he produced working sketches, often in a combination of charcoal and watercolour and sometimes in gouache. Born in Loanhead, he was great-grandson of the famous artist, and became a student at Edinburgh College in 1918, meeting Gillies in the following year. His closest friend at the time was William Crozier, ten years his elder with a knowledge of France and Italy and their artistic traditions. During the 1920s MacTaggart visited France on many occasions, going to the South as a cure for his ill health. The colours of the

95 William Wilson, *A Village in the South of France*
20 × 24 The Scottish Gallery, Edinburgh

Midi and its rich sensations are revealed in his work, although he also worked in Norway and in the North of France. Like Gillies, MacTaggart also enjoyed the Scottish landscape, in particular coastal views, and his watercolours are a powerful combination of ink, charcoal and coloured washes, which, while lacking the subtleties of Gillies or Maxwell, nevertheless reveal a strong artistic personality.

MacTaggart's friend **William Crozier** (1893–1930) was an important influence in the formative years of the Edinburgh Group, despite his early death and limited output. A student at Edinburgh College, he was a man of great intellectual ability with a knowledge of France and Italy, their languages and cultures. This breadth of knowledge was important for his contemporaries at the College, many of whom were encouraged to travel abroad. Crozier died before the real development of an Edinburgh Group 'style' in the 1930s, but his watercolours of the 1920s reveal a definite artistic character. In 1923 he visited Paris and studied at André Lhote's studio along with Gillies and Geissler, but whereas Gillies rejected Lhote's teaching, Crozier admired his work. The influence of the decorative Cubism of Lhote or Roger de La Fresnaye can be seen in *Berwick-on-Tweed* (fig. 96) with its strong sense of construction, achieved with charcoal outlines containing flat areas of wash, a style not unlike that of William Hanna Clarke. Other

96 William Crozier, *Berwick-on-Tweed* $10\frac{1}{2} \times 14\frac{1}{2}$ Private collection

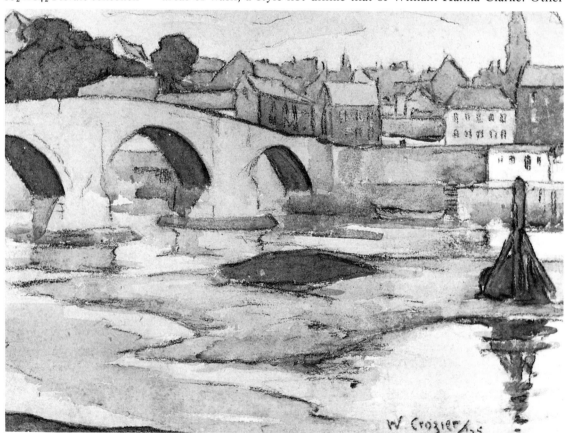

97 Penelope Beaton, *Leith Harbour*
13 × 20 The Scottish Gallery, Edinburgh

watercolours by Crozier of the later 1920s show the same stylish sense of construction, suggesting that he was seeking abstract pictorial qualities within a figurative framework. During the later 1920s, Crozier shared a studio with MacTaggart and together they visited France, Italy and the Netherlands. On his return from Europe in 1930, Crozier, who was haemophiliac, fell in the studio and died of internal bleeding at the age of 37.

Penelope Beaton (1886–1963) is remembered by students of Edinburgh College as a dedicated teacher in charge of the Junior Department of the School of Drawing and Painting, similar to the modern Foundation Course. As a student she had trained at the College, obtaining her Diploma in 1917 and teaching at Hamilton Academy for two years until she was invited to join the staff of the college in 1919. Her colleagues on the staff included A. B. Thomson and Donald Moodie, whose adventurous use of colour and fluid drawing greatly impressed her. Among the students of the period were Gillies, MacTaggart and Maxwell. Little has been written about Penelope Beaton's long career, and, until the recent retrospective, few of her paintings had been exhibited.[5] She spent much energy in her teaching and was less concerned about establishing a reputation as an artist than many of her contemporaries. During the 1930s her watercolours owed much to Gillies's Expressionist style although her colours were 'sweeter', but during the 1940s she moved towards a more constructed manner, painting views of east coast harbours like Stonehaven, Newhaven or Leith (fig. 97), as well as Iona. Her later watercolours make use of a pen-and-ink framework coloured with rich and sonorous tones. She was also a fine flower painter.

D. M. Sutherland (1883–1973) is closely associated with the Edinburgh artists as a result of his role as teacher at Edinburgh College between 1913 and 1933. Born in Wick, he studied at the RSA School

in Edinburgh where he was inspired by the teaching of Charles Mackie. In 1912 he joined A. R. Sturrock, G. Spence Smith, Eric Robertson, W. O. Hutchison and others to form the Edinburgh Group, while also exhibiting at the RSA. Visits to Paris and Spain in 1911 and to Holland and Belgium in 1913 were important for his development, and after the war, in the early 1920s, he was to return to Brittany for several summers' painting. After serving in the war, he returned to Edinburgh College and helped reform the Edinburgh Group in 1920 with the addition of Cecile Walton, Mary Newbery and Dorothy Johnstone, whom he was to marry in 1924. As a teacher Sutherland was respected and liked by his colleagues and students, who included Gillies, Geissler and MacTaggart. During the late 1920s he began to explore the north-east coast of Scotland visiting Caithness and the villages of Buchan, often camping with Gillies and Maxwell. Although primarily an oil painter, he produced fine watercolours and pen-and-wash drawings in which the influence of Gillies's landscapes can again be felt, especially in his energetic use of the pen. In 1933 Sutherland was appointed head of Gray's School of Art in Aberdeen and for the next 15 years he built up the reputation of the School. Sutherland continued to paint in northern Scotland, on the west coast at Plockton and Gruinard Bay, and on the east coast in Caithness and Cuits, Aberdeenshire where he retired in 1948. Sutherland's wife, **Dorothy Johnstone** (1892–1980) should be mentioned with the Edinburgh Group. The daughter of George Whitton Johnstone (1849–1901), she studied at Edinburgh College of Art working under E. S. Lumsden and winning a travelling scholarship to Italy. Her close friend Cecile Walton introduced her to E. A. Walton, the Newbery family, and members of the Glasgow School. Her earlier works are life-studies, portraits and figure-paintings in oils and in 1914 she was appointed to the staff of Edinburgh College. During the summer months, Dorothy Johnstone worked in Kirkcudbright along with artists such as Anna Hotchkis, May Brown, Cecile Walton, and, after their return from Paris, Jessie King and E. A. Taylor. Johnstone's stylish portraits of this period capture not only the sitter's character, but also the feel of Edinburgh society in the 1920s. Her marriage to D. M. Sutherland in 1924, followed by the birth of two children, meant a curtailment of her painting and, in 1933, the family moved to Aberdeen. During holidays to Plockton and to the east coast, she found time to paint landscapes, often in watercolour, and her reputation as a portrait painter, particularly of children, continued into the 1970s.

The staff of Edinburgh College included several other significant watercolourists. **Donald Moodie** (1892–1963) studied at the College before joining the staff in 1919, a teacher sympathetic to the progressive ideas of students such as Gillies, Maxwell and MacTaggart, his free watercolour technique with its daring use of colour and fluid drawing was admired by both pupils and staff. **Adam Bruce Thomson** (1885–1976) was also a member of staff interested in the new developments in art and was himself influenced by Gillies's watercolours of the 1930s,

98 Adam Bruce Thomson,
The Sound of Iona
12 × 16 The Scottish Gallery,
Edinburgh

owing much to Gillies's method of working on a large scale with rich colours and free, Expressionist drawing. Although he lacked that subtleness of line which makes Gillies's and Maxwell's work so distinctive, Thomson nevertheless created impressive watercolours, at times powerful, at times lyrical. His feel for nature and his response to colours in the landscape can be seen in *The Sound of Iona* (fig. 98). Working around Edinburgh, in the Borders and on Iona as well as in the Highlands, Thomson continued to work in watercolours throughout a long career and was President of the RSW from 1956 to 1963.

Henry Lintott (1877–1965) was an important and respected member of the College staff. Born in Brighton he studied at Brighton School of Art and the Royal College of Art, joining the staff of Edinburgh in 1902, when the college was still part of the Royal Institution, housed in the present RSA Galleries. In Edinburgh Lintott was known for his large oils of women in graceful dance or song, but he also painted intimate watercolours of the Sussex Downs and Richmond Park. There are several students of the same generation as Gillies, Maxwell, Redpath and MacTaggart whose work has not yet received the attention it deserves. **William Geissler** was a close friend of Gillies and joined the 1922 Group on its formation. In the following year he visited Paris with Gillies to study under Lhote, whose bright colours and bold formal design had a great influence on Geissler. Geissler's watercolours have been neglected although his work, depicting the Scottish land-

scape, is strong and colourful. **George Wright Hall** (1895–1974) was also a member of the 1922 Group, but was better known for his portraits. His watercolours of landscapes have a subtle use of pen-and-ink combined with rich colours, and are more controlled than those of MacTaggart and Thomson.

Although the artists around Gillies and Maxwell provided a progressive lobby between the wars in Edinburgh, there was also an important group of Edinburgh artists who had left Edinburgh College before the outbreak of war in 1914 and who had established the Edinburgh Group in 1912. **John Guthrie Spence Smith** (1880–1951) was born in Perth, and studied at the RSA Schools and Edinburgh College before the arrival of the more progressive teachers. Born both deaf and dumb, he was known with affection as 'Dumby' and was a well known figure in Edinburgh. His watercolours are boldly painted in large 'blobs' of colour which go beyond the more controlled Glasgow 'blottesque'. He enjoyed painting in France and many of his watercolours depict the bustle of a French market day. He also painted horses with sympathy and other watercolours depict farm horses ploughing or with carts. **Alick Riddell Sturrock** (1885–1953) was also a member of the 1912 Edinburgh Group and although he painted mostly in oils, his watercolours are of interest. Like Spence Smith he studied at Edinburgh College and the RSA Schools before the war; his watercolours deal with rural subjects and he creates massive forms out of farmbuildings, haystacks and trees. **John Rankine Barclay** (1884–1962) studied with Sturrock in Edinburgh. He worked in both oils and watercolour often depicting figures in a landscape or a town setting, in an individual and sometimes experimental style, which was, at times, inconsistent in quality. He was, however, a good draughtsman and his work deserves greater attention. He later moved to St Ives where he died.

There are other under-valued watercolourists who studied at Edinburgh College and whose work between the wars deserves some attention. **Robert Scott Irving** (born 1906) produced watercolours in a stylized manner which bears some similarity to John Nash. Born in Edinburgh he studied at the College from 1922 to 1927. He paints views around Edinburgh as well as on the west coast, in particular in Arran. **Charles Goddard Napier** (1889–1978) was a student at the College from 1911 to 1914 and was influenced by the ideas of David Alison. His style is quite different from the predominant Gillies influence, being based on elegantly designed flat areas of colour of an almost architectural severity. He enjoyed painting carefully constructed landscape and architectural subjects, while his figures have a charming frozen quality. Napier moved to Oxford for a period in the 1930s and painted scenes of London and Devon while working in the south. He held an exhibition in London in 1934 but later returned to Edinburgh.

Animal painting is less well represented in this period than during the later nineteenth century. William Walls continued to work throughout the 1920s and 1930s, but Edwin Alexander ceased work in 1914; Crawhall had died in the previous year. There were no animal and bird

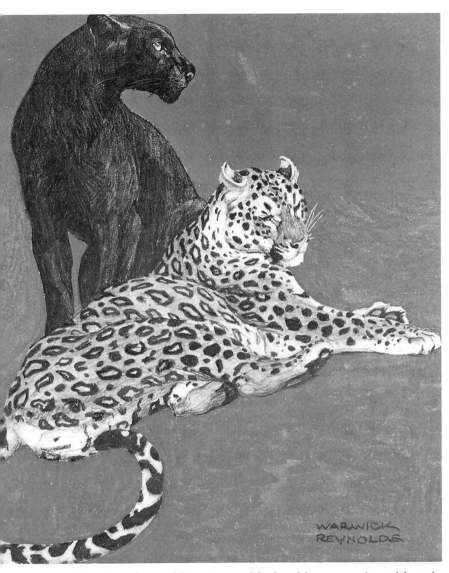

99 Warwick Reynolds, *Jaguar and Black Panther* $13\frac{1}{4} \times 11\frac{3}{8}$ Aberdeen Art Gallery and Museums

watercolourists who could compare with the older generation, although **John Murray Thomson** (1885–1974) did produce some fine watercolours of birds. He was born in Crieff and studied at Edinburgh College and the RSA Schools where he won the Carnegie Travelling Scholarship. Like William Walls he worked in Continental zoos including Paris, Rotterdam, Amsterdam and Berlin, and was also a member of staff at Edinburgh College. His watercolours of birds at their best are delicate and well-observed, although some of his larger watercolours are somewhat pedestrian in colour, handling and drawing. **Ralston Gudgeon** (born 1910) began exhibiting watercolours in the 1930s at the RSW. His paintings of birds are variable in quality: at times he combines careful observation with striking design, but on occasions his colours and composition appear forced. **Warwick Reynolds** (1880–

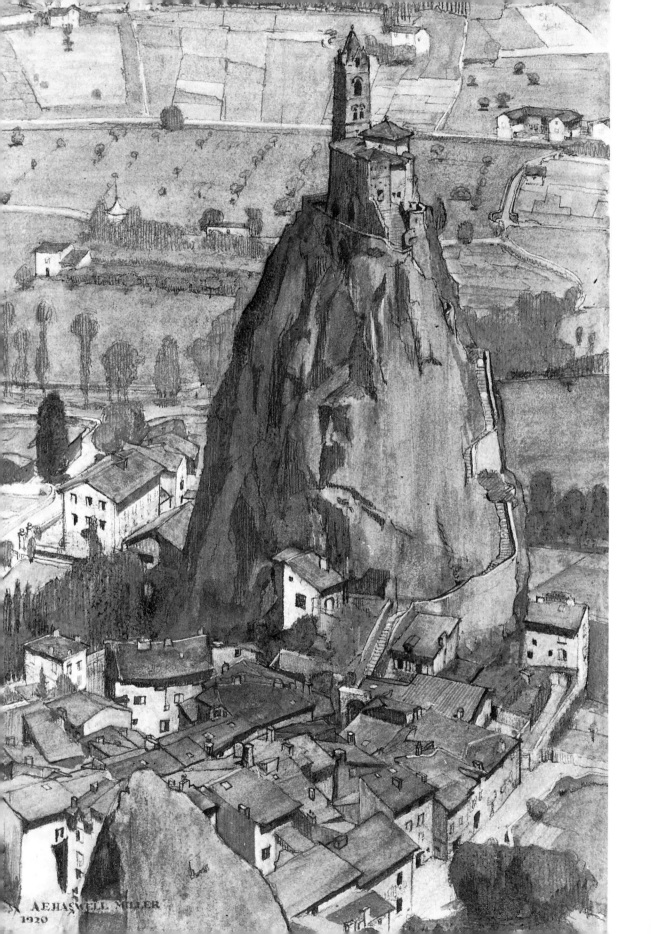

AEHASWELL MILLER
1920

1926) was not a Scottish artist, being born in London, but he settled in Glasgow and exhibited at the RSW. His father had worked as an illustrator in London and Warwick Reynolds himself had produced illustrations. This is reflected in his watercolours which have a strong sense of graphic design with clearly drawn animals against flat coloured backgrounds (fig. 99).

Whereas the influence of William Gillies can be felt in many water-colours produced in Edinburgh at this time, there is less sense of cohesion amongst the Glasgow watercolourists. **A. E. Haswell Miller** (1887–1979) was one of the leading figures in Glasgow between the wars. He studied at the School of Art from 1906 to 1909 joining the staff in the following year. After serving in the Great War he returned to the staff in 1919 and remained Assistant Professor until 1930 when he became Keeper and Deputy Director of the National Galleries of Scotland, a post he retained until his retirement in 1952. He is probably best known for his drawings of military costume and Highland dress and a retrospective exhibition of these was held in 1971 at the Imperial War Museum, London; but he also painted powerful landscapes in which an unusual and dramatic composition is combined with rich colours. *Rocher St Michel, Le Puy* (fig. 100) is an example of his con-structive use of line and flat areas of colour. His wife, **Josephine Haswell Miller** (1890–1975), also worked in watercolour. **George Houston** (1869–1947) was a prolific painter in both oils and water-colours, working in a style uninfluenced by modernist trends, similar in feeling to Lamorna Birch and possibly best described as 'late Impressionist'. He worked mainly in Ayrshire and Argyllshire and his talent lay in creating a feeling for the atmosphere, season, and climatic condition of each scene. His construction is usually simple and direct with wide expanses of pastures or a loch set against distant mountains. His watercolours, which can be quite large, have a delighful ease of execution, with clear colours and wet washes (fig. 101). His use of strong blues and greens is remarkable, as was his ability to paint snow. A critic, J. Taylor, wrote in *The Studio*:

> This artist paints in all weathers and seasons, but spring, with fresh tints and lingering frost bite, makes a special appeal to him. He catches its crisp-ness, and conveys its promise in a way that no other artist succeeds in doing . . . the intimate spirit of the country life is here.

James Hamilton Mackenzie (1875–1926) was a well known figure in Glasgow and was President of the Art Club in 1922–24. He was trained at the School of Art and won a Haldane Travelling Scholarship to Florence, continuing to visit the Continent, in particular Belgium and Italy, throughout his life. During the war he worked in German East Africa and his war-time drawings and watercolours were repro-duced in *The Studio Special War Number* of 1918. He worked in watercolours, oils and pastels and as an etcher with a strong sense of composition, often using black outlines. His watercolours are con-structed with a charcoal framework and bold colours, possibly influ-

100 Archibald Elliot Haswell Miller, *Rocher St Michel, Le Puy* 1920 $15\frac{3}{4} \times 10\frac{7}{8}$ Glasgow Art Gallery

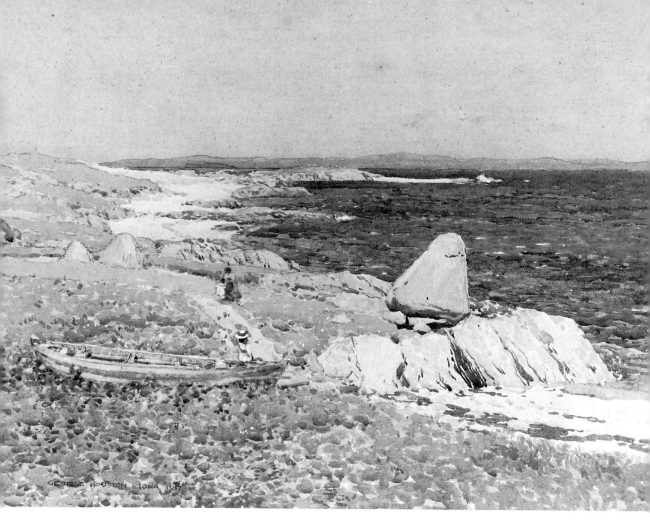

101 George Houston, *The Erratic Boulder, Iona* 1917 $17\frac{3}{4} \times 23\frac{1}{8}$ Glasgow Art Gallery

enced by the Colourists. He died in a train crash outside Glasgow aged 51. The career of **William Hanna Clarke** (1882–1924) was also ended tragically young when he fell from a ladder in his house in Kirkcudbright. Born in Glasgow, he settled in Kirkcudbright and painted mostly landscapes. His watercolours are firmly constructed with charcoal outlines filled in with fresh transparent washes in a style not unlike that of William Crozier (fig. 102).

Robert Eadie (1877–1954) worked in many fields including portraiture, poster design, lithography and watercolour. He was born in Glasgow and studied in Paris and Munich. Eadie was a fine draughtsman and his subjects included complex street scenes with figures, as well as elegant portraits and well-balanced landscapes. Possibly his most characteristic watercolours are those depicting beaches with figures in deck chairs or seated by the sea in which he captures the essence of the inter-war years. Eadie had a feel for costume and hairstyles and, whereas the work of the Edinburgh School is virtually timeless, Eadie's watercolours are fine period pieces (fig. 103). **Albert Gordon Thomas** (born 1893) was also a stylish watercolourist, born in Glasgow and trained at the School of Art. He was known not only as a painter and

illustrator, but also as a teacher in various institutions in the city. His watercolours are painted with panache, usually depicting the west coast with fresh colours, simple but effective composition, and a successful combination of charcoal and watercolour. **Robert Houston** (1891–1942) was a contemporary of Gordon Thomas at the School of Art, and was also a painter of the west coast and Isles. His watercolour style is powerful with strong outlines in charcoal, strong colours and dramatic composition. Houston's railway posters were also effective and popular, his strong sense of design being ideally suited to poster art.

James Miller (born 1893) is closely associated with Glasgow. Born in the city, he studied at the School of Art under Greiffenhagen and Anning Bell, and later taught etching there. His watercolours are powerfully constructed with pencil and charcoal outlines, and restrained washes. During the 1920s and '30s Miller travelled extensively abroad

102 William Hanna Clarke, *The Tolbooth, Kirkcudbright* $10\frac{1}{2} \times 14\frac{1}{2}$ Glasgow Art Gallery

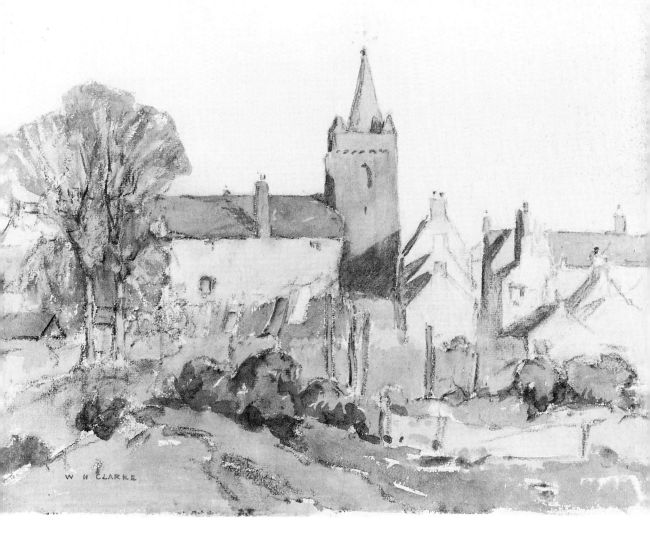

W H CLARKE

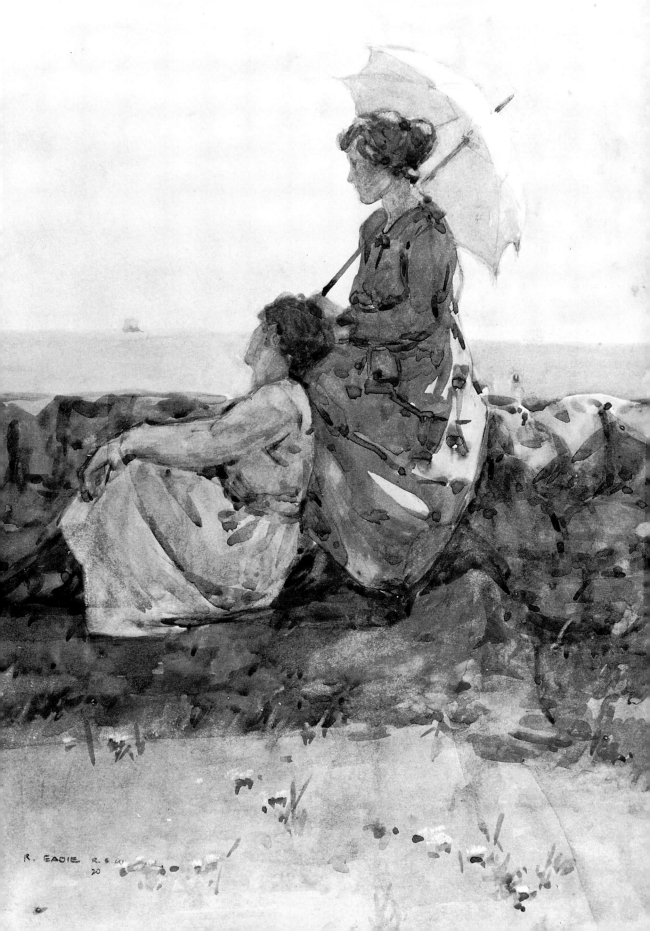

working in Spain, France, Italy and North Africa, while also working on the west coast and Skye, where he later had a house. During the war he produced some powerful watercolours of Glasgow's war damage, in which his heavy outlines and sombre colours are used to good effect. **Alex Macpherson** worked in Glasgow from the mid-1920s to the 1950s painting watercolours of the west coast and Arran. His watercolours are carefully constructed with pencil and ink outlines, resulting in solid, if somewhat unimaginative, views. **Charles Dowell** (died 1935) should also be mentioned as a watercolourist who studied at Glasgow School of Art under Fra Newbery and won a travelling scholarship to Rome. He painted extensively in watercolour, choosing views of harbours, estuaries and the open sea, capturing the effects of light on water. Dowell was also known in Glasgow for his portraits and interiors. Although **Charles Oppenheimer** (1875–1961) was born in Manchester, he lived in Kirkcudbright for many years, painting in both oils and watercolour. His landscapes are accomplished and his watercolour technique is sophisticated, being direct, fresh and realistic. A keen fisherman, Oppenheimer captures the effects of light on moving water or light on snow with great success.

There are a number of artists in this period associated with Aberdeen and the north-east. **James Cowie** (1886–1956) is one of the most interesting of modern Scottish artists, as he represents an aspect of modern British art rarely found in Scotland – a kind of 'Neue Sachlichkeit' imbued with visionary qualities. He did not see himself primarily as a watercolourist, using the medium as a stepping stone towards a finished canvas, and only comparatively rarely using watercolour as an end in itself. Born on a farm in Aberdeenshire, Cowie progressed from local school to become art master at Fraserburgh Academy in 1909 before enrolling at Glasgow School of Art in 1912. For 20 years he taught at Belshill Academy near Glasgow and it was here during the 1930s that he painted some haunting portraits of his pupils. For these portraits he produced pencil and watercolour sketches (fig. 104). His handling is sensitive, with an ability to move from sharp foreground detail to softer, wetter distances as seen in *Two Girls*. Cowie was interested in watercolour as part of a wide range of techniques. His interest in the methods of the Quattrocento painters, as well as later innovators like Degas, enabled him to experiment successfully with mixed media and he used watercolour, pastel, gouache and chalk freely together, at times in conjunction with oils. After a short period as Head of Painting at Gray's School of Art in Aberdeen, he moved to Hospitalfields, a baronial manor in Arbroath which Patrick Allan had established as a summer school for art students. Here Cowie was able to devote himself to painting, to the pursuit of literature and to teaching in the summer months. Some of his best still-lives were painted at this time with their almost Surrealist combination of objects and art historical references. *An Apple and its Reflection* (Aberdeen) combines several characteristics of Cowie's work of this period – the Tangara figurine, the series of windows or pictures

103 Robert Eadie, *By the Sea* 1920
$14\frac{1}{2} \times 10\frac{7}{8}$ Glasgow Art Gallery

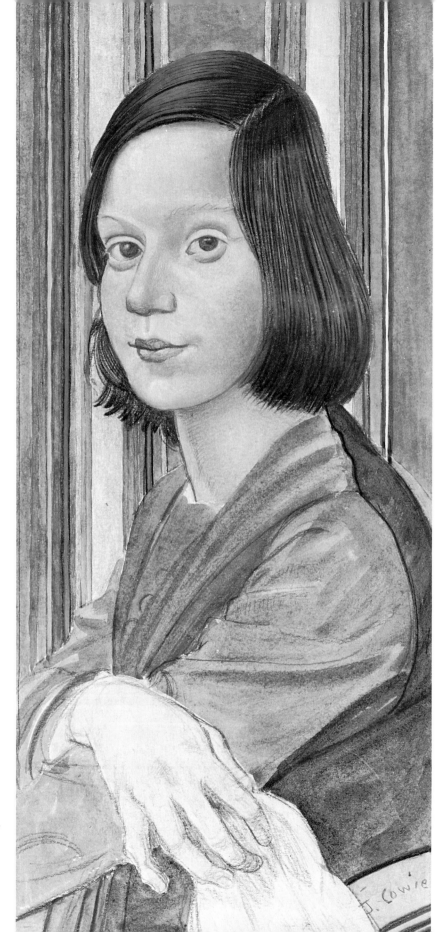

104 James Cowie, *The
Striped Background*
$15\frac{7}{8} \times 7\frac{1}{8}$ Glasgow Art Gallery

within pictures, and the highly effective use of mixed media. While at Hospitalfields, Cowie also resumed painting watercolour landscapes, from nature, which are detailed and closely observed. Although a quiet and unassuming man, Cowie had a considerable influence on many of his pupils. Whereas most of the Edinburgh School were interested only in their own work, with some passing acknowledgement to contemporary French art, Cowie was deeply involved in the Quattrocento and in the visionary work of Paul Nash. He disliked the free Expressionism of Gillies and his followers, and his constructive, literary approach to art came as a revelation to many students from Edinburgh – a revelation which left a lasting impression. Thus the work of **Henderson Blyth**, **Robert Colquhoun**, **Robert MacBryde** and **Joan Eardley** owed much to the alternative approach offered by Cowie. In particular the watercolours and pen-and-wash drawings of Henderson Blyth (1919–1970) with their unusual construction and selected detail, are indebted to the work of James Cowie.

The memory of **James McBey** (1883–1959) is recorded by the impressive McBey Print Room and Art Library in Aberdeen Art Gallery donated by his widow in 1961. Born in Newburgh, Aberdeenshire, McBey joined the North of Scotland Bank in Aberdeen in 1899 and enrolled for evening classes at Gray's School of Art. In 1910 he left the bank to devote himself to etching, visiting Amsterdam to study Rembrandt, and in the following year he moved to London to prepare for an exhibition at Goupil's. He visited Spain in search of new subjects, and returned with drawings of bullfights which he turned into prints. In 1912 he sailed for Morocco with James Kerr Lawson, the Canadian artist, and this began a long association with North Africa. It was here that McBey began to work in watercolour by adding coloured washes to his pen-and-ink drawings. In 1917, he was

105 James McBey, *The Long Patrol – Nightfall* 13th July 1917
8 × 13⅜ British Museum

appointed Official War Artist and was sent to Egypt with the British Expeditionary Force. During an intensely active two years, he produced some three hundred watercolours of Egypt and Palestine (BM and Imperial War Museum), including portraits of T. E. Lawrence and King Feisal (fig. 105). Many of these drawings later became the basis of a series of prints produced by McBey between 1919 and 1921.

During the post-war years, McBey worked hard producing many watercolours and etchings which fetched high prices in London galleries. His output was large and Martin Hardie, a close friend, has described his energy: 'Never was an artist more indefatigable. I have known in a day's bag an oil sketch, a brace of watercolours, several pen studies and an etching.'[65] McBey was also an enthusiastic traveller visiting Venice in 1924 and 1925. In 1929, and again in 1930, he sailed to the United States, where his work was greatly admired, and where he married Marguerite Loeb from Philadelphia. North Africa remained a draw to McBey, who introduced his wife to Morocco in 1932. They bought a house near Tangier, later buying a second property in Marrakesh, and some of McBey's best work was executed in Morocco. The outbreak of war in 1939 saw the McBeys in America, where they were

106 David West,
Lossiemouth
10 × 14 Private collection

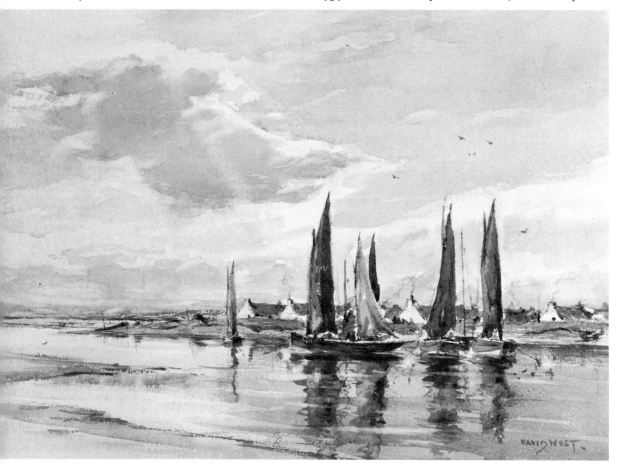

forced to remain for seven years. Despite problems with immigration officials and initial restrictions on their movements, they were able to visit California, the Pacific Coast and Havana. It was with relief, nevertheless, that they were able to return, in 1946, to Tangier, where McBey was to remain, with regular visits to Britain and America, until his death in 1959.

McBey's watercolours vary in quality. At his best his apparently effortless drawing, combined with fluent colour washes, create sparkling watercolours in which the heat of the Mediterranean is almost tangible. Some of the lesser sketches, however, executed rapidly and with verve, lack solidity and construction.

David West (1868–1936) was born in Lossiemouth, the son of a ship's captain. In his early years he went to sea and even took part in the Klondyke Gold Rush in Alaska in 1898, but returned to Lossie-

107 William Grant Murray, *Marble Rock and Harbour, Portsoy* $14\frac{1}{2} \times 20\frac{1}{4}$ Aberdeen Art Gallery and Museums

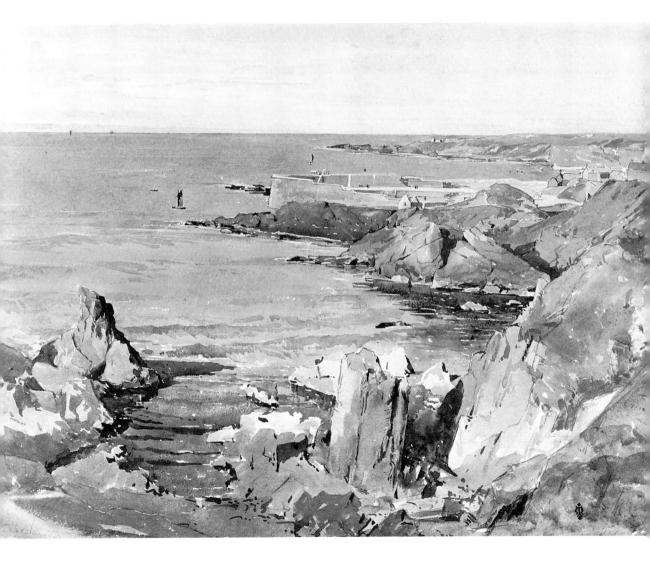

mouth where he worked as a watercolourist for the rest of his life, interrupted only by a short visit to South America in the mid-1920s. Very much a natural watercolourist, West excelled at seascapes with sailing boats set against the pearly light of the North Sea. His work was admired during his lifetime, and he was elected Vice President of the RSW. His 'wet' watercolours painted in subtle shades of blue and grey are today admired in the north-east (fig. 106). Another watercolourist of the area was **William Grant Murray** (1877–1950), born in Portsoy, along the Banff coast from Lossiemouth. Murray studied at Edinburgh College, the Royal College of Art and later in Paris. A successful art educationalist and administrator, he was Principal of Swansea School of Art and Craft, and Curator of Swansea Art Gallery, but he continued to paint watercolours of the north-east coastline. His style is fresh and highly professional with its crisp colours and firm draughtsmanship (fig. 107).

Several artists were working in watercolour in Dundee during this period. **John Gray** (1837–1958) was born in Angus and later taught at Grove Academy, Broughty Ferry as well as being a governor of Jourdanstoun College of Art, Dundee. Gray had a real feeling for the sea and his earlier watercolours depict fishing boats, harbours and east coast bays, painted in a direct style on rough paper. They are often on a large scale and evoke the wind-swept atmosphere of the east coast. He also painted watercolours of flowers, using a less coarse paper and with more concern over detail. It is as a flower painter that he is known, although his seascapes are the more interesting. John Gray was President of the RSW from 1952 to 1957. **James McIntosh Patrick** was born in Dundee in 1907 and studied at Glasgow School of Art. During the 1930s he painted landscapes in both oils and watercolour in a detailed manner which has more in common with English art of the period than the prevailing Expressionist tendencies of Edinburgh. His meticulous technique and close observation are rare in Scotland at this time and are particularly effective in his carefully composed views of rural landscape – a style which at times has a similar spirit to the landscapes of Stanley and Gilbert Spencer. His later watercolours, while showing the same observation and realism, are somewhat freer in handling (fig. 108).

As in most other periods, several Scottish artists settled in London in the early twentieth century and their art is no longer identified with the Scottish School. It is difficult to write objectively about **Sir William Russell Flint** (1880–1969) as some of his later watercolours have disguised the true quality of his work. As a draughtsman, few Scottish artists of this century can rival him, and as a watercolourist he had an extraordinary ability to use the medium to create effects. His Spanish dancing girls and his bathing 'belles', for which he is universally known, are but a small part of his large output, ranging from his exquisite early book illustrations to sensitive landscapes of Scotland, France and Spain.

Russell Flint was born in Edinburgh, the son of a graphic artist,

Francis Wrighton Flint, who also worked in watercolour, and who encouraged his son to paint; 'I had always painted, and drawn, persistently, consistently, ever since I can remember. I lost my first sketchbook when I was not more than five.'[7] He was sent to train as a lithographic draughtsman in an Edinburgh firm and in the evenings studied at the Royal Institution School. Like many other young artists, Flint was greatly influenced by *The Studio* which served as a link with the avant-garde in London. Another typical influence was that of the Dutch School: 'We were enthusiastic admirers of the works of the three brothers Maris, particularly those of James (who in Scotland was much in the fashion).'[8] In 1900 he visited the Continent with his brother, Robert Purvis Flint and painted watercolours in Dordrecht, Volendam and Amsterdam. In August 1900, Flint moved to London on the invitation of his friend Thornton Shields, who obtained for him a job with a firm of medical book illustrators. While producing medical

108 James McIntosh Patrick, *Burnmouth, Newtyle* $20\frac{1}{2} \times 29\frac{1}{2}$ Sir Norman Macfarlane

illustrations, Flint was also able to produce illustrations for magazines including *The Idler*, *The English Illustrated* and *Pearson's Magazine*, culminating in two illustrations for *The Gates of Brede* by Max Pemberton commissioned by *The Illustrated London News* in 1903. Flint was thus one of the many artists of the later nineteenth and early twentieth centuries whose real artistic training came not from art school as much as from years of painstaking work with illustrators and commercial printing companies – in many ways a better and more rigorous training.

In 1905 Flint exhibited a watercolour at the Royal Academy for the first time, and he was also becoming involved in colour, as opposed to black and white, illustration. His first colour illustrations were for *King Solomon's Mines* for Cassells and following his meeting with Phillip Lee Warner of the Medici Society, he produced some of his finest illustrations. These include *Morte d'Arthur*, *Marcus Aurelius*, *Heroes*, *Theocritus* and *The Song of Solomon* all for the Riccardi Press, a part of the Medici Society. *The Pine Tree by Etna* (fig. 109) shows Russell Flint's illustrative style with its firm composition, great detail and evocative atmosphere. His series of illustrations for *The Savoy Operas* published by George Bell and Sons in 1909–10 were bought by Marcus Huish and exhibited at the Fine Art Society. It is no exaggeration to claim that Russell Flint's book illustrations are amongst the finest of this period, and also represent some of his most successful watercolours.

During the pre-war period Russell Flint had begun to paint landscape in watercolour working in France, Scotland, and in 1912 in Italy. His watercolour style was strongly influenced by the 'wet' technique of Melville and the Glasgow School, and although he was to spend much time working in Spain and France, he retained a love for the Scottish landscape, painted, as always, on the spot. In the 1920s and '30s his reputation grew rapidly and his watercolours were avidly collected in Britain and especially in the United States. We have an account of his equipment for painting on the spot:

> With a half-double-elephant sheet of unblemished watercolour paper clipped to a half-double-elephant piece of plywood ... with my easel which dated from 1906; with my paint-box, especially made for me in 1927, with its grubby bit of sponge to wash it out and its collection of brushes of ancient sable and modern hog; with my three-legged stool upon which I never, or very seldom, sat; with my assortment of new, half-squeezed-out or almost entirely squeezed-out tubes of paint; with my aluminium half-litre water-bottle and my tin water-cup; my scrap of blotting-paper and my hedgehog of drawing-pins stuck in a cork; with my new sketching bag containing my reserve quarter-imperials of '300lb. rough'; with my little bottle of anti-mosquito lotion and my metal box of curiously strong peppermints; with my seven reserve paper clips ... with my tooth-brush case full of charcoal; with my length of cord to tie round the easel's legs to prevent them from straddling too widely on a marble floor; and, finally, with a few elastic bands ... I sallied forth.[9]

109 Sir William Russell Flint, *The Pine Tree by Etna*
13 × 10¾ Glasgow Art Gallery

The beauty of Russell Flint's later landscapes lies in their verve, spontaneity and colour. They pose no challenge, either intellectual or visual, and one admires their technical wizardry. It is this very technique which has aroused much criticism, for at a time when artists like Stanley Spencer, Joseph Southall and Paul Nash were rejecting superficial technical virtuosity in favour of close visual analysis, Russell Flint was continuing to rely upon technical dexterity. Few British artists, except maybe Melville, have captured the real heat of the South with such skill as Russell Flint, and as a painter of snow, both in the Alps and in Scotland, he has few rivals. His occasional lapses should not detract from Russel Flint's genius as an illustrator and watercolourist.

Sir David Muirhead Bone (1876–1953) was born in Glasgow where he studied at the School of Art, and trained as an architect before settling in London in 1901. His interest in architecture and his development as a successful etcher had a pronounced effect on his watercolour style, for as early as 1903 he was producing powerful drawings in charcoal with some coloured washes, depicting cathedrals or architectural details such as a Norman doorway or a Gothic window. Muirhead Bone's ability to capture the drama of a building is extraordinary, as can be seen in *The Court of Lions, Alhambra* (fig. 110). Throughout his long career as an artist, Bone travelled extensively, recording architectural views in Britain, France, Holland, Belgium, Sweden and Spain, and these drawings were used to illustrate many travel books.

During both World Wars, Muirhead Bone acted as an official war artist, and some of his most moving watercolours are drawings depicting the desolation and destruction on the Western Front during the Battle of the Somme in 1916, and using great economy of line and colour, he evokes the emptiness and horror of the trench landscape. A large collection of these war-time watercolours in the British Museum takes us through many of the famous battlefields – Contalmaison, La Boiselle, Vimy Ridge, Fricourt. In 1917, Bone produced equally successful drawings of the Grand Fleet and a selection of both series were published as *The Western Front* and *With The Grand Fleet*. In many of his watercolours depicting the war at sea, Bone creates a grey atmosphere with camouflaged ships against a leaden sky, and it is possible to argue that Muirhead Bone joins Frank Brangwyn and Henry Moore as one of the most poignant of war-time draughtsmen.

A group of Scottish artists settled in London and became identified with a certain style of watercolour painting of the early century. This style, typified by the watercolours of Wilson Steer, Philip Connard and Ronald Gray, is based on washes of delicate colour around free pencil outlines which eliminate detail and emphasize atmosphere. **Robert Purves Flint** (1883–1947) was the younger brother of Sir William Russell Flint, and settled in Whitstable, Kent after a period in London. His quiet, restrained views of estuaries painted in thin washes over sensitive pencil outlines are effective and harmonious. This understated watercolour style is similar to that of **Murray Urquhart** (born

110 Sir David Muirhead Bone, *The Court of the Lions, Alhambra* $14\frac{7}{8} \times 10\frac{3}{4}$ Glasgow Art Gallery

1880) who had been born in Kirkcudbright and studied at Edinburgh College of Art before moving south. Urquhart's atmospheric watercolours were exhibited at the New English Art Club, as were those of **Dugald Sutherland MacColl** (1859–1948), an art critic, art historian and Keeper of the Tate Gallery (1906–11), then of the Wallace Collection (1911–24). MacColl's watercolours also belong to this group of understated, atmospheric works.

One of the most remarkable of Scottish artists to settle in London was **James Pryde** (1866–1941). His father was a lecturer of English literature in Edinburgh and his mother was descended from Robert Scott Lauder. After studying at the RSA Schools, where he was a contemporary of D.Y. Cameron, he worked briefly in Paris, before moving to Herkomer's School in Bushey. Here he became a close friend of William Nicholson, working together as the Beggarstaff Brothers. Pryde's sister married William Nicholson in 1893, and Pryde's wide circle of friends included Orpen, Augustus John, Dudley Hardy, Whistler, Conder and Lavery. He led a Bohemian life and his output was small, and mostly in oils, but watercolour had a special place in his work, being used for planning his larger works, often in conjunction with gouache, and for sketching, either on the spot or from memory. His watercolours, like his oils, often deal with architectural subjects such as Venetian churches and palaces or London street scenes, with the occasional portrait. His friend, Alfred Rich, himself a dedicated watercolourist, wrote of Pryde: '... for stately and poetic conception he stands alone in the school of British watercolour painters; no one approaches him.'[10]

Postscript

Is there a Scottish School of watercolour painting, and, if so, what are its characteristics? This is a question which I have asked myself while writing this book, and, although there can never be a clear distinction between the English and Scottish Schools, there are, I believe, characteristics, trends and attitudes which distinguish the Scottish watercolourists from the 1840s onwards.

There is a lack of sentimentality and prettiness in both the subject matter and the handling of Scottish watercolours. The delighful cottage gardens of Helen Allingham and Birket Foster have few counterparts in Scotland; at times, maybe, Hugh Cameron, Robert Herdman and George Manson introduce an element of Victorian sweetness, but they remain exceptions to the bulk of Scottish art. An element of pathos is evident in some of the genre scenes of the Faeds or Gemmell Hutchison, but nevertheless, there is no Scottish 'cottage garden' school. This trait is also evident in the handling of a wider landscape. Whereas many English artists enjoy the rich foliage of an English summer, with sunlit country lanes and fields of ripening corn, the Scottish artists, maybe with the exception of the Border artists like Tom Scott or Robert Buchan Nisbet, prefer the harsher aspects of the Scottish landscape. Not only do the rugged mountains of the Highlands feature, but also the windswept coastal fields of the east coast. It is as if the harshness of Scottish everyday life is reflected in their watercolours – people are seen cutting peat, gathering seaweed or sheltering within a simple croft. The idyllic English pastoral tranquillity finds few counterparts in Scottish art, and it is interesting that David Cox, whose watercolours have a freshness and 'saltiness' which is similar to many Scottish watercolours, is often cited as an influence on Scottish artists, although little concrete evidence of such an influence can be found. It is thus an almost subconscious recognition of the fact that Scottish watercolours possess a breezy quality which is not typical of the English School.

Scottish artists were often great travellers, and comparatively few were content to remain in Scotland itself, however many times they might return to paint their country. Even those who did remain in Scotland travelled far and wide, often on foot, to discover new sketch-

ing grounds. The freshness of many Scottish watercolours is not, there-
fore, due solely to the Scottish landscape, and can be found in water-
colours painted in Holland, Italy and the Middle East. Spontaneity,
verve, brio – these are the most obvious characteristics of the Scottish
School, and when working in a medium which often requires imme-
diacy and assurance above all else, this particular Scottish quality often
results in highly effective watercolours. We know of Crawhall's obses-
sion with technique and of the problems which he set himself to solve
by painting on different grounds; we can also guess at Melville's tech-
nical efforts – his scrubbing out, the use of glass to gauge effects and
his possible use of cut paper stencils for highlights. Thus the spon-
taneity and verve were both intellectually controlled and made to work
for greater effect. This tradition certainly goes back to Wilkie whose
late watercolours have all the flair and technical skill which we associate
with the Glasgow School, and we can see the continuation of this
technical brilliance through the watercolours of John 'Spanish' Phillip,
Horatio McCulloch and McTaggart. It is possible to argue that the
intellectual application of many Scottish watercolourists was chan-
nelled more towards technique than towards literary or philosophical
content. Scottish legend and history plays a part in some Scottish
watercolours, but to a much lesser extent than the medieval mythology,
biblical stories, historical settings and literary references which domi-
nate English nineteenth-century watercolour painting. Many Scottish
history painters used watercolour as an escape from their official pic-
tures and commissions. There is no Rossetti, no Pinwell in Scottish
watercolours, despite the relatively short-lived Symbolist movement at
the turn of the century; moreover even in the twentieth century, few
Scottish watercolourists have been tempted down the path of Paul
Nash, Stanley Spencer or Joseph Southall. Indeed a comparison of the
Pre-Raphaelite Movement in the two countries reveals to what extent
the Scots indulged in the technical and visual, rather than the moral,
historical, political or even philosphical considerations of the Move-
ment. This does not imply that Scottish watercolourists were interested
solely in technique and surface effects. On the contrary, their innate
sense of line and composition often led to a deeper understanding of,
and expression of, human nature. Wilkie's ability to capture the expres-
sion of his sitters in the later Middle Eastern portraits and Melville's
success in capturing the dramatic moment, are paralleled by Bough's
sense of place and atmospheric effects and McTaggart's ability to bring
a seascape to life before your eyes. It is thus a difference of emphasis.

Just as the often harsh conditions of nineteenth-century Scottish life
affected the subject-matter of its artists, so the colours of the Scottish
landscape appear to have had a profound influence upon the palette of
many Scottish watercolourists. The clarity of the air, the possibility of
seeing distances in clear colours and the rich tones of the flora provide
the Scottish landscape with truly exceptional colours: the deep blues
of distant mountains, the rich purples of heather in flower, the vivid
turquoise of the clear loch water, the white sands of Machrihanish so

loved by McTaggart, and the sonorous red of the sunset so often painted by Waller Hugh Paton. How often do the Scottish watercolourists surprise us by their vivid colours? Did MacWhirter really see such vivid blues? Did Herdman really see Arran in such striking greens and blues? The answer is evident to anyone who has seen the Scottish landscape. The intensity of many Scottish watercolours can still shock when seen beside the more restrained and decorous English School, and, in addition, the apparent lack of watercolour 'rules' and traditions allowed a greater freedom to the Scottish watercolourists. Thus theories as to the use of bodycolour, to the application of washes, and above all, to the adherence to acceptable colour formulae rarely applied to Scottish art. In some ways, therefore, the fact that the Scottish School was late in forming, and had few traditions on which to build, was an advantage to the development of a progressive and adventurous watercolour style.

The influence of the Hague School on Scottish watercolours needs to be investigated further. There can be little doubt that artists like Israels, Maris and Weissenbruch were important in the development of a wet and broad watercolour technique. It also seems likely that they influenced the way that figures were painted. The stocky, 'dumpy' Dutch figure which appears so often in innumerable watercolours from McCulloch and Bough to Coventry and R. W. Allan cannot have derived solely from David Cox. If it is of Dutch origin, then why did it continue through the work of artists who had trained at the Trustees' Academy? This poses the problem of the extent to which Scottish art teaching either relied upon Dutch examples or actually ignored the question of figures within a landscape. Whatever the answer, it is certain that the English watercolour tradition was less significant to Scottish artists than the Hague School and French art, in particular the Barbizon School, Bastien-Lepage and his followers, and later in the century, the Impressionists.

Certain aspects of English nineteenth-century watercolour painting are not found in the Scottish School. The absence of the cottage-garden type has already been noted; in addition there is a shortage of overtly sentimental portraits or portrait groups either in interiors or in idyllic garden settings. This is possibly due to patronage rather than to artistic choice – after all both Sir William Quiller Orchardson and Robert Walker Macbeth were able to provide such subjects, but they had to move to London to sell them. The question of patronage of watercolours in Scotland must be examined further. Why were the humble interiors of the Faeds and Hugh Cameron preferred to the lush interiors of Orchardson or the sentimental garden scenes so popular in the south? Another absence is that of a true marine school. Certainly harbour scenes were popular – the sea seen from a port – but there were comparatively few marine watercolours in the tradition of Turner. There is no Scottish counterpart to Charles Bentley or Thomas Bush Hardy. Nor did their particular formula of rough sea with shipping on the horizon painted in attractive, if predictable, colours, with props

such as buoys or floating spars in the foregound, develop in Scotland. There are marine artists like William Clark, Colin Hunter and James Kay, but most Scottish artists like Sam Bough painted their marines close to land. Turner's influence was certainly felt much less North of the Border, and at the same time, Glasgow patrons preferred harbour scenes with their vessels safely in port, rather than riding the storm at sea.

During the first half of the twentieth century, Scottish watercolours grew further apart from the English School. The 'English' landscapes of Nash, Spencer and their circle had no role in Scotland, and Surrealism played only a minor part. On the other hand, the vigorous and expressive watercolours of Gillies, Redpath and the Edinburgh School had no parallel in England; nor did the work of the Colourists. At times, one can relate the work of certain artists, like Cowie, to English developments, but there is, nevertheless, a clearly identifiable Scottish School. Whether this survives into the later part of the twentieth century is less certain, as the range of styles of contemporary Scottish watercolours has broadened to encompass many different, and not necessarily Scottish, trends. A judgement must, however, await historical perspective.

Biographical dictionary of Scottish watercolour painters

Artists marked thus * are discussed in the main text.

Joseph Denovan Adam 1842–1896

A painter of animals, Highland landscape and still-life, and the son of Joseph Adam (fl. 1858–1880), he concentrated on animals in Highland settings, working in oils and watercolour. He established a school for animal painting at Craigmill, near Stirling, which became the centre for a group of Stirling and Glasgow artists. Established in 1887, Craigmill School was based on Adam's small farm and the students were encouraged to paint his herd of Highland cattle from life.
RSW 1883, ARSA 1884, RSA 1892

Joseph Denovan Adam, Junior died c. 1935

Worked with his father on the Craigmill farm, and became an animal painter in his own right. His watercolour style is looser and wetter than that of his father, with whom he sometimes collaborated on oil paintings.

James Adam 1730–1794

Robert Adam's younger brother and architectural partner. He was in Rome 1760–63. He painted watercolours, usually with architectural subjects.

Margaret Adam died 1820

Unmarried sister of Robert Adam and amateur draughtsman, her work is represented in the Blair Adam Collection by *Rocky Landscape with Trees and a Classical Building in the Distance* signed *M.A.*

Patrick William Adam 1854–1930

Born Edinburgh, his first successes were in portraiture. In 1889 he painted a notable series of Venetian views, and in 1896–97 a series of winter landscapes. In 1908 he settled in North Berwick where his well-known oils of interiors were painted. He worked mainly in oils and pastels, but his earlier landscapes were sometimes in watercolour.
ARSA 1883, RSA 1897, Society of Eight

John Macdonald Aiken 1880–1961

An Aberdeen artist, later head of Gray's School of Art, where he had himself been a student. He trained under Gerald Moira at RCA and was influenced by his decorative style. He painted mostly portraits in oils and watercolour, but also worked in stained glass.
ARSA 1923, ARE 1924, RSA 1935, RI 1944

George Aikman 1831–1906

Engraver and landscape painter in oils and watercolour. His oils are often sombre in colour, but his watercolours can be effective. He often chose harbour and coastal scenes using silvery greys with some bodycolour. His style was influenced by the Dutch School.
RSW 1878, ARSA 1880

James Alfred Aitken 1846–1897

Born in Edinburgh, he lived for a period in Dublin before returning to Edinburgh to study art, being influenced by Horatio McCulloch*. He later settled in Glasgow. A prolific watercolourist, he painted views of the Highlands and coastal scenes in a vigorous style with sparkling colours. He also worked in America and in Europe, his Venetian scenes being amongst his best work. He should not be confused with James Aitken and his son John Ernest Aitken, who worked in the north east of England and on the Isle of Man.
ARHA 1871 (resigned 1890), RSW 1878

Janet Macdonald Aitken 1873–1941

Born in Glasgow and studied at GSA and Co-
larossi's, Paris. A member of C. R. Mackin-
tosh's circle and a leading member of the
Glasgow Society of Lady Artists. She painted
portraits, landscapes and views of old build-
ings in oils and watercolour. A Memorial Ex-
hibition of Janet Aitken, Kate Wylie and Elma
Story was held at the Glasgow Society of Lady
Artists in 1942.

Annie Dunlop Alexander fl. 1917–1940

Trained at GSA where she was influenced by
the illustrative work of Jessie King and Ann
Macbeth. Produced watercolours, book illus-
trations and illustrated ceramics.

Edwin Alexander* 1870–1926

ARWS 1899, ARSA 1902, RWS 1910, RSW
1911, RSA 1913

James Stuart Carnegie Alexander born
1900

Etcher and landscape painter in watercolour
and oils. Lived in Selkirk and exhibited at Ait-
ken and Dott and the RSW.

Lena Alexander (Mrs Lees Duncan) died
1983

Studied GSA, painted in watercolour and
pastels. She often painted flowers, but also
views of Venice and Paris and some portraits.
She was the last surviving member of the Kirk-
cudbright School.

Robert Alexander* 1840–1923

Born Dalgaren, Ayrshire.
ARSA 1878, RSA 1888, RSW 1889 (resigned
1901)

Jessie Algie 1859–1927

Painter of flowers in oils and watercolour. She
was associated with the Craigmill group of ar-
tists near Stirling, where she lived for a period.
In 1908 she held an exhibition of flower paint-
ings at the Baillie Gallery, London, with
Annie Muir, Jessie King and Louise Perman.
Studied GSA.

Andrew Allan born 1863

Glasgow flower painter and illustrator, influ-
enced by the French *fin-de-siècle* style.

Archibald Russell Watson Allan 1878–
1959

Born Glasgow, studied at GSA and at Julian
and Colarossi in Paris. He worked mostly in
oils and pastels, painting domestic and garden
scenes, often with animals.
ARSA 1931, RSA 1932

Robert Weir Allan* 1851–1942

RSW 1880, NEAC 1886, ARWS 1887, RWS
1896, VPRWS 1908–10

Sir William Allan* 1782–1850

RSA 1829, PRSA 1837–50

Thomas Alston

Late-eighteenth/early-nineteenth-century land-
scape painter who worked in a neat topograph-
ical style.

I. W. Alston

A contemporary of David Allan* producing
genre watercolours of figures in rustic settings.

Miss Marion Ancrum fl 1885–1919 (Mrs
G Turnbull)

Painted watercolours of old Edinburgh which
can be seen in the City of Edinburgh Art
Collection.

David R. Anderson 1883–1976

Born in Glasgow, studied GSA followed by
Glasgow University and Ecole des Beaux Arts,
Paris. A journalist and editor by profession, he
was a keen amateur artist. He had a studio at
Gareloch, but retired to Ilkley, Yorkshire to
devote himself to art. He produced powerful
watercolours and chalk drawings of the drama-
tic landscape around Gareloch. His earlier
work appears to have been influenced by
Muirhead Bone*.

Martin Anderson 'Cynicus' 1854–1932

Landscape painter in oils and watercolour, and
cartoonist.

Robert Anderson 1842–1885

Line engraver who turned to watercolour, he
produced large and often powerful watercol-
ours of fishing boats and fishermen which were

exhibited at the RSA. He also painted scenes of rural life in Brittany and Holland. Although largely forgotten today, he appears to have seen successful in his lifetime.
RSW 1878, ARSA 1879

James Archer 1823–1904

A figure and portrait painter who studied at the Trustees' Academy under Sir William Allan* and Thomas Duncan. His principal work was in oils, but he was a good draughtsman, often using black chalk, and his rare watercolours are proficient. A member of the Smashers Club in Edinburgh, he moved to London in 1864 and died in Haslemere.
ARSA 1850, RSA 1858

Mary Armour born 1902

Born Blantyre, studied GSA under Forrester Wilson and Maurice Greiffenhagen. Married William Armour in 1927. She paints landscape, flowers, still-life in oils, pastels and watercolour.
ARSA 1940, RSW 1956, RSA 1958

William Armour 1903–1979

Husband of Mary Armour, born Paisley. Head of Drawing and Painting, GSA. Like his wife, he painted still-life and landscape in oils, pastels and watercolour. His watercolours are often atmospheric with a wet handling of the washes.
RSW 1941, ARSA 1958, RSA 1966

Peter C. Auld

Landscape painter, began to exhibit watercolours at the RSA in 1835. Moved from Ayr to Aberdeen c. 1844. Painted views of the Highlands and of Aberdeenshire, often around Balmoral.

George Bain 1881–1968

Born in Caithness, but moved to Edinburgh where he studied at ECA, later moving to London to study at RCA. After the First World War, during which he recorded incidents of the 26th Division in Salonika, he became Principal Teacher of Art at Kirkcaldy High School, a post he retained until retirement in 1946. An expert on Celtic art, he published an important study of the subject in 1951. He painted Scottish landscapes in watercolour and often worked abroad, particularly in the Balkans and Greece.

A retrospective exhibition was held in Kirkcaldy in 1978.

Edmund Baker fl. 1880–1910

Stirling artist who painted in oils and watercolours. He produced views of the Fife coast in a wet watercolour style influenced by the Dutch School.

Eve Baker

Studied in London and Paris and opened an atelier in Albany Chambers, Glasgow in 1898. Painted seascapes and harbours in oils and watercolour. A militant suffragist, she left Glasgow in 1915.

Leonard Baker fl. 1865–1910

Drawing Master at Stirling High School. Painted local views in Stirling and Fife landscapes in watercolour.

Vincent Balfour-Browne born 1880

Painter of sporting scenes in watercolour whose popularity has never waned. He held regular and successful exhibitions at the Fine Art Society.

R. M. Ballantyne fl. 1850–1885

Edinburgh artist who exhibited watercolours at the RSA. He mostly painted Scottish landscape, sometimes with pastoral figures, but also worked in Europe. Probably moved to London c. 1880.

Alexander Ballingall fl. 1880–1910

Watercolourist whose subject matter of coastal views is likened by Caw to that of J. D. Taylor, Andrew Black* and J. D. Bell. He specialized in views of east coast harbours, taking care over the details of rigging, and often working on a large scale. His drawing is precise, if a little hard. He also worked in Venice.

Violet Banks born 1896

Born in Kinghorn, Fife, and studied ECA. A friend of Ernest Lumsden, she was for some years art mistress at St Oran's School, Edinburgh. She exhibited watercolours at the RSW.

John James Bannatyne* 1836–1911
RSW 1878

James Bayne fl. 1880–1910

Lived and worked in Scotland, producing tightly composed landscape watercolours.

George Telfer Bear born 1874

Born at Greenock, studied GSA. Mostly an oil painter who was associated with the Colourists, but he did produce some powerful charcoal and wash drawings.

Penelope Beaton* 1886–1963
RSW 1952, ARSA 1957

J. Beattie-Scott fl. 1880–1905

An Aberdeen watercolourist who painted local views and coastal scenes in a tight, richly-coloured style.

Jonathan Anderson Bell 1809–1865

An architect, born in Glasgow and trained at Edinburgh University and Rome. He painted highly-coloured watercolours of Italian scenes and buildings, and architectural engravings of Scottish buildings and of Cambridge colleges, where he lived for a period.

John D. Bell fl. 1878–1910

A marine and coastal painter who worked mostly in watercolour. He specialized in breezy views of Scottish fishing villages and boats under sail. He also painted on the Isle of Man.
RSW 1878, resigned 1902

Harry Berstecher born 1893

Born in Glasgow, he painted fishing villages of the east coast, living for a period in Pittenweem. His fresh and energetic watercolour style is combined with a charcoal structure and is not unlike the contemporary work of William Hanna Clark* and William Crozier*.
RSW 1926

Erskine Beveridge died 1972

Seascape and coastal painter who lived in Glasgow. His watercolours are colourful and are sometimes similar to the work of Robert Clouston Young*.

Robert William Billings 1813–1874

A London architect who illustrated *The Baronial and Ecclesiastical Antiquities of Scotland* (1852) and other architectural books. His crisp watercolours of Scottish buildings can be found in several Scottish museums.

Graham Binny died 1929

Edinburgh watercolourist who painted portraits and figure subjects. His output was small.
RSW 1909

Mary Holden Bird died 1978

An English artist who worked on the west coast of Scotland. She was married to the cartoonist, Kenneth Bird, known as *Fougasse*, but had a house at Morar where she painted the sands of Arisaig and other coastal views. Her style is accomplished, having an almost Chinese emphasis upon well-placed brushstrokes, leaving white paper to shine through. At times her style can become slick and insubstantial, but, at her best, she produced sparkling watercolours which capture the colours and drama of the west coast. She signs with a monogram. Many photographic prints of her watercolours were made, and must be distinguished from the originals.

Andrew Black* 1850–1916

Marine watercolourist, studied GSA and Paris. A keen yachtsman, he had an intimate knowledge of the waters around Scotland.
RSW 1885

Ann Spence Black 1861–1947

A prolific watercolourist, born in Dysart, Fife, and worked in Edinburgh. She produced

many landscapes, but possibly the best works are her richly coloured flower pieces.
RSW 1917

E. Rose Black fl. 1920–39

Watercolourist who produced freely painted landscapes.

Thomas Bromley Blacklock 1863–1903

Kirkcudbright artist, trained in Edinburgh. He worked mostly in oils, but also did pen-and-ink illustrations. He originally painted landscape, but began to introduce children and fairies in the 1890s. Mentally affected by a spinal condition, he committed suicide in the Clyde near Greenock. His closest friend and helper in his later years was Ewan Geddes.

John Blair fl. 1880–1920

Edinburgh artist who worked largely in watercolour, producing views of towns and villages on the east coast, including topographical views of Edinburgh.

Dr Charles Blatherwick died 1895

An amateur artist, closely connected with the founding of the RSW in 1878. He was, by profession, a doctor and practised in Highgate, London before moving to Rhu as Chief Inspector of Alkali and Chemical Works for Scotland and Northern Ireland in 1865. A novelist and watercolourist, he painted Scottish landscapes in a tight style. Twice married; his daughter from his first marriage – Lily Blatherwick – married his stepson, A.S Hartrick. President, Glasgow Art Club 1891–93.
RSW 1878

Lily Blatherwick 1854–1934 (Mrs A.S. Hartrick)

Daughter of Dr Charles Blatherwick, born in Richmond, but moved to Scotland with her father in 1865. A founder member of the RSW in 1878, and a distinguished painter of flowers. Married A.S. Hartrick in 1896, moved to Gloucestershire where she painted many successful landscapes and flower pieces. Died in Fulham.
RSW 1878, ASWA 1886, SWA 1898

Robert Henderson Blyth* 1919–1970

Born Glasgow, studied GSA. Taught at ECA from 1946, moving to Aberdeen in 1954. Head of Drawing and Painting, Gray's School of Art, Aberdeen, 1960–70.
RSW 1949, ARSA 1949, RSA 1957

Sir Muirhead Bone* 1876–1953

Born Partick, Glasgow, studied GSA. Official War artist 1916–18. Official Admiralty artist 1939–46.
NEAC 1902, Knighted 1937, RE, HRWS

Lt Colonel Charles Gordon Borrowman 1892–1956

Born Edinburgh, commissioned Indian Army 1912, studied ECA part-time. For much of his life, Borrowman was in India where he painted landscapes in watercolour. On his retirement he settled in Dunkeld, where he continued to paint.
RSW 1945

Alfred Edward Borthwick 1871–1955

Born Scarborough, trained ECA, London and Paris. He painted landscapes and religious subjects in both oils and watercolour. His landscapes can be effective using a free, wet and typically Scottish watercolour technique. His daughter, Marjorie Borthwick, also painted in watercolours.
ARE 1909, RSW 1911, ARBA 1927, ARSA 1928, 1930, PRSW 1932–1951, RSA 1939

Sam Bough* 1822–1878
ARSA 1856, RSA 1875, RSW 1878

W. Bowie

Amateur Aberdeen artist working in the 1920s. Painted somewhat naive views of Aberdeen.

Alexander Stuart Boyd 1854–1930

Journalist and magazine illustrator, born Glasgow, studied GSA. He illustrated Charles Blatherwick's novel *Peter Stonnor* with Guthrie in 1884, and worked for *Punch*. In 1905 a series of his sketches were published as *Glas-*

gow Men and Women. He was also an accomplished flower painter, and a group of flower paintings dated 1905 are in Glasgow Art Gallery. He lived for many years at St John's Wood before emigrating to New Zealand, where he died.
RSW 1885

James Boyle 1872–1935

Perth artist, manager of Pullars of Perth. Painted landscapes in watercolour.

Ernest Edward Briggs 1866–1913

Born Broughty Ferry, died Dunkeld. Trained at the Slade under Legros. A keen fisherman, many of his watercolours are concerned with angling in rivers or views of fishing villages. He wrote and illustrated *Angling and Art in Scotland* (1908) and contributed illustrations to other books on fishing. His watercolours are often on a large scale, the paint being well-worked and used almost as oil. The effects are usually impressive.
RI 1906, RSW 1913

Theodore Charles Ferdinand Brotchie 1868–1937

Born in Ceylon, studied ECA. Director of Glasgow Art Galleries and a writer on art. He also painted watercolours of the Scottish landscape.

Robert Brough 1872–1905

Born in Invergordon, Ross, but brought up in Aberdeen, Brough became a successful portrait painter with an elegant style. He worked mostly in oils, but painted watercolours in the 1890s, some of which relate to his visit to Paris. He used watercolour in a bold and effective way. Died in a railway accident.
ARSA 1904

Alexander Kellock Brown* 1849–1922
RSW 1878, RI 1878, ARSA 1892, RSA 1908

Henry James Stuart Brown 1871–1941

Landscape etcher who also worked in watercolours. He enjoyed flat landscapes with wide skies, working in East Anglia and Holland. Lived in Linlithgow.

Helen Paxton Brown 1876–1956

Born Glasgow, studied GSA. A close friend of Jessie King* and other members of her circle, she produced embroidery designs which, like those of Annie French, were illustrated in *The Studio*. She was a successful portrait painter and developed a proficient, elegant style both in oils and watercolour. She also painted groups of figures in cafes with great skill, revealing her witty personality and personal style. Taught GSA 1911–17. Retired from Glasgow to live in Kirkcudbright.
Lauder Award 1923

James Michael Brown fl. 1880–1910

Edinburgh artist who painted landscapes in watercolour, often with a sporting content.

May Marshall Brown 1887–1968

Born May Mary Robertson, studied ECA before marrying William Marshall Brown*, whose style of painting greatly influenced her. Painted watercolours of fishing villages and boats, also working in France and Holland. Her style is fresh with a lively, wet handling of the washes.
RSW 1936

Thomas Austen Brown 1857–1924

Born Edinburgh, studied RSA Schools. Moved to London c. 1890. Caw traces his development from the early 'daintily clad rustic girls' to a rustic realism closer to Clausen and La Thangue. He worked at Cambuskenneth and was associated with the 'Glasgow Boys', working both in oils and watercolour.

He later lived in Northern France where he painted watercolours in a bold, if somewhat clumsy style, possibly in an attempt to keep up with post-war developments. He was influenced by book illustration and produced views of Etaples for publication. He died in Boulogne.
RI 1888, RSW 1889, ARSA 1889

Thomas Wyman Brown 1868–1930

Painted landscapes and flowers in oils and watercolour, but was particularly noted for his paintings of fish. Lived in Perth.

William Beattie Brown 1831–1909

Born Haddington, studied Trustees' Academy. A popular painter of the Scottish Highlands in oils and watercolour. His colours tend to be dull, but his watercolours can be effective.
ARSA 1871, RSA 1884

William Beattie Brown, Junior fl. 1895–1915

Painted in a similar style to his father, but achieved less success. Also painted some watercolours.

William Fulton Brown* 1873–1905
RSW 1894

William Marshall Brown* 1863–1936

Born Edinburgh, studied RSA Schools and South Kensington. Lived and worked in Edinburgh and Cockburnspath.
ARSA 1909, RSA 1928, RSW 1929

Robert Alexander Brownlie fl. 1880–1900

Painter of coastal views and fishing villages. His output was small.
RSW 1890

Harriet Bruce* fl. 1822–1899

An intriguing artist who lived in Edinburgh and Argyllshire. She painted detailed watercolours showing the influence of Pre-Raphaelitism. Signs with a monogram.

Elizabeth York Brunton born 1880

Born Musselburgh, studied ECA. Painted views of Continental markets in both oils and watercolour, sometimes using linen as a ground. Spent much time in Paris, and exhibited only rarely in Scotland.
Member, Colour Woodcut Society

David Bryce 1803–1876

Edinbugh architect who painted watercolours of architectural subjects.
ARSA 1851, RSA 1856, FRIBA

Robert Brydall 1839–1907

Born Glasgow, studied GSA under Charles Heath Wilson*, he later became second Master at GSA. Known today for his book, *Art In Scotland. Its Origins and Progress* (1889), he also painted watercolours, mostly landscapes based on his trips to Italy and Switzerland.

Allan Buchanan fl. 1880–1900

Glasgow watercolourist and oil painter whose landscapes were exhibited at the Glasgow Institute.

Mrs E. Oughtred Buchanan fl. 1930–40

Edinburgh painter working in the style of Gillies*.

James Buchanan born 1889

Born Largs, studied GSA. Painted landscapes and figures of North Africa in watercolour.

Peter Buchanan fl. 1860–1910

Glasgow painter of landscape in oils and watercolour, who began exhibiting at the RSA in the 1860s. Painted coastal and harbour scenes.

Thomas Bunting 1851–1928

Aberdeen artist who painted landscapes in Aberdeenshire and Perthshire. Often chose views with rivers or the sea, using muted silvery tones. Painted in both oils and watercolour.

James G. Burgess 1865–1950

Amateur artist, studied Dumbarton Art School. Established a firm of interior decorators and became a friend of the 'Glasgow Boys'. He lived in Helensburgh and painted local scenes.

William Burn-Murdoch 1862–1939

Lithographer and etcher who also worked in oils and watercolour. Studied in Antwerp and Paris, acquiring a knowledge of European developments in art. Contributed to *The Evergreen – The Book of Spring* and *The Book of Summer* (1895 and 1896) published by Patrick Geddes*. He later settled in Edinburgh painting figure subjects, portraits and landscapes relating to his trips abroad.

James M. Burnet 1788–1816

Younger brother of John Burnet*. Born Mus-

selburgh, studied under David Scott at the Trustees' Academy.

David Duguid Burnett fl. 1920–40

Edinburgh landscape watercolourist who exhibited at the RSW.

Miss J. S. Burnett died c. 1960

Painter of flowers and landscapes in watercolour. Probably from Dundee, she lived and worked for a period in the 1890s in London.

Robert Burns* 1869–1941

ARSA 1902, resigned 1920

Alexander Hohenlohe Burr* 1835–1899

ROI 1883

John Burr* 1831–1893

RBA 1875, ROI 1883, ARWS 1883

Nancy Burton 1891–1972

Born Insh, Inverness-shire, studied GSA, Paris and Italy. She specialized in painting animals, and lived on a farm in Tyndrum, Perthshire for many years. During the early 1930s she visited India, Kashmir and Afghanistan where she painted many watercolours. RSW 1932. Lauder Award 1924

William Paton Burton 1828–1883

Born in Madras, the son of an officer in the Indian Army, he was educated in Edinburgh, before joining the office of the architect David Bryce. He devoted much time to watercolour painting and travelled widely, including India and Egypt. Moved from Edinburgh to Surrey in the 1860s, and painted landscapes of Surrey and Sussex. Returned to Scotland and died at Cults, Aberdeenshire. His watercolours are competent, if a little dull. RSW 1882

Florence St John Cadell 1877–1966

Born Cheltenham, moved to Edinburgh. Painted landscapes in oils and watercolour; her best works are her colourful watercolours of Continental market places and of Paris. She travelled abroad regularly to paint. Her still-life is less effective. Her sister, **Agnes Cadell,** also painted.

Francis Campbell Boileau Cadell* 1883–1937

Society of Eight 1912, ARSA 1931, RSW 1935, RSA 1937

James Cadenhead* 1858–1927

RSW 1893, ARSA 1902, RSA 1921

James Cadzow 1881–1941

Born Carluke, but moved to Broughty Ferry as a child. Studied ECA. Art master, Dundee High School and President of Dundee Arts Society. Painted landscapes of Scotland in a powerful style, using strong charcoal outlines and rich washes. Also produced pencil drawings and etchings.

John Cairns* fl. 1845–1870

Probably born in Paisley.

Edwin Sherwood Calvert 1844–1898

Born in England, lived in Glasgow painting quiet, but effective landscapes in watercolour. His earlier works depict coastal scenes and fishing villages, but his later work is more distinctive. He paints pastorals in subdued tones, sometimes introducing figures of shepherds. His watercolours are usually entitled *Reverie* or *Pastoral* rather than names of specific locations. Caw likens his style to that of Corot. RSW 1878

Sir David Young Cameron* 1865–1945

ARE 1889, RE 1895, ROI 1902, ARSA 1904, ARWS 1904, RSW 1906, RWS 1915, ARA 1916, RSA 1918, RA 1920, HRSW 1934, Knighted 1924

Hugh Cameron* 1835–1918

ARSA 1859, RSA 1869, RSW 1878, ROI 1883, HRSW 1916

Katharine Cameron* 1874–1965 (Mrs Arthur Kay)

Studied GSA and Colarossi, Paris. RSW 1897, ARE 1920, RE 1964

Mary Cameron c. 1865–1921 (Mrs Alexis Miller)

Born Edinburgh, studied Edinburgh and Paris. She painted large oils of Spanish and

rural scenes, but also did watercolours based on her trips abroad. She specialized in bull fighting scenes, and lived for a period in Madrid and Seville. She later worked in the South of France.

Alexander Campbell 1764–1824

Topographical artist who worked in pen and sepia washes. Author of *Journey from Edinburgh through Parts of North Britain* 1802.

James Campbell fl. 1860–1880

Amateur Glasgow artist who painted views of Glasgow in sepia.

Tom Campbell fl. 1880–1900

Glasgow topographical artist.

Tom Campbell 1865–1943

Landscape watercolourist who painted views of the west coast and Islands, using a sharp, highly coloured style. He often painted children on beaches, and his views of sands with sea-birds can be effective.

John Carlaw 1850–1934

Born Glasgow, lived Helensburgh. An animal painter and friend of the Glasgow Boys, he worked mostly in watercolour using a wet technique typical of the Glasgow School. His best works are effective with a well-controlled, fluent handling of washes, but less good examples can be poorly drawn and weak in technique.
RSW 1885

William Carlaw 1847–1889

The brother of John Carlaw, died young aged 42. Like his brother, he was connected with the Glasgow School, but he concentrated on watercolours of marine subjects, working in Scotland and in the west of England.
RSW 1878

Robert Carrick 1829–1904

Genre painter, born in the west of Scotland, moved to London in the 1840s.
ARI 1848, RI 1850, ROI 1883

Robert Carrick fl. 1845–1885

Glasgow artist who worked in the same lithographic studio as William 'Crimean' Simpson*, and painted in a similar style. Painted watercolours of Glasgow and its surrounding countryside.

William Arthur Laurie Carrick born 1879

Trained as an architect, but turned to painting for health reasons. Painted watercolours of landscapes, coastal and beach scenes. His style is free and can be effective.

Evelyn Carslaw 1881–1968

The wife of a Glasgow surgeon, born Evelyn Workman. Born Glasgow, studied GSA and Paris. She painted views of Holland, Spain, Italy and Scotland in oils and watercolour, and produced illustrations for *Leaves from Rowan's Logs* (1944), a book written by her husband, a keen yachtsman, about a cruise around the west coast. A close friend of Norah Nielson Gray* she lived in Helensburgh.

James Cassie* 1819–1879

Signs with a monogram based on his initials.
ARSA 1869, RSW 1878, RSA 1879

Sir James Caw 1864–1950

Born Ayr, studied GSA. Author of *Scottish Painting Past and Present* (1908) the first and most comprehensive work on Scottish art, and of several other studies of Scottish artists. Curator of the National Galleries of Scotland (1907) and the Scottish National Portrait Gallery (1895). He also painted landscapes in pastels and watercolour, often choosing coastal scenes.

George Paul Chalmers* 1833–1878

ARSA 1867, RSA 1871, RSW 1878

Hector Chalmers fl. 1870–1935

Edinburgh landscape painter in oils and watercolours.

Sir George Clerk

A relation of Sir John Clerk of Eldin*, he worked as an amateur watercolourist in the

late eighteenth century, painting darkly toned wash drawings with dramatic *chiaroscuro*.

Robert Cochran died 1914

Amateur artist who was Provost of Paisley. Travelled in Egypt and painted watercolours of that country. Also worked in Holland and Western Isles.
RSW 1910

Laelia Armine Cockburn fl. 1910–1940

Studied at the Lucy Kemp-Welsh School at Bushey. Painted somewhat sweet oils, water-colours and pastels of animals, particularly foals and ponies, but she also painted some landscapes. Her colours and technique are light and often effective.
RSW 1924

James B. Cook fl. 1917–1940

Glasgow landscape and coastal artist who worked in watercolours. His *Cullen Harbour* was admired in *The Studio* at the RSA in 1921.

Gertrude Mary Coventry 1885–1964 (Mrs E. Robertson)

The daughter of R. M. Coventry*, born Glasgow, studied GSA. Painted in Holland, Belgium and Scotland with her father. Married in 1915 and moved to Wales, later moved to Manchester (1934) and to Canada (1962) where she died.

Robert McGown Coventry* 1855–1914

RSW 1889, ARSA 1906

Lilian Horsburgh Cowan-Douglas born 1894

Born on Mull, trained ECA. Painted flower pieces in watercolour.

James Cowie* 1886–1956

ARSA 1936, RSA 1943

Agnes Cowieson fl. 1880–1940

Painted attractive watercolours of figures on beaches and in interiors. In the 1890s she travelled to South Africa, Malaya and Java. She often painted Portobello Sands, near Edinburgh.

Max Cowper 1860–1911

Born Dundee, worked as an illustrator for the *Dundee Courier*, he later moved to London to join the staff of the *Illustrated London News*. He painted market scenes and figures in oils and watercolour.

John Craig

Early nineteenth-century Edinburgh artist who painted landscapes in oils and watercolour. Painted many views of east coast fishing villages and marine subjects, mostly in watercolour.

Robert Craig-Wallace fl. 1920–1940

Glasgow painter and etcher. His views of shipping and yachting on the Clyde have sparkle and capture the flavour of the inter-war years.

James Hall Cranston 1821–1907

Born Perth, studied at the Slade before returning to Perth. Painted Perthshire landscapes in both oils and watercolour in a careful, yet not over-worked style. His work is similar to that of Thomas Fairbairn*.

Edmund Thornton Crawford* 1806–1885

ARSA 1839, RSA 1848

Robert Cree Crawford 1842–c. 1924

Born Govanbank, studied at Glasgow University before moving to Canada. He later returned to Scotland and made a local reputation for his portraits in oil. Also painted watercolours of landscapes and marine scenes.
RSW 1878

Thomas Hamilton Crawford fl. 1880–1933

Architectural painter in watercolours and draughtsman. He painted church interiors and façades in Britain and France, and did illustrations of Edinburgh for R. L. Stevenson's *Picturesque Notes*. Moved to London in 1893, and later lived in Hertfordshire.
RSW 1887

William Crawford 1811–1869

Born Ayr, he specialized in drawings in crayon. Member of The Smashers, he produced wash drawings for the club, along with the Faeds*.
ARSA 1860

William Caldwell Crawford fl. 1895–1936

Landscape painter in oils and watercolours based in the Lothians.

Joseph Crawhall* 1861–1913

RSW 1887, resigned 1893

Lionel Townshend Crawshaw 1864–1949

Born in Doncaster, he studied law before taking up painting. Studied in Germany and Paris, settled in Edinburgh. Painted a wide variety of subjects, including views of towns with figures, and flowers. His second wife, **Frances Crawshaw,** also painted flowers

RSW 1923

William Crozier* 1893–1930

ARSA 1930

William Skeoch Cumming 1864–1929

Born Edinburgh, studied ECA and RSA Schools. A painter of military subjects, mostly in watercolour. He served in the Boer War, and made watercolours of incidents during the campaign. He also painted portraits in watercolour. His wife **Belle Skeoch Cumming** born 1888 also worked in watercolour.

Stanley Cursiter* 1887–1976

RSW 1914, ARSA 1927, RSA 1937, Director NGS 1930–48, King's Painter and Limner in Scotland 1948, Secretary RSA 1953–5, PRSW 1951–2.

Kenneth J. Cuthbertson fl. 1920–1940

Edinburgh artist who painted landscapes in watercolour between the wars. He often painted abroad, especially in Italy.

William Dalglish 1857–1909

Born Glasgow, studied under A. D. Robertson, a local art teacher with a studio in Dundas Street, and at GSA. He painted marine subjects, often in watercolour, in a style similar to that of J. D. Taylor*, his contemporary in Glasgow.

Alastair Dallas fl. 1920–1940

Watercolourist who painted landscapes of Kirkcudbright.

Amy Dalyell died 1962 (Mrs J. Birrell)

Edinburgh artist who exhibited at the RSA and RSW, painting landscapes, often with figures.

RSW 1883

Alexander Davidson 1838–1887

Painter of historical subjects and genre, similar in style to his friend Duncan Mac-Kellar. Often depicted scenes from the life of Prince Charles Stuart, but also painted old buildings. His watercolours are often large, and somewhat over-worked.

RSW 1883

Mary C. Davidson died 1950

Edinburgh artist who worked mostly in watercolour, painting landscapes in Scotland and France, and many flower pieces. Her work is competent with light colours but occasionally weak in drawing. Painted some Indian landscapes.

RSW 1936

Mabel Dawson 1878–1965

Born Edinburgh, studied ECA under Robert McGregor* and William Walls* who taught her to paint animals and birds, for which she became known. She also painted east coast fishing villages, interior and flowers. Her style is fluent and wet, not unlike that of Emily Paterson*. She was also noted for embroidery.

RSW 1917

William Deas born 1876

A pupil of William Proudfoot in Perth, he was an amateur artist until 1923 when he devoted his career to art. He lived in Forgandenny, Perthshire and painted the Perthshire landscape in a fresh watercolour style.

Eugene Dekkert fl. 1900–1940

Probably from a Dutch family, he worked in Glasgow and later in St Monance, painting coastal views in a wet watercolour style, influenced by the Dutch School.

William Dennistoun 1838–1884

Trained as an architect, painted architecture in watercolour. First President of the Glasgow Art Club 1867–68, he later moved to Italy and died in Venice. His earlier works are views of

Glasgow, while his later watercolours depict Italian buildings and landscape. His style is somewhat staid.

De Courcy Lewthwaite Dewar 1878–1959

Born Kandy, studied GSA and Central School, London. On staff of GSA 1898–1928. Enameller, metal-worker and black and white artist. Author of *The History of the Glasgow Society of Lady Artists' Club* (1950).

Jessie Alexandra Dick 1896–1976

Born Largs, studied GSA. On staff of GSA 1921–1959. Painted in oils and watercolour. ARSA 1960

Thomas Elder Dickson born 1899

Studied GSA under Greiffenhagen, later lectured on History of Art at ECA. Painted Scottish landscapes in oils and watercolour.

Anna Dixon died 1959

Edinburgh artist, trained RSA Schools under Walton* and Walls*. Painted effective watercolours in a fluent style, depicting the landscape and crofts of western Scotland and the Isles. Also painted domestic animals, donkeys and horses, sometimes with children.
RSW 1917

Cowan Dobson born 1893

Born Bradford, studied ECA. Lived in Glasgow and London, painting portraits in oils, but also watercolour studies of heads.

Henry John Dobson 1858–1928

Born Peeblesshire, studied ECA. Apart from a visit to America in 1911, he lived and worked in Edinburgh and Kirkcudbright, painting and illustrating genre and Scottish interiors. His energetically worked watercolours are luminous and successful. He exhibited with A. K. Brown* at the Scottish Gallery, 1900. His two sons, Cowan Dobson and H. R. Dobson, both painted.
RSW 1890

Henry Raeburn Dobson born 1901

Studied ECA, and turned, like his brother, to portraiture. Some of his watercolours of old Scottish characters are not unlike those of Henry Wright Kerr*.

Alexander Brownlie Docharty 1862–1940

Nephew of James Docharty (1829–1878), a landscape painter who worked in oils, he studied part-time at GSA under Robert Greenlees, and after a period designing calico, he took up painting as a profession in 1882. Studied in Paris in 1894. Lived and worked in Kilkerran, Ayrshire, but also painted the Highlands and European countries, visiting Venice on several occasions. Worked mostly in oils, but his watercolours can be fine with good composition and sensitive colour.

James L. C. Docharty died c. 1915

Glasgow landscape watercolourist who painted west coast views.

Albert Charles Dodds 1888–1964

Born Edinburgh, trained ECA and RSA Schools. Dodds was one-armed and was Drawing Master at Edinburgh Academy for many years. He painted landscapes in Italy, France, and southern England, as well as in Scotland, and his work is consistently well-painted, with confident, fluid technique.
RSW 1937

John Milne Donald 1819–1866

Primarily an oil painter, born in Nairn, lived in Glasgow. Largely self-taught, he did some watercolours of views in Glasgow in a style similar to that of Fairbairn* and Simpson*.

Tom Donald 1853–1883

Glasgow landscape painter in watercolours who worked in the West Highlands and on the west coast. A Founder Member of the RSW, he died five years later aged only 30.
RSW 1878

John Donaldson 1737–1801

One of the earliest Scottish artists to paint portraits in watercolour. Born in Edinburgh, he moved to London in 1762 where he painted miniatures on ivory, decorated porcelain, and produced pencil and watercolour portraits and caricatures.

James Douglas* 1858–1911
RSW 1900, resigned 1907

Sir William Fettes Douglas* 1822–1891
ARSA 1851, RSA 1854, PRSA 1882–91

William Douglas 1780–1832
Portrait painter usually on a small or miniature scale. Born Fife, died Edinburgh. Miniature painter for Scotland to Princess Charlotte and Prince Leopold. His work has considerable charm, and often includes animals.

Thomas Millie Dow* 1848–1919
RSW 1885, NEAC 1887, RCI 1903

Charles R. Dowell died 1935
Born Glasgow, studied GSA, travelling scholarship to Rome.
RSW 1933

John Patrick Downie 1871–1945
Born Glasgow, studied at the Slade and in Paris and was influenced by Hague School watercolours, developing a wet and fluid style. He painted interiors and genre, as well as fishermen in Scotland, in both oils and watercolour.
RSW 1903

Patrick Downie* 1854–1945
RSW 1902

Charles Altamont Doyle 1832–1893
Born London of an Irish Catholic family and taught by his father, John Doyle (1797–1868). Sent to Edinburgh in 1849, aged 17, to work in the Scottish Office of Works, where he remained for 30 years. He turned to alcohol, and was eventually committed to Montrose Royal Lunatic Asylum. Illustrated a number of books between 1859 and 1877 and produced humorous watercolours such as *Curling Match on Duddingston Loch* (Edinburgh City Art Collection) and *Bank Holiday* (National Gallery of Ireland, Dublin). His later work, painted in the Asylum, is introspective and brooding. His brother, Richard Doyle (1824–

1883) pursued a successful career in London as an illustrator and artist. C. A. Doyle's son was Sir Arthur Conan Doyle.

James Drummond* 1816–1877
Appointed Keeper NGS 1868.
ARSA 1845, RSA 1852

T. Dudgeon
Mid-nineteenth-century topographical artist, represented in Glasgow Art Gallery by *The Clyde from Denottar Hill*.

W. Nugent Dunbar
Scottish artist living in Rome during the 1820s. Painted watercolours of Italy which were exhibited at the RSA.

John Duncan* 1866–1945
ARSA 1910, RSA 1923, RSW 1930

John Duncan fl. 1917–1938
Watercolour painter of birds, he often composed in circles or ovals, and his drawings, although not outstanding, can be attractive.

Thomas Duncan 1807–1845
Historical painter in oils, trained at the Trustees' Academy. Painted watercolour portraits in a fresh manner which are very different from his historical canvases. Died aged 38.
RSA 1830, ARA 1843

J. Stirling Dyce died c. 1900
Son of William Dyce*, painted landscapes in France, England and Scotland in oils and watercolour, and some portraits. He lived in England, but retained links with Aberdeen, where he sometimes exhibited. His style shows a continuing influence of detailed Pre-Raphaelite landscape.

William Dyce* 1806–1864
ARSA 1835, ARA 1844, RSA 1848

Robert Eadie* 1877–1954
RSW 1917, VPRSW

Meg Easton fl. 1920–1939 (Mrs Viols)
Edinburgh artist who painted landscape

watercolours in a free, wet style between the wars.

Joseph Woodfall Ebsworth* 1824–1908

Studied Trustees' Academy under Sir William Allan* and David Scott*. In addition to architectural views of Edinburgh, he also painted landscapes of Italy and England.

Marjorie Evans died 1907 (Mrs A. Scott Elliot)

Flower and landscape painter in watercolours. RSW 1891, resigned 1902

James Faed Senior* 1821–1911

Painted fresh watercolours of the Scottish coast and landscape, although his main work was the engraving of paintings by his brothers and other artists, including Sir Noel Paton* and Daniel MacNee.

James Faed Junior 1847–1920

Landscape painter and illustrator of Sloan's *Galloway*.

John Faed* 1820–1902

ARSA 1842, RSA 1851

Thomas Faed* 1826–1900

ARSA 1849, ARA 1861, RA 1864

Thomas Fairbairn* 1820–1884

RSW 1882

David Farquharson 1840–1907

A painter of Highland moors and Lowland river valleys, almost entirely in oils, despite his membership of the RSW, where he rarely exhibited. ARSA 1882, RSW 1885, ROI 1904, ARA 1905

John Farquharson fl. 1880–1905

Watercolour painter of some talent, who specialized in coastal views of Scotland and the West Country. Lived in Edinburgh and London.

Frederick Arthur Farrell 1882–1935

Self-taught etcher and draughtsman influenced by Muirhead Bone*, he produced powerful watercolours of the Battle of Ypres in 1917. He also did illustrations for *The 51st Highland Division War Sketches* (1920). He later painted and etched views of London, Glasgow, Paris and other cities. His work as an etcher is comparable to that of many of his contemporaries and deserves more attention. Lived mostly in Glasgow.

George Straton Ferrier 1852–1912

The son of James Ferrier*, he painted fine, broad landscapes and seascapes influenced by the Hague School. His skies can be particularly successful, with touches of grey, yellow and pink. Lived in Edinburgh. RSW 1881, RI 1898

John Fleming 1792–1845

Born and lived in Greenock on the Clyde. Exhibited in Glasgow and became a member of the West of Scotland Academy. Painted Highland and Ayrshire landscape in oils and watercolours, and illustrated books on Scottish scenery. His work is rare.

J. S. Fleming fl. 1900–1920

Stirling architect who painted the old buildings of Stirling and Cambuskenneth.

Robert Purvis Flint* 1883–1947

RSW 1918, ARWS 1932, RWS 1937

Sir William Russell Flint* 1880–1969

ROI 1912, RSW 1913, ARWS 1914, RWS 1917, ARA 1924, ARE 1931, RE 1933, RA 1933

David Foggie* 1878–1948

RSW 1918, ARSA 1926, RSA 1930

J. Forster

Late eighteenth-century Edinburgh topographical artist.

Gordon Mitchell Forsyth 1879–1952

Pottery designer and painter who is famous for his work for Pilkington Tile and Pottery Company. Born Fraserburgh, studied Gray's School of Art, Aberdeen and RCA. He painted

watercolours of landscape and ceramics which he signed with a monogram.
RI 1927

Robert Fowler* 1853–1926

Born Anstruther, trained Liverpool College of Art.
RI 1891

Alexander Fraser I* 1786–1865

ARSA 1840

Alexander Fraser II* 1828–1899

ARSA 1858, RSA 1862, RSW 1878

John Simpson Fraser fl. 1870–1900

Painted seascapes and coastal scenes in watercolour.
RSW 1878

Jessie Frier* fl. 1870–1912

Edinburgh artist who painted interiors and landscapes in a tight but delicate style.

Robert Frier* fl. 1870–1910

Edinburgh artist, painted landscapes and figures.

David Fulton* 1848–1930

Born Parkhead, near Glasgow, studied GSA. Painted in oils and watercolour, his best landscapes depict figures in fields or beside streams, often bathed in sunlight. He also painted children in the open air, often with animals. His genre scenes of interiors are less successful.
RSW 1890

James Black Fulton 1875–1922

Architect and watercolourist. Painted views of Venice and Constantinople, influenced by Mackintosh* and Keppie*, also painted flower watercolours where the influence of Mackintosh is particularly strong.
FRIBA

Samuel Fulton 1855–c. 1940

Glasgow painter of animals, in particular dogs, who worked mostly in oils, but did some watercolours.

Elspeth Galloway born 1889

Edinburgh landscape watercolourist, who also worked in Italy.

Everett Galloway fl. 1918–1940

Landscape artist who worked in Perth and Belfast. Painted views of the Highlands in a wet technique with effective colours.

Andrew Archer Gamley died 1949

Born Johnshaven, Kincardineshire, studied RSA Schools. He lived on the east coast in Pittenweem, and later in East Lothian, painting harbour scenes which capture the effects of light on water, using a light watercolour technique. Sometimes his watercolours lack firm drawing and composition, appearing somewhat flimsy. Also worked in Spain.
RSW 1924, VPRSW

David Gauld 1865–1936

Member of the Glasgow School, he very rarely used watercolour, except as studies for stained glass windows.
ARSA 1918, RSA 1924

Ewan Geddes 1866–1935

Edinburgh artist who painted in Perthshire, dying at Blairgowrie. He painted quiet, but poetical, landscapes which are sensitive in their subdued tonality. His snow scenes combine Scottish wet watercolour technique with fine detail.
RSW 1902

Walter Geikie* 1785–1837

ARSA 1831, RSA 1834

William Gibb 1839–1929

Born Laurieston, the elder brother of **Robert Gibb** RSA (1845–1932), the military painter. Trained as a lithographer, but became known for his accurate watercolours of objects of applied art – church gold and silver, relics, Oriental porcelain. His work is superbly detailed but, as Martin Hardie points out, 'they cannot be called inspiring'. Illustrated *Dundee: Its Quaint and Historic Buildings* by A. C. Lamb (1895).

James Brown Gibson born 1880

Studied GSA. Painter in oils and watercolour, etcher, designer and sculptor. Exhibited landscapes at the RSW.

William Alfred Gibson 1866–1931

Spent 10 years in the Royal Glasgow Queen's Own Yeomanry and saw service in the Boer War, but after a short business career, he turned to art. His work is often in oils, but he did paint watercolours, strongly influenced by the Dutch School. His favourite subjects are river views, painted in subdued tones of greys and blues, often with the use of bodycolour.

James Giles* 1801–1870

RSA 1830

John A. Gilfillan fl. 1820–1840

Served in the Navy before turning to art; Professor of Painting in Glasgow c. 1830–1840, but emigrated to New Zealand where he died. Painted marine subjects and views of Glasgow in watercolour, using a cool style with silvery colours and clear drawing.

Alexander Bryson Gillespie fl. 1900–1940

Edinburgh artist who worked in oils and watercolour.

Floris Mary Gillespie 1882–1967

Born Bonnybridge, studied GSA, taught at Stranraer High School, died Edinburgh. Watercolour painter.

Janetta S. Gillespie 1876–1956

Sister of Floris Gillespie, studied GSA, taught Bonnybridge School, Stirlingshire. Painted still life and flowers in watercolour.
RSW 1943

Margaret Gillies 1805–1887

The daughter of a Scottish merchant who settled in London, she was orphaned young and brought up by Lord Gillies in Edinburgh. She returned to London in 1823 and studied under Frederick Cruikshank and later in Paris. She painted miniatures and watercolours of single figures, often Scottish, in landscape settings. Her figures are often sentimental, somewhat like those of Robert Herdman, and she was influenced by Pre-Raphaelite detail. Although she lived in London and later in Hampshire, she made regular visits to Scotland.
ARWS 1852

Sir William George Gillies* 1898–1973

ARSA 1940, RSA 1947, RSW 1950, CBE 1957, ARA 1965, Kt 1970, RA 1971, PRSW 1963–69

James Gilmour fl. 1885–1937

Glasgow artist who painted landscape watercolours in a fresh, loose style with sparkling colours.

John Hamilton Glass fl. 1890–1925

Prolific painter of coastal views in Scotland and Holland. He lived in Musselburgh and often worked on the east coast in Angus and Fife, but also painted on Iona. His watercolours vary greatly in quality; some can be effective in a breezy, open style while others lose all sense of structure. His figures tend to be rather dumpy, and his colours grey. His wife **Mary Williams** produced watercolours in a similar style.

William Glover fl. 1875–1900

Amateur Glasgow landscape painter who was a theatre manager and scene painter by profession. Painted coastal scenes and landscapes of the west coast, often with rather weak drawing.
RSW 1878

David Goodfellow 1871–1941

A baker from Broughty Ferry who painted watercolours of flowers and landscapes.

James Gordon fl. 1820–1850

Aberdeen artist who painted views of Aberdeen, often for reproduction. A sound draughtsman, he used a mixture of charcoal, pencil and wash in a fluent syle. His work was used for Nichols's *Cities and Towns of Scotland*.

George Russell Gowans 1843–1924

Aberdeen artist who painted watercolour landscapes and some portraits in oils. His large and

often powerful landscapes of the north east of Scotland have broad skies and wide expanses of fields and moors.
RSW 1893

George Gray fl. 1880–1910
Edinburgh landscape painter who produced some tightly composed and well executed watercolours, often with a luminous use of colour. His work deserves greater attention.

James Gray died 1947
A flower painter who worked in Edinburgh. His work is often free and effective; he also painted landscapes in watercolour. His wife Jean Lyal Christie was also a watercolourist.
RSW 1936

John Gray* 1873–1957
RSW 1941, PRSW 1952–1957

Norah Nielson Gray* 1882–1931
Born Helensburgh, studied GSA.
RSW 1914

Rosalie Gray 1883–1955
Born Glasgow, née Rosalie Campbell, studied GSA. Watercolourist and embroiderer.

Georgina Mossman Greenlees 1849–1932 (Mrs Graham Kinloch Wylie)
Born Glasgow, the daughter of Robert Greenlees, studied GSA, taught GSA 1875–1880. A somewhat weak watercolourist, she painted views of Venice, Rome, Capri and Assisi, as well as Switzerland and Belgium.
RSW 1878

Robert Greenlees 1820–1896
Headmaster of GSA prior to Fra Newbery*. Produced landscapes and domestic scenes in watercolour.
RSW 1878

G.M. Greig died 1867
Edinburgh artist who painted watercolours of interiors, picturesque buildings and views of Edinburgh. He also painted children and seaside scenes. During his lifetime he had a considerable reputation as a watercolourist.

Alec Grieve 1864–1933
Born Dundee, studied at Dundee Art College and Colarossi's, Paris. In the circle of Dutch Davidson*, he later painted powerful watercolours of Tayport and Dundee. A founder of the Tayport Art Circle.

William Mortimer Grubb fl. 1875–1900
Art Master at Dundee High School in the 1880s. Painted attractive domestic scenes and local views in watercolour.

Ralston Gudgeon* born 1910
RSW 1937

William Hackstoun 1855–1921
Trained in Glasgow as an architect, but attracted the attention of Ruskin who taught him for a period. He lived for a time in London, but worked mostly in Scotland, particularly in Fife and Perthshire. Some of his watercolours are straightforward landscapes, but others have a distinctive stylization using strange linear patterns for hills and clouds, often combined with strong colours.

George Wright Hall* 1895–1974
Studied ECA and RSA Schools, later taught at Manchester School of Art. His watercolours were influenced by the work of Gillies and Wilson, and his fluent penwork is combined with rich colours.

Keeley Halswelle* 1832–1891
ARSA 1865, RI 1882

James Whitelaw Hamilton* 1860–1932
RSW 1895, ARSA 1911, RSA 1922

Thomas Crawford Hamilton fl. 1880–1900
Painter of portraits, figures and religious subject in oils and watercolours.

Thomas Hamilton 1785–1858
Important Edinburgh architect responsible for Edinburgh Royal High School, the Burns Memorial, Ayr and many other buildings. A particularly fine architectural watercolourist.
RSA 1826

Hans Hansen 1853–1947

Born Copenhagen, educated in Edinburgh and studied art under R. B. Nisbet* and J. Ross, developing a style superficially similar to Melville*. He worked extensively abroad, in the Middle East, North Africa and Spain, visiting Russia in the 1890s. The quality of his work varies greatly; at his best he could produce attractive, decorative views of Eastern markets or bull-fights, but at times his work is weak in drawing and crude in colour.
RSW 1906–1913

Charles Martin Hardie 1858–1916

A leading figure and historical painter born in East Linton and trained RSA Schools. Although he painted almost entirely in oils, he painted some watercolour landscapes during his earlier career, often as studies for the setting of his historical works.
ARSA 1886, RSA 1895

Martin Hardie 1875–1952

Educated at St Paul's School and Trinity, Cambridge, he studied under Sir Frank Short. He was the nephew of Charles Martin Hardie and retained strong links with Scotland and Scottish painters. A fine watercolourist, he painted views in France and Italy and East Anglia, using a firm pen outline and a fluid watercolour technique – a style not unlike that of his close friend, McBey*. Keeper of Prints and Drawings, VAM, 1921–35 and author of books on the history of watercolours.
ARE 1907, RE 1920, RI 1924, VPRI 1934, RSW 1934, CBE 1935

Edward Hargitt* 1835–1895
ARI 1865, RI 1867, ROI 1883

Archibald Standish Hartrick 1864–1950

Born Bangalore, India, returned with his army family to Scotland in 1866. On the death of his father, his mother married Dr Charles Blatherwick, an amateur watercolourist. Studied at the Slade and Académie Julian, Paris, where he was influenced by modern French painting. In 1896 he married his step-sister, Lily Blatherwick and moved to Gloucester-shire from London, where he had been working since c. 1890.
NEAC 1894, ARWS 1910, RWS 1922, OBE

Sir George Harvey* 1806–1876

Born St Ninians, Perthshire, studied Trustees' Academy.
ARSA 1826, RSA 1830, PRSA 1864–1876

Nellie Ellen Harvey died 1949

Stirling artist, the niece of Sir George Harvey*, studied under J. Denovan Adam at Craigmill and in Paris. Painted watercolours of genre scenes, birds and domestic fowl.

George Hay 1831–1912

Figure painter in oils, who also painted watercolours of elegantly dressed ladies, sometimes in fancy dress.
ARSA 1869, RSA 1876, RSW 1878, Secretary RSA 1881–1907

James Hay fl. c. 1880–1900

Minor painter of genre and objects of applied art in oils and watercolour.

Peter Alexander Hay 1866–1952

Born Edinburgh, studied RSA Schools, Paris and Antwerp. Known as a portrait painter in oils and watercolours in the style of Sholto Douglas and A. E. Borthwick, he also painted landscapes, often in Perthshire, but also in France in the 1920s. His firm drawing is combined with sparkling colour.
RSW 1891, RI 1917

Robert Hay 1799–1863

An Egyptologist who painted detailed watercolours of Egypt.
RSA 1841

Thomas Marjoribanks Hay* 1862–1921
RSW 1895

William Hardie Hay born 1859

Born Birkenhead, son of John Hay the architect, studied GSA. Painted Highland and west coast scenes in watercolour and oils, and also worked in Belgium.

Joseph Henderson* 1832–1908

RSW 1878

Joseph Morris Henderson 1863–1936

The son of Joseph Henderson*, studied GSA, and was influenced by his father's later style and subject matter. Painted mostly seascapes and coastal scenes in oils, but also used water-colour.

ARSA 1928, RSA 1936

His brother **John Henderson** (died c. 1924) also painted similar subjects in oils and water-colour.

Keith Henderson 1883–1982

Although an English painter, Henderson is as-sociated with the Scottish School via his later work which was painted and exhibited in Scot-land. He lived for many years in Fort William and at nearby Spean Bridge, where he painted powerful, simplified watercolours.

RP 1912, ARSW 1930, ARWS 1930, ROI 1934, RSW 1936, RWS 1937, OBE

Barclay Henry fl. 1890–1940

Minor marine artist, connected with the Craigmill School, Stirling, he worked in oils and watercolour.

George Henry* 1858–1943

NEAC 1887, ARSA 1892, RSW 1900, RP 1900, RSA 1902, ARA 1907, RA 1920

Robert Herdman* 1829–1888

ARSA 1858, RSA 1863, RSW 1878

Robert Duddingston Herdman 1863–1922

The son of Robert Herdman*, studied RSA Schools and Paris. Painted romantic scenes often inspired by poetry or literature, as well as genre. Painted some landscapes in Holland and Spain. Worked mostly in oils, but exhi-bited some watercolours at the RSW.

ARSA 1908

George Heriot 1766–1844

Amateur artist, the son of the Sheriff-Clerk of East Lothian, and himself a civil servant,

later becoming Deputy Post-Master General of Canada (1799–1816). On his retirement he returned to Scotland and painted views of Spain, France, Wales, Scotland and the Thames Valley. He was influenced by the work of Paul Sandby. Published *Travels through Canada* which he illustrated himself.

James Heron fl. 1873–1919

Edinburgh watercolourist who painted west coast scenes and views of Edinburgh. His colour is restrained and often silvery in tone, and his compositions are effective despite his rather weak drawing of figures.

David Octavius Hill* 1802–1870

RSA 1826, Secretary RSA 1830–38

Andrew Healey Hislop 1887–1954

Teacher of drawing ECA, he painted land-scapes in oils and watercolour, using a free style. His wife, **Margaret Ross Hislop** (1894–1972, RSA 1964) also painted, but only rarely used watercolour.

William Brassey Hole 1846–1917

English artist who painted scenes from Scot-tish history, murals and produced etchings of famous paintings. He lived in Edinburgh where he had been brought up, and painted some west coast landscapes in watercolour.

ARSA 1878, RE 1885, RSW 1885, RSA 1889

Alexander Campbell Holms 1862–1898

Paisley watercolourist, studied GSA and Paris. Illustrated the poems of Spencer, Tennyson and Rossetti.

RSW 1893

Edmund Holt died 1892

Painter of Edinburgh characters and scenes in watercolour.

Bruce James Home 1830–1912

Topographical artist, studied Trustees' Aca-demy under Robert Scott Lauder*. Curator of the Outlook Tower and first Curator of Edin-burgh Municipal Museums. Painted pen-and-wash views of Edinburgh streets and courts.

Jane Hope 1766–1829

Probably the daughter of the 2nd Earl of Hopetoun, she married Henry Dundas, later Viscount Melville, in 1793. Her second marriage was to Thomas, 1st Lord Wallace. Described by a contemporary as 'a rather elegant woman, possessing a good figure over which drapery might be thrown with good effect', she was taught by David Allan and produced a number of somewhat naive watercolours, mostly landscapes.

Anna M. Hotchkis 1885–1984

Studied GSA (between 1906 and 1910) in Munich and ECA under Robert Burns*. Taught at Yenching University, Peking 1922–24, lived in China 1926–37. Published books on Chinese art, paints in watercolours and oils. Lives in Kirkcudbright.

Isobel Hotchkis 1879–1947

Sister of Anna Hotchkis, born Crookston, studied GSA. Painted portraits in oils, and later, because of ill health, in watercolour.

George Houston* 1869–1947

RSW 1908, ARSA 1909, RI 1920, RSA 1921

John Rennie Mackenzie Houston* 1856–1932

RSW 1886

His brother **Charles Houston,** who lived at Rutherglen, painted landscapes in watercolour.

Robert Houston* 1891–1942

Born Kilbirnie, Ayrshire, studied GSA. RSW 1936

James Howe 1780–1836

An animal painter in oils who also did pen-and-wash drawings of horses and figures in a humorous manner. The son of the parish minister of Skirling, Peebleshire, he was patronized by the Earl of Buchan. His drawing was assured, if crude at times.

James Huck fl. 1911–1939

Landscape painter in oils and watercolour working in Glasgow.

Stephen Humble fl. 1820–1840

Painter of flowers in watercolour.

Thomas Hunt 1854–1929

Born Skipton, studied Leeds and GSA, became President of the Glasgow Art Club 1906–08. He painted animals and local characters, with some landscapes. His watercolour style is vigorous and unsophisticated, but has an energy and scale which can be successful. RSW 1885, ARSA 1914

Colin Hunter* 1841–1904

RSW 1879, RE 1881, RI 1882, ROI 1883, ARA 1884

James Brownlie Hunter fl. 1880–1920

Edinburgh artist and engraver, painted landscapes and coastal scenes.

John Young Hunter 1874–1955

The son of Colin Hunter*, born Glasgow, studied RA Schools, London. Painted romantic scenes of figures in gardens and interiors in oils and watercolour. Went to USA c. 1925; lived in Suffolk for many years. RBA 1914

His wife **Mary Young Hunter** (1878–1936) also painted in watercolour and they jointly illustrated *The Clyde* by Neil Munro (1907).

Mason Hunter 1854–1921

Born Linlithgowshire, studied Edinburgh School of Design, he painted seascapes and coastal views in watercolour and oils in a style similar to R. Clouston Young*. RSW 1889, ARSA 1913

Robert Gemmell Hutchison* 1855–1936

RSW 1895, ARSA 1901, RSA 1911

Isobel Wylie Hutchison fl. 1897–1939 (Mrs H. Morley)

Landscape painter, she often depicted the rugged mountains of Greenland in a broad style, making good use of the whiteness of bare paper. She also painted the lochs of Scotland and views in America.

James Hutton 1894–1957

Marine watercolourist, born Broughty Ferry.

John Irvine 1805–1888

Landscape painter in watercolour. His style is somewhat naive and he was probably an amateur.

Robert Scott Irvine* born 1906

RSA 1933, RSW 1934

Jet Jardine fl. 1914–1940

Helensburgh watercolour painter influenced by the watercolours of James Paterson.

William Myles Johnston 1893–1974

Born Edinburgh, studied ECA under William Walls*, he spent five years in America painting pastels. Returned to Edinburgh and taught at John Watson's College. Decorated pottery with animal designs. Moved to Kirkcudbright in 1940 where E. A. Taylor* and Jessie King* were friends. Worked with Sir Robert Lorimer on the Scottish National War Memorial in Edinburgh Castle, where he executed the heraldic blazoning. Died in a fishing accident.

William Borthwick Johnston 1804–1868

An academic painter of historical scenes and miniatures, he was the first curator of the NGS. Like many of his contemporary Academicians he was also a sensitive watercolourist, although he painted few. *Landscape with Peasant Girl carrying a Pitcher* (VAM) is a delicate example set in an Italian landscape reminiscent of early Turner.

ARSA 1840, RSA 1848

Dorothy Johnstone* 1892–1980 (Mrs D. M. Sutherland)

ARSA 1962

George Whitton Johnstone* 1849–1901

Born Forfar, studied RSA Schools, having been apprenticed to a cabinet maker. He painted quiet landscapes with rivers and trees which are serene rather than powerful, and show a Dutch influence. He painted in Fife and in Northern France, and worked in oils and watercolours. He was the father of Dorothy Johnstone*.

ARSA 1883, RSW 1885, RSA 1895

Alexander Kay fl. 1813–1840

Edinburgh topographical and landscape artist, exhibited at the Society of Dilettantes and the RSA. A prolific watercolour painter of Scottish landscape, shipping and coastal scenes, his style was influenced by 'Grecian' Williams*, although his drawing is weaker.

Archibald Kay 1860–1935

Born Glasgow of a Caithness family, studied GSA and Académie Julian, Paris. A prolific painter of landscapes in oils and watercolours, he worked in Scotland, Belgium, France, Italy, Denmark and Holland, in a style influenced by the Dutch School. His watercolour technique was broad and wet.

RSW 1892, ARSA 1916, RSA 1930

James Kay* 1858–1942

Born Arran, studied GSA.

RSW 1896, ARSA 1933, RSA 1938

John Kay 1742–1826

Born Dalkeith, apprenticed to a barber before turning to miniature painting and caricature in 1784. His *Edinburgh Portraits* depict local characters, his watercolour style being influenced by David Allan*.

Violet McNeish Kay 1914–1971

Born Glasgow, the daughter of James Kay*, studied GSA. She painted watercolours of the west coast in a bold manner, using large blobs of strong colour.

RSW 1947

Henry Keir 1902–1977

Glasgow artist who left school at 14 to become a house painter and sign writer while attending GSA evening classes. He painted the working-class areas of Glasgow – tenements, back-streets and pubs in a sombre style. He also sketched gypsies and travellers, and did illustrations for Edward Gaitens's *Gorbal Novels*, recording a fast-disappearing aspect of Glasgow.

George Meikle Kemp 1794–1844

Architect, famous for Edinburgh's Scott

Memorial, who also worked in watercolours in a style similar to that of Thomas Hamilton.

Jeka (Jacobina) Kemp 1876–1966

Born Bellahouston, Glasgow, she studied art in London and Paris before travelling to Italy, Holland and North Africa. She exhibited her French landscapes at the Glasgow Society of Lady Artists, the Glasgow Institute and in 1912 held her first one-man exhibition at Macindoe's Gallery, Glasgow. A critic described her in 1914 as 'a distinguished disciple of Melville' and her colour and technique are derived from Melville, although her style is somewhat cruder. She remained in France until 1939, although she had given up painting in 1927, and returned to Dorset. Her most successful watercolours are of figures on beaches or in interiors flooded with the light of Southern France.

John Kennedy fl. 1850s

Landscape painter who was Master of the School of Art in Dundee. His watercolours are delicately drawn and have fresh colours. A group of watercolours painted in 1855 relate to Burns's life (NGS).

William Kennedy 1859–1918

Born and studied in Paisley and later in Paris (1880–5), he painted mostly in oils, influenced by Bastien-Lepage. He specialized in military scenes and animals, and was associated with the Glasgow School. Settled in Tangiers in 1912 for health reasons, he painted Arab scenes and horses. His watercolours are comparatively rare.

William Denholm Kennedy 1813–1865

Born Dumfries, studied RA Schools in London. Became a friend of William Etty, and thus belongs more to the English School than to Scotland, from which he had permanently emigrated. He was an excellent watercolourist and painted fresh and delicate landscapes often relating to his visits to Italy.

Jessie Keppie* 1868–1951
RSW 1934

John Keppie* 1863–1945

Born Glasgow, studied Glasgow University and Paris. Worked in the architectural firm of Campbell, Douglas and Sellars before going into partnership with Honeyman, being joined later by C. R. Mackintosh*. His watercolours are particularly effective, at times showing the influence of Melville in his blottesque handling of the medium, at other times revealing E. A. Walton's* influence, especially in his landscapes.
ARSA 1920, RSA 1937, FRIBA

Henry Wright Kerr* 1857–1936
RSW 1891, ARSA 1893, RSA 1909

James Kerr-Lawson 1864–1939

An interesting artist of many talents – painter of figures, landscapes and portraits in oils and watercolour, decorative artist and lithographer. He was born in Anstruther, Fife, and after a childhood in Canada, returned to study art in Paris and Rome. His oils were influenced by the New English Art Club painters and by the subdued colours of the Camden Town School, while his watercolours of Spanish and Italian towns and markets often sparkle.

James Kinnear fl. 1875–1917

Edinburgh landscape painter who worked in a style similar to that of James Heron. Painted landscapes and views of Edinburgh, some of which were reproduced in the *Art Journal*.

Leslie Gordon Kinnear 1901–1976

Dundee landscape and figure painter who worked largely in watercolour.

Nicol Laidlaw born 1886

Born Edinburgh, studied ECA and Paris. Painted watercolour landscapes of the Lothians, portraits in oils and illustrations.

Annie Rose Laing 1869–1946

Born Glasgow, née Annie Low, studied GSA, married James Garden Laing*. Painted landscapes and children, mostly in oils.

Frank Laing* 1862–1907
ARE 1892

James Garden Laing* 1852–1915
RSW 1885

Helen Adelaide Lamb died 1981
Born Prestwick, studied GSA. Illuminator of manuscripts and pencil draughtsman.

Mildred Lamb 1900–1947 (Mrs Walter Connor)
Sister of Helen Lamb, studied GSA. Illustrated many books 1923–37 and painted in watercolour.

William B. Lamond 1857–1924
Born Newtyle, near Dundee, he worked for many years on the Caledonian Railway. He developed a talent for portrait painting at which he made a reputation, but later turned to landscapes and especially seascapes. His vigorously painted harbour scenes are often effective, and his lack of formal training resulted in a direct and powerful style.
RBA 1904

Thomas Reynolds Lamont 1826–1898
Born in Greenock, he studied in Paris along with Du Maurier and Poynter at the Atelier Gleyre. These student days are recalled by Du Maurier in *Trilby* in which Lamont is *The Laird*. He painted period pieces in watercolour, with figures dressed in elegant eighteenth-century costume, often posed in beautiful gardens. His technique is fine – he is obsessed by detail and at the same time he creates luminous colours, which may have been influenced by Pre-Raphaelitism. His subject-matter does not always do justice to his technique.
ARWS 1866

George Nasmyth Langlands died 1940
Trained in Edinburgh and Paris, he was a prolific artist both in oils and watercolour, painting Scottish east coast and Highland scenes, but also working abroad, in Belgium and Holland. His work is quietly competent.
RSW 1896

Charles James Lauder* 1841–1920
Related to Robert Scott Lauder*, studied GSA under Charles Heath Wilson*.
RSW 1885, resigned 1913
His second wife, **Gertrude Lauder** 1855–1918, was a member of the Glasgow Society of Lady Artists and bequeathed £250 to establish the Lauder Prize for the best work in the annual exhibition.

Nancy Lauder born 1880
Glasgow painter of flowers in oils and watercolours.

Sir John Lavery* 1856–1941
Born Belfast, studied Haldane Academy, Glasgow, Heatherley's, Atelier Julian, Paris. Almost exclusively an oil painter, Lavery nevertheless executed a series of finished watercolours in 1885 probably intended for his patrons in Glasgow and Paisley. They show the influence of E. A. Walton* in technique although Lavery's admiration for Crawhall* is also evident.
NEAC 1887, ARSA 1893, RP 1893, RSA 1896, ARHA 1906, RHA 1907, HROI 1910, ARA 1911, knighted 1918, RA 1921

David Law 1831–1902
Born Edinburgh, studied Trustees' Academy, he worked as an engraver producing detailed maps, eventually working for the Ordnance Office in Southampton. He later devoted himself entirely to watercolour painting, being influenced by Birket Foster and the later Pre-Raphaelites. He painted landscapes in England, Scotland, Wales and had a particular love for detailed shipping scenes, which he found in Venice. His watercolours are often large with fine drawing and detail.
RE 1881, RSW 1882, RBA 1884, HRBA 1893

Cecil Gordon Lawson 1851–1882
Lawson's links with Scotland are tenuous – he was born in Shropshire of Scottish parents and lived most of his life in London, but he retained many Scottish characteristics both in his personality and in his broad, powerful watercolour style.

William Leiper 1839–1916

Distinguished architect who moved from a Gothic style towards the Free School approach of Norman Shaw, designing many houses in Helensburgh. He also painted watercolours of the west coast.
RSW 1879, ARSA 1892, RSA 1896

Richard Principal Leitch died 1882

Born Glasgow, the brother of W. Leighton Leitch, he settled in London and taught drawing. Travelled extensively in Italy and Switzerland, and visited Egypt. His watercolour style is somewhat heavy, although his best work can be effective.

William Leighton Leitch* 1804–1883
RI 1862, RWS 1862, VPRI

Otto Theodore Leyde 1835–1897

Born in Germany, he came to Edinburgh as a youth and worked as a lithographic artist. Painted oils and watercolours depicting Scottish landscape and scenes from rural life, often with well-drawn figures. His handling of children, painted with fresh colours and sympathy, is particularly fine. He also painted portraits in watercolour.
ARSA 1870, RSW 1879, RSA 1880, RE 1881

James Little fl. 1880–1910

Edinburgh artist who painted townscapes and seascapes in a proficient style, his colours tending towards a restrained grey-green tonality.

Robert Little* 1854–1944
RSW 1885 (resigned 1904, re-elected 1910) ARWS 1892, RWS 1899, ROI 1901, VPRWS 1913–16, HRSW 1936

John Lochhead 1866–1921

Born Glasgow, studied RSA Schools. Landscape painter who worked mostly in oils, but did some watercolours; connected with Craigmill School in Stirling. Travelled widely abroad.
RBA 1911

John Harold Bruce Lockhart 1889–1956

Teacher and sportsman who became Headmaster of Sedburgh after a period at Rugby. He painted landscapes in watercolour, often relating to his visits abroad.

William Ewart Lockhart* 1844–1900
ARSA 1871, RSA 1878, RSW 1878, ARWS 1878, RE 1881, RP 1897

W. M. Lockhart fl. c. 1870–1912

Pupil of Thomas Fairbairn*, a topographical artist who worked in Glasgow.

George Logan

Well-known designer of furniture and interiors for Wylie and Lochhead Ltd. Also painted fine watercolours of interiors which show how well many of the Glasgow designers could handle watercolour. Lived in Greenock and exhibited occasionally at the Glasgow Institute. Watercolours of his decorative schemes were reproduced in magazines of the period, including *The Studio*.

John O. Long died 1882

Scottish landscape painter, probably from Glasgow, who moved to London c. 1860. Painted landscapes of Arran and the Highlands.
RSW 1878

John Henry Lorimer 1856–1937

Successful painter of Scottish history and life. Born Edinburgh, studied Edinburgh University, RSA Schools, and Carolus Duran atelier, Paris. During a long career, he exhibited many watercolours at the RWS and RSW choosing different subjects – at times he paints landscapes in Scotland and France, or architectural views of cathedrals and their details (his brother was the architect Sir Robert Lorimer), while at other times he paints individual figures, such as Flemish lace weavers, or families in interiors. His watercolour style was influenced by the restrained colours he used for his oils, which themselves owe much to Whistler. He favoured tones of grey, white and

cream, with occasional touches of stronger colour.
ARSA 1882, RSW 1885, ROI 1890, RP 1892, RSA 1900, ARWS 1908, RWS 1834

Isabella Wylie Lowe 1855–1925

Perthshire miniature painter who also did landscapes in watercolour in a fresh and professional style.

Ernest Stephen Lumsden* 1883–1948

Born London, trained Reading School of Art, Paris and ECA, he settled in Edinburgh and became associated with many progressive Edinburgh artists between the wars. His reputation was established through his etchings, but as a younger man he had painted many good watercolours relating to his travels abroad. In particular his watercolours of India are fine, but he also painted in China, Japan, Korea, Canada, France and Spain.
His wife **Mabel Royds** painted in oils and produced interesting colour woodcuts.
ARE 1909, RE 1915, ARSA 1923, RSA 1934

Thomas Bonar Lyon born 1873

Studied GSA and on the Continent, art master at Irvine Academy. Lived in Ayrshire and painted its landscape and coast in both oils and watercolours. His work was influenced by other Glasgow marine and coastal artists including MacMaster* and Black*.

Walter MacAdam 1866–1935

Born and resident in Glasgow and had a summer studio in Lochwinnoch, Renfrewshire. Painted Highland and west coast views in oils and watercolour in a style which is sound rather than exciting, with colours tending towards browns. He also worked after 1918 on Majorca.
RSW 1894

Hamilton Macallum* 1841–1896

RSW 1878, RI 1882, ROI 1883

Kate Macaulay fl. 1870–1900

Landscape watercolour artist, she moved from Scotland to Capel Curig, North Wales. Her watercolours are carefully composed and drawn, but not overworked. She particularly enjoyed coastal scenes.
RSW 1878, resigned 1898

Robert Walker Macbeth 1848–1910

Born Glasgow, son of the portrait and genre painter, Norman Macbeth (1821–1888), he moved to London in 1870 to work as an illustrator for *The Graphic*, and thus really belongs to the English School. He worked in oils and watercolours, painting scenes from rural life and studies of fishermen, maidens and country people. His earlier work was influenced by Fred Walker and Pinwell, but his later watercolours have more colour and a freer technique. He was also a successful etcher. His brother, **Henry Macbeth-Raeburn** (1860–1947) was known for his oils, etchings and illustrations, painting very few watercolours. Born in Helensburgh, studied RSA Schools and Paris, his reputation, like that of his brother, was made in London.

Madge MacBrayne 1883–1949

Born Glasgow, studied GSA, a painter in oils and watercolours and sculptress. Lauder Award for watercolours 1931.

Alexander MacBride 1859–1955

Born Cathcart, studied GSA and Paris. Painted landscapes in oils and watercolours choosing tranquil rural scenes often with sunlight coming through trees, or figures by a river. Influenced by Impressionism, he worked in Scotland, England and Italy.
RSW 1887, RI 1899

William MacBride died 1913

Glasgow landscape painter who worked mostly in oils, but did some watercolours.

Dugald Sutherland MacColl* 1859–1948

Born Glasgow, studied London University, Lincoln College, Oxford, Westminster School of Art and the Slade.
NEAC 1896, RSW 1938

Horatio McCulloch* 1805–1867

ARSA 1834, RSA 1838

James MacCulloch died 1915

Landscape artist who worked in oils and water-colours. Lived in London for many years, although his subjects are almost entirely of the Highlands and Islands. His watercolour style is tight and his colours tend to be sweet, with purple mountains and pinks and yellows in the sky.
RBA 1884, RSW 1885

Arthur MacDonald fl. 1895–1940

Glasgow painter of seascapes and coastal scenes. Most of his work is in oils, but he did watercolours in a style similar to that of Andrew Black* and James MacMaster*.

John Blake MacDonald 1829–1901

Born Morayshire, studied RSA Schools, he became known for paintings of incidents during the Jacobite Rebellions. He later turned to pure landscape in both oils and watercolour and painted Highland and coastal views. During the 1870s he visited Venice and exhibited watercolours of Venice at the RSA. At its best, his work was fresh and effective, despite somewhat weak drawing.
ARSA 1862, RSA 1877, RSW 1878

Margaret Macdonald* 1865–1933 (Mrs Charles Rennie Mackintosh)
RSW 1898, resigned 1923

Lily McDougall 1875–1958

Still-life and flower painter in oils and water-colour, who worked in Edinburgh. Founder member of Scottish Society of Women Artists.

Norman McDougall fl. 1880–1927

Glasgow landscape painter in oils and water-colour.

Tom McEwan* 1846–1914
RSW 1883

Andrew MacGeorge 1810–1891

Glasgow lawyer and local historian who painted meticulous views of Glasgow in pencil and watercolour.

Mabel Victoria MacGeorge 1885–1960

The niece of the Earl of Minto, she caused a minor sensation by marrying the artist Hugh Munro, at that time a penniless painter cutting woodblocks for Charles Mackie*. She married William Stewart MacGeorge (1861–1931) in 1929, a year after Munro's death, and began to paint watercolours seriously. She had been trained by J. Campbell Noble* and had acquired a proficient technique. She painted many parts of Scotland, including the Western Isles, the Lothians (where she lived for many years) and Perthshire. Her watercolours, which are often quite large, are painted with spirit and confidence.
RSW 1930

John McGhie 1867–1952

Glasgow artist, studied GSA, RA Schools and Paris. Painted seascapes, coastal and harbour scenes mostly in oils, but also in watercolour.

Hannah Clarke Preston MacGoun 1864–1913

Painted children in watercolour in a soft style influenced by the Dutch School, also painted interiors and genre in watercolour. Illustrated children's books. Lived Edinburgh.
RSW 1903

John Douglas MacGregor died 1951

Interesting Glasgow watercolourist whose work was strongly influenced by Surrealism.

Robert McGregor 1847–1922

Born Yorkshire, studied RSA Schools, worked in damask printing trade in Dunfermline. He later moved to Edinburgh where he worked as an illustrator and painter, mostly in oils, of rural life. His subjects were inspired by Bastien-Lepage and Millet, and although his style was most suited to oil painting, he did occasionally work in watercolour.
ARSA 1882, RSA 1889

William York MacGregor* 1855–1923
RSW 1885, NEAC 1892, ARSA 1898, RSA 1921

Robert Ranald McIan 1803–1856

An actor who gave up the stage to paint Scottish history and legends. He had a studio in London and Fort William, where he painted figures in Highland costume and local traditions in both oils and watercolour. He illustrated the *Books of the Clans* and also painted birds in watercolour.
ARSA 1852
His wife **Fanny McIan** 1814–1897 was also an artist and taught at the Government School of Design. She was the first woman artist in Scotland to be honoured, becoming an Honorary RSA in 1854.

Robert McInnes 1801–1886

Painter of rural life, genre and portraits. His watercolour style was influenced by the later work of Wilkie* and the work of John Phillip*, although he lacked their draughtsmanship. A friend of William Bell Scott*, McInnes worked in London, Scotland and Italy.

Edith A. Macintyre fl. 1925–1939

Landscape painter from Broughty Ferry who worked in watercolour and pastels.

Charles Mackay born 1868

Glasgow furniture designer who also painted watercolours. Studied GSA.

Thomas Hope McKay fl. 1900–1930

Glasgow painter of fishing boats, harbours and coastal scenes in oils and watercolour. His style was influenced by the 'wet' Glasgow technique.

Alexander Balfour McKechnie 1860–1930

Born Paisley, studied GSA, he painted mostly in watercolour, travelling in North Africa, Egypt and Europe as well as in Scotland.
RSW 1900

Duncan MacKellar 1849–1908

Born Inverary, studied GSA and London. Worked in a photographer's studio tinting prints before turning to full-time painting in 1875. He painted genre and historical scenes in oils and watercolours, his speciality being figures in interiors, either of quaint country cottages or of stately baronial halls. His technique is sensitive and delicate.
RSW 1885

Andrew McKenzie born 1886

Glasgow architect, studied GSA and Glasgow School of Architecture. Also worked in watercolour.

James Hamilton Mackenzie* 1875–1926

RSW 1910, ARE 1910, ARSA 1923

Charles Hodge Mackie* 1862–1920

RSW 1901, ARSA 1902, RSA 1917.
His sister **Annie Mackie** (fl. 1885–1934) painted flowers in watercolour.

Peter Robert Macleod Mackie 1867–1959

Landscape painter in oils and pastels who was strongly influenced by Whistler. He painted some watercolours, although these are rare. Curator, Kirkcaldy Art Gallery and Museum from 1929.
ARSA 1933

Finlay Mackinnon died c. 1935

Landscape painter born and lived at Poolewe, Ross-shire, studied South Kensington and Paris. Exhibited Scottish landscapes from the 1890s at the Fine Art Society, Walker's and the Bruton Gallery. He was very Scottish in his dress and speech, and was considered a character in the London art world. His watercolours are, however, less distinguished, with pale colours and rather ordinary composition.

William McLauchlan

Late-nineteenth-century watercolour landscape painter from Paisley, probably amateur.

Duncan McLaurin 1849–1921

Born Glasgow, studied Edinburgh School of Design and Heatherley's. Lived in Helensburgh, painting cattle and Highland landscape. His earlier work can be good – his watercolours have rich, glowing colours with a romantic appeal, but his later work tends to be

brown and somewhat dull. His output was small.
RSW 1878

Kenneth McLeay* 1802–1878

Born Oban, studied Trustees' Academy.
ARSA 1826, resigned and re-elected 1829, RSW 1878

Macneil McLeay died 1848

Brother of Kenneth, painter of landscapes mostly in oils, but also of watercolours and gouaches.
ARSA 1836

Alexander Matheson McLellan 1872–1957

Landscape, portrait and decorative painter and stained-glass designer. Born Greenock, studied RA Schools and Paris. Painted classical and historical themes in watercolour, as well as landscapes in Scotland and Europe, in particular Holland. His style is careful and deliberate, and sometimes lacks sparkle. His success led him abroad and he worked in London, Paris and New York.
RBA 1910, RSW 1910

James MacMaster* 1856–1913
RSW 1885, RBA 1890

John McNairn 1881–1946

Glasgow painter influenced by the Colourists and by contemporary French painting. His watercolours are bold and colourful. Publisher of the *Hawick News.*

Robert Russell MacNee died 1952

Born Milngavie, studied GSA. Specialized in painting domestic animals and fowls in farmyard settings, he worked largely in oils, but also did watercolours. His watercolours of chickens, often dappled in sunlight in an Impressionist manner, can be effective.

Andrew McNeil

Twentieth-century Glasgow artist who painted views of Glasgow, Edinburgh and other towns in oils, watercolour and pen-and-ink.

Bessie MacNicol 1869–1904 (Mrs Alexander Frew)

Studied GSA and Paris, married the marine painter, Alexander Frew. Essentially a painter in oils of sensitive portraits and maternity scenes, she also produced delicate watercolours. Died in childbirth.

John McNicol born 1862

Landscape painter and master gilder, born Glasgow, lived Ayrshire. His landscape watercolours can be attractive with light colours and a sensitive touch. His son, Ian McNicol, the Glasgow art dealer, also painted landscapes in oils and watercolour.

John MacNiven* died 1895

Born Glasgow, worked with Glasgow Corporation Water Department for several years before turning to art, having had no formal training. Painted coastal views, the Clyde and the Highlands.
RSW 1891

Alexander MacPherson 1904–1970

Landscape painter in watercolour, lived Paisley, worked on the west coast, often on Arran. His watercolours have a firm construction with pencil or charcoal outlines.
RSW 1932, VPRSW

John Macpherson

Late-nineteenth-century landscape watercolourist, press artist and illustrator who settled in London in the 1870s. His style was tight and carefully executed, with some freedom in the skies. His son Douglas was also a press illustrator.

William McTaggart* 1835–1910
ARSA 1859, RSA 1870, RSW 1878

Sir William MacTaggart* 1903–1981
ARSA 1937, RSW 1946, RSA 1948, PRSA 1959

John MacWhirter* 1839–1911
ARSA 1867, RSW 1878, ARA 1879, RE 1881, RI 1882, HRSA 1882, RA 1893

Allan D. Mainds 1881–1945

Studied GSA, where he later taught; Professor of Fine Art, Durham University, specializing in History of Art. He painted landscape and still-life, designed costumes and posters. His watercolours were bold and colourful, being influenced by his knowledge of contemporary French art.
ARSA 1929

H. Maliphant

Early-nineteenth-century painter working in oils and watercolours. His watercolours usually include architectural subjects, drawn with considerable skill and with a dramatic use of light and shade.

Stirling Malloch 1865–1901

Perth artist, trained ECA, Paris, Holland and Italy. Because of ill health, he took a cruise in the Baltic in the 1880s and painted some interesting watercolour sketches. He later painted views in Perthshire in a 'wet' style, often effectively fresh. He drowned while bathing in New Jersey, USA.

Elliot Marten fl. 1886–1910

Landscape watercolourist who lived at Hawick, Roxburgh and painted the Borders, Northumberland and Westmorland.

A. S. Masson

Early-nineteenth-century landscape painter working in oils and watercolours. Exhibited RSA.

John George Mathieson fl. 1918–1940

Stirling artist influenced by D. Y. Cameron*. He painted and etched landscapes and views of towns in a tightly constructed style.

James Muir Mathieson fl. 1890–1925

Musician who painted watercolours of marine and coastal scenes.

Osborne Henry Mavor 1888–1951

The Glasgow playwright who wrote under the name of James Bridie. He also painted caricatures and illustrations to plays in a lively, colourful style; signs OHM.

John Kidd Maxton 1878–1942

Born Perth, studied GSA, worked in Glasgow as a stained glass and interior designer. Later moved to Edinburgh where he painted in watercolour using a free style which is not always successful. His subjects are Scottish landscapes.

Hamilton Maxwell 1830–1923

Painter of landscapes and architectural views, he was born in Glasgow but went to Australia in 1852 to dig for gold, moving to Bombay as a banker. Returned to Glasgow in 1881 and took up painting. He worked much in France and North Africa in a style which is sometimes clumsy and somewhat insensitive, possibly as the result of attempting large-scale watercolours with insufficient daughtsmanship.
RSW 1885

John Maxwell* 1905–1962

ARSA 1945, RSA 1949

Sir John Stirling Maxwell 1866–1956

Amateur watercolour painter who lived in Pollock House, Glasgow and was an expert on rhododendrons. His watercolours have an unusual frozen style which can be charming at times, especially when he is concerned over detail. Painted views in Scotland and on the Continent. Trustee of the Wallace Collection and NGS.
RSW 1936, HRSW 1938

William Meldrum 1865–1942

Glasgow artist who painted views of Glasgow in watercolour, using restrained tones of blues, purples and greys with some bodycolour. Befriended many of the Glasgow Boys and Pringle*.

Arthur Melville* 1855–1904

RSW 1885, ARSA 1886, ARWS 1888, RWS 1899

Archibald Elliot Haswell Miller* 1887–1979

RSW 1924

James Miller* born 1893

RSW 1934

James Miller

Early-nineteenth-century Glasgow artist who painted still-life, animals and birds in watercolour.

J. R. Miller fl. 1880–1910

Glasgow watercolourist who painted coastal scenes and harbours in Scotland and Holland in a wet watercolour style similar to that of MacMaster* and Black*.

John Miller 1911–1975

Born Glasgow, studied GSA and Hospitalfields.

ARSA 1957, RSA 1966, PRSW 1969–1974

Josephine Haswell Miller* 1890–1975

Born Glasgow, studied GSA, Paris and London under Sickert. Taught GSA until 1932. Settled in Dorset 1952.

ARSA 1938, Lauder Award 1922

William Miller 1796–1882

Watercolourist and engraver, born Edinburgh, studied under G. Cooke, the engraver, in London. Foundation Associate Member of the RSA in 1826, withdrew after the first meeting, later elected Hon. RSA in 1862. His best works are Turneresque landscapes of Scotland with delicate greens and blues.

Charles S. Mills 1859–1901

Dundee artist and original member of the Tayport Art Circle, he painted fresh landscapes with a good sense of light.

John MacLauchlan Milne 1886–1957

Born Edinburgh, studied ECA and Paris. Lived Dundee for most of his life, later moving to Arran. Painted Perthshire and the east coast in oils and watercolour.

ARSA 1934, RSA 1938

Joseph Milne 1857–1911

The father of John MacLaughlan, worked in Perth, Dundee and along the Tay. Painted mostly in oils, but his occasional watercolours have strong colours with bodycolour added.

James Milne

Aberdeen artist painting scenes of Aberdeen in the 1890s.

George Mitchell

Dundee watercolourist of the early twentieth century, his landscapes are successfully painted in a broad style.

John Mitchell 1837–1929

Born Deeside, he attended evening classes under James Giles*. His uncle – **John Mitchell** – was a Peterhead artist, who had been a fellow pupil of John Phillip* at the Trustees' Academy, and, with P. C. Auld, he taught John Mitchell to paint. After an apprenticeship at a local lithographic company, Mitchell went to the Slade to study. He returned to Aberdeen and painted many scenes around the town, including Balmoral where Queen Victoria patronized him. He also gave lessons in painting to the Royal Family. His landscapes are highly coloured with strong blues and purples in the mountains, and vivid green and yellows in the foreground fields. His talent as a colourist makes up for occasional weaknesses as a draughtsman.

John Campbell Mitchell* 1862–1922

ARSA 1904, RSA 1918

Madge Young Mitchell 1892–1974

Born Uddingston, near Glasgow, trained at Gray's School of Art, Aberdeen, becoming a member of staff in 1911. She painted many portraits in oils and watercolour, and also produced some watercolour landscapes.

Peter McDowall Mitchell 1879 – c. 1940

Born Galashiels, studied GSA. Painted landscapes of the West Highlands in oils and watercolour.

Elizabeth Gowanlock Molyneaux 1887–1969

Prolific watercolour painter of landscapes in Scotland, France and Italy. Often painted on Arran. She lived in Edinburgh and painted in a fluent, 'wet' style, not unlike that of Emily Paterson* and Anna Dixon.

RSW 1923, Lauder Award 1924

Donald Moodie* 1892–1963

ARSA 1943, RSA 1952, President SSA 1937–1941, Secretary RSA 1959–1963.

Eleanor Allen Moore 1885–1955 (Mrs E. A. Robertson)

Born Northern Ireland, studied GSA. Married Dr Robert Cecil Robertson in 1922 and on his appointment in Public Health with the Shanghai Municipal Council, moved to China in 1925. Painted the people and towns of the Yangtze Delta, some of which were exhibited by Ian McNicol in Kilmarnock in 1934. Evacuated from Shanghai during the Sino-Japanese War in 1937, she returned to Scotland but painted little. Her daughter, Ailsa Tanner, comments that her watercolours 'offer a lively and valuable record of life in the China of fifty years ago seen from a foreigner's eyes, a China that has changed in so many ways since'.

Henry Morley 1869–1937

Born Nottingham, studied Nottingham School of Art, settled in Cambuskenneth, Stirling c. 1894, where he painted landscapes in oils and watercolour. His wife, **Isabel Morley** (née Isabel Hutchison) also painted.

Annie Wilhelmina Morton born 1878

Edinburgh artist trained ECA, where she later taught, and Paris. Painted watercolours of landscapes and birds.

Thomas Corsan Morton 1859–1928

Born Glasgow, studied GSA and Paris, a minor member of the Glasgow School. Keeper NGS and Curator of Kirkcaldy Art Gallery. He painted mostly in oils, but his rare watercolours were admired by contemporary critics.

Anne Davidson Muir 1875–1951

Born Hawick, studied ECA and Heriot Watt, moved to Glasgow 1905. Made her name as a flower painter in watercolour exhibiting with Jessie King*, Jessie Algie and Louise Perman in London at the Baillie Gallery, and in Glasgow. Her style is fluent and 'wet', similar to that of Ann Spence Black and Elizabeth Moly-

neaux. She also painted heads of old people, similar to those of Henry Wright Kerr*.
RSW 1915

David Muirhead 1867–1930

Born Edinburgh, studied RSA Schools and Westminster School under Fred Brown. Moved to London in 1894, and became involved with the New English Art Club, being influenced by the restrained colours which often characterized watercolours of this group. He painted watercolours of estuaries, rolling fields and broad skies, often in East Anglia, in a style which is always effective, if, at times, somewhat unexciting. His work really belongs to the English School in spirit and style.
NEAC 1900, ARWS 1924, ARA 1928

George Muirhead born 1881

Perth artist given some lessons by William Proudfoot, he painted views of the landscape around Perth in watercolour.

John Muirhead 1863–1927

The brother of David, born Edinburgh, studied RSA Schools. Moved to London and painted landscape watercolours in a style similar, if a little broader, to that of his brother.
RSW 1892

Hugh Munro 1873–1928

Watercolour flower painter and illustrator, he worked for Charles Mackie* cutting woodblocks and was the first husband of Mabel Victoria MacGeorge. His flower pieces are often effective with rich colours and good technique, without being too showy. Also painted figures and beach scenes. He worked as art critic for *The Glasgow Herald*.

Alexander J. Murray fl. c. 1880–1910

Aberdeen watercolourist who painted local views.

Charles Murray 1894–1954

Born Aberdeen, studied GSA and in Rome. Painted landscapes, still-life and theatrical figures in oils, watercolour and gouache. His watercolours attempt a modernism which is

not entirely successful, influenced by contemporary stage design and illustration.

Sir David Murray* 1849–1933

RSW 1878, ARSA 1881, ARWS 1886, ROI 1886, RWS 1886, HRSW 1886, ARA 1891, RA 1905, RI 1916, PRI 1917, HRSA 1919

David Scott Murray 1866–1935

Art Master, Perth Academy and President of the Perth Art Association, he painted attractive landscapes in watercolour. He had a 'wet' style with subtle sense of colour.

George Murray 1875–1933

Born Blairgowrie, studied ECA and RCA. Specialized in decorative painting and mosaics, but also painted fine watercolours in a vibrant style. Used vertical and horizontal brushstrokes to create a pattern of colour, which combined with his strong colours, gives a sense of movement to his landscapes of Scotland, Italy and Spain.
ARCA

James T. Murray died 1931

Edinburgh landscape painter who worked in oils and watercolour, painted coastal scenes on the east coast.
RSW 1927

William S. Myles c. 1850–1911

Born Forfar, painted in Broughty Ferry before moving to Arbroath in 1895. Painted Perthshire landscapes and views around Arbroath in oils and watercolour, and was friendly with J. W. Herald*.

Charles Goddard Napier* 1889–1978

RSW 1913

Anne Nasmyth 1798–1874

Daughter of Alexander*, married Manchester engineer William Bennett. Painted landscapes in oils and watercolour.

Barbara Nasmyth 1790–1870

Daughter of Alexander*, taught at York Place School and moved to Patricoft on death of father in 1840. Settled in London c. 1850. Painted views of the Lake District in oils and watercolour.

Charlotte Nasmyth 1804–1884

Youngest daughter of Alexander*, worked in oils and watercolour.

James Nasmyth 1808–1890

Youngest son of Alexander*, successful engineer, his *Autobiography* remains the main source of information about the family. Retired to Penshurst, Kent in 1856 and devoted himself to painting landscapes, fantasies and foreign views in watercolour.

Jane Nasmyth 1788–1867

Eldest daughter of Alexander* and organizer of the York Place School. Affectionately known as 'Old Solid', she painted views of Scotland in oils and watercolour.

George Neil fl. 1885–1930

Glasgow artist painting watercolours in a fluent 'wet' style.

John Nesbitt 1831–1904

Marine painter, lived Edinburgh and painted oils and watercolours in a subdued palette.

G. S. Nichol fl. 1870–1885

Edinburgh topographical artist who produced detailed and carefully drawn views of Edinburgh and its surroundings.

Peter Walker Nicholson* 1856–1885

Trained as a lawyer before attending Ruskin's Drawing School in Oxford. According to his biographer, J. M. Gray, his best watercolours were painted between 1882 and 1885.

Erskine Nicol* 1825–1904

ARSA 1855, RSA 1859, ARA 1866.

He had two sons, **Erskine E. Nicol** (died 1926) a landscape painter in oils and watercolour and **John Watson Nicol** (1856–1926) a portrait and historical painter who rarely used watercolour.

Pollock Sinclair Nisbet 1848–1922

Brother of Robert Buchan, studied Edinburgh and Italy. Painted landscapes, often of foreign countries – Italy, Spain, Morocco, Tunisia

and Algeria. His watercolour style is tight and rather unimaginative, with solid colours.
RSW 1881, ARSA 1892

Robert Buchan Nisbet* 1857–1942

Born Edinburgh, studied RSA Schools and Paris.
RSW 1887, RBA 1890, RI 1892 (resigned 1907), ARSA 1893, RSA 1902, HRSW 1934
His wife **Margaret Dempster Nisbet** painted miniatures.

James Campbell Noble* 1846–1913

Studied RSA Schools; essentially an oil painter, he did some landscape watercolours influenced by the Dutch School.
ARSA 1879, RSA 1892

Robert Noble 1857–1917

Cousin of James Campbell Noble, also primarily an oil painter, but executed the occasional landscape watercolour in a loose wet style.
ARSA 1892, ROI 1897, RSA 1903

Marie L. Norie fl. 1880–1890

Landscape painter in watercolour, probably from Edinburgh.
RSW 1887

John Oliphant

Early-nineteenth-century portrait painter who also worked in watercolour, painting landscapes, often on Arran.

Charles Oppenheimer* 1875–1961

RSW 1912, ARSA 1927, RSA 1934

Jack Orr fl. 1909–1939

Glasgow artist who specialized in painting birds in watercolour. His watercolours of parrots and exotic birds are often large and painted in a dashing style on silk or linen, probably influenced by Joseph Crawhall*.

Monro Scott Orr born 1874

Glasgow artist, studied GSA. Produced decorative drawings and illustrations for books, using clear, bold outlines and a simplified style.

Stewart Orr 1872–1944

Brother of Monro Orr, studied GSA and initially produced illustrations, but later turned to landscape painting in watercolour. Lived for many years at Corrie House, Corrie, Arran and many of his landscapes are of Arran. Used fresh colours, a fluid style and achieved sparkling effects.
RSW 1925

James Orrock 1829–1913

Born Edinburgh, qualified as a dentist and practised in Nottingham before moving to London in 1866. His style was influenced by David Cox, and is similar to that of Claude Hayes, Thomas Collier and E. M. Wimperis with whom he made regular painting expeditions around England. His work belongs in spirit and style to the English School. He was also a lecturer on, and connoisseur and collector of, English watercolours.
ARI 1871, RI 1875

Stuart Park 1862–1933

Studied in Glasgow and Paris. Primarily a flower painter in oils, but occasionally produced watercolours.

Alexander Nisbet Paterson* 1862–1947

ARSA 1911, RSW 1916, FRIBA

Emily Murray Paterson* 1855–1934

Painted the Ypres Battlefield in 1918, exhibited in London.
RSW 1904, ASWA 1910

Hamish Constable Paterson 1890–1955

The son of James Paterson*, studied ECA, seriously wounded in the First World War. Painted many excellent watercolours of the South of France during the 1920s and 1930s, but the quality of his work varies.

James Paterson* 1854–1932

RSW 1885, ARSA 1896, RSA 1910, PRSW 1922–1932

Mary Viola Paterson 1899–1982

The daughter of A. N. Paterson* and Maggie Hamilton (1867–1952), studied GSA, Slade and Paris. Painted oils, watercolours and pastels, often of French subjects.

R. Stirling Paterson fl. 1890–1940

Landscape painter working in oils and watercolours. Painted coastal views with boats in a sombre style.

Donald Paton fl. 1890–1910

The Lake District artist Edward Thompson also used the name Donald Paton.

Frederick Noel Paton 1861–1914

The son of J. Noel Paton*, he painted landscapes in watercolour.

Sir Joseph Noel Paton* 1821–1901

ARSA 1846, RSA 1850, Queen's Limner 1866, offered PRSA in 1891, but declined.

Peter Paton fl. 1830–1850

Painted watercolours of Rome, Naples and Sicily, and views around Edinburgh. There are a group of sepia drawings (NGS) done for the Abbotsford edition of Sir Walter Scott's work (1842–47) where they appear as woodcuts. The drawings are finely executed with a good sense of light and shade.

James McIntosh Patrick* born 1907

Born Dundee, studied GSA under Greiffenhagen and in Paris. Lectured Duncan of Jordanstone College of Art.
ARE 1932, ARSA 1949, RSA 1957

Christian Peddie fl. 1892–1937 (Mrs Henderson Tarbet)

Painted landscapes in watercolour.

George Peddie 1883–1911

Illustrator and watercolour painter.

James Dick Peddie fl. 1880–1918

Edinburgh landscape painter in oils and watercolour.

William Penny

Early-nineteenth-century engraver and topographical artist who lived in Midcalder, near Edinburgh. Painted views of Edinburgh in pen-and-ink, and engraved other artists' work.

Samuel John Peploe* 1871–1935

ARSA 1918, RSA 1927

William Watson Peploe 1869–1933

Brother of S. J. Peploe*. Influenced by Beardsley's drawings prior to 1918, when he came under the influence of the Vorticists.

Arthur Perigal* 1816–1884

ARSA 1841, RSA 1868, RSW 1878

Louise Ellen Perman 1854–1921 (Mrs James Torrance)

Born Eastwood, studied GSA, married James Torrance* 1912. A painter of flowers, mostly in oils, she also painted some flower pieces in watercolour; often exhibited with Jessie Algie, Jessie King* and Anne Muir.

John Pettie 1839–1893

Oil painter of historical and costume pieces, he used watercolour as a means of working up larger compositions. A fellow student of McTaggart* and MacWhirter* at the Trustees' Academy, he moved to London in 1862. His watercolours are usually of elegantly dressed aristocrats with titles like *A Spanish Grandee* or *The Challenge* (both Orchar).
ARA 1866, HRSA 1871, RA 1873

Colin Bent Phillip 1855–1932

The son of John Phillip*, studied in London and RSA Schools. He lived in London and Devon for most of his life, but returned regularly to Scotland to paint. He produced large watercolours of Highland scenes which can be effective, but at times appear oversized for their subject matter and repetitious.
ARWS 1886, RSW 1890 (resigned 1907), RWS 1898

John Phillip* 1817–1867

ARA 1857, HRSA 1857, RA 1859

Charles Gustav Louis Phillips 1863–1944

Born Montevideo, the son of Scottish parents, he studied in Dundee under W. M. Grubb and worked in Dundee painting local views in a competent style. He recorded the Royal Visit to Dundee of 1914 in watercolour.

Sir George Pirie 1863–1946

Born Campbeltown the son of a doctor, he attended Glasgow University before turning to art. Studied Slade and in Paris. He painted animals and birds, as well as some landscape. As a draughtsman he was excellent with a fluid and confident line. To his pencil drawings he often added watercolour in a free and 'wet' style, and he also made extensive use of body-colour and pastel. In the 1880s he was associated with the Glasgow Boys, and in the early 1890s, he was in Texas for a period, drawing horses and ranching scenes.
ARSA 1913, RSA 1923, PRSA 1933–1944, HRSW 1934

Sir Francis Powell* 1833–1914

ARWS 1857, RWS 1876, PRSW 1878–1914

William M. Pratt born 1855

Born Glasgow, studied GSA and Paris. Marine painter in oils and watercolour. Lived Lenzie.

D. R. Prentice fl. 1868–1898

Landscape and coastal painter in watercolours, he worked in the Highlands and on the east coast.

William Proudfoot 1822–1901

Perth painter, studied art in Italy. Painted landscapes and still-life, taking up watercolour (which he called 'diluted art') late in life, aged about 70. His landscape watercolours are effective and have freshness and verve, whereas his still-life watercolours are more highly finished.

John Milne Purvis 1885–1961

Born Perth, studied GSA before travelling on the Continent and North Africa. Head of Drawing and Painting at Dundee College of Art. Exhibited oils and watercolours based on his many trips abroad, particularly to Spain, North Africa and Turkey.

Agnes Middleton Raeburn 1872–1955

Born Glasgow, studied GSA, member of the C. R. Mackintosh* circle, contributing to *The Magazine* 1893–6. Her early work is influenced by Glasgow Symbolism, but her later watercolours of landscapes in France and Holland and of flowers are free and 'wet' in style. Art Mistress, Laurel Bank School and President, Glasgow Society of Lady Artists 1940–43. Her output of watercolours was large, but of a consistent quality.
RSW 1901, Lauder Award 1927

Ethel Maud Raeburn 1867–1953

Edinburgh artist, painted watercolours of landscapes, her best work being those painted in Venice.

William Bruce Ellis Ranken 1881–1941

Born Edinburgh, studied Slade, lived mostly in England and France. His output of oils and watercolours was large and included portraits, interiors, landscapes and townscapes. At his best, his watercolours are freshly handled and well drawn, such as *View of Hampton Court* (Dundee), but some of his interiors are too large and overworked. His watercolours of gardens in Paris and London can be particularly charming.
ROI 1910, RI 1915, RP 1916, VPROI 1920

Arabella Louise Rankin born 1871

Perthshire oil and watercolour artist who produced a number of coloured woodcuts.

Andrew Scott Rankin born 1868

Born Aberfeldy, studied Edinburgh, joined staff of several magazines including *Today* and *Idler*. Painted landscapes in oil and watercolour in a somewhat 'sweet' but effective style. Also painted animals and genre. Illustrated articles for *Art Journal* including 'Aberfeldy and its Neighbourhood' and an article on the Glasgow International Exhibition.

William Wellwood Rattray 1849–1902

Born St Andrews, educated Glasgow University before turning to art. Painted landscapes in oils and watercolour, almost entirely of Highland and east coast views. Although his watercolour technique is rather heavy, with the paper being well-worked and the colours absorbed into the scrubbed surface, his work can capture the grandeur of the Highlands.
RSW 1885, ARSA 1896

Anne Redpath* 1895–1965

ARSA 1947, RSA 1952, ARA 1960, ARWS 1962, OBE 1955.

W. Birch Regnordson fl. 1880–1900

Painter of the Perthshire Highlands, his watercolours are detailed and accurate without being overworked.

Archibald David Reid 1844–1908

Born Aberdeen, the brother of Sir George Reid* and Samuel Reid, studied RSA Schools. Travelled in Europe painting architecture, rivers and pastoral scenes especially in Holland, Northern France, Spain and Venice. Influenced by the Dutch School, his watercolours are well composed and restrained in colour. His figures are often somewhat wooden.
RSW 1883, ARSA 1892, ROI 1898

Flora Macdonald Reid fl. 1879–1938

Sister of J. R. Reid, studied RSA Schools, and learnt much from her brother. Settled in England, first in Cornwall and later in London. Painted landscapes and market scenes on the Continent in oils and watercolour.

Sir George Reid* 1841–1913

ARSA 1870, RSA 1877, PRSA 1891–1902, RSW 1892, HROI 1898, knighted 1902

John Robertson Reid 1851–1926

Born Edinburgh, studied RSA Schools, moved to Cornwall and later to London. Worked both in oils and watercolour, painting landscapes and views of Cornish harbours. His watercolour style is powerful and dramatic, with deep blues and greens applied energeti-

cally to rough paper. He was not interested in delicate drawing, preferring to achieve movement and drama in a breezy style, which shows the influence of David Cox. His watercolours with their powerful skies and dramatic effects have a special quality of their own.
RBA 1880, ROI 1883, RI 1891

Samuel Reid 1854–1919

Born Aberdeen, younger brother of Sir George Reid*, he was a poet and author in addition to being a watercolourist. His watercolours which depict cathedrals, architecture and landscape, are carefully executed, the medium being treated almost like oil. His works are competent rather than exciting.
RSW 1884

James Reville born 1904

Born Sheffield, settled in Dundee. Watercolour and oil painter of flowers and still-life.
RSW

Warwick Reynolds* 1880–1926

RSW 1924

Joseph Kent Richardson died 1971

Art dealer, connoisseur, collector, sportsman and watercolourist. A fine pencil draughtsman much in the style of D. Y. Cameron*, his watercolours of rural scenes and landscapes are relaxed and colourful.
RSW 1917

James Riddell 1857–1928

Born Glasgow, studied GSA, Head of the Art Department, Heriot Watt College, Edinburgh. Painter of landscapes and interiors with figures in oils and watercolour. Worked in Belgium, Holland, Canada and Scotland. His watercolours were often large using rubbed paper to achieve a broad, somewhat indecisive style. His seascapes and coastal scenes are probably his most effective works.
RSW 1905, ARSA 1919

Alexander Ritchie fl. 1830–45

Topographical and historical painter in oils and watercolour, lived and worked in Edinburgh.

David Ritchie

Nineteenth-century topographical artist probably from Edinburgh.

David Roberts* 1796–1864

HRSA 1829, ARA 1838, RA 1841

Alexander Duff Robertson 1807–1886

Teacher of drawing in Glasgow, painted good views of the city in pencil and watercolour.

Andrew Robertson 1777–1845

Born Aberdeen, studied under Alexander Nasmyth in Edinburgh, and received advice from Raeburn. Painted miniature portraits in watercolour on ivory in north east Scotland before moving to London in 1801, where he painted portraits of the Royal Family. He used watercolour in a meticulous but delicate manner.

Archibald Robertson 1745–1813

First cousin of Robert Adam*, he was a professional soldier who rose to become Lieutenant-General in the Royal Engineers. Served in America and his *Diaries and Sketches in America 1762–1780* were published in 1930. While involved in the War of Independence, he found time to paint landscapes in watercolour in monochrome with firm drawing and good composition. Much of his work is now in New York, but there are examples in Edinburgh (NGS) and the National Gallery of Wales.

Archibald Robertson c. 1765–1835

Elder brother of Andrew Robertson, born Aberdeen, moved to America in 1791 to establish a drawing school. Painted miniatures in watercolour. His younger brother, **Alexander Robertson** (1772–1841) followed him to America in 1792 and also painted portraits in watercolour.

J. D. Robertson fl. 1880–1900

Landscape painter who produced competent, highly coloured watercolours which he signed with a monogram.

M'Culloch Robertson fl. c. 1900–1920

Landscape watercolourist probably from Perthshire.

Tom Robertson 1850–1947

Studied GSA, and in Paris. Produced landscapes, coastal scenes and seascapes mostly in oils, in an Impressionist style with bright colours and a good sense of sunlight. His watercolours are comparatively rare.
RBA 1896, ROI 1912 (retired 1937)

Alan Ian Ronald born 1899

Studied ECA. Painted on the east coast, and in England and Germany. He often painted harbours and quayside views in a powerful and effective style.
RSW 1935

Christina Paterson Ross 1843–1906

Daughter of R. T. Ross* and sister of Joe Ross, she painted figures in interiors, fishing scenes, landscapes and romantic compositions. Her colours are restrained but she used a wet technique often on quite a large scale.
RSW 1880

Robert Thorburn Ross* 1816–1876

ARSA 1852, RSA 1869

Joseph Thorburn Ross 1858–1903

Son of R. T. Ross*, he acquired much of his father's broad skill as a watercolourist. Painted seascapes and coastal scenes, often with figures or birds in the foreground. His watercolours have a spontaneity which he sometimes lost when working them up into large oils.
ARSA 1896

Tom Ross 1876–1961

Dundee artist known for his lithographs of Dundee town views. He also worked in oils and watercolours, the latter having strong colours and a wet technique.

James Rowat

The brother of Jessie Rowat (Mrs Francis Newbery), he painted landscapes, interiors and flowers in oils and watercolour.

John Runciman 1744–1776

Brother of Alexander Runciman* whom he followed to Italy. Died in Naples aged 24 either as a result of depression or of tuberculosis. Very few drawings by him survive, however *Bothwell Castle* (NGS) shows considerable promise.

Mrs Joyce Watson Rutherford fl. 1920–1940

Née Watson, landscape painter in watercolour.

Maggie Rutherford fl. 1900–1914

Glasgow watercolour artist who painted landscapes and flowers.

Lady Mary Ruthven* 1789–1885

Talented amateur watercolourist, married James, Lord Ruthven in 1813. Her watercolours of Greek temples, vases and sculpture are detailed and highly finished.

George Sanders 1774–1846

Painter of miniatures and full-length portraits, born Kinghorn, Fife, and made his reputation in London. There are 26 watercolours after Dutch and Flemish paintings by Sanders in the NGS.

Robert Sanderson fl. 1880–1905

Oil and watercolour painter of coastal and fishing scenes.

David Sassoon born 1888

Born in Walton on Thames, moved to Kirkcudbright in the early 1920s where he painted landscapes of south west Scotland.

John Alexander Schetky 1785–1824

Born Edinburgh, the son of a German musician who played the 'cello in the Edinburgh Musical Society, he joined the army as a surgeon and painted whenever possible, occasionally collaborating with his brother on naval pictures. He died on service on the west coast of Africa, having painted and exhibited a number of landscapes and marine watercolours.

John Christian Schetky 1778–1874

Elder brother of J. A. Schetky, studied with Alexander Nasmyth* and helped his mother run drawing classes for young ladies in Edinburgh, continuing the classes after his mother's death in 1795. Visited Paris and Rome in 1801, and moved from Edinburgh in 1808 on his appointment as Drawing Master at the Royal Military College, Sandhurst. 1811–1836 Drawing Master at the Royal Naval College, Portsmouth. Largely an oil painter of marine views, but he also executed some watercolours. 1844 Master Painter in Ordinary to Queen Victoria.

David Scott* 1806–1849

RSA 1830

Tom Scott* 1854–1927

RSW 1885, ARSA 1888, RSA 1902

Walter Scott fl. 1899–1938

Edinburgh landscape painter in watercolours and etcher.

William Bell Scott* 1811–1890

HRSA 1887

R. Seaton

Early-nineteenth-century Aberdeen artist who painted views in and around Aberdeen in a competent style which owed something to Hugh 'Grecian' Williams*. His figures are well drawn. Alexander Nasmyth* adapted Seaton's work for his views of Aberdeen.

Charles Sellar 1856–1926

Perthshire portrait and landscape painter; took a degree in Law at Edinburgh University before turning to art. Had a studio in Perth and built up a local reputation painting east coast fishing villages and Perthshire views. His style is rather 'sweet' with good colours and sense of light, although his drawing is imprecise. RSW 1893

D. Ramsay Sellars 1854–1922

Landscape watercolourist probably from Dundee.

Mary E. Seton fl. c. 1920–1940

East Lothian landscape watercolourist.

William Somerville Shanks 1864–1951

Born Gourock, studied GSA. Became a leading portrait, still-life and flower painter being influenced by Manet, Lavery* and other fluent oil painters of the late nineteenth century. His style was better suited to oils, but he nevertheless produced many good watercolours in a dashing style showing freedom combined with great draughtsmanship, often making extensive use of bodycolour.
ARSA 1923, RSW 1925, RSA 1934

Charles Kirkpatrick Sharpe 1781–1851

Amateur artist involved in literature and the theatre, he was a friend of Sir Walter Scott and David Scott*. He painted drawings in pen and wash illustrating literary subjects as well as watercolours of theatrical scenes. His caricatures are quite successful being influenced by Rowlandson, but his watercolour portraits are rather weak.

James Elliot Shearer 1858 – c. 1940

Born Stirling, lived Edinburgh. Painted landscapes and, in particular, flowers in watercolour.

John Sheriff ('Dr Syntax') 1816–1844

Edinburgh caricaturist. A large collection of his pen and ink drawings is in Edinburgh City Art Collection.
ARSA 1839

William Sheriff fl. c. 1880–1900

Glasgow painter in oils and watercolours of views in and around Glasgow.

Jane Hunter Shield fl. 1880–1895

Edinburgh watercolour artist who made a reputation for her flower pieces and studies of birds. She ceased work in 1895.
RSW 1885 (resigned 1903)

Thornton Shiells fl. 1898–1938

A close friend of the young Russell Flint*, he encouraged him to move to London. Lived in England from 1898, working as an illustrator and watercolourist.

John Shirreffs fl. 1890–1937

Aberdeen painter in oils and watercolour, he produced watercolours of interiors of Highland cottages and Highland landscapes with figures. Also painted portraits in oils.
RSW 1895 (written off 1909, although he continued to exhibit into the 1930s)

Agnes Mary Sim 1887–1978 (Mrs Smythe)

Montrose watercolour painter of portraits, figures and landscape.
RSW 1927

William 'Crimean' Simpson* 1823–1899
ARI 1874, RI 1879, ROI 1883

William Simson* 1800–1847
RSA 1826

Alexander Garden Sinclair 1859–1930

Primarily an oil painter of landscapes and portraits, a member of the Society of Eight. He also produced some fine watercolours in a broad, 'wet' style, influenced by the Dutch School. He painted views in Northern France and Scotland, in particular Iona. His large skies and free handling of the medium make his watercolours attractive. He was a contributor to *Evergreen* in his earlier years.
ARSA 1918

Christine S. Sloan 1887–1975

Born Glasgow, studied GSA, taught Laurel Bank School. Watercolour artist.

David Small 1846–1927

Painter of old Glasgow, he produced topographical watercolours for *By-Gone Glasgow*, as well as watercolours of Edinburgh, Stirling and Dundee. He also worked as a photographer in Dundee. His style is rather tight, even hesitant, but he had a great sympathy for old buildings and streets.

John W. Small fl. 1880–1900

Stirling architect who painted architectural views of Stirling and other towns in the area.

William Small 1843–1929

Studied RSA Schools, moved to London

1865. His illustrations appeared in many magazines, and he also painted in oils and watercolour. His watercolours are often romantic and are beautifully executed being close in style, as Caw points out, to those of Fred Walker and his circle.
RI 1870, HRSA 1917

John Smart* 1838–1899
ARSA 1871, RSA 1877, RSW 1878, RBA 1878

James Smieton 1869–1935
Art Master, Perth Academy; painted views of Perth in watercolour in a restricted, almost monochrome, palette.

Alexander C. Smith 1875–1922
Amateur painter and naturalist, he lived in Perth and painted birds in oils and watercolour.

Alexander Munro Smith 1860–1933
Born Falkirk, studied GSA, moved to London c. 1884, returning to Scotland c. 1915. Illustrator and watercolourist.

David Murray Smith 1865–1952
Studied ECA and RSA Schools, moved to London in 1893, remaining in southern England for the rest of his life despite regular trips to Scotland to paint. His landscapes are rather austere with broad skies dominating the landscape, which he rarely populates. He also worked in Italy, in particular Venice, and in Wales. He was successful in his time, but today his watercolours appear somewhat empty.
RBA 1905, ARWS 1916, RSW 1934 (resigned 1940), RWS 1934

Edwin D. Smith
A contemporary of Kenneth MacLeay*, he painted some fine portraits in watercolour in the early nineteenth century.

Garden Grant Smith* 1860–1913
In addition to being a watercolourist, he was a keen golfer and wrote books about the sport.
RSW 1890

Jane Stewart Smith 1839–1925
Edinburgh topographical artist; wrote and illustrated *The Grange of St Giles* (1898) and *Historic Stones and Stories of Bygone Edinburgh* (1924).

John Guthrie Spence Smith* 1880–1951
RSA 1932, RSA 1940

Joseph Calder Smith 1876–1953
Born Arbroath, worked in Arbroath and Dundee painting landscape in oils and watercolour. His watercolours are well drawn.

Tom Smith fl. 1914–1935
Edinburgh watercolour artist who painted many coastal scenes.

William Ryle Smith fl. 1885–c. 1914
Art teacher and watercolourist working at Broughty Ferry; the uncle of Sir William Gillies*.

Dorothy Carleton Smyth 1880–1933
Born Glasgow, studied GSA. Designed costumes for Quinlan Opera Company, Frank Benson Shakesperean Company and Glasgow Repertory Theatre. Taught GSA 1914–1933 and selected as successor to John Revel as Director GSA but died before taking up the appointment. Broadcast talks to children on BBC as 'Paint Box Pixie'. Painted in watercolours and pastels, illustrated several books.

Olive Carleton Smyth 1882–1949
Sister of Dorothy Smyth, born Glasgow studied GSA, staff of GSA 1902–1914, becoming Head of Design GSA 1933. Her earlier watercolours were in a visionary style similar to that of Norah Nielson Gray*, but her later work was influenced by Chinese brush drawing. Also used a naive, stylized manner.

James Smyth fl. 1920–35
Edinburgh watercolour and oil painter; on the staff of ECA.

Daniel Somerville fl. 1780–1825
Engraver, etcher and watercolour artist in Edinburgh; painted views of Edinburgh.

Harry Spence 1860–1928

Glasgow artist, painted landscapes in oils and watercolour.

NEAC 1887, RBA 1909

George Clark Stanton* 1832–1894

ARSA 1862, RSA 1885

Gourlay Steell 1819–1894

Animal painter in oils, he also painted some watercolours of still-life, often with dead animals, studies of Scottish characters and animal studies. Trained at the Trustees' Academy, Curator NGS 1882–1894.

ARSA 1846, RSA 1859

James Stein fl. 1820–1840

Watercolour painter of landscapes around the Tweed and the Borders. Lived in Coldstream and later, Haddington.

Robert Macaulay Stevenson 1854–1952

Born Glasgow, studied GSA. Essentially an oil painter and part of the Glasgow School, he also produced a number of watercolours, often of nocturnal landscapes.

RSW 1906 (struck off 1913)

Henry Stewart born 1897

Watercolour painter and etcher from Glasgow.

Nellie Stewart fl. 1900–1935

Watercolour painter of flowers, gardens and landscape.

Elma Story 1886–1941

Born Edinburgh, studied GSA, Edinburgh and Paris. Painted watercolour landscapes, often views of Iona. Memorial exhibition of her work was held at the Glasgow Society of Lady Artists, 1942, along with Janet Aitken and Kate Wylie.

M. Fleming Struthers fl. 1895–1910

Stirling artist involved with the Craigmill Group, he painted birds and landscapes in watercolour.

Sir James Stuart 1779–1849

5th Baronet of Allanbank, Berwickshire. Born Rome, died Edinburgh; amateur painter and etcher and friend and neighbour of Sir Walter Scott at Melrose. Colnaghi published 2 sets of 6 etchings by Stuart illustrating Scott and Byron in 1821. Seven years later a further set of etchings *Gleanings from the Portfolio of an Amateur* was published. Stuart was a prolific watercolourist painting landscapes and battle-scenes in a fluent pen and wash style. He also painted subjects inspired by literature. His best works are probably his landscape sketches of Scotland, especially his fresh views of the Isle of Arran.

Mary Newbery Sturrock born 1890

Daughter of Fra and Jessie Newbery*, studied GSA and married **Alick Riddell Sturrock*** (1885–1953), a landscape painter who worked largely in oils. Paints watercolours of flowers – her earlier work was influenced by C. R. Mackintosh*, but her later work has become more naturalistic.

David Macbeth Sutherland* 1883–1973

ARSA 1922, RSA 1937

J. A. Henderson Tarbert died 1938

Prolific Edinburgh landscape and coastal painter in oils and watercolour. His colours are strong, possibly influenced by Cadell's* watercolours.

John D. Taylor* fl. 1875–1900

Glasgow oil and watercolour artist who specialized in marine subjects executed in an accurate and detailed manner. His watercolours often have a naive charm. President of the Glasgow Art Club 1884–85.

William Taylor

Mid-nineteenth-century landscape painter, lived at Campsie. Painted views of Loch Ard, Loch Lomond, Ben Venue and the surrounding areas, mostly in watercolour.

Rosa Mary Templeton c. 1868–1936

Born British Guiana, died Helensburgh. Watercolourist.

John Terris* 1865–1914

RSW 1891, RI 1913

Albert Gordon Thomas* 1893–1970
RSW 1936

Grosvenor Thomas 1856–1923
Member of the Glasgow School, born in Australia. Essentially an oil painter but worked sometimes in watercolour, often depicting romantic views of rivers and lakes with trees, painted in sonorous colours. He was a collector of, and dealer in, Japanese antiques and stained glass, selling much of his collection to Sir William Burrell.
RSW 1892 (resigned 1908)

Adam Bruce Thomson* 1885–1976
ARSA 1937, RSA 1940, RSW 1947, PRSW 1957–1963

Alexander P. Thomson died 1962
Glasgow watercolourist, painted views of the Highlands in a conservative style, apparently unaffected by twentieth-century artistic developments. He used rough paper and a well controlled watercolour technique, often on a large scale, which resulted in satisfying work of a high quality.
RSW 1922

Horatio Thomson fl. 1884–1906
Watercolour painter of Glasgow streets and scenes.

Reverend John Thomson of Duddingston 1778–1840
Important oil landscape painter, he rarely used watercolour except as studies for oils. The few known wash drawings by Thomson show a firm outline with free washes used in an almost modern way. *Duddingston Loch and Neighbourhood* (VAM) cited by Martin Hardie is now known not to be by Thomson.

J. Leslie Thomson 1851–1929
Born Aberdeen, studied Slade and became part of the English School, returning only rarely to Scotland. Painted river scenes in oils and watercolour in England, Brittany and Normandy. His style, which was influenced by

his fellow Scot in London, David Muirhead, was competent rather than striking.
RBA 1883, NEAC 1887, ROI 1892, ARWS 1910, RWS 1912, HROI 1921

John Murray Thomson* 1885–1974
Studied RSA Schools and Paris.
RSW 1917, ARSA 1939, RSA 1957

Alexander Mason Trotter 1891–1946
Edinburgh watercolour artist, painted very detailed and 'frozen' interiors and still-life. Used watercolour in a deliberate and highly worked style. His large still-life watercolours can be striking in effect.
RSW 1930

Murray McNeel Caird Urquhart* born 1880
RBA 1914

William Fleming Vallance* 1827–1904
ARSA 1975, RSW 1878, RSA 1881

William Walls* 1860–1942
ARSA 1901, RSW 1906, RSA 1914

Ada Hill Walker died 1956
St Andrews artist, studied London and GSA, returned to St Andrews where she painted the Fife coast in a dashing watercolour style. Her stylish figure studies are typical of their period.

Constance Walton 1865–1960 (Mrs W. H. Ellis)
Sister of E. A. Walton*, a good decorative flower painter in watercolours who used a formal composition.
RSW 1887

Edward Arthur Walton* 1860–1922
RSW 1885, NEAC 1887, ARSA 1889, RP 1897, RSA 1905, PRSW 1914–1922

Hannah Walton 1863–1940
Born and died Glasgow, sister of E. A. Walton*. Miniature painter and painter on glass and china.

George Patrick Houston Watson 1887–1960

Architect and watercolour painter, studied ECA. His watercolours are sensitive, using pencil outlines and light colours; usually painted landscapes.
RSW 1938

James Watson

Twentieth-century artist, art master at Morgan Academy, Dundee. Painted landscape, sometimes with figures, in France, Spain and Scotland, using a dynamic watercolour style influenced by Melville*.

T. R. Hall Watson fl. 1890–1914

Glasgow watercolour and oil painter of Scottish landscapes.

D. Watts fl. 1918–1938

Landscape watercolour artist who painted views of the east coast in a wet watercolour style.

Thomas Webb fl. c. 1820–1860

Topographical watercolour artist who worked in Edinburgh.

Walter Weir died 1816

Edinburgh genre painter, studied in Italy and worked in a style influenced by David Allan*. His faces are more of caricatures than Allan's, suggesting that he had seen the work of Geikie*.

Wilma Law Weir fl. 1912–1940

Born Glasgow, studied ECA. Painted landscapes in oils and watercolour.

William Page Atkinson Wells* 1872–1923
RBA 1906

David West* 1868–1936
RSW 1908, VPRSW

John White 1851–1933

Born Edinburgh, moved to Australia as a child, returned to study at RSA Schools. Moved to England c. 1880 and painted delicate oils and watercolours of the English countryside in a pretty style. Later lived in Devon.
RBA 1880, RI 1882, ROI 1886

John G. Whyte c. 1836–1888

Amateur Glasgow artist, dentist by profession, Founder Member of the RSW. He was a keen collector of paintings by the Glasgow Boys, and painted in watercolours himself. His subjects were usually flowers in natural settings such as woods or meadows, and trees. Painted some still-life.
RSW 1878

David Wilkie* 1785–1841
ARA 1809, RA 1811, HRSA 1832

James Francis Williams 1785–1846

Born Perthshire, worked in London as a scene painter, returned to work in the theatre in Edinburgh in 1810. Elected Foundation Member RSA in 1826 and devoted himself entirely to landscape. His watercolours are restrained, his colours influenced by the earlier topographical artists, and his work is lacking in sparkle.
RSA 1826

Thomas Williams died c. 1885

Glasgow artist, painted views of the Clyde and the landscape surrounding Glasgow in oils and watercolour.

Alexander Wilson

A Scot who emigrated to America and illustrated his important book *American Ornithology* published in 7 volumes between 1808 and 1813.

Charles Heath Wilson* 1809–1882
ARSA 1835

David Forrester Wilson 1873–1950

Decorative and portrait painter who worked in oils and on large murals. Trained GSA, he became an important member of the teaching staff. His few watercolours date to his earlier, Symbolist period in which stylization plays an important part.
ARSA 1930, RSA 1933

Margaret Thomson Wilson 1864–1912
(Mrs James Hamilton Mackenzie)
Born Cambuslang, studied GSA. Painted in Holland and later, after her marriage to J. Hamilton Mackenzie*, in Italy.

Mary Georgina Wade Wilson 1856–1939
Born Falkirk, studied Edinburgh and Paris. Watercolourist and pastelier, she illustrated books on gardens and exhibited her paintings of gardens with considerable success.

James C. L. Wilson fl. 1885–1911
Glasgow watercolour landscape artist.

Peter Macgregor Wilson died 1928
Studied GSA and London and Antwerp. Travelled widely, working in America, India, Persia, Russia and Europe. His watercolours are always competent with firm composition and solid colours, but at times his drawing is weak.
RSW 1885 (resigned 1926)

Thomas Wilson fl. 1870–1914
Edinburgh landscape painter in oils and watercolour.

William Wilson* 1905–1972
ARSA 1939, RSW 1946, RSA 1949

William Heath Wilson 1849–1927
The son and pupil of Charles Heath Wilson*, he was headmaster of Glasgow School of Art for a period. Painted genre and landscape, often in Italy, where he spent much time. Essentially an oil painter.

Helen Wingate (Mrs Thornton)
Daughter of Sir James L. Wingate*, painted landscapes in oils and watercolour.

Sir James Lawton Wingate* 1846–1924
ARSA 1879, RSA 1889, PRSA 1919–1924

John Crawford Wintour* 1825–1882
ARSA 1859

Peter Wishart* 1852–1932
ARSA 1925

Frank Watson Wood 1862–1953
Born Berwick-on-Tweed, studied South Kensington and Paris. Second Master at Newcastle School of Art 1883–9 and Headmaster of Hawick School of Art 1889–99. Exhibited regularly in Edinburgh; he was known for his watercolours of sailing ships and various battleships, and he also painted effective, wet watercolours of the Highlands and Borders.

Charles Nicholls Woolnoth* 1815–1906
RSW 1878

Margaret Isobel Wright 1884–1957
Sister of James Wright, born Ayr, studied GSA. Painted watercolours of the west coast and harbours; also painted children. Died Gourock.

James Wright died 1947
Trained GSA, painted breezy views of the west coast in bright, vibrant colours with exuberant brushwork. Also worked in France.
RSW 1920, VPRSW

Kate Wylie 1877–1941
Born Skelmorlie, studied GSA, painted portraits, flowers and landscapes in oils and watercolour. Her watercolour style is similar to that of Emily Paterson*, while her flower pieces are similar, if a little freer, to those of Constance Walton. She often painted on Arran where she stayed in a cottage on Blackwater Foot. In 1942 a Memorial Exhibition of her work and that of Janet Aitken and Elma Story was held at the Glasgow Society of Lady Artists.

Jane Cowan Wyper 1866–1898
Born Glasgow. Marine and coastal painter, killed by falling over a cliff on Sark.
RSW 1896

Bessie Innes Young 1855–1936
Born Glasgow, studied GSA and Paris. Shared a studio with Annie French* and Jane Younger c. 1902–1910, and their work was often exhibited together. She painted landscapes mostly in oils, but did exhibit some watercolours of landscapes and flowers.

Robert Clouston Young* 1860–1929
RSW 1901

William Young 1845–1916
Glasgow artist who, with William Dennistoun and Cowans, established the Glasgow Art Club. An amateur artist for many years, he turned professional in 1878. Painted oils and watercolours of the west coast and Arran in a detailed and well worked style. In addition to painting, Young was known as a local historian and expert on early art and archaeology.
RSW 1880

Jane Younger 1863–1955
Born Glasgow, studied GSA and at the Craigmill School. Her sister, Anna, married Walter Blackie, the publisher who commissioned Hill House, Helensburgh, from C.R. Mackintosh*. Worked in Paris in the 1890s, and shared a studio with Annie French* and Bessie Young c. 1902–1910. She painted mostly in watercolour and developed a bold, colourful, almost Pointillist style for her landscapes. Painted in Scotland, often on Arran, and in France.

ADDENDA

Andrew (André) Douglas 1870–1935
Born Midlothian, studied and lived in Edinburgh. Spent several years in France. Painted in oils and watercolours, the latter often on a large scale depicting markets and cattle in landscapes.
ARSA 1920, RSA 1933

Chris J. Fergusson 1867–1957
Born Dumfries, studied GSA under Fra Newbery and Crystal Palace School of Art, London. Principal art mistress, Glasgow High School for Girls. Lauder Award, Glasgow Society of Lady Artists 1933, 1938, 1954. With E.A. Hornel, Jessie King, E.A. Taylor and others founded the Dumfries and Galloway Fine Art Society whose first exhibition was in 1922. Painted in oils and watercolours, mostly Scottish landscape and architecture.

Arthur Henry Jenkins born 1871
Born Galashiels, studied ECA and Colarossi, Paris. Taught at Trinity College, Glenalmond and Edinburgh Academy later moving South to Somerset where he was art master of King's School, Bruton. Painted in oils and watercolours in a broad, painterly style with rich colours. Often worked abroad, particularly in Italy and France.

Thomas Millons born 1859
Born Edinburgh. Spent many years at sea becoming a sea captain. Made many studies of marine and atmosphere effects which he used successfully in his oils and watercolours, the latter painted in a broad, wet style.

Appendices

APPENDIX 1

PRESIDENTS OF THE ROYAL
SCOTTISH SOCIETY OF PAINTERS IN
WATER-COLOURS

1878–1914	Sir Francis Powell
1914–1922	E. A. Walton
1922–1932	James Paterson
1932–1951	E. A. Borthwick
1951–1952	Stanley Cursiter
1952–1957	John Gray
1957–1963	Adam Bruce Thomson
1963–1969	Sir William Gillies
1969–1974	John Miller
1974–	William Baillie

APPENDIX 2

ORIGINAL LIST OF THE SCOTTISH
SOCIETY OF WATER-
COLOUR PAINTERS 1878

President	Francis Powell
Vice-President	Sam Bough
Treasurer	Charles Blatherwick
Auditors	John Smart
	A. K. Brown
Council	George Aikman
	W. E. Lockhart
	William McTaggart
	David Murray
	J. G. Whyte
Members	G. Aikman
	James Aitken
	Robert Anderson
	J. J. Bannatyne
	J. D. Bell
Members—*contd.*	Charles Blatherwick
	Samuel Bough
	A. K. Brown
	Hugh Cameron
	E. S. Calvert
	William Carlaw
	James Cassie
	William Glover
	Robert Greenlees
	George Hay
	Joseph Henderson
	Robert Herdman
	W. E. Lockhart
	J. O. Long
	R. W. Macbeth
	H. Macullum
	J. B. Macdonald
	Duncan McLaurin
	William McTaggart
	John MacWhirter
	David Murray
	Waller Hugh Paton
	Arthur Perigal
	Francis Powell
	John Smart
	W. F. Vallance
	John G. Whyte
	C. N. Woolnoth
Associates	J. D. Adam
	Lily Blatherwick
	R. C. Crawford
	Tom Donald
	Thomas Fairbairn
	Georgina Greenlees
	David Law
	James McCulloch
	George Ferrier
	William Young

APPENDIX 3

SCOTTISH MEMBERS OF THE ROYAL SCOTTISH SOCIETY OF PAINTERS IN WATER-COLOURS (to 1946)

This list is based upon the list in the 1946 RSW Catalogue. English members of the Society and Scottish artists working solely in the south are not included.

There is some discrepancy over election dates, due to the fact that initially Associate Members were elected, but this practice soon ended. Some catalogues treat election to Associate Membership as election date, while others date it only on election to full Membership.

Members who had died before 1946

Name	Date of Election
Denovan Adam	1880
George Aikman	1878
James A. Aitken	1878
Robert Alexander	1889
Edwin Alexander	1911
Robert Weir Allan	1880
Robert Anderson	1878
J. J. Bannatyne	1878
J. D. Bell	1878
Graham Binny	1909
Charles Blatherwick	1878
Lily Blatherwick	1878
Andrew Black	1885
Sam Bough	1878
A. S. Boyd	1885
Ernest Edward Briggs	1913
A. K. Brown	1878
Thomas Austen Brown	1889
William Fulton Brown	1894
W. Marshall Brown	1929
Robert Alexander Brownlie	1890
William P. Burton	1882
F. C. B. Cadell	1935
James Cadenhead	1893
Edwin Sherwood Calvert	1878
John Carlaw	1885
William Carlaw	1878
James Cassie	1878

Name	Date of Election
George P. Chalmers	1878
W. B. Chamberlin	1887
Robert Cochran	1910
Robert McGown Coventry	1889
R. C. Crawford	1878
T. Hamilton Crawford	1887
Joseph Crawhall	1887
Alexander Davidson	1883
Henry J. Dobson	1890
Tom Donald	1878
James Douglas	1900
Charles R. Dowell	1933
John Downie	1903
Patrick Downie	1902
John Duncan	1930
Marjorie Evans	1891
Thomas Fairbairn	1882
David Farquharson	1885
George Ferrier	1881
Alexander Fraser	1878
John Simpson Fraser	1883
David Fulton	1890
Ewan Geddes	1902
William Glover	1878
George Russell Gowans	1893
George Graham	1927
Norah Nielson Gray	1914
Robert Greenlees	1878
Walter Grieve	1934
J. Whitelaw Hamilton	1895
George Hay	1878
Thomas M. Hay	1895
Joseph Henderson	1878
George Henry	1900
Robert Herdman	1878
William Hole	1885
A. C. Holms	1893
John Rennie Houston	1886
Robert Houston	1936
Thomas Hunt	1885
Colin Hunter	1879
Mason Hunter	1889
R. Gemmell Hutchison	1895
George Whitton Johnstone	1885
Archibald Kay	1892
James Kay	1897
Henry Wright Kerr	1891

Name	Date of Election	Name	Date of Election
James Laing	1885	James Riddell	1905
G. Nasmyth Langland	1896	Christina Ross	1880
C. J. Lauder	1885	Tom Scott	1885
David Law	1882	Charles A. Sellar	1893
William Leiper	1879	Jane Hunter Shield	1885
Otto Leyde	1879	John Shirreffs	1895
W. E. Lockhart	1878	John Smart	1878
J. O. Long	1878	A. Reginald Smith	1926
J. H. Lorimer	1885	D. Murray Smith	1934
Walter McAdam	1894	Garden Grant Smith	1890
H. Macallum	1878	John Terris	1891
Kate Macaulay	1879	Grosvenor Thomas	1892
James McCulloch	1885	Mason Trotter	1930
J. B. Macdonald	1878	W. F. Vallance	1878
Margaret Macdonald	1898	E. A. Walton	1885
C. R. Mackintosh	1898	William Walls	1906
John McDougall	1885	David West	1908
Tom McEwan	1883	John G. Whyte	1878
Hanna McGoun	1903	Peter McGregor Wilson	1885
W. Y. MacGregor	1885	Charles Woolnoth	1878
A. B. McKechnie	1900	Mrs Georgina Wylie	1878
Duncan MacKellar	1885	Jane Cowan Wyper	1896
J. Hamilton Mackenzie	1910	Robert Clouston Young	1901
Charles Mackie	1902	William Young	1880
Duncan McLaurin	1878		
Kenneth Macleay	1878	**Honorary Members**	
James MacMaster	1885	D. Y. Cameron	1934
John McNiven	1891	Hugh Cameron	1916
William McTaggart	1878	W. Fettes Douglas	1882
John MacWhirter	1878	James Guthrie	1890
Hamilton Maxwell	1885	Robert Little	1885
Arthur Melville	1885	Daniel McNee	1878
John Muirhead	1892	David Murray	1878
James T. Murray	1927	Robert Nisbet	1887
Pollock S. Nisbet	1881	George Pirie	1934
Marie Norie	1887	George Reid	1892
Stewart Orr	1925		
Emily Murray Paterson	1904	**Members alive in 1946**	
James Paterson	1885	William Armour	1941
Waller Hugh Paton	1878	Harry Berstecher	1926
Arthur Perigal	1878	Ann Spence Black	1917
Colin Bent Phillip	1890	Colonel G. Borrowman	1945
Francis Powell	1878	A. E. Borthwick	1911
Wellwood Rattray	1885	Mary Marshall Brown	1936
A. D. Reid	1883	Nancy Burton	1932
Samuel Reid	1885	Katherine Cameron	1897
Warwick Reynolds	1924	Laelia A. Cockburn	1924

Name	Date of Election	Name	Date of Election
Lionel T. Crawshaw	1923	Alexander MacBride	1887
Stanley Cursiter	1914	M. V. MacGeorge	1930
Amy Dalyell	1883	Alex McLellan	1910
Mary C. Davidson	1936	Alex Macpherson	1932
Mabel Dawson	1917	James Miller	1934
Anna Dixon	1917	Elizabeth Molyneaux	1923
A. C. Dodds	1937	Anne D. Muir	1915
Robert Eadie	1917	Charles Napier	1913
Purvis Flint	1918	Charles Oppenheimer	1912
W. Russell Flint	1913	Alexander N. Paterson	1916
David Foggie	1918	Agnes Raeburn	1901
Andrew A. Gamley	1924	J. Kent Richardson	1917
Janetta Gillespie	1943	Alan Ian Ronald	1935
James Gray	1936	William Somerville Shanks	1925
John Gray	1941	Agnes Sim	1927
Ralston Gudgeon	1937	A. Gordon Thomas	1936
Martin Hardie	1934	Alexander P. Thomson	1922
Peter Alexander Hay	1891	J. Murray Thomson	1917
Keith Henderson	1936	Constance Walton	1887
R. Scott Irving	1934	G. P. H. Walton	1938
Jessie Keppie	1934	James Wright	1920

Notes

Chapter 1 EARLY SCOTTISH
WATERCOLOURS

1. HOLLOWAY, J. and ERRINGTON, L., *The Discovery of Scotland. The Appreciation of Scottish Scenery through Two Centuries of Painting*, National Gallery of Scotland, Edinburgh, 1978, pp. 33–46

2. SKINNER, BASIL, *Scots in Italy in the Eighteenth Century*, National Gallery of Scotland, Edinburgh, 1966

3. FLEMING, J., 'Allan Ramsay and Robert Adam in Italy', *Connoisseur*, 1956, vol. CXXXVII, pp. 78–84

4. OPPÉ, P., 'Robert Adam's Picturesque Compositions', *Burlington*, 1942, LXXX, pp. 56–59

5. Letter of 1766 published in A. T. BOLTON, *The Architecture of Robert and James Adam*

6. John Clerk of Eldin. An exhibition organized by Geoffrey Bertram with the support of the Scottish Arts Council and Phillips, Edinburgh, 1978

7. CLERK, SIR JOHN, 'Trip to the North of Scotland as far as Inverness in May 1739', Mss in Register House, Edinburgh

8. CRAIG, G. Y., (edited) 'Theory of the Earth: The Lost Drawings', Scottish Academic Press, 1978

9. Letter from George Paton to Richard Gough, 1779, National Library of Scotland

10. For a discussion of More's Falls of the Clyde paintings see Holloway and Errington op. cit. pp. 47–55 and IRWIN, D. and F, *Scottish Painters at Home and Abroad 1700–1900*, Faber and Faber, 1975, pp. 133–38

11. Letter from More to Thomas Harvey, August, 1785, Royal Academy, London

12. IRWIN, D., 'Jacob More – Neo-Classical Landscape Painter', *Burlington* vol. CXIV, 1972, pp. 775–9. Several watercolours are illustrated in this article.

13. HOLLOWAY, J., 'Projects to illustrate Allan Ramsay's Treatise on Horace's Villa', Master Drawings, 1976

14. CAW, SIR JAMES, *Scottish Painting Past and Present*, Edinburgh, 1908, pp. 38–9

15. MACMILLAN, D., 'Alexander Runciman in Rome', *Burlington* CXII, 1970, pp. 23–31

16. *The European Magazine*, 1790

17. ibid.

18. POWELL, N., 'Brown and the Women of Rome', *Signature* XIV, 1952, pp. 40–50. Several examples of Brown's work are illustrated.

19. *The European Magazine*, 1790

20. IRWIN, D. and F., op. cit. pp. 114–18

21. For a detailed examination of these academies see IRWIN op cit. pp. 83–97

22. These include David Wilkie, Alexander Carse, David Roberts. Walter Geikie, Alexander Fraser and the engraver, W. H. Lizars.

Chapter 2 TOWARDS A SCOTTISH SCHOOL

1. E. T. Crawford, John Ewbank, Robert Gibb, Patrick Gibson, Thomas Hamilton, George Harvey, D. O. Hill, Kenneth MacLeay, William Simson and Patrick Syme.

2. HOLLOWAY and ERRINGTON, op. cit. pp. 87–101

3. LOCKHART, J. G., *The Life of Sir Walter Scott*, 1893, pp. 353–4

4. IRWIN op. cit., p. 138

5. There is some doubt as to the exact dates of this trip; Nasmyth left in either 1782 or 1783 and returned either late 1784 or early 1785

6. NASMYTH, J., *An Autobiography*, ed. Samuel Smiles, 1883, p. 40

7. A drawing exists inscribed 'Done in the Company of R. Burns' (NGS) as does a pencil drawing entitled 'Robert Burns and Alexander Nasmyth at Roslin Castle' (SNPG)

8. KEMP, M., 'Alexander Nasmyth and the Style of Graphic Eloquence', *Connoisseur*, 1970, pp. 92–100

9. NASMYTH, op. cit. p. 37

10. ibid., pp. 57–8, 99

11. ibid., p. 99
12. KEMP, op. cit. pp. 96–8
13. NASMYTH, op. cit. p. 99
14. There is some doubt as to the date of his move to London, but 'St Paul's Cathedral from Lambeth Marsh' (NGS) is dated June 1807 which would suggest that he moved south in the spring of that year.
15. NASMYTH, op. cit. pp. 58–9
16. ibid., pp. 59–60
17. HARDIE, M., *Watercolour Painting in Britain*, vol. 3, 1968, pp. 176–77
18. IRWIN, op. cit. p. 229
19. WILLIAMS, Hugh 'Grecian', *Travels in Italy, Greece and the Ionian Islands*, 2 vols, Edinburgh, 1820, vol. 1, p. 41
20. ibid., vol. 1, p. 246
21. ibid., vol. 2, p. 126
22. CUNNINGHAM, A., *The Life of Sir David Wilkie*, 3 vols, 1843, vol. 1. pp. 37–8
23. 20 of these watercolours were sold in Sotheby's in 1980 for £20,000.

Chapter 3 SIR DAVID WILKIE AND HIS INFLUENCE

1. CUNNINGHAM, op. cit. vol. 1, pp. 37–8
2. ibid., vol. 1, p. 54
3. ibid., vol. 1, pp. 117–18
4. Letter to Thomas Wilkie 9 November 1825. Quoted Cunningham, op. cit. vol. 2, p. 183
5. Letter to Sir Robert Peel, February 1826. Quoted Cunningham, op. cit. vol. 2, p. 237
6. ibid, vol. 2, p. 253
7. ibid., vol. 2, p. 288
8. Letter to his sister 31 March 1828. Quoted Cunningham, op. cit. vol. 2, p. 512
9. MILES, H., 'Adnotatiunculae Leicestrienses: Wilkie and Washington Irving in Spain' *Scottish Art Review*, new series XII, 1, 1969, pp. 21–5
10. Obituary in 'The Spectator' quoted in 'The Examiner', 13 June 1941
11. Letter to Lady Baird. Quoted in Virtue, *The Wilkie Gallery*, London (n.d.)
12. VIRTUE, op. cit.
13. CAW, op. cit. pp. 180–1
14. MCKERROW, M., *The Faeds*, Canongate, 1982, p. 126
 Mary McKerrow provides a well-illustrated account of this interesting family of painters.

Chapter 4 THE MID-CENTURY

1. *Scottish Art and Artists*, a pamphlet by 'Iconoclast', 1860, quoted by Holloway and Errington, op. cit. p. 25
2. From an advertising card in the possession of Miss Herdman
3. HERDMAN, M., 'A Painter Rediscovered', *Scotland's Magazine*, new series LXLIII, 3, June 1970 pp. 225–64 and SPARROW, J., 'A Scottish Artist in Italy', *Country Life*, 1 October 1970, pp. 824–5. An exhibition of Italian sketches was arranged by John Sparrow and Mary Herdman in Oxford and Aberdeen.
4. In the possession of T. A. S. Macpherson of Edinburgh who kindly showed them to me.
5. Miss Herdman has a sketchbook entitled 'Extension of Notes in Italy' dated 1844. In these extended drawings, as in the Sutherland album, one senses a lack of the vitality which characterizes the earlier Italian watercolours.
6. Sketchbook in Aberdeen Art Gallery 1862–3
7. MACGEORGE, A. *William Leighton Leitch. Landscape Painter. A Memoir*, Blackie, 1884, p. 30
8. ibid., p. 57
9. ibid., pp. 97–8
10. ibid., p. 109
11. HARDIE, M., op. cit. vol. 3 p. 186
12. BALLANTINE, J., *The Life of David Roberts*, Edinburgh, 1866, pp. 14–15
13. ibid., p. 55, Letter to Hay from Gibraltar, April 1833
14. ibid., pp. 83–84, Journal, 30 September 1838
15. ibid., p. 87, Journal, 15 October 1838
16. ibid., p. 89, Journal, 19 October 1838
17. ibid., p. 137–8, Journal, 2 May and 4 May 1839
18. RUSKIN, J., Letter to his father, 29 September 1851
19. RUSKIN, J., Letter to his father, 23 October 1851
20. STIRLING, A. M., *Victorian Sidelights*, quoted in H. GUITERMAN *David Roberts R. A.* London, 1978, p. 25
21. ibid., p. 26
22. HARDIE, op. cit. vol. 3, p. 182
23. EYRE-TODD, G. (ed.), *Autobiography of William Simpson RI*, Fisher and Unwin, London, 1903, p. 7
24. CAW, SIR JAMES, op. cit. p. 292
25. ibid., p. 150

26. Organized by Angela Weight, on whose research an article in the *Leopard Magazine* 'James Cassie RSA 1819–1879' was based.

Chapter 5 THE INFLUENCE OF PRE-RAPHAELITISM

1. RUSKIN, J., 'Generalization and the Scotch Pre-Raphaelites', A letter in the *Witness* 27 March, 1858, reprinted in *Arrows of Chance*, 1880, vol. 1, pp. 110–14
2. RUSKIN, J., Letter to his parents 17 July 1853, reprinted in COOK, E. T. and WEDDERBURN, A., *The Works of John Ruskin* 1904, p. xxi
3. RUSKIN, J., Letter to his parents 19 August 1853, Cook and Wedderburn op cit. p. xxvii
4. RUSKIN, J., Edinburgh Lecture, 18 November 1853
5. A detailed account of Dyce's life has been published recently: Marcia Pointon, *William Dyce 1806–1869*, Clarendon Press, Oxford, 1979
6. POINTON, M., op. cit., p. 26
7. STALEY, A., 'William Dyce and Outdoor Naturalism' *Burlington* CV, 1963, pp. 470–7
8. POINTON, M., op. cit., p. 173
9. MINTO, W. (ed.), *Autobiographical Notes of the Life of William Bell Scott*, 2 vols, London, 1892, vol. 1, p. 47
10. ibid., vol. 2, p. 10
11. ibid., vol. 2, pp. 75–6
12. ibid., vol. 2, pp. 324
13. ibid., vol. 1, pp. 262–3
14. RUSKIN, J., *Generalization and the Scotch Pre-Raphaelites*, 27 March 1858
15. CAW, SIR JAMES., op. cit., p. 195
16. ibid., p. 119
17. SINCLAIR, W. M., *John MacWhirter, Art Journal Special Number*, 1903, p. 22
18. MACWHIRTER, J., *The MacWhirter Sketchbook*, Cassel 1906, p. 7
19. MACWHIRTER, J., *Landscape Painting in Watercolour*, Cassel 1900, p. 16

Chapter 6 TOWARDS A FREER STYLE

1. Letter to J. W. Carmichael, the Newcastle painter, dated 3 June 1845. Quoted in S. Gilpin, *Sam Bough RSA*
2. Several detailed watercolours by Lady Ruthven are in the NGS.
3. GILPIN, op. cit., p. 157
4. ibid., p. 157

5. PINNINGTON, E., 'Alexander Fraser RSA' *Art Journal*, 1904, pp. 375–76 From an autobiographical manuscript left unfinished on Fraser's death.
6. ibid., p. 376
7. PINNINGTON, E., 'Robert Scott Lauder RSA and his Pupils' *Art Journal*, 1898, pp. 339–43 and pp. 367–71. For a comprehensive account of the Trustees' Academy and the role of Robert Scott Lauder, see LINDSAY ERRINGTON, *Master Class: Robert Scott Lauder and his Pupils*, National Gallery of Scotland, 1983
8. CAW, SIR JAMES *William McTaggart. A Biography and an Appreciation*, Glasgow, 1917, p. 71. Caw gives a detailed account of McTaggart's watercolour technique pp. 105–18
9. ibid., p. 116
10. ibid., p. 118
11. ibid., p. 206
12. MACWHIRTER, J., *Landscape Painting in Watercolours*, Cassell, 1907, p. 56
13. ibid., p. 11
14. MACWHIRTER, J., *Sketches from Nature*, with an introduction by Mrs MacWhirter, Cassell, 1913, p. vii
15. PINNINGTON, E., *Studio* vol. 44, 1908, p. 146
16. CAW, SIR JAMES, *Scottish Painting Past and Present*, p. 166

Chapter 7 THE GLASGOW SCHOOL

1. Accounts of the Glasgow School can be found in IRWIN, D. and F. op. cit., HARDIE, W., *Scottish Painting 1837–1939*, Studio Vista, 1976, MARTIN, D., *The Glasgow School of Painting* George Bell, 1897, (reprinted by Paul Harris Publishing, 1976) BILLCLIFFE, ROGER, *The Glasgow Boys*, John Murray, 1985; Scottish Arts Council, *The Glasgow Boys*, exhibition catalogues by W. Buchanan and others, 1968 and 1971
2. PATERSON, JAMES, 'The Art Student in Paris' *Scottish Art Review* vol. 1, 1888–9
3. WOOD, MARTIN, 'The Art of the Late Arthur Melville RWS ARSA' *Studio* vol. 37, 1906, p. 291
4. MACKAY, AGNES E., *Arthur Melville. Scottish Impressionist* F. Lewis, Leigh-on-Sea, 1951, plate 5
5. ibid., plate 1
6. FEDDEN, R., 'Arthur Melville RWS' OWS Club, 1923–4, p. 41 'Robert Weir Allan's Recent Paintings and Drawings'

7. WOOD, MARTIN, *The Studio* vol. 46, 1909, pp. 90–2

8. BELL, NANCY, 'Robert Weir Allan' *Studio*, vol. 23, 1901, p. 236

9. Sold at Phillips, London, 1979

10. PATERSON, JAMES, 'The Art Student in Paris' *Scottish Art Review* vol. 1, 1888–9

11. MARTIN, op. cit., p. 70

12. BURY, ADRIAN, *Joseph Crawhall 1861–1913 The Man and the Artist* Skilton, London, p. 68–9

13. WALKER, A., Stoddart, 'The Art of Joseph Crawhall' *Studio*, vol. 69, 1917, p. 16, quoting a letter from Lavery.

14. ibid., p. 16

15. WOOD, T. MARTIN, 'Some Recent Watercolours by Edwin Alexander' *Studio*, vol. 53, 1911, p. 90

16. GARSTIN, NORMAN, 'The Work of T. Mille Dow' *Studio*, vol. 10, 1897, pp. 151–2

17. I am indebted to Kenneth Roberts whose research into Herald's art and life has revealed many interesting facets of this artist's work.

18. *The Arbroath Herald*, 24 October 1914

19. ibid.

20. Letter written by Fra Newbery, quoted by James Meldrum in his Scottish Arts Council catalogue, *John Quinton Pringle*, 1981, p. 8

21. For an account of Pringle's somewhat chaotic shop see Sir Denis Brogan's personal recollections, *Scottish Arts Review*, IX, 1964

22. Letter to James Meldrum from Whalsay, 8 August 1924. Quoted in James Meldrum, op. cit., p. 44

23. EDDINGTON, A., 'The Paintings of James Lawton Wingate PRSA,' *Studio* vol. 77, 1919, p. 101

24. I am indebted to Dr Hamish Walls for information about his father and his father's relations by marriage – Edwin Alexander and Charles Mackie – and for showing me many of his father's watercolours.

Chapter 8 ART NOUVEAU AND SYMBOLIST WATERCOLOURS

1. REDON, ODILON, *A Soi-meme*, Journal 1867–1915

2. BILLCLIFFE, ROGER, *Mackintosh Watercolours*, Glasgow Art Gallery and the Fine Art Society, 1978

3. ibid., p. 28

4. BILLCLIFFE, R., 'J. H. MacNair in Glasgow and Liverpool' Transactions of the Walker Art Gallery, Liverpool 1970–1, pp. 48–74

5. ARTHUR, ELIZABETH, 'Glasgow School of Art Embroidery 1894–1920' Decorative Arts Society Journal No. 4, 1980, pp. 18–25

6. Quoted by Paul Stirton in his catalogue 'Robert Burns' Fine Art Society, 1976

7. I am indebted to John Kemplay and Anne Robertson for their help in introducing me to the work of Eric Robertson and Cecile Walton.

8. HARDIE, W., 'The Hills of Dream Revisited. George Dutch Davidson 1879–1901' *Scottish Art Review*, new series, XIII 4, 1972

Chapter 9 THE TWENTIETH CENTURY

1. From Fergusson's 'Notes', quoted by Margaret Morris in *The Art of J. D. Fergusson. A Biased Biography*, Blackie, 1974, pp. 37–8

2. DICKSON, T. Elder, *W. G. Gillies* Modern Scottish Painters, 1974, p. 17

3. ibid., p. 66

4. From a card written to Dr Lillie in 1951

5. At the Scottish Gallery, Edinburgh, 1982

6. HARDIE, MARTIN in The Print Collector's Quarterly, quoted in *The Early Years of James McBey, An Autobiography 1883–1911*, ed. Nicolas Barker, OUP, 1977

7. FLINT, SIR WILLIAM RUSSELL, *In Pursuit: An Autobiography*, p. 39

8. ibid., p. 86

9. ibid., p. 176

10. RICH, ALFRED, *Watercolour Painting* Seeley, Service and Co., London, 1918, p. 231

Select bibliography

This bibliography should be used in conjunction with the comprehensive bibliography in *Scottish Painters at Home and Abroad 1700–1900* by the Irwins and the more selective bibliography in William Hardie's *Scottish Painting 1837–1939*

GENERAL BOOKS, CATALOGUES AND ARTICLES

ABERDEEN ART GALLERY, *Permanent Collection Catalogue*, compiled by Charles Carter. Aberdeen, 1968

ARMSTRONG, SIR WALTER, *Scottish Painters. A Critical Study*, Seeley and Co., London, 1888

BATE, PERCY, *Art at the Glasgow Exhibition 1901*, Virtue, London, 1901

BATE, PERCY, *The English Pre-Raphaelite Painters. Their Associates and Successors*, G. Bell and Sons, London, 1899

BILLCLIFFE, ROGER, *The Glasgow Boys*, John Murray, 1985

BROWN, GERARD BALDWIN, *The Glasgow School of Painters*, J. Maclehose, Glasgow, 1908

BRYDALL, ROBERT, *Art in Scotland. Its Origins and Progress*, Blackwood, Edinburgh, 1889

CAW, SIR JAMES, *Scottish Painting Past and Present 1620–1908*, J. C. and E. C. Jack, Edinburgh, 1908 (reprinted 1975)

CAW, SIR JAMES, *Scottish Portraits*, 2 vols, J. C. and E. C. Jack, Edinburgh 1902–3

CAW, SIR JAMES, 'The Present Condition of Art in Scotland' *Art Journal*, 1898, pp. 45–9, 69–73

CAW, SIR JAMES, 'A Phase of Scottish Art' *Art Journal*, 1894, pp. 75–80

CHRISTIES AND EDMISTONS, GLASGOW, Illustrated catalogues of Sales of Scottish Pictures

CROAL, T. A., 'The Edinburgh Pen-and-Pencil Club' *Art Journal*, 1899, pp. 232–4

CURSITER, STANLEY, *Scottish Art to the Close of the Nineteenth Century*, George Harrup and Co., London, 1949

CURSITER, STANLEY, *Looking Back: A Book of Reminiscences*, Edinburgh, 1974

DEWAR, DECOURCY LEWTHWAITE, *History of the Glasgow Society of Lady Artists' Club*, Maclehose, Glasgow, 1950

DUNDEE CITY ART GALLERY, *Catalogue of the Permanent Collection*, compiled by W. R. Hardie, 1973

DUNDEE CITY ART GALLERY, *Arthur Melville 1855–1904*, catalogue by Gerald Deslandes, 1977

EYRE-TODD, G., *Who's Who in Glasgow in 1909*, Gowans and Gray, Glasgow, 1909

THE FINE ART SOCIETY *The Glasgow School of Painting*, catalogue introduced by W. R. Hardie, 1970, *Let Glasgow Flourish*, catalogue introduced by Roger Billcliffe and Elizabeth Bird, 1979 Other catalogues published by the Fine Art Society, including the '*100 Years of Scottish Painting*' series, provide invaluable information.

FINLAY, IAN, *Art in Scotland*, Longmans, 1945

FINLAY, IAN, *Art in Scotland*, O.U.P., 1948

GEDDES, PATRICK (ed.), *Evergreen. A Northern Seasonal*, 4 issues, Edinburgh 1895–6

GLASGOW, *The Glasgow Society of Lady Artists in 1882*, Centenary Exhibition Catalogue, 1982

FERGUSSON, J. D., *Modern Scottish Painting*, William Maclennan, Glasgow, 1943

HARDIE, MARTIN, *Watercolour Painting in Britain*, 3 vols, Batsford, 1966–8

HARDIE, WILLIAM R., *Scottish Painting 1837–1939*, Studio Vista, 1976

HARRIS, PAUL, *A Concise Dictionary of Scottish Painters*, Harris Publishers, Edinburgh, 1976

HARTRICK A. S., *A Painter's Pilgrimage through Fifty Years*, C.U.P., 1939

HAY, GEORGE, *The Book of Hospitalfield*, A Memorial of Patrick Allan Fraser HRSA of Hospitalfield, Arbroath, 1894 (privately printed)

HELENSBURGH AND DISTRICT ART CLUB, *West of Scotland Women Artists*, 25th Anniversary Loan Exhibition, Introduction by Ailsa Tanner.

HONEYMAN, T. J., *Three Scottish Colourists*, Thomas Nelson and Sons, 1950

IRWIN, DAVID AND FRANCINA, *Scottish Painters at Home and Abroad 1700–1900*, Faber and Faber, 1975

IRWIN, DAVID, 'The Falls of Clyde' *Country Life*, 1975

IRWIN, FRANCINA, 'The Scots Discover Spain', *Apollo* XCIX, 1974, pp. 353–57

IRWIN, FRANCINA, 'Lady Amateurs and their Masters in Scott's Edinburgh', *Connoisseur* CLXXXV, 1974, pp. 230–237

IRWIN, FRANCINA, 'Artists on the Isle of Arran', *Scotland's Magazine*, September, 1975

MCCONKEY, KENNETH, 'From Grez to Glasgow: French Naturalist Influence in Scottish Painting', *Scottish Art Review* vol. XV, November 1982, pp. 16–34

MACKAY and RINDER, *The Royal Scottish Academy 1826–1916*, Glasgow, 1917

MACKAY, WILLIAM DARLING, *The Scottish School of Painting*, Duckworth and Co., London, 1906

MARTIN, DAVID, *The Glasgow School of Painting* (with an introduction by Francis H. Newbery), George Bell and Sons, 1897

MILES, HAMISH, *Early Exhibitions in Glasgow I (1761–1838) Scottish Art Review*, new series, VIII, 3, 1962, pp. 26–30
II (1841–1855)
ibid., 4 pp. 26–9

MILLAR, A. H., 'Hospitalfields: A Proposed College for Artists', *Art Journal*, 1896, pp. 246–8

NATIONAL GALLERY OF SCOTLAND, *Catalogue of Scottish Drawings*, Keith Andrews and J. R. Brotchie, 1960
Selected Scottish Drawings, Keith Andrews, 1960
The Discovery of Scotland, exhibition catalogue by Lindsay Errington and James Holloway, 1978
Master Class: Robert Scott Lauder and his Pupils, exhibition catalogue by Lindsay Errington, 1983

PINNINGTON, EDWARD, 'Robert Scott Lauder RSA and his Pupils', *Art Journal*, 1898, pp. 339–43; 367–71

PINNINGTON, EDWARD, *The Art Collection of the Corporation of Glasgow*, Glasgow, 1898

POWER, WILLIAM, 'Glasgow and the Glasgow School', *Scottish Art Review*, 1946

REID, J. M. and HONEYMAN, T. J., *Glasgow Art Club 1867–1967*, Glasgow, 1967

SCOTTISH ARTS COUNCIL Exhibition catalogues
The Artist and the River Clyde, 1958–9
The Glasgow Boys, catalogue by W. Buchanan and others, 1968 and 1971

A Man of Influence; Alex Reid, catalogue by Ronald Pickvance, 1967
Mr Henry and Mr Hornel visit Japan, catalogue by W. Buchanan, A. Tanner and L. L. Ardern, 1978
Three Scottish Colourists, catalogue by W. R. Hardie, 1970

SCOTTISH NATIONAL PORTRAIT GALLERY, *Visit of George IV to Edinburgh 1822*, catalogue by Basil Skinner, 1961

SKINNER, BASIL, *Scots in Italy in the Eighteenth Century*, Edinburgh, 1966

SKINNER, BASIL, 'Andrew Wilson and the Hopetoun Collection', *Country Life* CXLIV, 1968, pp. 370–2

SOTHEBY'S ILLUSTRATED CATALOGUES of Scottish Picture Sales held at various locations in Scotland.

SPENCER, ISOBEL, 'Francis Newbery and the Glasgow Style', *Apollo* XCVIII, 1973, pp. 286–93

STALEY, ALLEN, *Pre-Raphaelite Landscape*, O.U.P., 1973

STIRLING SMITH ART GALLERY AND MUSEUMS, *The Artists of Craigmill and Cambuskenneth*, Catalogue by Fiona Wilson, 1978

TONGE, JOHN, *The Arts of Scotland*, Kegan Paul, Trench and Trubner, 1938

WHITE, J. W. GLEESON, 'Some Glasgow Designers and their Work', *Studio* vol. 11, 1897, pp. 86–100, 225–36, X, pp. 47–51

WILLIAMS, IOLO, *Early English Watercolours*, London, 1952

INDIVIDUAL ARTISTS

Robert Adam

SCOTTISH ARTS COUNCIL, *Robert Adam and Scotland. The Picturesque Drawings*, exhibition catalogue by A. A. Tait, 1972

TAIT, A. A., *Robert Adam at Home, 1728–1978 Drawings from the Collection of Blair Adam*, catalogue

TAIT, A. A., 'The Picturesque Drawings of Robert Adam', *Master Drawings* IX, 2, 1971, pp. 161–71

OPPÉ, PAUL, 'Robert Adam's Picturesque Compositions', *Burlington Magazine*, LXXX, 1942, pp. 56–9

BOLTON, ARTHUR THOMAS, *The Architecture of Robert and James Adam 1758–1794* 2 vols, *Country Life* and George Newnes, London, 1922

FLEMING, JOHN, *Robert Adam and his Circle in Edinburgh and Rome*, London, 1962

Edwin Alexander

WOOD, T. MARTIN, 'Some Recent Watercolours by
 Edwin Alexander', *Studio* vol. 53, 1911, pp. 90–
 100

David Allan

GORDON, THOMAS CROUTHER, *David Allan of Alloa*,
 Alva, 1951
SCOTTISH ARTS COUNCIL, *The Indefatigable Mr
 Allan*, catalogue by Basil Skinner, 1973

Robert Weir Allan

WOOD, MARTIN, 'Robert W. Allan's Recent Paintings
 and Drawings', *Studio*, vol. 46, 1909, pp. 89–100
BELL, NANCY, 'Robert Weir Allan', *Studio*, vol. 23,
 1901, pp. 228–237

George Bain

KIRKCALDY ART GALLERY, exhibition catalogue,
 1978

Sam Bough

GILPIN, SIDNEY, *Sam Bough RSA*, George Bell and
 Sons, London, 1905

John Brown

GRAY, J. M., 'John Brown the Draughtsman',
 Magazine of Art, July 1889, pp. 310–15
POWELL, NICHOLAS, 'Brown and the Women of
 Rome', *Signature* XIV, 1952, pp. 40–50

Robert Brough

PINNINGTON, EDWARD, 'Robert Brough, Painter',
 Art Journal, 1898, pp. 146–9

Robert Burns

TAYLOR, E. A., 'Robert Burns' Pictures of
 Morocco', *Studio*, vol. 81, 1921, pp. 86–90
FINE ART SOCIETY, *Robert Burns Limner*, catalogue
 with introduction by Paul Stirton, 1978
BOURNE FINE ART, *Robert Burns*, catalogue with
 introduction by Martin Forrest, 1982

Alexander Hohenlohe Burr

DAFFORNE, JAMES, 'Alexander Hohenlohe Burr',
 Art Journal, 1870, pp. 309–11

John Burr

DAFFORNE, JAMES, 'John Burr', *Art Journal*, 1869,
 pp. 337–9

James Cadenhead

WALKER, A. STODDART, 'A Scottish Landscape
 Painter: James Cadenhead', *Studio*, vol. 55,
 1912, pp. 10–20

F. C. B. Cadell

FINE ART SOCIETY, *F. C. B. Cadell 1883–1937*, A
 Centenary Exhibition with Introduction by
 Roger Billcliffe

D. Y. Cameron

BAYES, WALTER, 'Paintings and Etchings of D. Y.
 Cameron', *Studio*, vol. 36, 1905, pp. 3–19

Hugh Cameron

'Hugh Cameron RSA', *Art Journal*, 1902, pp. 17–
 20; 297–300

Kate Cameron

MARILLIER, H. C., 'The Romantic Water-Colours of
 Miss Cameron', *Art Journal*, 1900, pp. 148–9

George Paul Chalmers

GIBSON, ALEXANDER and WHITE, JOHN FORBES,
 George Paul Chalmers, Edinburgh, 1879
PINNINGTON, EDWARD, *George Paul Chalmers and
 the Art of his Time*, Glasgow, 1896
PINNINGTON, EDWARD, 'George Paul Chalmers
 RSA', *Art Journal*, 1897, pp. 83–8

John Clerk of Eldin

BERTRAM, GEOFFREY, *John Clerk of Eldin 1728–1812*,
 Edinburgh, 1978
CLERK, SIR JOHN, *Memoirs . . . extracted by himself
 from his own Journals*, ed. J. M. Gray,
 Edinburgh, 1892

Joseph Crawhall

BURY, ADRIAN, *Joseph Crawhall: The Man and the
 Artist* Charles Skilton, London, 1958
BATE, PERCY, 'Joseph Crawhall – Master
 Draughtsman', *Studio*, vol. 32, 1904, pp. 219–25
MARTIN, DAVID, 'Some Paintings by Joseph
 Crawhall', *Studio*, vol. 3, 1894, pp. 166–170
T. C. M., 'The Crawhalls of Mr William Burrell's
 Collection', *Studio*, vol. 83, 1922, pp. 177–186
WALKER, A. STODDART, 'The Art of Joseph
 Crawhall' *Studio*, vol. 69, 1917, p. 16

James Cowie

CALVOCORESSI, RICHARD, *James Cowie*, National
 Galleries of Scotland, SNGMA, 1979

OLIVER, CORDELIA, *James Cowie*, Modern Scottish Painters, Edinburgh, 1980

ARTS COUNCIL, *James Cowie. Memorial Exhibition*, catalogue introduced by D. P. Bliss, 1957

Stanley Cursiter

EDDINGTON, ALEXANDER 'The Paintings and Lithographs of Stanley Cursiter', *Studio*, vol. 82, 1921, pp. 21–5

George Dutch Davidson

HARDIE, WILLIAM, 'The Hills of Dream Revisited. George Dutch Davidson 1879–1901', *Scottish Art Review*, new series, XIII 4, 1972, pp. 18–23, 34.

Sir William Fettes Douglas

'Sir William Fettes Douglas PRSA', *Art Journal*, 1906, pp. 118–20

The Doyle Family

VICTORIA AND ALBERT MUSEUM, *Richard Doyle and his Family*, Exhibition catalogue, 1983

T. Millie Dow

GARSTIN, NORMAN, 'The Work of T. Millie Dow', *Studio*, vol. 10, 1897, pp. 145–52

James Drummond

CANONGATE TOLBOOTH MUSEUM, EDINBURGH, *James Drummond RSA Victorian Antiquary and Artist of Old Edinburgh*, exhibition catalogue, 1977

John Duncan

TAYLOR, E. A., 'Some Pictures by John Duncan ARSA', *Studio*, vol. 80, 1920, pp. 139–47

BOURNE FINE ART, *John Duncan. A Scottish Symbolist*, Catalogue by Martin Forrest, 1983

William Dyce

POINTON, MARCIA, *William Dyce 1806–1869*, O.U.P., 1979

ABERDEEN ART GALLERY, *Centenary Exhibition of the Work of William Dyce R.A.*, catalogue by Charles Carter, 1964

STALEY, ALLEN, 'William Dyce and Outdoor Naturalism', *Burlington Magazine*, CV 1963, pp. 470–7

Faed Brothers

MCKERROW, MARY, *The Faeds – a Biography*, Canongate, Edinburgh 1982. Includes a comprehensive bibliography for all members of the Faed family.

DAFFORNE, JAMES, 'John Faed', *Art Journal*, 1871, p. 237

'Thomas Faed', *Art Journal*, 1871, pp. 1, 62

J. D. Fergusson

MACFALL, HALDANE, 'The Paintings of John D. Fergusson RBA', *Studio*, vol. 40, 1907, pp. 202–10. Contains interesting illustrations of Fergusson's earlier work.

MORRIS, MARGARET, *The Art of J. D. Fergusson. A Biased Biography*, Blackie, Glasgow, 1974

Sir William Russell Flint

PALMER, ARNOLD, *More than Shadows*, A Biography of W. Russell Flint, *The Studio*, 1943

FLINT W. R., *In Pursuit: An Autiobiography*, Medici Society, London, 1969

FLINT, W. R., *Breakfast in Perigord*, Charles Skilton, London, 1968

FLINT, W. R., *Drawings*, Collins, London, 1950

FLINT, W. R., *Minxes Admonished; or Beauty Reproved*, Golden Cockerel Press, London, 1955

FLINT, W. R., *Models of Propriety*, Michael Joseph, London, 1951

SANDILANDS, G. S., *Famous Watercolour Painters: W. Russell Flint*, Studio, 1928

LEWIS, RALPH, *Sir William Russell Flint 1880–1969* Skilton, 1980

BALDRY, A. L., 'A Romanticist Painter: W. Russell Flint', *Studio*, vol. 60, 1914, pp. 252–63

ROYAL ACADEMY, LONDON, *Works by Sir William Russell Flint*, Catalogue, 1962

Alexander Fraser

PINNINGTON, EDWARD, 'Alexander Fraser RSA', *Art Journal*, 1904, pp. 375–9

James Giles

GILES, JAMES, *Castles of Aberdeenshire*, Spalding Club, Aberdeen, 1936

ABERDEEN ART GALLERY, *James Giles RSA*, exhibition catalogue by Fenton Wyness

HERDMAN, MARY B., 'A Painter Rediscovered', *Scotland's Magazine*, new series LXLIII, 3, 1970, pp. 255–64

SPARROW, JOHN, 'A Scottish Artist in Italy', *Country Life*, October 1970, pp. 824–5

Sir William Gillies

DICKSON, T. ELDER, *W. G. Gillies*, Modern Scottish Painters, Edinburgh, 1974

SMART, ALISTAIR, 'The Art of W. G. Gillies',
Scottish Art Review, 1955, vol. 5

SCOTTISH ARTS COUNCIL, *William Gillies and the
Scottish Landscape*, exhibition catalogue, 1980

Norah Nielson Gray

Memorial Exhibition Catalogue 1932, Forward by
A. Bowman

A. S. Hartrick

HARTRICK, A. S., *A Painter's Pilgrimage through 50
Years*, C.U.P., 1939

PALMER, ARNOLD, 'A. S. Hartrick', *Old Water
Colour Society Annual*, vol. XXX

Sir George Harvey

'George Harvey', *Art Journal*, 1850, p. 341, *Art
Journal*, 1858, pp. 73–5

James Whitelaw Hamilton

WALKER, A. STODDART, 'The Paintings of James
Whitelaw Hamilton', *Studio*, vol. 60, 1914,
pp. 9–19

Joseph Henderson

BATE, PERCY, *The Art of Joseph Henderson*,
Glasgow, 1908

George Henry

SCOTTISH ARTS COUNCIL, *Mr Henry and Mr Hornel
visit Japan*, catalogue by W. Buchanan, A.
Tanner and L. Arden, 1978

BATE, PERCY, 'The Work of George Henry',
Studio, vol. 31, 1904, pp. 3–12

BUCHANAN, GEORGE, 'Galloway Landscape',
Scottish Art Review, new series, VIII, 4, 1960,
pp. 13–17

D. O. Hill

HILL, D. O., *Sketches of Scenery in Perthshire*,
Perth, 1821

Colin Hunter

ARMSTRONG, WALTER, 'Colin Hunter', *Art Journal*,
1885, pp. 117–20
'Mr Colin Hunter ARA', *The Scots Pictorial*,
1898, pp. 295–6

J. Young Hunter

BALDRY, A. L., 'The Work of Mr and Mrs J. Young
Hunter', *Studio*, vol. 28, 1903, pp. 271–9

Leslie Hunter

HONEYMAN, T. J., *Introducing Leslie Hunter*, Faber
and Faber, 1937

Gemmell Hutchison

SETOUN, GABRIEL, 'Gemmell Hutchison', *Art
Journal*, 1900, pp. 321–6

Dorothy Johnstone

WALKER, JESSICA, 'Cecile Walton and Dorothy
Johnstone', *Studio*, vol. 88, 1924, pp. 80–7

ABERDEEN ART GALLERY and THE FINE ART SOCIETY,
Dorothy Johnstone ARSA 1892–1980, Memorial
Exhibition Catalogue, 1983

George Whitton Johnstone

GILBERT, W. M., 'G. W. Johnstone RSA', *Art Journal*,
1899, pp. 146–9

Jessie King

SCOTTISH ARTS COUNCIL, *Jessie M. King*, exhibition
catalogue by Cordelia Oliver. Includes extensive
bibliography and list of illustrated books.

WATSON W. R., 'Miss Jessie M. King and her
Work', *Studio*, vol. 25, 1902, pp. 176–88

Sir John Lavery

ULSTER MUSEUM AND FINE ART SOCIETY, *Sir John
Lavery RA 1856–1941*, exhibition catalogue by
Kenneth McConky, 1984

LAVERY, SIR JOHN, *The Life of a Painter*, Cassell
and Co., 1940

SPARROW, WALTER S., *John Lavery and his Work*,
Kegan Paul, Trench and Trubner, 1911

LITTLE J. S., 'Cosmopolitan Painter: John Lavery',
Studio, vol. 27, 1903, pp. 3–13, 110–20

CARTER A. C. R., 'John Lavery RSA', *Art Journal*,
1904, pp. 6–11

William Leighton Leitch

MACGREGOR, ANDREW, *William Leighton Leitch. A
Memoir*, Blackie and Son, 1884

Robert Little

BALDRY, A. L., 'Robert Little – A Review of his
Work', *Studio*, vol. 41, 1907, pp. 173–81

John Lorimer

STEVENSON, R. A. M., 'J. H. Lorimer', *Art Journal*,
1895, pp. 321–4

Hamilton Macallum

DAFFORNE, JAMES, 'The Works of Hamilton
Macallum', *Art Journal*, 1900, pp. 149–51

Ann Macbeth

NEWBERY, F. H., 'An Appreciation of the Work of
Ann Macbeth', *Studio*, vol. 27, 1903, pp. 40–9

James McBey

ABERDEEN ART GALLERY, *James McBey Centenary
Exhibition*, catalogue, 1984
PARKER, NICHOLAS (ed.), *The Early Years of James
McBey: An Autobiography 1883–1911*, O.U.P.,
1977
SALAMAN, MALCOLM, 'The Watercolour Drawings
of James McBey', *Studio*, vol. 61, 1914, pp. 97–107

Horatio McCulloch

FRASER, ALEXANDER, *Scottish Landscape. The Works
of Horatio McCulloch*, Edinburgh, 1872
GLEN, WILLIAM, 'Horatio McCulloch RSA', *Art
Journal*, 1867, pp. 187–8

Tom McEwan

'Tom McEwan RSA', *Art Journal*, 1896, pp. 15–19

W. Y. MacGregor

TAYLOR, E. A., 'W. Y. MacGregor', *Studio*, vol. 89,
1925, pp. 90–2

J. Hamilton Mackenzie

TAYLOR, E. A., 'J. Hamilton Mackenzie – Painter
and Etcher', *Studio*, vol. 78, 1920, pp. 148–55

Charles Rennie Mackintosh

HOWART, THOMAS, *Charles Rennie Mackintosh and
the Modern Movement*, London, 1952
MACLEOD, ROBERT, *Charles Rennie Mackintosh*,
London, 1968
SCOTTISH ARTS COUNCIL, *Charles Rennie
Mackintosh*, exhibition catalogue by A.
McLaren Young, 1968
BILLCLIFFE, ROGER, *Mackintosh Watercolours*,
Glasgow Art Gallery and Fine Art Society, 1978
BILLCLIFFE, ROGER, *Architectural Sketches and
Flower Drawings, by Charles Rennie Mackintosh*,
London, 1977
HUNTERIAN MUSEUM, UNIVERSITY OF GLASGOW,
Flower Drawings by Charles Rennie Mackintosh,
catalogue by Roger Billcliffe, 1977
SCOTTISH ART REVIEW, 'Charles Rennie
Mackintosh', *Special Number*, XI, 4, 1968

J. H. MacNair

BILLCLIFFE, ROGER, 'J. H. MacNair in Glasgow and
Liverpool', Walker Art Gallery, Annual Report
and Bulletin 1970–1, pp. 48–74

William McTaggart

CAW, SIR JAMES, *William McTaggart. A Biography and
an Appreciation*, Maclehose, Glasgow, 1917
CAW, SIR JAMES, 'A Scottish Impressionist', *Art
Journal*, 1894, pp. 243–6
EDDINGTON, ALEXANDER, 'William McTaggart
RSA. Painter of Sea and Land', *Studio*, vol. 67,
1909, pp. 83–93
NATIONAL GALLERY OF SCOTLAND AND THE TATE
GALLERY, *Centenary Exhibition of Paintings by
William McTaggart*, 1935

Sir William MacTaggart

WOOD, HARVEY, *William MacTaggart*, Modern
Scottish Painters, Edinburgh, 1974

John MacWhirter

MACWHIRTER, JOHN, *Landscape Painting in Water-
colour*, Cassell, London, 1906
MACWHIRTER, JOHN, *Hints to Students on Landscape
Painting in Water Colour*, London, 1900
MACWHIRTER, JOHN, *Sketches from Nature*, with an
Introduction by Mrs MacWhirter, Cassell,
London, 1913
MACWHIRTER, JOHN, *The MacWhirter Sketchbook*,
Cassell, London, 1906
SINCLAIR, WILLIAM M., 'John MacWhirter RA',
Art Journal, Art Annual 1903
DAFFORNE, JAMES, 'The Work of John MacWhirter',
Art Journal, 1879, pp. 9–11

George Manson

GRAY, JOHN MILLER, *George Manson and his Work*,
privately printed, Edinburgh, 1880

John Maxwell

MCCLURE, DAVID, *John Maxwell*, Modern Scottish
Painters, Edinburgh, 1976

Arthur Melville

MACKAY, AGNES ETHEL, *Arthur Melville, Scottish
Impressionist, 1855–1904*, F. Lewis Ltd., Leigh-
on-Sea, 1951
FEDDEN, ROMILLY, 'Arthur Melville', *Old Water
Colour Society*, 1, 1923
WOOD, T. MARTIN, 'The Art of the Late Arthur
Melville', *Studio*, vol. 37, 1906, pp. 285–93

A. E. Haswell Miller

TAYLOR, E. A., 'Mr and Mrs A. E. Haswell Miller', *Studio*, vol. 87, 1924, pp. 266–70

John Mitchell

SHEWAN, JAMES M., 'John Mitchell: Queen Victoria's Favourite Artist', *Deeside Field Club*, Autumn, 1980

David Muirhead

GIBSON, FRANK W., 'David Muirhead. Landscape and Figure Painter', *Studio*, vol. 57, 1913, pp. 97–107

Jacob More

IRWIN, DAVID, 'Jacob More, Neoclassical Landscape Painter', *Burlington Magazine*, CXIV, 1972, pp. 774–9
HOLLOWAY, JAMES, 'Projects to illustrate Allan Ramsay's Treatise on Horace's Villa', *Master Drawings*, 1976

Nasmyth Family

JOHNSON, PETER AND MONEY, ERNLE, *The Nasmyth Family of Painters*, F. Lewis, Leigh-on-Sea, 1977
NASMYTH, JAMES, *An Autiobiography*, ed. Samuel Smiles, London and Edinburgh 1883
SKINNER, BASIL, 'Nasmyth Revalued', *Scottish Art Review*, new series, X, 3, 1966, pp. 10–13, 28

Erskine Nicol

DAFFORNE, JAMES, 'Erskine Nicol RSA ARA', *Art Journal*, 1870, pp. 65–7

Monro Orr

SHARP, WILLIAM, 'Monro S. Orr', *Art Journal*, 1900, pp. 310–12

Emily Paterson

'Waterways in Colour', *Art Journal*, 1907, pp. 273–8

James and Alexander Nisbet Paterson

BELGRAVE GALLERY, LONDON, *The Paterson Family. One Hundred Years of Scottish Painting 1877–1977*
CAW, SIR JAMES, 'James Paterson PRSW RSA RWS', *Old Water Colour Society*, vol. X
PATERSON, JAMES, 'The Art Student in Paris', *Scottish Art Review*, vol. 1, 1888–9

Sir Noel Paton

STORY, ALFRED, 'Sir Noel Paton: His Life and Work', *Art Journal*, 1895, pp. 97–128
SCOTTISH ARTS COUNCIL, *Paton*, exhibition catalogue by A. Auld, Edinburgh, 1967
NOEL-PATON, MARGARET H., *Tales of a Grand-Daughter*, privately printed, Elgin, 1970

S. J. Peploe

CURSITER, STANLEY, *Peploe: An Intimate Memoir of an Artist and his Work*, Nelson, London, 1947
FERGUSSON, J. D., 'Memoirs of Peploe', *Scottish Art Review*, new series, VIII, 3, 1962, pp. 9–12, 31–2
GUI, ST BERNARD, 'The Work of S. J. Peploe', *Studio*, vol. 101, 1931, pp. 101–8

John Phillip

ABERDEEN ART GALLERY, *John Phillip*, exhibition catalogue by C. Carter, 1967
'John Phillip', *Art Journal*, 1867, pp. 127, 153–7

Sir George Pirie

PINNINGTON, EDWARD, 'Mr George Pirie', *Art Journal*, 1907, pp. 364–6

John Quinton Pringle

SCOTTISH ARTS COUNCIL, *John Quinton Pringle*, exhibition catalogue by D. Brown, J. Meldrum and H. Stevenson, 1981, Edinburgh
JOHNSTON, ELIZABETH, 'John Quinton Pringle 1864–1925', *Scottish Art Review*, new series, IX, 2, 1963, pp. 1–4, 28.
BROGAN, DENIS, 'John Quinton Pringle', *Scottish Art Review*, new series, IX, 3, 1964
BUCHANAN, GEORGE, 'Some Influences on McTaggart and Pringle', *Scottish Art Review*, new series, XV, 2, 1979, p. 30
GLASGOW ART GALLERY, *John Q. Pringle 1864–1925: A Centenary Exhibition*, catalogue by J. Meldrum and A. Auld, 1964

James Pryde

HUDSON, DEREK, *James Pryde*, London, 1949
HIATT, CHARLES, 'Some Drawings by James Pryde', *Studio*, vol. 23, 1901, pp. 101–6

Anne Redpath

BRUCE, GEORGE, *Anne Redpath*, Modern Scottish Painters, Edinburgh, 1974
SCOTTISH ARTS COUNCIL, *Anne Redpath Memorial Exhibition*, catalogue, Edinburgh, 1965

Sir George Reid

GRAY, J. M., 'George Reid', *Art Journal*, 1882,
p. 361

BROWN, G. BALDWIN, 'Sir George Reid PRSA',
Magazine of Art, 1892, pp. 196–203

David Roberts

ROBERTS, DAVID, *Egypt and Nubia from drawings
made on the spot*, 3 vols, London, 1846–9

ROBERTS, DAVID, *The Holy Land, Syria, Idumea,
Arabia, with historical descriptions by George
Croly*, 3 vols, 1842–9

BALLANTINE, JAMES, *The Life of David Roberts,
compiled from his Journals and other sources*,
Edinburgh, 1866

GUITERMAN, HELEN, *David Roberts RA*, privately
printed, London, 1978

HARDIE, MARTIN, 'David Roberts', *OWS Club*,
1947, pp. 10–20

SCOTTISH ARTS COUNCIL, *David Roberts: Artist
Adventurer*, exhibition catalogue, 1981

GUILDHALL ART GALLERY, *David Roberts and
Clarkson Stanfield*, exhibition catalogue by J. L.
Howgego, London, 1967

HELEN GUITERMAN, 'David Roberts', *OWS Club*,
part I, 1984

Eric Robertson

CITY OF EDINBURGH ART CENTRE, *Eric Robertson*,
exhibition catalogue by John Kemplay, 1974

Alexander Runciman

BROWN, JOHN, 'Obituary of Alexander Runciman',
Caledonian Mercury, 26 October 1785

ANON, 'Biographical Sketch of Alexander
Runciman', *Scots Magazine*, August 1802

BOOTH, SUSAN, 'The Early Career of Alexander
Runciman and his Relations with Sir James
Clerk of Penicuik', *Journal of the Warburg
and Courtauld Institutes* XXXII, 1969,
pp. 332–43

MACMILLAN, DUNCAN, 'Alexander Runciman in
Rome', *Burlington Magazine* CXII, January
1970, pp. 23–3

John C. Schetky

SCHETKY, MISS, *Sketches from . . . Career of John C.
Schetky*, Edinburgh and London, 1877

David Scott

SCOTT, WILLIAM BELL, *Memoirs of David Scott
RSA*, Edinburgh, 1850

GRAY, J. M., *David Scott RSA and his Works*, W.
Blackwood and Sons, Edinburgh, 1884

NATIONAL GALLERY OF SCOTLAND, *William Blake
and David Scott*, exhibition catalogue,
Edinburgh, 1914

Tom Scott

PINNINGTON, EDWARD, 'Tom Scott RSA', *Art
Journal*, 1907, pp. 17–21

William Bell Scott

SCOTT, WILLIAM BELL (ed. W. Minto),
*Autobiographical Notes of the Life of William
Bell Scott*, 2 vols, London, 1892

FREEDMAN, WILLIAM F., *The Letters of Pictor
Ignotus: William Bell Scott's Correspondence with
Alice Boyd 1859–1884*, John Rylands University
Library of Manchester, 1976

CLAYTON-STAMM M. D. E., 'William Bell Scott:
Observer of the Industrial Revolution', *Apollo*
1969, pp. 386–90

*Illustrations to the King's Quair of King James
VI of Scotland painted on the staircase of Penkill
Castle, Ayrshire by William Bell Scott*,
Edinburgh, 1887

William 'Crimean' Simpson

EYRE-TODD, G. (ed.), *Autobiography of William
Simpson*, Fisher Unwin, London, 1903

SIMPSON, WILLIAM, *Seat of War in the East*, 2 vols,
London, 1855–6

India Ancient and Modern, London, 1867

Meeting in the Sun, London, 1874

COLNAGHI'S, LONDON, *Mycenae, Troy and Ephesus:
A Collection of Watercolours, drawings and
sketches exhibited at P. and D. Colnaghi and Co.
1878*

*Exhibition of Mr William Simpson's Water-
Colour drawings of India, Tibet and Cashmere*,
London, 1862

Simpson also illustrated a number of books and
souvenirs devoted to the Crimean War, the
Franco-Prussian War, Abyssinia and India.

James Skene of Rubislaw

SKENE, JAMES, *A Series of Sketches of the existing
localities alluded to in the Waverley Novels*,
Edinburgh, 1829

R. Macaulay Stevenson

BATE, PERCY, 'The Works of R. Macaulay
Stevenson', *Studio*, vol. 22, 1901, pp. 232–42

Patrick Syme

SYME, PATRICK, *Practical Directory for Learning Flower Drawing*, Edinburgh, 1810
A Treatise of British Song-Birds, 2 vols, Edinburgh, 1823

E. A. Taylor

TAYLOR, J., 'A Glasgow Artist and Designer. The Work of E. A. Taylor', *Studio*, vol. 33, 1905, pp. 217–26

Grosvenor Thomas

BALDRY, A. L., 'The Work of Grosvenor Thomas', *Art Journal*, 1904, pp. 351–4
WEST, W. K., 'The Landscape Paintings of Mr Grosvenor Thomas', *Studio*, vol. 41, 1907, pp. 257–62

Archibald Thorburn

SOUTHERN, JOHN, *Archibald Thorburn Landscapes: The Major Natural History Paintings*, Hamilton, 1981
FISHER, J. (ed.), *Thornburn's Birds*, Mermaid, 1982
Thornburn's Naturalist Sketchbook, Introduced by Robert Dougall, Joseph, 1977

Cecile Walton

WALKER, JESSICA, 'Cecile Walton and Dorothy Johnstone', *Studio*, vol. 88, 1924, pp. 80–7

E. A. Walton

CAW, SIR JAMES, 'A Scottish Painter: E. A. Walton', *Studio*, vol. 26, 1902, pp. 161–70
WALKER, A. S., 'The Recent Paintings of E. A. Walton RSA', *Studio*, vol. 58, 1913, pp. 260–70
TAYLOR, E. A., 'E. A. Walton PRSW RSA, Memorial Exhibition', *Studio*, vol. 87, 1924, pp. 10–16
BOURNE FINE ART, *E. A. Walton*, exhibition catalogue with introduction by Helen Weller, Edinburgh, 1981

William Wells

TAYLOR, J., 'A Glasgow Painter: William Wells RBA', *Studio*, vol. 50, 1910, pp. 266–75

Sir David Wilkie

BROWN, DAVID BLAYNEY, *Sir David Wilkie. Drawings and Sketches in the Ashmolean Museum*, Morton Morris and Co., and the Ashmolean Museum, 1985
CUNNINGHAM, ALLAN, *The Life of Sir David Wilkie*, 3 vols, London, John Murray, 1843
The Wilkie Gallery, A Selection of the best pictures of the late Sir David Wilkie RA including his Spanish and Oriental sketches with notices biographical and critical, Virtue, n.d.
ERRINGTON, LINDSAY, *A Tribute to Wilkie*, National Gallery of Scotland, 1985
GOWER, LORD RONALD, *Sir David Wilkie*, 1902
CAMPBELL, J. PATRICIA, 'Drawings related to Wilkie's Painting of Columbus at the Convent of La Rabida', *North Carolina Museum of Art Bulletin*, VIII, 3, 1969, pp. 1–26
DODGSON, CAMPBELL, *The Etchings of Sir David Wilkie and Andrew Geddes*, A catalogue, London, 1936
ANDREWS, KEITH, 'A Sheet of Early Wilkie Sketches', *Scottish Art Review*, new series, X, 3, 1966, pp. 5–9, 28
IRWIN, FRANCINA, 'Wilkie at the Cross-Roads', *Burlington Magazine*, CXVI 1974, pp. 214–16
MILES, HAMISH, 'Adnotatiunculae Leicestrienses: Wilkie and Washington Irving in Spain', *Scottish Art Review*, New Series, XII, 1, 1971, pp. 1–6, 29
ROYAL ACADEMY OF ARTS, LONDON, *Paintings and Drawings by Sir David Wilkie*, catalogue by John Woodward, 1968

Hugh William 'Grecian' Williams

WILLIAMS, H. W., *Travels in Italy, Greece and the Ionian Islands*, 2 vols, Edinburgh, 1820
WILLIAMS, H. W., *Select Views in Greece*, 2 vols, London, 1829
Catalogue of Views in Greece, Italy, Sicily and the Ionian Islands painted in Watercolours, Edinburgh, 1822
Catalogue of Sketches, Drawings, Prints and Pictures being a portion of the Works of the late Hugh William Williams, Edinburgh, 1829

J. Lawton Wingate

CAW, SIR JAMES, 'J. Lawton Wingate', *Art Journal*, 1896, pp. 73–6

John Crawford Wintour

GRAY, J. M., 'The Art of John Crawford Wintour', *Scottish Art Review*, old series, I, 1888, pp. 28–9

Index

Aberdeen, Lord 74
Academies: Establishment of 32; Foulis 32; Nasmyth Drawing School 32, 35–7; David Allan's School 32; RSA, formation 33; RSW 290–3; St Luke 32; Trustees Academy 29, 32
Adam, Joseph Denovan 245
Adam, Joseph Denovan Junior 245
Adam, James 245
Adam, Margaret 245
Adam, Patrick William 245
Adam, Robert 15–19, 33
Adam, Susannah 18
Adamson, Robert 85
Aiken, John Macdonald 245
Aikman, George 245
Aitken, James Alfred 245
Aitken, John Ernest 245
Aitken, Janet Macdonald 246
Albert, Prince 92, 95
Alexander, Annie Dunlop 246
Alexander, Daniel 49
Alexander, Edwin 130, 131, 141, 146, 147–9, 169, 171, 183, 222, 246
Alexander, James Stuart Carnegie 246
Alexander, Lena 246
Alexander, Robert 146, 148, 150, 246
Algie, Jessie 246
Alison, David 148, 211, 222
Allan, Andrew 246
Allan, Archibald Russell Watson 246
Allan, David 27–32, 40, 52, 59, 60, 62
Allan, Patrick 229
Allan, Robert Weir 130, 131, 132, 133–6, 145, 148, 153, 202, 243, 246
Allan, Sir William 52, 62–3, 86, 89, 97, 125, 246
Allingham, Helen 241
Allom, Thomas 246
Alston, Thomas 246
Alston I. W. 246
Ancrum, Marion 246
Anderson, David R. 246
Anderson, Martin 'Cynicus' 246
Anderson, Robert 246–7
Anderson, William 49–50
Archer, James 66, 247
Armour, George Denholm 146, 149–50

Armour, Mary 247
Armour, William 247
Auld, Peter C. 247

Bain, George 247
Baird, General Sir David 56, 58
Baker, Edmund 247
Baker, Eve 247
Baker, Leonard 247
Bakst, Léon 191
Balfour-Browne, Vincent 247
Ballantyne, John 104
Ballantyne, R. M. 247
Ballet Russe 191, 208
Ballingall, Alexander 247
Banks, Violet 248
Bannatyne, John James 108, 248
Barbizon School 110, 127, 162, 165, 243
Barclay, John Rankine 193, 222
Bastien-Lepage, Jules 132, 135, 142, 159, 172, 243
Bayne, James 248
Bear, George Telfer 248
Beardsley, Aubrey 179
Beaton, Penelope 211, 219, 248
Beattie-Scott, J. 248
Beggarstaff Brothers 158
Belhaven, Lady 114
Bell, Jonathan Anderson 248
Bell, John D. 248
Bell, Robert Anning 227
Bentley, Charles 243
Berstecher, Harry 248
Beveridge, Erskine 248
Billings, Robert William 248
Binny, Graham 248
Birch, S. J. Lamorna 225
Bird, Mary Holden 248
Black, Andrew 161, 248
Black, Ann Spence 248–9
Black, E. Rose 249
Blacklock, Thomas Bromley 249
Blake, William 100
Blair, John 249
Blatherwick, Charles 249
Blatherwick, Lily (Mrs A. S. Hartrick) 249

Blyth, Robert Henderson 231, 249
Bone, Sir Muirhead 238–9, 249
Bonnar, William 62
Bonington, Richard Parkes 95
Borrowman, Charles Gordon 249
Borthwick, Alfred Edward 249
Boswell, Elizabeth 51
Bough, Sam 63, 88, 108, 110, 112–116, 119, 125, 163, 165, 213, 242, 243, 244, 249
Bowie, W. 249
Boyd, Alexander Stuart 249–50
Boyd, Alice 98–9
Boyle, James 250
Brangwyn, Sir Frank 133, 238
Braque, Georges 208
Briggs, Ernest Edward 250
Brotchie, Theodore Charles Ferdinand 250
Brough, Robert 250
Brown, Alexander Kellock 125, 139, 250
Brown, Henry James Stuart 250
Brown, Helen Paxton 250
Brown, James Michael 250
Brown, John of Rome 24, 25–7, 74
Brown, May Marshall 250
Brown, Thomas Austen 250
Brown, Thomas Wyman 250
Brown, William Beattie 251
Brown, William Beattie Junior 251
Brown, William Fulton 155, 156, 251
Brown, William Marshall 251
Brownlie, Robert Alexander 251
Bruce, Harriet 108, 251
Brunton, Elizabeth York 251
Bryce, David 251
Brydall, Robert 251
Buchan, Lord 27
Buchanan, Allan 251
Buchanan, E. Oughtred 251
Buchanan, James 251
Buchanan, Peter 251
Bunting, Thomas 251
Burgess, James G. 251
Burn-Murdoch, William 251
Burne-Jones, Sir Edward 193, 194, 195
Burnet, James M. 251
Burnet, John 61–2, 79, 97

Burnett, David Duguid 252
Burnett, Miss J. S. 252
Burns, Robert 30, 35, 252
Burns, Robert (artist) 148, 188, 190–1, 192, 252
Burr, Alexander Hohenlohe 69, 252
Burr, John 69, 252
Burton, Nancy 252
Burton, William Paton 252
Butterfield, William 95

Cadell, Florence St John 252
Cadell, Francis Campbell Boileau 204, 205–6, 208, 252
Cadenhead, James 169, 170, 252
Cadzow, James 252
Cairns, John 108, 252
Calvert, Edwin Sherwood 252
Cameron, Sir David Young 151–2, 183, 240, 252
Cameron, Hugh 71, 118, 124, 167, 241, 243, 252
Cameron, Katherine 183, 185, 186, 252
Cameron, Mary 252–3
Campbell, Alexander 253
Campbell, James 253
Campbell, Tom 253
Campbell, Tom 253
Carlaw, John 253
Carlaw, William 253
Carmichael, Stewart 197
Carolus-Duran, Emile Auguste 130, 169
Carrick, Robert 253
Carrick, Robert 82, 253
Carrick, William Arthur Laurie 253
Carse, Alexander 59–60, 61
Carslaw, Evelyn 253
Cassie, James 87–8, 253
Cathcart, Lord 27
Caw, Sir James 253
Celtic Revival 188
Chagall, Marc 213
Chalmers, George Paul 118, 124, 253
Chalmers, Hector 253
Chavannes, Puvis de 152, 188
Chisholm, Alexander 62
Christie, J. E. 150
Clark, John Heaviside 50
Clark, William 88, 244
Clark, William Hanna 218, 226–7
Claude Lorrain 22, 25, 32, 34, 35, 110
Clerk, Sir George 253–4
Clerk, Sir John of Penicuik 15, 16, 18–20, 22, 33
Cochran, Robert 254
Cockburn, Lord 20, 42
Cockburn, Laelia Armine 254
Constable, John 110
Constant, Benjamin 130
Cook, James B. 254
Cooper, Richard 24
Cooper, Richard Junior 24
Cordiner, Charles 32
Corot C-J-B 132, 137

Cotman, J. S. 40
Courtois, Gustave
Coventry, Gertrude Mary 254
Coventry, Robert McGown 153, 243, 254
Cowan-Douglas, Lilian Horsburgh, 254
Cowie, James 229–231, 244, 254
Cowieson, Agnes 254
Cowper, Max 254
Cox, David 37, 40, 110, 114, 116, 163, 165, 241
Cozens, Alexander 18
Craig, John 254
Craig-Wallace, Robert 254
Crane, Walter 188
Cranston, James Hall 254
Crawford, Alexander Hunter 190
Crawford, Edmund Thornton 88, 254
Crawford, Robert Cree 254
Crawford, Thomas Hamilton 254
Crawford, William 254
Crawford, William Caldwell 255
Crawhall, Joseph 130, 131, 139, 141, 143–7, 148, 149, 150, 151, 169, 171, 183, 222, 242, 255
Crawshaw, Frances 255
Crawshaw, Lionel Townshend 255
Crozier, William 211, 215, 218–19, 255
Cubism, 208, 210, 211, 218
Cumming, Belle Skeoch 255
Cumming, William Skeoch 255
Cursiter, Stanley 210, 255
Cuthbertson, Kenneth J. 255

Dadd, Richard 97, 100
Dagnan-Bouveret, Pascal Adolphe 130, 162
Dalglish, William 255
Dallas, Alastair 255
Dalyell, Amy 255
Davidson, Alexander 255
Davidson, George Dutch 197–9
Davidson, Mary C. 255
Dawson, Mabel 255
Deas, William 255
Dekkert, Eugene 255
Delacour, William 24–5
Delville, Jean 183
Dennistoun, William 255
Derain, André 131
Dewar, De Courcy Lewthwaite 256
Dick, Jessie Alexandra 256
Dickson, Thomas Elder 256
Dixon, Anna 256
Dobson, Cowan 256
Dobson, Henry John 256
Dobson, Henry Raeburn 256
Docharty, Alexander Brownlie 256
Docharty, James 70, 125
Docharty James L. C. 256
Dodds, Albert Charles 256
Donald, John Milne 113, 125, 256
Donald, Tom 256
Donaldson, Andrew 34, 48–9, 82, 88

Donaldson, John 256
Douglas, James 168, 257
Douglas, Sir William Fettes 66, 116, 127, 257
Douglas, William 257
Dow, Thomas Millie 151, 152, 172, 257
Dowell, Charles R. 229, 257
Downie, John Patrick 257
Downie, Patrick 160, 257
Doyle, Sir Arthur Conan 257
Doyle, Charles Altamont 257
Doyle, John 257
Doyle, Richard 257
Drummond, James 72, 89–90, 257
Dudgeon, T. 257
Dufy, Raoul 206
Duguid, Henry 90
Dunbar, W. Nugent 257
Duncan, John 188–90, 193, 195, 197, 198, 202, 257
Duncan, John 257
Duncan, Thomas 257
Dutch Schools 37, 127, 130, 136, 153, 165, 167, 169, 243
Dyce, J. Stirling 257
Dyce, William 84, 94–7, 106, 151, 257

Eadie, Robert 226, 228, 257
Eardley, Joan 231
East, Sir Alfred 143
Easton, Meg 257–8
Ebsworth, Joseph Woodfall 90, 92, 258
Ecclesiological Movement 95
Edinburgh College of Art 202–3, 211, 219
Ednie, John 188
Egg, Augustus 97
Erskine, David 25, 27
Evans, Marjorie 258
Ewbank, John Wilson 88
Expressionism 210, 211, 231

Faed, James (Senior) 66, 167, 241, 243, 258
Faed, James (Junior) 258
Faed, John 66, 167, 241, 243, 258
Faed, Thomas 66–9, 167, 241, 243, 258
Fairbairn, Thomas 88–9, 114, 258
Faroe Islands 48
Farquharson, David 258
Farquharson, John 258
Farrell, Frederick Arthur 258
Fauvism 131, 206, 208
Fergusson, John D. 208–10
Ferrier, George Straton 258
Ferrier, James 106, 258
Fielding, Copley 75
Finnie, John 107
Flaxman, John 27, 52
Fleming, John 258
Fleming, J. S. 258
Flint, Francis Wrightson 235
Flint, Robert Purvis 235, 238, 258
Flint, Sir William Russell 234–8, 258

Foggie, David 197, 198–9, 201, 258
Forster, J. 258
Forsyth, Gordon Mitchell 258–9
Foster, Myles Birket 241
Fowler, Robert 259
Fraser, Alexander I 62, 79, 259
Fraser, Alexander II 88, 111, 112, 113, 114, 116–17, 259
Fraser, John Simpson 259
French, Annie 181, 182
Fresnaye, Roger de la 218
Frier, Jessie 108, 259
Frier, Robert 108, 259
Friesz, Othon 208
Frith, William Powell 97
Fulton, David 155, 259
Fulton, James Black 259
Fulton, Samuel 145, 259
Fuseli, Henry 24, 25, 52
Futurism 210

Galloway, Everett 259
Gamgee, Clara 108
Gamgee, John 108
Gamley, Andrew Archer 259
Gauld, David 150, 160, 172, 173, 259
Geddes, Andrew 79
Geddes, Ewan 259
Geddes, Patrick 188–9, 190, 192
Geikie, Walter 60–1, 259
Geissler, William 211, 218, 221–2
George IV 54, 72
Gibb, Robert 259
Gibb, Robert 50–1
Gibb, William 259
Gibson, James Brown 260
Gibson, Patrick 47–8
Gibson, William Alfred 260
Giles, James 72, 73–5, 78, 87, 92, 260
Gilfillan, John A. 260
Gillespie, Alexander Bryson 260
Gillespie, Floris May 260
Gillespie, Janetta S. 260
Gillies, Margaret 260
Gillies, Sir William George 185, 211–13, 215, 216, 217, 218, 219, 220, 221, 244, 260
Gilmour, James 260
Gilpin, William 18
Girtin, Thomas 165
Glasgow School of Art 175, 179, 202–3
Glass, John Hamilton 260
Glover, William 260
Gogh, Vincent Van 143
Goodfellow, David 260
Gordon, James 260
Gowans, George Russell 260–1
Graham, John 32, 52, 53, 61
Graham, Tom 118
Gray, George 261
Gray, James 261
Gray, John 234, 261
Gray, Norah Nielson 183, 184, 261
Gray, Rosalie 261

Greenlees, Georgina Mossman 261
Greenlees, Robert 70, 153, 165, 261
Greiffenhagen, M. 227
Greig, G. M. 261
Grieve, Alec 261
Grubb, William Mortimer 261
Gudgeon, Ralston 223, 261
Gunn, Herbert 211
Guthrie, Sir James 130, 131, 138, 139, 141, 145, 150, 159

Hackstoun, William 261
Haghe, Louis 79, 82
Hall, George Wright 211, 222, 261
Hall, S. C. 100
Halswelle, Keeley 109, 261
Hamilton, Duke of 46, 55
Hamilton, Gavin 29
Hamilton, James Whitelaw 139, 145, 150, 261
Hamilton, Thomas Crawford 261
Hamilton, Thomas 261
Hamilton, Sir William 27, 28
Hansen, Hans 155, 262
Hardie, Charles Martin 262
Hardie, Martin 262
Hardy, Thomas Bush 243
Hargitt, Edward 109, 262
Hartrick, Archibald Standish 262
Harvey, Sir George 63, 72, 85–6, 93, 262
Harvey, Nellie Ellen 262
Hay, George 262
Hay, James 262
Hay, Peter Alexander 262
Hay, Robert 262
Hay, Thomas Marjoribanks 168, 262
Hay, William Hardie 262
Haydon, Benjamin Robert 53
Henderson, John 263
Henderson, Joseph 123, 124, 131, 263
Henderson, Joseph Morris 263
Henderson, Keith 263
Henry, Barclay 263
Henry, George 130, 131, 139, 141–3, 145, 167, 173, 263
Herald, James Watterston 130, 155–8, 172, 177, 211, 213
Herdman, Robert 65, 66, 68, 69, 97, 104–6, 108, 122, 241, 243, 263
Herdman, Robert Duddingston 263
Heriot, George 263
Herkomer, Hubert von 155
Heron, James 263
Hill, David Octavius 46, 81, 84–5, 93, 100, 263
Hislop, Andrew Healey 263
Hole, William Brassey 263
Holloway, Charles 140
Holms, Alexander Campbell 263
Holt, Edmund 263
Home, Bruce James 263
Honeyman, John 175
Hope, Jane 264
Hopetoun House 30

Hornel, Edward Atkinson 131, 143, 150, 159, 173
Hotchkis, Anna M. 220, 264
Hotchkis, Isobel 264
Houston, Charles 264
Houston, George 225, 226, 264
Houston, John Adam 69, 97, 100, 102–4, 105, 108
Houston, John Rennie Mackenzie 71, 264
Houston, Robert 227, 264
Howe, James 264
Huck, James 264
Huish, Marcus 273
Humble, Stephen 264
Hunt, Thomas 264
Hunt, William Holman 96, 97
Hunter, Colin 118, 123, 124, 244, 264
Hunter, George Leslie 159, 206
Hunter, James Brownlie 264
Hunter, John Young 264
Hunter, Mary Young 264
Hunter, Mason 264
Hutchison, Robert Gemmell 71, 166, 167, 241, 264
Hutchison, Isobel Wylie 264
Hutchison W. O. 220
Hutton, James 264
Hutton, Dr James 19

Impressionism 110, 130, 135, 205
Irvine, John 265
Irvine, Robert Scott 222, 265
Irving, Washington 55
Israels, Joseph 70, 130, 169, 243

Jacquesson de la Chevreuse 130
James I (of Scotland) 98
Japanese art 131, 143, 146, 181
Jardine, Jet 265
Johnston, William Myles 265
Johnston, William Borthwick 265
Johnstone, Dorothy 193, 220, 265
Johnstone, George Whitton 220, 265

Kandinsky, Wassili 198
Kay, Alexander 265
Kay, Archibald 265
Kay, James 160, 244, 265
Kay, John 265
Kay, Violet McNeish 265
Keene, Charles 145
Keir, Henry 265
Kemp, George Meikle 265–6
Kemp, Jeka 266
Kennedy, John 266
Kennedy, William 150, 266
Kennedy, William Denholm 266
Keppie, Jessie 185, 266
Keppie, John 185, 187
Kerr, Henry Wright 169, 266
Kerr-Lawson, James 231, 266
King, Jessie M. 179–81, 188, 195, 208, 220
Kinnear, James 266

Kinnear, Leslie Gordon 266
Knight, Dame Laura and Harold 192
Knox, John 54, 111

Laidlaw, Nicol 266
Laing, Annie Rose 266
Laing, Frank 197, 198, 200, 267
Laing, James Garden 161, 267
Lallemand, Jean-Baptiste 16
Lamb, Helen Adelaide 267
Lamb, Mildred 267
Lamond, William B. 267
Lamont, Thomas Reynolds 108, 267
Landseer, Sir Edwin 72
Langlands, George Nasmyth 267
Lauder, Charles James 160, 267
Lauder, Gertrude 267
Lauder, Nancy 267
Lauder, Robert Scott 69, 104, 109, 118, 120, 125
Laurens, Jean Paul 130, 137
Lavery, Sir John 130, 131, 143, 145, 147, 150, 267
Law, Andrew 159
Law, David 267
Lawson, Cecil Gordon 267
Le Conte, John 90
Léger, Fernand 213
Leiper, William 268
Leitch, Richard Principal 268
Leitch, William Leighton 72, 75-8, 92, 111, 268
Lewis, John Frederick 79
Lewis, Wyndham 159, 194
Leyde, Otto Theodore 268
Lhote, André 211, 218, 221
Lindsay, Sir Coutts 76
Lintott, Henry 221
Little, James 268
Little, Robert 161-2, 268
Lizars, W. H. 88, 111
Lochhead, John 268
Lockhart, John Harold Bruce 268
Lockhart, William Ewart 59, 65-6, 125, 268
Lockhart, W. M. 268
Logan, George 188, 268
Long, John O. 268
Lorimer, John Henry 268
Lowe, Isabella Wylie 269
Lumsden, Ernest Stephen 220, 269
Lyon, Thomas Bonar 269

MacAdam, Walter 269
Macallum, Hamilton 124, 269
Macaulay, Kate 269
Macbeth, Ann 181, 183
Macbeth, Robert Walker 243, 269
Macbeth-Raeburn, Henry 269
MacBey, James 231-3
MacBrayne, Madge 269
MacBride, Alexander 269
MacBride, William 269
MacBryde, Robert 231
MacColl, Dugald Sutherland 240, 269

McCulloch, Horatio 63, 72, 75, 109, 110-12, 114, 116, 125, 132, 242, 243, 269
MacCulloch, James 270
MacDonald, Arthur 270
Macdonald, A. G. 113-14
MacDonald, John Blake 270
Macdonald, Frances (Mrs Frances MacNair) 173, 175-9
Macdonald, Margaret (Mrs C. R. Mackintosh) 173, 175-9, 185, 270
McDougall, Lily 270
McDougall, Norman 270
McEwan, Tom 70, 270
MacGeorge, Andrew 270
MacGeorge, Mabel Victoria 270
McGhie, John 270
MacGoun, Hannah Clarke Preston 270
MacGregor, John Douglas 270
MacGregor, Robert, 270
MacGregor, William York 137, 139, 141, 150-1, 270
McIan, Fanny 271
McIan, Robert Ranald 271
McInnes, Robert 271
Macintyre, Edith A. 271
Mackay, Charles 271
McKay, Thomas Hope 271
McKay, William Darling 137
McKechnie, Alexander Balfour 271
MacKellar, Duncan 271
McKenzie, Andrew 271
Mackenzie, Sir George 48
Mackenzie, James Hamilton 225-6, 271
Mackie, Annie 271
Mackie, Charles Hodge 188, 191-2, 193, 220, 271
Mackie, Peter Robert Macleod 271
Mackinnon, Finlay 271
Mackintosh, Charles Rennie 172-5, 176, 177, 178, 179, 185, 203-5, 246
McLauchlan, William 271
McLaurin, Duncan 271-2
McLeay, Kenneth 92, 169, 272
McLeay, Macneil 272
McLellan, Alexander Matheson 272
MacMaster, James 161, 272
MacNair, Herbert 173, 175-7, 179
McNairn, John 272
MacNee, Sir David 75, 111
MacNee, Robert Russell 272
McNeil, Andrew 272
MacNicol, Bessie 272
McNicol, Ian 272
McNicol, John 272
MacNiven, John 161, 272
MacPherson, Alexander 229, 272
Macpherson, Douglas 272
Macpherson, John, 272
McTaggart, William 93, 110, 117-20, 123, 124, 131, 132, 135, 167, 202, 210, 242, 243, 272
MacTaggart, Sir William 211, 217, 218, 219, 272

MacWhirter, Agnes Eliza 109
MacWhirter, John 72, 93, 108-9, 110, 118, 120-3, 131, 243, 272
Mainds, Allan O. 273
Maliphant, H. 273
Malloch, Stirling 273
Mann, Harrington 151
Manson, George 70, 126, 241
Maris Brothers 130, 161, 169, 235, 243
Margret, Albert 146, 206
Marten, Elliot 273
Martin, David 141, 150
Mary, Queen of Scots 30
Masson, A. S. 273
Mathieson, John George 273
Mathieson, James Muir 273
Matisse, Henri 146, 206, 215
Mauve, Anton 169
Mavor, Osborne Henry 273
Maxton, John Kidd 273
Maxwell, Hamilton 273
Maxwell, John 211, 212, 213-15, 218, 219, 220, 273
Maxwell, Sir John Stirling 273
Meldrum, William 273
Melville, Arthur 110, 130, 131-4, 135, 136, 138, 139, 140, 141, 143, 145, 147, 148, 150, 155, 157, 185, 202, 205, 208, 242, 273
Menpes, Mortimer 143
Millais, John Everett 93, 94, 96, 97, 100, 102
Miller, Archibald Elliot Haswell 224-5, 273
Miller, James 227, 229, 274
Miller, James 274
Miller, John 274
Miller, Josephine Haswell 225, 274
Miller, J. R. 274
Miller, Patrick 35
Miller, William 274
Mills, Charles S. 274
Milne, James 274
Milne, John MacLauchlan 274
Milne, Joseph 274
Milton, Lord 25
Mitchell, George 274
Mitchell, John 274
Mitchell, John 274
Mitchell, John Campbell 165, 274
Mitchell, Madge Young 274
Mitchell, Peter McDowall 274
Moira, Gerald 213, 245
Molyneaux, Elizabeth Gowanlock 274
Monet, Claude 110, 135
Moodie, Donald 211, 219, 220, 275
Moore, Eleanor Allen 275
Moore, Henry 123
Moore, Henry 238
More, Jacob 15, 20-2, 23, 25, 32, 35, 41
Morley, Henry 275
Morley, Isabel 275
Morot, Aimé 145
Morton, Annie Wilhelmina 275

Morton, Thomas Corsan 139, 151, 275
Muir, Anne Davidson 275
Muirhead, David 275
Muirhead, George 275
Muirhead, John 275
Muller, William 116, 163
Munch, Edward 198, 211–12
Munro, Hugh 275
Murillo 55, 64
Murray, Alexander J. 275
Murray, Charles 275–6
Murray, Sir David 165–7, 276
Murray, David Scott 276
Murray, George 276
Murray, James T. 276
Murray, William Grant 233–4
Myles, William S. 276

Napier, Charles Goddard 222, 276
Nash, Paul 159, 222, 231, 242
Nasmyth, Alexander 32, 33, 34–8, 39, 45, 50, 75, 78
Nasmyth, Anne 276
Nasmyth, Barbara 276
Nasmyth, Charlotte 276
Nasmyth, James 34, 35, 36, 37, 38, 39
Nasmyth, Jane 276
Nasmyth, Patrick 37, 39–40, 79
Nazarenes, 94
Neil, George 276
Nesbitt, John 276
Newbery, Francis 140, 159, 173, 175–6
Newbery, Jessie (née Jessie Rowat) 175–6, 179, 181, 183
Newbery, Mary (see Mary Newbery Sturrock)
Nichol, G. S. 276
Nicholson, Peter Walker 126, 276
Nicholson, William 51
Nicholson, Sir William 146, 155, 240
Nicol, Erskine 66, 69, 169, 276
Nicol, Erskine E. (Junior) 69, 148, 276
Nisbet, Margaret Dempster 277
Nisbet, Pollock Sinclair 276–7
Nisbet, Robert Buchan 165, 241, 277
Noble, James Campbell 132, 277
Noble, Robert 277
Nolde, Emil 212
Norie, Marie L. 277
Norie family 20, 24, 32, 50
Norwich School 37, 110

Oliphant, John 277
Oppenheimer, Charles 229, 277
Orchardson, Sir William Quiller 243
Orr, Jack 277
Orr, Monro Scott 277
Orr, Stewart 277
Orrock, James 277
Ossian 30
Oxford Union Debating Chamber 98
Ozenfant, Amédée 213

Park, Stuart 150, 160, 277
Parrish, Maxfield 183
Parsons, Sir Alfred 143
Paterson, Alexander Nisbet 154, 277
Paterson, Emily Murray 167, 277
Paterson, Hamish Constable 277
Paterson, James 130, 137–8, 139, 145, 154, 202, 277
Paterson, Mary Viola 278
Paterson, R. Stirling 278
Paton, Donald 278
Paton, Frederick Noel 278
Paton, Sir Joseph Noel 278
Paton, Peter 278
Paton, Waller Hugh 72, 94, 100–2, 105, 106, 122
Patrick, James MacIntosh 234, 235, 243, 278
Paul, Robert 32
Peddie, Christian 278
Peddie, George 278
Peddie, James Dick 278
Peel, Sir Robert 54, 55, 56
Penicuik House (Midlothian) 18, 22
Penkill Castle (Ayrshire) 98–9
Penny, William 278
Peploe, Samuel John 159, 208, 278
Peploe, William Watson 278
Perigal, Arthur 86–7, 278
Perman, Louise Ellen 278
Pettie, John 278
Phillip, Colin Bent 278
Phillip, John 59, 63–5, 66, 242, 278
Phillips, Charles Gustav Louis 279
Picasso, Pablo 208
Pitfarvane House (Fife) 30
Piranesi, Giovanni Battista 23
Pirie, Sir George 150, 279
Playfair, William 19
Pleinairism, 110, 116, 123
Powell, Sir Francis 141, 279
Poussin, Gaspard 45
Pratt, William M. 279
Prentice, D. R. 279
Pre-Raphaelitism and its influence 69, 93–109, 110, 118, 122, 168, 242
Pringle, John Quinton 158–160, 172
Proudfoot, William 279
Pryde, James 146, 155, 240
Purvis, John Milne 279

Raeburn, Agnes Middleton 279
Raeburn, Ethel Maud 279
Ramsay, Allan 16, 22, 35
Ramsay, Allan (poet) 29, 52
Ranken, William Bruce Ellis 279
Rankin, Arabella Louise 279
Rankin, Andrew Scott 279
Rattray, William Wellwood 280
Redon, Odilon 172, 213
Redpath, Anne 211, 215–16, 244, 280
Regnordson, W. Birch 280
Reid, Alexander 206
Reid, Archibald David 280
Reid, Flora Macdonald 280

Reid, Sir George 127–9, 280
Reid, John Robertson 280
Reid, Samuel 280
Ressich, John 210
Reville, James 280
Reynolds, Sir Joshua 29
Reynolds, Warwick 223, 225, 280
Ricardo, Halzey 107
Rich, Alfred 240
Richardson, Joseph Kent 280
Riddell, James 280
Ritchie, Alexander 280
Ritchie, David 281
Roberts, David 50, 72, 75, 78–82, 92, 132, 151
Robertson, Alexander Duff 281
Robertson, Alexander 281
Robertson, Andrew 281
Robertson, A. D. 281
Robertson, Archibald 281
Robertson, Archibald 281
Robertson, Eric Harald 190, 192–5, 220
Robertson, Graham 133
Robertson, J. D. 281
Robertson, M'Culloch 281
Robertson, Tom 281
Robinson, Caley 195
Roche, Alexander 149, 150
Roelofs, Willem 130, 161
Romanticism 134
Ronald, Alan Ian 281
Rose, Robert Traill 196–7
Ross, Christina Paterson 281
Ross, Robert Thorburn 129, 281
Ross, Joseph Thorburn 281
Ross, Tom 281
Rossetti, Dante Gabriel 97, 193, 195, 242
Roussel, Theodore 133, 140
Rowat, Jessie (see Mrs Francis Newbery)
Runciman, Alexander 15, 22–4, 25, 29, 32
Runciman, John 282
Ruskin, John 79, 80, 81, 82, 93–4, 95, 96, 97, 100, 101, 102, 108–9
Russell, Walter 146
Rutherford, Joyce Watson 282
Rutherford, Maggie 282
Ruthven, Lady Mary 114, 282

Salmon, James 188
Sandby, Paul 15, 16, 29
Sanders, George 282
Sanderson, Robert 282
Sargent, John Singer 133, 155
Sassoon, David 282
Schetky, John Alexander 282
Schetky, John Christian 282
Scott, David 94, 97, 99–100, 282
Scott, Robert 61, 90
Scott, Tom 162–5, 241, 282
Scott, Walter 282

Scott, Sir Walter 33, 50, 53, 62, 66, 72, 165
Scott, William Bell 97–9, 282
Scottish Art Review 137, 140
Seaton, R. 282
Segonzac, Dunoyer de 208
Sellar, Charles 282
Sellars, D. Ramsay 282
Seton, Mary E. 282
Shakespeare, William 30, 108
Shanks, William Somerville 159, 283
Sharpe, Charles Kirkpatrick 283
Shearer, James Elliot 283
Sheriff, John 283
Sheriff, William 283
Shield, Jane Hunter 283
Shiells, Thornton 235, 283
Shirreffs, John 283
Sickert, Walter 159
Sidaner, Henri Eugene le 192
Sim, Agnes Mary 283
Simpson, William 'Crimean' 78, 82–3, 89, 132, 283
Simson, William 46, 63, 88, 283
Sinclair, Alexander Garden 283
Skene, James of Rubislaw 50
Sloan, Christine S. 283
Small, David 283
Small, John W. 283
Small, William 283–4
Smart, John 125, 284
Smashers' Club 66
Smieton, James 284
Smith, Alexander C. 284
Smith, Alexander Munro 284
Smith, David Murray 284
Smith, Edwin D. 284
Smith, Garden Grant 154, 155, 284
Smith, Jane Stewart 284
Smith, John Guthrie Spence 193, 220, 222, 284
Smith, Joseph Calder 284
Smith, Tom 284
Smith, William Ryle 211, 284
Smyth, Dorothy Carleton 284
Smyth, Olive Castleton 284
Smyth, James 284
Society of Antiquarians of Scotland 19, 27
Somerville, Daniel 284
Southall, Joseph 242
Spence, Harry 145, 285
Spencer, Gilbert 234
Spencer, Sir Stanley 159, 234, 242
Stanfield, Clarkson 75, 78
Stanton, George Clark 108, 285
Steell, Gourlay 285
Steer, Wilson 140
Stein, James 285
Stevenson, James 51
Stevenson, Robert Macaulay 126, 150, 285
Stewart, Henry 285
Stewart, Nellie 285
Stokes, Adrian 183

Story, Elma 285
Stott, William of Oldham 152
Strang, Sir William 151
Struthers, M. Fleming 285
Stuart, Sir James 285
Sturrock, Alick Riddell 220, 222, 285
Sturrock, Mary Newberry 220, 285
Sutherland, the Duke of 74
Sutherland, David Macbeth 193, 211, 219–20, 285
Symbolism 172–3, 188, 198, 199–201, 213
Syme, Patrick 51

Tarbert, J. A. Henderson 285
Taylor, Ernest Archibald 181, 185, 188, 191, 208, 220
Taylor, John D. 139, 285
Taylor, William 285
Templeton, Rosa Mary 285
Terris, John 153–4, 285
Thomas, Albert Gordon 226–7, 286
Thomas, Grosvenor 150, 286
Thomson, Adam Bruce 192, 211, 215, 219, 220–1, 286
Thomson, Alexander P. 286
Thomson, Horatio 286
Thomson, John, of Duddington 34, 37, 111, 286
Thomson, J. Leslie 286
Thomson, John Murray 223, 286
Thorburn, Archibald 169–71
Torrance, James 188
Trevelyan, Sir Walter 97
Trotter, Alexander Mason 286
Tuke, Henry Scott 137
Turner, Joseph Mallord William 53, 76, 243–4

Urquhart, Annie 183
Urquhart, Murray McNeel Caird 238, 240, 286

Valencienne, Henri de 73
Vallance, William Fleming 124, 286
Velasquez 55, 64
Vernet, Horace 75
Vienna 178, 203
Victoria, Queen 56, 72, 74, 75–6
Vlaminick, Maurice de 208
Vorticism 191, 194

Walls, William 149, 171, 192, 222, 286
Walker, Ada Hill 286
Walker, Fred 163
Wallington Hall (Northumberland) 97–8
Walton, Cecile 193, 194–5, 220
Walton, Constance 286
Walton, Edward Arthur 126, 130, 131, 138–41, 143, 145, 146, 193, 202, 220, 286
Walton, Hannah 286
Warner, Phillip Lee 237

Watercolour Technique 33, 43–5, 119, 133, 138, 141, 145–6, 148, 205, 214, 237
Watson, George Patrick Houston 287
Watson, James 287
Watson, T. R. Hall 287
Watts, D. 287
Webb, Thomas 287
Weir, Walter 287
Weir, Wilma Law 287
Weissenbruch, Jan Hendrik 130, 161, 243
Wellington, Duke of 56
Wells, William Page Atkinson 162, 163, 287
West, Benjamin 52
West, David 232–4
Westminster, Palace of 95, 97
Whistler, James Abbot McNeil 131, 140, 143, 147, 173
White, E. Fox 108–9
White, Gleeson 177
White, John 287
Whyte, John G. 287
Wilkie, David 45, 46, 52–9, 60, 61, 62, 63, 65, 66, 79, 132, 242, 287
William IV 56
Williams, Hugh 'Grecian' 29, 33, 34, 37, 38, 40–5, 51, 111
Williams, James Francis 287
Williams, Mary 260
Williams, Thomas 287
Wilson, Alexander 287
Wilson, Andrew 33, 34, 37, 45–7, 53, 55, 60, 63, 73, 84
Wilson, Charles Heath 83–4, 95, 287
Wilson, David Forrester 287
Wilson, George 107
Wilson, Margaret Thomson 288
Wilson, Mary Georgina Wade 288
Wilson, James C. L. 288
Wilson, John 'Old Jock' 49–50, 79
Wilson, Peter Macgregor 288
Wilson, Thomas 288
Wilson, Wiliam 216–17, 288
Wilson, William Heath 288
Wingate, Helen 287
Wingate, Sir James Lawton 167, 288
Wint, Peter de 165
Wintour, John Crawford 125–6, 288
Wishart, Peter 210, 288
Wood, Frank Watson 288
Wood, Robert 16
Woolnoth, Charles Nicholls 107, 288
Wright, Margaret Isobel 288
Wright, James 288
Wylie, Kate 288
Wyper, Jane Cowan 288
Wyse, Henry 157

Young, Bessie Innes 288
Young, Robert Clouston 160–1, 289
Young, William 289
Younger, Jane 289

Zentner J. L. C. 16